W9-ASP-948

PN Cohen, David S.
1993.5 Screen plays
.U6
C623 89051405
2008

PN
1993.5 Cohen, David S.
.U6 Screen plays
C623
2008 89051405

MAY 0 8

DAVID GLENN HUNT
MEMORIAL LIBRARY
GALVESTON COLLEGE

DAVID GLENN HUNT
MEMORIAL LIBRARY
GALVESTON COLLEGE

SCREEN PLAYS

SCREEN PLAYS

HOW 25 SCRIPTS MADE IT TO A THEATER NEAR YOU—FOR BETTER OR WORSE

David S. Cohen

DAVID GLENN HUNT
MEMORIAL LIBRARY
GALVESTON COLLEGE

HarperEntertainment
An Imprint of HarperCollins*Publishers*

SCREEN PLAYS. Copyright © 2008 by David S. Cohen. All rights reserved. Printed in the United States of America. No part of this book may be used or reproduced in any manner whatsoever without written permission except in the case of brief quotations embodied in critical articles and reviews. For information address HarperCollins Publishers, 10 East 53rd Street, New York, NY 10022.

HarperCollins books may be purchased for educational, business, or sales promotional use. For information please write: Special Markets Department, HarperCollins Publishers, 10 East 53rd Street, New York, NY 10022.

FIRST EDITION

Designed by Daniel Lagin

Library of Congress Cataloging-in-Publication Data has been applied for.

ISBN 978-0-06-118919-7

08 09 10 11 12 WBC/RRD 10 9 8 7 6 5 4 3 2 1

For Esther, who left too soon, and for Sue Ellen and Miranda, who arrived just in time

CONTENTS

SCREEN PLAYS

INTRODUCTION

What's the best thing you ever wrote?

It's not a trick question. Pretty much everybody, at some point in life, puts pen to paper, or fingers to keys, to express something important. A poem. A business proposal. Song lyrics. A joke. Maybe a love letter.

If you're not a writer by trade, that's probably where it ended. You wrote it, someone read it.

But did you show it to anyone before you sent it? Did someone change it without permission? If it was a class project, did your teacher suggest improvements? Did you take those suggestions? If so, how did you feel afterward? Did the suggestions really help? Even if they did, did it mean as much to you as it did before?

Complicated, isn't it?

WHEN I was maybe twelve years old, I was in an art class, and I was making a candleholder in the shape of a sperm whale. I wasn't trying to make something particularly creative, just a candleholder. The tail was the handle, and the candle went in where the whale's blowhole would be.

My art teacher told me it would be more interesting if the tail were bent. Then he bent the tail—just a little, but enough to make it different. That's how it was fired and that's how it came back to me for posterity. My parents still have it in their house. Sometimes I come across it when I'm visiting them. I still get irritated, thirty-five years later, every time I see that bent tail. Maybe it is more interesting that way, but it isn't what I wanted it to be, and it never will be.

I could bury it someplace where I won't have to look at it anymore, but I'm convinced that if I do, in five thousand years, some future archaeologist will unearth it, look at my signature in the clay, and say, "Pretty good candleholder, except for that bent handle. Bad choice by David Cohen, that. Why would he have done such a thing?"

Well, Mr. Future Archaeologist, he did it because he was twelve and he had a hard time standing up to his teacher. Because he thought maybe it *would* be more interesting if the tail were bent. Because he hadn't learned yet that people who want to help you, no matter how well-meaning, don't necessarily share your taste, or that other people make changes to suit *their* needs, even though it's *your* candleholder, with *your* name on it, and *you're* the one who's going to have to live with the results.

Yeah, that tail still bugs me.

What may bug me more is how hard it was to learn the lesson of that experience. If I could go back in time and visit myself on the day I brought that candleholder home, I think I'd put my arm around the boy's shoulders and say: "Young David, if that candleholder bothers you, never, never, *never* try to be a screenwriter."

Guess it's just as well I can't do that. I probably wouldn't have listened to me anyway.

THIS is a book about twenty-five movies and how their tales, so to speak, got bent. Many of these movies are good; some of them are bad. Some are good because a lot of people bent their tale. Others are good because nobody did. Some are bad for the same reasons.

This is not a book about how to write a hit movie. If I knew how to do that, I'd be doing it. For that matter, there's no reason to think that *anybody* knows how to write a hit movie. Nobody cranks out hit after hit without a break. Pixar Animation Studios, collectively, managed to do that for its first twenty years or more, but that was not the work of a single screenwriter. Besides which, there probably isn't any single strategy that works in every situation. What worked for Todd Solondz when he was writing *Happiness* or Sofia Coppola when she was putting together *Lost in Translation* would never have worked for Ken Nolan trying to adapt *Black Hawk Down*, for Jerry Bruckheimer or David Franzoni trying to keep *Gladiator* on track for Steven Spielberg and DreamWorks. Writing a spec script is different from adapting a novel is different from writing from a pitch.

Instead of being about "how to do it," this book is about "how I did it"

(apologies to Mel Brooks). It looks at how these twenty-five screenplays got written. Part of that process happens with a writer alone, often in the dead of night, balancing perfectionism and impatience. That is the part that most "how to write a screenplay" books address. The problem with those books is that they tend to minimize what happens when the screenplay actually might be produced.

Writing a *movie* is a bit different from writing a screenplay. With the possible exception of homemade animation, movies are a collaborative effort. Turning the screenplay into a movie means working with producers, investors, a studio or distributor, actors, and usually a director. All have desires that must be considered, whether it's a financier's need for a reasonable expectation of a return on her investment or a star's aversion to disappointing his fans. That process of getting notes, rewriting, fighting for some things and letting go of others, getting fired and rewritten, even occasionally getting rehired, is as much a part of writing a movie as the thrashing out of the first draft.

I wrote the first versions of these stories for *Script* magazine's "From Script to Screen" series, which I've been writing, with occasional interruptions, since 1997. When we started, the editor of *Script*, Shelly Mellott, asked me to read the script for *The Pallbearer*, then see the movie, and compare the two. No problem; I was just making the transition from screenwriting to journalism, and I was glad just to be writing for publication and getting a little money back. I wasn't very comfortable, though, with a series of articles that was only my opinions and observations. I mean, I'm a pretty smart guy and a pretty good writer and all, but who cares what I have to say, really?

At the beginning of 1998, I talked Shelly into letting me include quotes from the writer in the story. She was a little skeptical at first, but the movie was *Fallen*, and I got a one-on-one interview with screenwriter Nick Kazan, who is nothing if not opinionated. There was some good backstory, too: Kazan had fought behind the scenes to keep his sophisticated supernatural thriller from becoming an Arnold Schwarzenegger action movie. The article was a hit, and Shelly was sold. "From Script to Screen" stopped being opinion/criticism (well, mostly) and turned into, dare I say, actual journalism.

Before we go further, let me lay out my biggest bias in these articles. As far as I'm concerned, in every "From Script to Screen" story, the writers are the heroes. Always. Sometimes they're flawed heroes, sometimes they're lonely heroes, but they're heroes nonetheless. Sometimes they came up with amazing ideas out of whole cloth, extempore from their mother wit. Sometimes

they had the insight to crack an adaptation problem that nobody else could solve.

Some of them were hired guns, just doin' a job and tryin' their best on a project where hardly anybody cared whether the script was really any good, as long as it would lure a couple of stars to be in the picture and the studio could get the film out for its release date. As far as I'm concerned, those guys are heroes, too.

One thing I learned, though, is that in Hollywood, the heroes don't always win—at least, not offscreen.

One successful screenwriter observes that when movie people have meetings, people defer to the cinematographer on matters of lighting, because he's the cinematography expert. They defer to the production designer on the look of the movie, because she's the design expert. But nobody defers to the screenwriter as the story expert. Almost everyone feels free to talk to the screenwriter as if anyone could do story better than he can.

There are plenty of reasons for this. One is that a good script often looks effortless. The story flows so smoothly that you can't imagine it turning out any other way. The characters say what they say and do what they do because it's their nature. The whole thing seems to just work.

In fact, it seems so solid, so inevitable, that it looks easy to improve it. Can't we try *this*? Wouldn't it be more interesting if we did *that*? I'd like it if we could put *this* in . . .

Writers know, though, that a structure that looks as solid as a granite statue can actually be as delicate as a silk tapestry. Pull on a thread and the whole thing can unravel. Nonetheless, development executives, directors, and stars yank on those threads, then leave the writer to try to weave something beautiful from the debris. As a result, studio "development" is one of Hollywood's ongoing embarrassments. A studio will buy a spec script for a small fortune, put it through years of expensive rewrites, and at the other end of the process wind up with something they never would have paid ten cents for if it had been sent to them in the first place.

Once a script has been through that process, it's hard to go back. Too many people have invested money and effort in changing it. Sometimes, though, it happens. Clint Eastwood endeared himself to writers everywhere when, after coming on board as director of a Western written by David Webb Peoples (best known then for *Blade Runner*), he read every draft and declared the spec draft the best. It took him a while to make the film, but when he did, he didn't change much. His biggest change may have been the name. *The*

Cut-Whore Killings was dropped for a simpler title: *Unforgiven*. Peoples got an Oscar nomination and the movie became a classic.

Great story, huh? On the other hand, a couple of years later my brother, then an executive for Savoy Pictures, read another David Peoples script. He raved about it. Warner Bros., the same studio that released *Unforgiven*, bought it. But this one didn't go to Clint Eastwood; it was directed by Paul W.S. Anderson. It was called *Soldier*, and while I don't know what happened along the way, it wasn't a classic. As of summer 2007 Peoples hasn't had another movie made since.

That's life—for a screenwriter.

NOW, a word from your author:

The world will little note nor long remember the details of my career, but let me tell you a story never written in *Script*, or anywhere else in print for that matter: the story of how I came to know the ups and downs of the screenwriting life, my own "From Script to Screen" story.

I was a theater brat. I grew up in Brighton, a suburb of Rochester, New York, and in those days Brighton High was a bit of a theater factory. We did two or three shows a semester and turned out more than the typical number of showbiz pros: actor and sometime soap star Aaron Lustig and Emmy-nominated production designer Scott Heineman were a few years ahead of me. My brother Steve and his pal Ken Sanzel, both screenwriters, were a few years behind me. There are plenty more.

I worked on every show I could. If I wasn't acting, I was stage managing or designing lighting or whatever else I could do. I got the bug for stage directing in those years and studied acting and directing at SUNY Albany. I did well there, graduating with honors and becoming the first theater major in the history of the university to be inducted into Phi Beta Kappa.

None of which mattered one whit when I hit the streets.

I did a season of regional theater as a stagehand at Geva in Rochester, then moved to New York, determined to take a shot at a Broadway career. Camped out on a friend's floor in Woodside, Queens, close enough to the elevated 7 train line to be awakened by the trains at rush hour. Directed half of a bill of one-acts for an upstart theater company. Later auditioned for a production of Gorky's *Summerfolk* for the same troupe, got cast as one of the young lovers, a small part in a big ensemble. I did fine. But I became convinced that the world didn't need me as an actor.

Directing, however, was another matter. I was good at it, despite severely

underdeveloped people skills, and became convinced I could really make an impact on the theater scene as a director. I directed another one-act for another upstart theater company, even got a good review in the *Village Voice*.

But I was spinning my wheels. I was working a day job, doing theater by night, getting nowhere—a common experience, I think. Many years later I interviewed John McTiernan, the director of *Die Hard* and the remake of *The Thomas Crown Affair*. He, too, had come from upstate New York with the dream of being in theater.

"I wanted to be a stage director, but I didn't have a trust fund," said McTiernan. "It's a gentleman's avocation. It's not a career."

Yup.

So there I was, a few years out of college, realizing that the career I'd wanted wasn't a career at all—unless you happened to be Trevor Nunn or Jerry Zaks—and not sure what to do next. I decided I'd better learn the business side of show business.

So I started "interning" for a casting director—in other words, working for free two days a week. That led to some actual jobs in casting, including a stint working for Broadway casting directors Meg Simon and Fran Kumin. I assisted with casting for a few Broadway shows, including the famous Peter Allen flop *Legs Diamond* and the prizewinning *M. Butterfly*.

Now, I've done a lot of things, onstage and backstage; I've seen my byline on front-page stories and my credit on TV screens. But the biggest thrill I ever got from work was walking in the stage door of a Broadway house and hearing the doorman say, "Hi, David." I still get chills thinking about it.

But work got slow and Meg and Fran had to lay me off. I immediately landed a job for the head of the literary department at Agency for the Performing Arts, a midsize bicoastal agency. My boss, Rick Leed, represented film and TV writers.

It was a great education for me. I learned how writer deals worked, and I got that business education I'd wanted. I also began to see that while the writers I helped represent were very creative, hard-working people, they weren't necessarily any more creative or hard-working than the people I did theater with at night. They did, however, get paid a lot more money, and as I was now thirty years old and still struggling to make ends meet, that was getting more important.

Something else was percolating, too: I was beginning to have glimmerings that I should try writing. My mother, bless her heart, had always said I

should be a writer, but I'd never overcome the fear of the blank page. Then a close friend died in an accident. I was badly shaken, as were all his friends, and I wrote a condolence letter to his parents. I heard later that the letter had been a comfort to them and that they'd showed it to many of their visitors. It began to occur to me that maybe my writing could be useful. I was sure the world didn't need me as an actor, but maybe it did need me as a writer. To get there, though, I needed a little inspiration.

It came in two pieces.

Let me back up and say that I grew up a bit of a horror and sci-fi geek, the kind of kid who read *Famous Monsters of Filmland* and studied the makeup techniques of Lon Chaney. *Dark Shadows*? Loved it, though I had to sneak it behind Mom's back. Reruns of *Star Trek*? I'm there. Heck, I even liked *Space: 1999* and *UFO*.

So in New York in the late 1980s, I never missed an episode of *Star Trek: The Next Generation*. In the show's third season, which aired while I was working at APA, was an episode called "Who Watches the Watchers." Great episode, amazing writing. And as a bonus, onetime *Dark Shadows* babe Kathryn Leigh Scott was a guest star.

It turned out the script had been written by two APA clients, Hans Beimler and Richard Manning. So I called their agent in the LA office and told him how much I'd enjoyed the episode. He said to call them and tell them. I called their office at *Star Trek*. Their assistant said, "When are you coming out here to visit?"

Visit? Visit the Paramount lot? Visit the *set*?

So that December, despite a nasty case of bronchitis, I got on a plane for Los Angeles. Got to watch part of an episode being shot ("Yesterday's Enterprise" for you Trekkers). Came back feeling itchy to be part of it. Began to tumble around an idea for a *Star Trek* story I wanted to see.

Then the other shoe dropped: A *Star Trek* episode aired that was absolutely awful. Incoherent, annoying, badly written. Lame. As bad as "Watchers" had been good. I won't name it, to protect the innocent.

I thought, "Sheesh, I can do better than that."

Can't I?

So a few days later, I called up one of my oldest friends, Martin Winer. Martin and I had been pals since our days at Brighton. We met in ninth grade biology, when we were teamed to dissect a frog. Or so Martin says. He remembers me; I remember the frog. (That's not a slap at Martin. You see,

something happened while I was, um, working on the frog. I slipped with the scalpel and accidentally cut something in the frog I wasn't supposed to and . . . well, I don't wanna talk about it.)

Anyway, Martin and I did a lot of theater together, pined after the same girls, groused over not getting the same parts. Then he graduated early and went off to college. By the time I was tumbling over the idea of being a writer, he was a PhD in physiology with experience in recombinant DNA—in short, a gene jockey. He was working at a lab at Columbia but didn't seem to me to be any happier with his science career than I was with my theater career.

I asked him if he wanted to write a *Star Trek* script with me and pitched him an idea. He thought about it a little and said yes. We turned out to be a good team. I was a theater guy who mainly read nonfiction, especially popular science, for pleasure. He was a scientist who devoured science fiction and fantasy novels. So I'd come in and pitch some weird science thing I'd just read about in so-and-so book by Michio Kaku and he'd say that Neal Stephenson or Bruce Sterling had done that in such-and-such novel.

Eventually we wrote a *ST:TNG* spec and sent it in. The producers liked it enough to invite us to come in and pitch. Being new to this, we were unduly excited. We paid our way to L.A., stayed with friends, went in for a meeting. Saw Gene Roddenberry riding in one of those studio golf carts, with "Enterprise" stenciled on the side. Didn't meet him, though.

Sat down to pitch, feeling good. Halfway through our first pitch, they stopped us and said that we were doing something in the story that they don't like to do. I'll spare you the details of what that thing was, but my stomach turned over. We had been very careful to bring in a wide variety of pitches, but they had picked out the one thing they all had in common—something that, until that moment, we hadn't even given any thought to. We were dead in the water and we knew it.

We finished our pitch, mostly for the practice, though Martin and I didn't need a lot of practice pitching. We'd both been actors and we were good at it. They were gracious enough to let us finish, and they complimented us on our pitching. But the bottom line was "Thanks for coming, guys. Feel free to come in again. Buh-bye."

We went out drinking that night at Dominick's, an old Rat Pack hangout in West Hollywood, with some of my friends from APA. I was so down that I didn't even notice that the cute redhead behind the bar would have been happy to console me. Or so a friend said later.

Back in New York, Martin and I decided to move to L.A. and really give

this writing thing a try. My boss took a job for some of his clients, working as president of Wind Dancer Production Group, the company that made the show *Home Improvement*. He brought me with him to Los Angeles. I settled in Hollywood. Martin came out some months later.

By the time he arrived, having worked first in an agency and then at a TV production company, I knew something about how to go about this. The rule of thumb for an aspiring TV writer was not to write a script for the show you want to work on, but for some other show.

For example, if you write a spec *Everybody Loves Raymond* and send it to the producers of *Everybody Loves Raymond*, they pick it apart, saying "That's not right" or "We wouldn't do that." Instead, if you want to write for *Everybody Loves Raymond*, you should write a spec *Two and a Half Men* and send it to *Raymond*, where (with luck) the producers will laugh and invite you in for a meeting. If all goes well, maybe you get an assignment, then get on staff, and you're on your way.

Well, a poker buddy of ours, actor Dick Herd, was a regular on *SeaQuest DSV*, Steven Spielberg's futuristic undersea NBC series. We figured we had a connection there and could at least get our script read. So we set about working on a spec for another show we liked: *Star Trek: Deep Space Nine*.

We had enjoyed *Deep Space Nine*'s pilot and the mythic overtones it suggested, as the show's protagonist, Commander Sisko, was believed by an alien race to be the "Emissary" from their gods, as prophesied in their scriptures.

It occurred to us that Sisko's bosses couldn't be very comfortable with that. What if they pulled a *Heart of Darkness* on him and sent someone to extract him from this situation? The perfect chance to do so, we decided, was if there was some specific prophecy about the Emissary. If Sisko doesn't fulfill the prophecy, that would, ipso facto, prove he's not the Emissary. We'd raise the stakes by having a pencil-pushing staff officer threaten to transfer him to another command if he doesn't end this "Emissary" talk.

The problem, we decided, was that Sisko really *was* the Emissary, so every effort to extricate him from this situation only furthered the prophecy. By the end, even the pencil-pushing staff officer has played a role in the prophecy and is in it as deep as Sisko, so Starfleet Command decides to just live with the whole situation.

We had a great time writing it. We named the admiral sent to relieve Sisko "Marlowe" as an homage to *Heart of Darkness*. We named a character "Yarka" after one of my favorite theater professors at SUNY Albany, Jarka

Burian. We spent some time coming up with a set of rhyming couplets for the prophecy; the meter scanned and everything. We even wrote a "Rule of Acquisition": "Faith can move mountains of inventory."

We called the script "Destiny."

It came out pretty darn good, if I do say so myself. If you want to see what our spec draft looked like, you can download it from my website.

So we gave it to Dick Herd, who passed it along to the *SeaQuest* producers. Since it had come out so well, I called up one of the assistants at the APA office in L.A. and asked her to send it in to *Star Trek*. What the heck, right?

Months passed. We never heard an answer from *SeaQuest*, despite Dick's inquiries, though to be fair that show had bigger problems than the status of an unsolicited spec script from a couple of unproduced writers who happened to play cards with one of the actors. Then, out of the blue, while I sat at my desk at Wind Dancer, came a phone call from my friend at APA.

"*Star Trek* loves your script," she said. "They want to buy it. They said, 'We want to be in business with these guys.'"

Oh . . . my . . . God.

Soon the deal was done. Martin and I shopped for agents, settling, unwisely, on a team of big-time spec agents at one of the big agencies. Meanwhile we prepared for our shot at being TV writers. I asked a young writer working at Wind Dancer, Rita Hsiao, if she had any advice for our first story meeting with the show's producers.

"Uh-huh," she said, nodding. "Uh-huh, uh-huh, uh-huh."

Good advice. I like Rita Hsiao.

So one morning we drove yet again through the arched gates of Paramount to our first story meeting. I brought my favorite Chinese tea and a mug, just to have something familiar with me to calm my nerves. We were ushered into a large office where the show's writers congregated to greet us. They were very friendly. I was very nervous.

Ira Steven Behr, the number-two writer-producer on the show, said they loved our Rule of Acquisition. That made me feel a little less nervous, but not much.

Michael Piller, the executive producer and showrunner, called the meeting to order.

"Congratulations, guys," he said. "You've written the best spec script ever for our show." I am sure I was very proud to hear that, or I would have been, if he hadn't kept right on talking.

"There's just one thing that we need to change . . ." That thing, he said,

was that he didn't think Starfleet would threaten to relieve Sisko of his command.

What went through my head, at that moment, was *This script will never work without that*. More than ten years later, I have a little bit more sympathy for Piller's position than I did at the time. It doesn't seem like that hard a change. What's the big deal? But we had bled and sweated over that script, argued over it, thrashed it out a dozen different ways. I just *knew*.

But that's not what I said. I said, "Uh-huh." I did point out, I think, that we needed to raise the stakes in the story somehow, and that without the threat of Sisko's transfer we'd need to come up with something else. They agreed.

So we spent that meeting coming up with a new story outline, and then Martin and I went off to write it up. I was still optimistic. I felt like we'd done well, we'd held our own. We belonged. And the outline they gave us didn't seem *so* hard to write, after all. If we could just do a good job with their changes, we'd be fine.

In the middle of our rewrite came another phone call. They were having trouble with a script; would we want to take a crack at rewriting it on very short notice? It would start shooting in about five days.

Later I would learn that this was their way of auditioning writers for a staff job, which was exactly the shot we wanted. Apparently, my instincts about our first meeting had been right. Our writing was good, we'd been agreeable enough in the writers' room, and *Star Trek* had a tradition of finding writers this way—including Ron Moore, who went on to great success as the showrunner of the new *Battlestar Galactica*.

So they messengered us copies of the script and the outline. We opened the envelope and started reading. What followed was a moment of slack-jawed astonishment that only someone who grew up with *Star Trek* can fully appreciate. Those of you who didn't, well, humor me for a moment.

The episode in question, called "Detour," was the first episode to revisit the "Mirror, Mirror" universe established in the original series. (Non-Trekkers: Think of this as a parallel universe where each of our heroes has an evil twin. Where our Federation is benevolent, the Empire is brutal, and so on.) Fans had been hoping to revisit this universe for the entire run of *The Next Generation*, but the producers had never done it. Now they were handing us a chance to write the episode.

But what was *really* amazing, we thought, was that the outline they sent us stunk. It read like a parody. We sat around laughing and doing Nancy Kerrigan

impressions: "Whyyy, whyyy, whyyyyy?" We could certainly do better than *that*.

This, in hindsight, was our moment of hubris, and the screenwriting gods punished us for it with Sophoclean precision.

We stayed up all night, hammered out an outline we liked. For some reason, we couldn't get it to print properly, and we were punchy; "it may well be the only time in my life I've actually been incapacitated by laughter," Martin says now. The next morning we sent it to Ira Behr, who was working with us on this. It was so different from what they'd given us that we even gave it a different title, "Crossover," which had to do both with the characters crossing into different universes and crossing over various lines of behavior.

Now, I should have known better from my days around *Home Improvement* and the other Wind Dancer shows, and if you've ever worked as a TV writer, by now you're probably already shaking your head in anticipation of the disaster to come. In television, you see, the writer writes what the outline *says* he should write. The outline is worked out by the writer-producers. The story in it is tested and scrutinized; everybody gets to slam the doors and kick the tires. Before it's official, the showrunner signs off on it. Only then is it given to the writer to be turned into a script. At that point, the writer does not have license to change the outline. Period, the end, roll credits, house lights up.

If you're a writer on a series, especially an outside writer on a freelance assignment, that outline is *God*. Or at least the word of God.

If Ira Behr had given us the speech I just gave you, we would have been frustrated and disappointed, but we would have written the outline. He didn't. He said, "Okay, guys . . ." and told us to go for it.

So we stayed up all night again and wrote the first couple of acts, from our own outline, then sent them over to Paramount.

I don't know exactly what happened next. I have this vague picture in my head of Michael Piller getting the script and asking Ira, "What the $*%! is going on? This isn't the outline." And Ira basically saying, "I don't know what they're doing." But maybe he said, "They sent me a new outline and I said okay." Maybe. I don't know, I wasn't there.

What I do know is that a phone call came, in which we got a very short version of the "the outline is God" speech. Crestfallen, we wrote up the rest of the script according to the outline. But by that point, I think, we had pretty much blown the audition.

That left our own script still to be rewritten. We did a completely new script, with entirely new scenes and dialogue based on the new outline we'd

gotten. They didn't like it. We came back in. We went to the writers' room. They beat out a new outline with us, this time bringing other writers into the room to join us. Martin reminds me: "Each time we did an outline with them we'd only get about as far as the middle of Act Three. Then they'd go off for lunch and tell us to finish up the rest of the script on our own." We wrote it. Another page-one rewrite. They liked it even less.

Now we were down to our last contractual rewrite under a scale WGA contract, the "polish." We came back in, this time with still more writers in the room, and they beat out part of yet another page-one rewrite and sent us off to write it. They hated it.

And that was that.

"Destiny" had become a "troubled script," now in worse shape than that awful *ST:TNG* script that had made me think "I can do better than that" in the first place. Someone eventually rewrote "Destiny," we never knew who. Piller and the other producers had promised to invite us to the set, since it was our first script, so we could watch a little filming and meet the cast, but when I called to see when we could come in, his assistant told us they'd finished shooting it already.

There was a little good news: They gave us sole "written by" credit. We decided to take that as an "attaboy" for our hard work. Either that or nobody wanted their name associated with it. I never asked which.

The show aired some months later. Not a word of our dialogue made it in, not even that Rule of Acquisition they'd liked so much. In fact, more of our dialogue made it into "Crossover," the script we rewrote, which doesn't have our names on it.

In the edited, as-aired version of the show, they kept the basic "A" plot and some of our characters. For some reason, though, they mentioned the prophecy but somehow left out the information that the Emissary had a role to play in that prophecy, so as far as I'm concerned the story basically makes no sense. Buncha guys running around trying to stop Sisko from doing something, without ever saying why it matters whether he does it or not. I still get a headache when I watch it.

You can find "Faith can move mountains of inventory" in the official *Star Trek* book of Rules of Acquisition, and our names in the acknowledgments in the front. That's kind of nice.

Not so nice was something I saw years later in an authorized *Deep Space Nine* companion book (I won't plug it by name) that promised the behind-the-scenes history of each episode. The authors, who never spoke to either me

or Martin, said in their "Destiny" chapter something to the effect that the episode became a troubled script "when freelancers Cohen & Winer couldn't deliver . . ." Ouch. Well, I guess that's true. But it's also self-serving spin from the producers of the show—and we did, after all, deliver the spec they bought in the first place.

(As a result of that experience, I have tried in this book not to slam any writer I haven't spoken to. It's way too easy to get spun in this town.)

Later, a TV development executive at Wind Dancer told me that he had a friend who loved "Destiny" and said it was his favorite *Deep Space Nine* episode. Go figure. Hell, it's not even *my* favorite *Deep Space Nine* episode. They eventually did several episodes that were closer to our script than the one that has our name on it. I remember watching and thinking, "Hey, they ripped that off from our script!" then remembering they *bought* our script. They can't rip it off because they *own* it.

After the failed *Star Trek* experiment, I left my job at Wind Dancer and traveled abroad for a few weeks. Trekked in the Himalayas, ate duck tongues in Hong Kong. When I got back, Martin and I did a couple more pitches to *DS9* and eventually to *Star Trek: Voyager.* The *Star Trek* people always complimented our pitching and we were told we did "funny" really well. But they never bought anything.

Meanwhile, our agents were steering us away from pitching and toward writing feature screenplays. It was good advice. The problem with pitching a TV series is basically you're working for the show for free.

But Martin and I had a lot of trouble finishing our scripts. Martin remembers that "We'd get halfway through an outline, then one or the other of us would start pulling at that thread, and we'd be back at square one."

Worse, I'd made a huge strategic error on returning from my travels: I'd started working as a script reader. A script reader is hired by a producer, studio, or agency to read a script and write a report on it, called "coverage," with a synopsis, analysis, and a recommendation on whether to buy, consider, or pass.

I was good at it, and fast, so I made a living at it, but it was a huge mistake. Reading and writing coverage on two or even three scripts a day made me so sick of screenplays that I never wanted to work on one when the day was over. Plus the money was terrible. I had to work seven days a week to keep my head above water.

This is common, and as a result, freelance readers have a high burnout rate. Most last about two years. I lasted three, reading about six hundred scripts

and forty books in that time. By the time I gave it up, I would get physically ill when I picked up a screenplay. To this day I avoid reading scripts, which pretty much rules out any future jobs in screenplay development.

Eventually, Martin and I slogged our way to the end of a horror spec and gave it to our agent. He said, "Well, I read it and I'm not sure what to make of it."

Martin says, "I know my immediate reaction was 'A movie would be nice.'" Alas, that didn't happen. Not long after, Martin and I stopped writing together. For all intents and purposes, we didn't talk for about eight years, until I invited him to weigh in on the text you are now reading.

But even as I was drifting away from screenwriting, I was learning a new trade, though I didn't know it at the time. I was learning to get right to the heart of a story and summarize it in dispassionate, concise prose, often on a very short deadline, on a page where space was at a premium. In other words, I was learning skills I'd need to be a reporter.

A couple of years later, I befriended an editor at the *South China Morning Post* over the Internet. When she came to L.A. on business, I impressed her with how hard I worked. She was looking for a stringer in town and threw me an assignment to cover a press junket.

My first article was about *Twister*. I had no idea what I was doing. But I knew the business and I wasn't intimidated by actors or directors. My copy wasn't great, but my editor was patient. I discovered I liked this journalism thing, I was good at it, and it wasn't crazy-making, like screenwriting.

In the meantime, too, my life was unraveling, in the way that so many lives unravel in L.A. I'll skip the details, but for those considering following this path, just be warned: If you let it, L.A. will take whatever cracks you may have in your personality and blow them wide open. It's happened to a lot of people. A lot of them ended up dead. I just ended up miserable. In time, with help, my life improved.

In the meantime, a lot of things happened. Martin moved back to Rochester. Dominick's closed and reopened, trying to be hip all over again. Michael Piller died. I got a new career, one I like a lot, as a journalist, first as a freelancer and then full-time at *Variety*. I like *Variety*, by the way. There may be no more fun job in journalism than writing *Variety* headlines, and I especially liked beating the competition on a scoop. What can I say? I'm a competitive guy.

I don't miss screenwriting, though there are still a few stories inside my head trying to get out. Someday. But I'll probably write them as novels. I

want to have one version where nobody bent the tale but me. Then, maybe, if someone buys the rights, I'll see if I can get paid to write a draft. Then again, maybe not.

As for "Destiny," well, I still cash the residuals checks—oh boy, do I cash them—and one of these days I'll buy the DVD. Enough time has passed that it might be nice to hang a blowup on the wall of the screen that says "Written by David S. Cohen & Martin A. Winer." Mainly, though, I console myself with the thought that somewhere, someday, a young soon-to-be writer will watch "Destiny" on DVD or Spike TV or something and think, "Sheesh! That was lame and made no sense. I can do better than that. Can't I?"

Go get 'em, kid. Godspeed.

Gladiator

CREDITS

DIRECTED BY Ridley Scott
SCREENPLAY BY David Franzoni and John Logan and William Nicholson
STORY BY David Franzoni
PRODUCERS: Branko Lustig, Douglas Wick, and David Franzoni
EXECUTIVE PRODUCERS: Laurie MacDonald and Walter F. Parkes
STUDIO: DreamWorks SKG
PRODUCTION COMPANY: DreamWorks SKG
ORIGINAL MUSIC BY Hans Zimmer and Lisa Gerrard
CINEMATOGRAPHY BY John Mathieson
FILM EDITING BY Pietro Scalia
CASTING BY Louis Digiaimo
PRODUCTION DESIGN BY Arthur Max
SET DECORATION BY Crispian Sallis
COSTUME DESIGN BY Janty Yates

MAJOR AWARDS

ACADEMY AWARDS: Best Picture; Russell Crowe—Actor; Tim Burke, Neil Corbould, Rob Harvey, John Nelson—Visual Effects; Janty Yates—Costume Design; Scott Millan, Bob Beemer, Ken Weston—Sound
GOLDEN GLOBES: Best Picture (Drama); Hans Zimmer, Lisa Gerrard—Original Score
BAFTA AWARDS: Best Film, Audience Award; Best Picture (Drama); Arthur Max—Production Design; John Mathieson—Cinematography; Pietro Scalia—Editing

CAST

Russell Crowe . . . *MAXIMUS*
Joaquin Phoenix . . . *COMMODUS*
Connie Nielsen . . . *LUCILLA*
Oliver Reed . . . *PROXIMO*
Richard Harris . . . *MARCUS AURELIUS*
Derek Jacobi . . . *GRACCHUS*
Djimon Hounsou . . . *JUBA*
David Schofield . . . *FALCO*
John Shrapnel . . . *GAIUS*
Tomas Arana . . . *QUINTUS*
Ralf Moeller . . . *HAGEN*
Spencer Treat Clark . . . *LUCIUS*
David Hemmings . . . *CASSIUS*

BUSINESS DATA

ESTIMATED BUDGET: $103 million
RELEASE DATE: May 1, 2000
U.S. GROSS: $187.7 million
FOREIGN GROSS: $271 million

REVIEW HIGHLIGHTS

"After an absence of 35 years, the Roman Empire makes a thrilling return to the bigscreen in *Gladiator*. A muscular and bloody combat picture, a compelling revenge drama and a truly transporting trip back nearly 2,000 years, Ridley Scott's bold epic of imperial intrigue and heroism brings new luster and excitement to a tarnished and often derided genre that nonetheless provided at least one generation of moviegoers with some of its most cherished youthful memories." —**TODD McCARTHY,** *VARIETY*

"*Gladiator* suggests what would happen if someone made a movie of the imminent extreme-football league and shot it as if it were a Chanel commercial." —**ELVIS MITCHELL,** *NEW YORK TIMES*

1 | "GET A LIFE"

GLADIATOR • DAVID FRANZONI

With the possible exception of showbiz legacies like Jason Reitman and Sofia Coppola, everyone starts out in the movie business at the bottom of the same mountain. We look up at the summit and start trudging, daydreaming all the way about the view from the top.

Pretty much all of us imagine ourselves at a podium, statuette in hand, thanking the Academy, but other than that, we may well disagree about what, exactly, the top of the mountain *is*. Some daydream of making a film for the ages, like *Citizen Kane*; others of having millions flock to their movies at the multiplex. Some want fame, some crave respect, others just want money.

Whatever the screenwriting mountain is, by the mid-1990s David Franzoni had set up camp pretty darn near the summit. He was an established writer with money in the bank and a staff to help him. He'd been nominated for an Emmy and was the sole credited screenwriter on Steven Spielberg's slavery saga *Amistad*, so he had not just credibility, but cachet. And he was on a first-name basis with Spielberg, too—ideally positioned to pitch a movie. So well positioned, in fact, that when he pitched a big-budget gladiator movie, he barely had to open his mouth to sell it.

How many people have dreamed of being in just such a spot? But the story of Franzoni and *Gladiator*, while generally a happy tale, is a warning that in movies—as in mountaineering—the weather at the summit can turn very, very suddenly, for better or for worse.

I met Franzoni at the bar at the Peninsula Hotel in Beverly Hills, steps away from the movie business's epicenter of excess, the I. M. Pei–designed headquarters of the Creative Artists Agency. Not coincidentally, CAA repped

Franzoni. He doesn't carry himself like an ink-stained wretch; he arrived in a sport coat and slacks, not worn jeans, looking less like a writer than a producer—which, as it happens, he is. He was credited as a producer on *Gladiator*; a few months later, that credit would put a Best Picture Oscar in his trophy case.

Nor is Franzoni the classic tortured, introverted writer. He is raw and enthusiastic. He tells gripping, funny stories. He can talk for an hour and leave you wanting more. If ever a man was born to pitch, it's Franzoni. He also, as it turns out, is a self-described "bad boy" and not one to take an insult lying down. All these qualities serve him well in the movie business.

It was May 2000 when we met, and Franzoni was fifty-two, a twenty-four-year vet of the movie business. *Gladiator* had premiered to generally positive reviews. He'd sent me several drafts of the screenplay, but they turned out to be so different from the movie that I just let him tell me where the whole project started.

Thereby, not surprisingly, hangs a tale.

"Honestly," he said, "the idea originated when I was twenty-two and I was bumming around the world on a motorcycle. I was in Baghdad, and I traded a really good book on the Irish Revolution for a book on the Colosseum. It was a very tawdry, exploitative book about the Roman games. It was a book by Daniel P. Mannix, who has written tons of stuff. He was a sword swallower at one time; he became a writer. He wrote the book that *The Fox and the Hound* is based on.[1]

"He took a lot of ancient sources and pieced together the story of an animal trainer in the Colosseum. He explored the provincial arenas and modern-day sort of spinoffs, but what he really did was connect in my head gladiators and O. J. Simpson, or any great athlete, and the worship of athletes.

"From that point on, even though I didn't know I'd end up being a screenwriter, I was trying to find a way into the Colosseum, to the gladiator."

Franzoni may not have known he wanted to be a screenwriter, but he'd always loved film and wanted to get involved in the film business. Somehow, he ended up being a geology major in college and still didn't have a career when he set out on that motorcycle trip.

"When I was driving to Lahore, India [sic], on my motorcycle, I had an

[1]Mannix's 1958 account on the Roman games was *Those About to Die*, reprinted in 2001 (after *Gladiator*'s success) by I Books as *The Way of the Gladiator*.

especially difficult night getting to Lahore, because the roads went out in the jungle and they ended, and the signs were wrong, and I got diesel fuel instead of gasoline in my bike, and the water was bad. But I remember the sun came up and I was in Lahore. And I thought, *You know what? If I can do that, I can do anything.* And this is still easier than that.

"So I figured, okay, I'm over the hump that I can do that. The second hump was that you have to make a decision to do it or die trying. So once I got that organized in my head, I decided I wanted to do it. I wanted to be in film more than anything else in the world. And since this is my life, why can't I have that? Why settle for second best when even the best isn't enough?"

His family had a business, and he had the chance to join it, but his get-into-film-or-die-trying resolve was reinforced when he actually got shot back in his Los Angeles apartment.

"I decided, fuck it, I want to do this. Because what difference does it make? I'm dead anyway."

So he spent five years writing on his own. "I remember the day I broke through," he said. "I had a meeting with Sissy Spacek and I come out and I've got a flat tire. And my spare's flat. I've got twenty-six bucks. I take the spare and roll it down the street. For twelve bucks they patch it for me and I roll it back. I get home. I don't really have an agent, I have a girl at CAA who's representing me on the side. I get home and there's a message. 'Sissy wants to hire you, and we sold the spec script.'" He was twenty-eight.

It would be about another ten years before he got his first official movie credit, for the 1986 adventure comedy *Jumpin' Jack Flash*. He got story and shared screenplay credit for the film, which marked the rather unlikely collaboration of action überproducer Joel Silver and director Penny Marshall, who was directing her first feature film. Marshall fared a little better with *Jumpin' Jack Flash* than Franzoni, as she would go on to make *Big* just two years later. Franzoni had to wait a while longer for his next produced credit: HBO's 1992 film *Citizen Cohn*, based on Nicholas von Hoffman's biography of Roy Cohn. The film earned him an Emmy nomination and established his knack for adapting historical material.

"Cut to 1995," he said. "I'm in Rome for some reason, working on *Amistad* for Steven [Spielberg]. Because we were going to Rome, I had my book-finder find that Daniel P. Mannix book. And as a testament to the book itself, my book finder wouldn't give it to me until he had finished reading it. Because you can't put it down; it's like a drug.

"So I got to Rome, I'm reading it, I'm doing *Amistad*, and on the side I'm

kind of going nuts. My wife was going, 'Why don't you pitch [the gladiator idea] to Steven?' I said, 'I still have to work it out.'

"One day I read that Commodus had gone into the Colosseum as a gladiator and that he had been killed by a gladiator named Narcissus, about which there's nothing except that he did that. I thought *Fuck, I'm in, I've got my way.*"

So, finally, Franzoni mentioned to DreamWorks' Walter Parkes, who would eventually become an executive producer on *Gladiator*, that he was thinking about an ancient-Rome movie. Then Franzoni asked producer Doug Wick (*Stuart Little*; *Girl, Interrupted*) to come onto the project. Wick jumped at the chance.

Good news? Well, yes and no, since Wick had a first-look deal at Sony, while Franzoni had just signed a three-picture deal at DreamWorks. For Wick to do the project, Sony would have to give *Gladiator* a big thumbs-down. In short, said Franzoni, "Doug and I are both fucked."

But Franzoni has been working in Hollywood a long time. He knows a few tricks.

"I said, 'Doug, here's what we'll do," he remembered. " 'Lisa [his assistant at the time] and I will go in to [see] a lower-echelon executive at Sony, and I'll totally fuck up the pitch, do the worst job I've ever done in my life. We'll get the pass.'

"Steven, meanwhile, is over at CAA hanging out, and goes, 'Okay, what are you guys going to bring?' And my agent said (because I told her not to) 'David Franzoni wants to bring you an idea about a gladiator.' Steven said, 'You mean an ancient Roman gladiator?' She said yes. He said, 'I want to be there for that meeting.' So I get this call from Steven's office, 'Steven has two days, he wants to be there, choose one.' So I chose the last one. Meanwhile I've got to get the pass from Sony."

He pitched to Sony, emphasizing the gore and hitting every point that would drive up the cost of production. In a twist straight out of *The Producers*, though, "they loved it. Loved it."

That landed him in a pitch to a higher-up at Sony, Lisa Henson, about two or three days later. "Right away I know, we win," he said. "She was like, 'I don't know, a gladiator, couldn't he be in maintenance in the Colosseum or something?' I said, 'Lisa, I don't know, a hundred-million-dollar movie about a guy who shovels lion shit? I'm not sure.'

"So I know we got the pass, so we're clear. Three or four days later, I go over to see Steven and Walter.

"Steven goes, 'David, how you doin'?'

" 'Good.'

" 'Gladiator? Rome? Emperor-type stuff? The Colosseum?'

"I go, 'Yeah.'

"He goes, 'Okay.'

"I had a pitch, but I didn't even get it out of my mouth. He just said, 'Let's do it. Okay.' "

To a novice, this sounds like a dream come true. Steven Spielberg buys your pitch in the first ten seconds? What could be better than that? Spielberg, though, is famous for his business savvy, and there's a sound business reason to say yes to a pitch without actually hearing it. If you're a producer and you hear a pitch and say yes, you're saying yes to what you heard. If you try to change it later, that makes for big arguments. On the other hand, if all you hear is "Gladiator, Rome, emperor-type stuff, the Colosseum," well, that's all you've said yes to. This puts the writer at something of a disadvantage later on, as both God and the devil are *always* in the details. This would prove to be especially true of *Gladiator*.

Still, twenty-five years after swapping books in Baghdad, Franzoni was finally going to get to the Colosseum. With Spielberg's blessing in hand, Franzoni reassured Walter Parkes that he did actually have a story and went off to write. A few months later, he turned in his first draft, dated October 1997.

This 130-page script is different in almost every detail from the finished movie. The hero's name is different. The dialogue is different and so are the fight scenes. Characters who live in the movie die in the original script. Some characters from the movie aren't in the script at all.

There is no provincial arena in the middle of the movie. The hero is a victim of both the Roman Senate and the emperor, not Commodus alone. Commodus's sister Lucilla has no adorable son and she dies horribly in the arena. The hero's family turns out to be alive, not murdered by the legions as in the film, and escapes to safety at the end.

Yet with all that, it is unmistakably the same movie that opened in May 2000. In Franzoni's original story, a Spanish/Roman general is betrayed by new emperor Commodus, cast into slavery as a gladiator, and becomes a hero in the Colosseum. The gladiator reveals himself to the emperor, but the emperor does not dare kill the mob's new favorite.

Instead Commodus uses subterfuge, arranging more and more difficult

challenges for the gladiator, including surprise animal attacks. The gladiator becomes more popular, which makes him more and more dangerous to the emperor, and the emperor becomes more tyrannical. Finally, the two men kill each other in the arena.

That's *Gladiator*, all right.

Two other credited writers followed Franzoni: John Logan (*Any Given Sunday*, *The Aviator*) and William Nicholson (*Shadowlands*, *Firelight*). Franzoni, who was also a producer on the film, calls them both friends and praises their work. Yet all the essential elements were in Franzoni's first draft.

None of that has stopped director Ridley Scott, among others, from complaining publicly about the script. In covering the film later, *Entertainment Weekly* wrote that "last-minute writers" were brought in to "hash out a completely new second act."

The implication that his draft led to all these problems, which included Russell Crowe threatening to quit the picture, leaves Franzoni livid. "I bitterly resent that, because it's not true. I can't tell you how outraged I am by hearing that."

Franzoni even wrote a letter to *EW*, in which he cited one of the WGA's arbitrators, who apportioned the writing credits. "*Gladiator* is certainly David Franzoni's story," said the arbitrator, "from the conception, to the characters, to the beats of the plot, the original writer's vision has been maintained all the way to the shooting draft."

In the letter, Franzoni himself goes on to say, "Clearly the usual torturous rewriting process has led the filmmakers back to my original script rather than away from it . . . I am proud that my original vision is so masterfully executed and so thoroughly successful."

Certainly it was Franzoni's idea to give the gladiator genre a gritty new tone. "My vision from the beginning was, this is not *Ben-Hur*, it's *All Quiet on the Western Front*," he said. "This is a grown-up movie about war, death, and life in Rome. The life of a gladiator. That's why I insisted he be a pagan, not a Jew or a Christian. I didn't want us to define our enemies by where they went to worship. I wanted to pull all that out from under it."

So Franzoni, steeped in the actual history of the times, went to work creating a hero the audience could root for even if he was fighting for militaristic, bloodthirsty, decadent Rome.

Get a Life

In this town, if you're a screenwriter, the two biggest things that are important [are]: One, get a life, because the only stuff that's any good is writing about the life you've led, not about the movies you've seen. And two, don't pay any attention to what's going on in this town. I've never read the trades. I don't go to any screenings. I don't go to any parties unless I have to. I don't pay any attention to the shit that's going on here. Because if you do, you'll start doing what they want you to do, and it's always wrong. It's always wrong. That's why they make such shitty movies. So you have to just be free of this place, even if you're here.

I'm sitting with Ridley watching the final mix [of *Gladiator*] and Ridley goes, "You know, Franzoni, you've got to do another one, because, Jesus Christ, it's hot now. Michael Mann is developing *Gates of Fire* and *Julius Caesar*." I said, "Ridley, we're here because I wasn't chasing somebody else before. Do you think now I'm going to start chasing myself?" Then Michael Mann came to see the movie. Now he's doing Muhammad Ali.

"The problem I had was, I had to create a Roman general who was a hero and believed in the greatness of Rome, but he couldn't have been to Rome and seen how awful it was," he said. "I knew that Augustus had created the Felix Divisions after he had defeated Anthony and Cleopatra because he felt he needed a permanent presence in Spain.

"So I thought, okay, I'll have a Spanish Roman general. It's feasible he would never have been to the capital, and he's only been drawn to the front because actually Marcus Aurelius had drawn all these troops to fight against the Germans, including the Felix Divisions."

Franzoni began the story with his hero, then named Narcissus, leading the Felix Divisions to a victory over the Germans. As in the movie, trouble begins soon after. In the script, Emperor Marcus Aurelius dies, and the new emperor Commodus orders Narcissus to withdraw, intending to offer payments to the Germans to end the war.

Outraged that his men have fallen in vain, Narcissus refuses. Mistrusted by both the Senate and Commodus, Narcissus is arrested and sold into slavery without trial.

"So I thought, *Well, here we have a gladiator, a Roman general who's*

condemned to die, ends up as a gladiator, becomes a hero in the Colosseum, and because the Colosseum is the machine that Commodus is using to keep himself in power, he can't kill him. That was really the inspiration for the whole thing."

The real-life Commodus is remembered by history as one of the most vicious Roman emperors, even more malevolent than the film version. Franzoni, though, dismisses the historical portrayal of Commodus as "mendacious" propaganda by later historians who sought to justify the murder of the emperors. He wanted a more complex villain.

"When I saw Commodus, I thought, *Here we have Ted Turner,*" said Franzoni, "a man who can combine politics and entertainment to create a power base. I thought he was a little flipped. I think that that came out pretty well in the movie. But he was also brilliant, because when he arrived in Rome after abandoning the war against the Germans, he was very unpopular. So his answer was, throw games, and it worked.

"I didn't want to make Commodus nuts. I wanted to make him a little bit off, but he had to be smart enough to pull this off." So his creation would have none of the madness of John Hurt's Caligula in *I, Claudius*. "Plus he makes a better enemy," added Franzoni. "He's formidable."

From the beginning, Franzoni also considered how young Commodus would relate to his legendary philosopher-king father. "Commodus, in my mind, had an absolute need to dominate his family, because he'd always been dominated by his father, and it was something he could never solve. There was also a sense that he could trust no one."

Gladiator's Commodus has reason to be fearful, too, because in Franzoni's vision, the Roman mobs are like a dangerous force of nature. This may be the biggest difference between *Gladiator* and Stanley Kubrick's classic gladiator film, *Spartacus*: *Gladiator* takes a much darker view of the common man.

Spartacus portrays gallant common folk rising up against their oppressors. When the gladiator Spartacus fights in the ring and is nearly killed, the only audience is a few indifferent Roman aristocrats who make small talk as the death struggle plays out before them.

In *Gladiator*, on the other hand, it is the mob that screams for blood. The common people, in the form of the Colosseum audience, are the ultimate tyrant, more powerful than even the emperor. "You can provide what this animal needs, you can feed the animal, but in the end it'll eat you," said Franzoni. The real power struggle, then, is the battle for the hearts of a fickle public.

If that sounds a bit like a description of the United States at the dawn of the new millennium, that is no accident.

"I see this as the America of tomorrow. Right now, America is the land where everyone has the right to their opinion. Tomorrow, America will become the country where everyone's opinion is equally right. That's the politically correct syndrome. That will then, since the Constitution can't cope with that concept, begin the unwinding of the concept of a republic. That's what happened in Athens, and Rome became that. I think eventually we'll get there. I honestly do believe that."

Keep in mind that Franzoni was saying this in mid-2000, before 9/11, the Patriot Act, the prison at Guantánamo, the trimming away at habeas corpus, and the controversies over patriotism and the power of the executive that emerged in the mid-2000s.

"There are so many elements of ancient Rome during that period that are almost identical to America today that it's almost unavoidable," said Franzoni. "Street gangs dominating the inner cities. Politicians using the media, entertainment, to control the masses. The concept that the masses can be controlled in a thoughtless manner. That very idea is becoming more and more clearly American. That was a core idea of Roman politics; the idea that their voices can be corralled to sing as one is definitely Rome after the Republic.

"It just seemed to me that Commodus represented the politician of tomorrow—we're sort of getting there now—who exploits the media absolutely to control the public."

Franzoni's first draft also emphasized the gladiatorial games as showbiz. Proximo, the gladiator-trainer played by Oliver Reed, was originally based on Michael Ovitz, the longtime chief of CAA, who was then the most powerful player in the movie business.[2]

Also, because Franzoni's first draft took Narcissus directly to Rome, Narcissus has more time to build a following in circus-mad Rome. That helped Franzoni explore the sheer commercialism of the Roman games. Franzoni included everything from olive oil endorsements by champion gladiators to glitzy sales pitches for chariots, with Proximo wheeling and dealing gleefully throughout.

These endorsements may seem like comic anachronisms, but as the saying goes, you can't make this stuff up. Though the scenes were eventually cut

[2]Ovitz's fall from power after leaving his agency position to become president of the Walt Disney Co. has been well chronicled. Unlike Proximo, he was not banished to some small agency in the provinces, but he has been rumored to be sporting a bushy beard not unlike Oliver Reed's.

from the film, Franzoni said that second-century gladiators really did make big money endorsing products. (Unfortunately, as another saying goes, truth doesn't have to be believable; fiction does.)

"In the first draft I felt, and I've always felt this about first drafts, that you need to put in everything. That you need to not hold back. Though stuff is absolutely going to get whittled down, directors will like some stuff, and will fix on it, will want to do this or that. So I like to have a really rich background, so that a director can pick and choose. You make it as rich as you possibly can."

Ridley Scott was hired to direct, and Russell Crowe signed on to play Narcissus, attracted by the strength of Franzoni's drafts. As Franzoni rewrote—he did more than a dozen drafts—some of the elements of the final film came into focus.

The hero's gladiator training, originally set in Rome, was moved to a provincial arena in Morocco. "It made it easier for us to bring Maximus in and have him challenge the emperor without having it go on and on and on and on."

He did several more drafts after Scott came onto the picture, but disagreements began to arise among Franzoni, the DreamWorks producers, and Scott. First there were concerns about the contemporary dialogue. Franzoni wanted to keep the dialogue contemporary, like the celebrated television adaptation of *I, Claudius*. Some pushed for a more formal sound.

Another disagreement arose over a scene in the Colosseum where his hero reveals his identity to the emperor. It was not quite the film's "money moment" monologue, where Maximus intones, "I will have my vengeance," but the sense of the beat was the same. Some insisted that the scene should be cut, convinced that if Commodus knew Narcissus was alive, he would have Narcissus killed immediately.

"My argument was twofold," said Franzoni. "One, we own the paper, we can write whatever we want. And it's such a delicious idea that the audience is going to go with it. He moons the emperor and the emperor can't kill him."

The key, as Franzoni saw it, was that Commodus needed to give the crowd what it wanted. Once the crowd had adopted Narcissus/Maximus as its hero, Commodus's hands were tied. "It's like a lose-lose situation for [Commodus]," Franzoni says. "The bottom line is, we wouldn't have a movie if Max didn't pull his mask off and go 'Fuck you.' There's no movie."

Franzoni also knew that his hero would be driven by love of family, but some of the "torturous" rewriting came from trying to figure out how to put the family on the screen.

Franzoni always pushed to have a scene on the German front between Narcissus and his family. In the original draft, Narcissus is arrested, then told his family is dead. Later, he learns they are alive, but rather than flee Rome with them, Narcissus returns to the arena to confront Commodus, knowing they will never be safe while Commodus is alive. Narcissus's family escapes to safety as Narcissus dies in the ring.

That was yet another disagreement. In Franzoni's first draft, Narcissus finally died in the Colosseum, as he does in the film. Franzoni was told that just couldn't happen.

"Of course, everybody said, 'He can't die, he's the hero!' Ridley said it; everybody said it. I thought, 'Well, I'm not going to get fired over that.'" So Franzoni obliged. Narcissus survives in Franzoni's last pass, even though that ending never did fit his notion of the story.

"We're doing a film about ancient Rome, gladiators, where there's no hope, where these people for no good reason at all are condemned to absolute horrible death. So why can't we kill him? It's not like we're making a tonal break in the film.

"I meant it to be a tragedy. I think in the first draft there were a lot of distractions that kept it light. In subsequent drafts I wasn't allowed to kill Max, but I always meant it to be a tragedy."

Against his better judgment, Franzoni spared Narcissus, but there were other arguments and Franzoni continued to resist. He began to realize his days as the writer on the project were numbered.

"You get a sense when people are getting frustrated and they don't know what to do, when they want to bring somebody else in. It's not like Ridley or someone said 'Take this out or we'll fire you.' But they felt there was something wrong that they couldn't resolve."

Franzoni knew he was in a box. If he followed his own judgment, he would be replaced by someone who would follow the notes. If he took the notes, he would be replaced because the script wasn't working.

"I feel it's more honorable to fall on your own sword," he said. "I try to do what's right for the script, and will make some concessions if I don't consider them to be lethal. But to me, taking out the family and removing the gladiator confronting the emperor was lethal."

After his last draft, dated August 1998, he was replaced by John Logan.

Franzoni remained on the picture as a producer, however, giving him the unusual chance to watch his successors work. "Once you have that producer hat on, you have a different take," he explained. "Even if you don't agree with

everything, you have to keep that train rolling. All the good stuff, even if I didn't write it, has to stay in. And all the bad stuff, even if I did write it, has got to come out."

Franzoni continued to argue for his concerns while Logan wrote more drafts. Parkes and DreamWorks continued to listen, though at times they wondered out loud if he was being "the jilted writer."

Meanwhile, more of the final story elements emerged. Franzoni credits Logan with taking Commodus's political problem in a personal direction. "He took it from 'I can't live up to my father' to 'My father didn't love me.' That was brilliant."

Logan also wrote in the boy Lucius. Franzoni doesn't remember who thought of the idea first, but he remembers that the boy was originally meant to be Narcissus's son, not Lucilla's. "I think Commodus would get off on the idea of killing the father and keeping one of the sons and bringing him up in his image." Initially, that helped address Franzoni's concern about seeing Narcissus's family on the screen. Later on, once Lucius became Lucilla's son, that issue resurfaced.

One of the film's most memorable bits was invented at this stage, too: Maximus's habit of rubbing and smelling the earth before he fights. Russell Crowe told a press conference that he had found a lot of significance in the gesture. "To me it was about earthing himself and reminding himself of his mortality before he faced death," he explained.

Whatever Crowe put into it, the writers had something more basic in mind when they thought up the bit. "It was originally intended to give the audience a cue that he was ready to kill. Period. That's all," remembers Franzoni.

Franzoni saw problems with the rewrites, too. The scenes in the provincial arena had solved one problem, by delaying Narcissus's confrontation with Commodus. It had created another problem, though, which nearly stopped the film in its tracks.

"The problem was this," he explained. "Once we kept Maximus out of Rome until the end of Act Two, what went on in Rome was problematical in two ways. One, from a storytelling point of view, since we want to be with our hero, he wasn't in Rome. And if you were going to be in Rome, you had to have something going on."

The emphasis on scenes in Rome left little for Maximus to do. He had lines, but Franzoni felt their hero had become inactive. It was clear to him that in order for the story to work, there would have to be less emphasis on scenes in Rome and more emphasis on the hero's journey.

Others were unconvinced. They saw that their hero was on almost every page and had plenty of lines. How could Franzoni say the part wasn't strong enough?

It took the first of Russell Crowe's much-publicized blowups to prove Franzoni's point. Crowe had finished *The Insider* and turned his attention back to *Gladiator*. When he saw the latest script, he threatened to walk off the picture.

Walter Parkes asked Franzoni what he thought was wrong with the script. "I said, I don't see the two trains on a collision course, Maximus and Commodus. We spend all this time in Rome, with people we've met and issues we've discussed, doing nothing. We spend five minutes in Morocco, with people we have just met, including Proximo, with gladiators who we haven't met, and we don't spend any time with our hero's whole journey. I think if we reverse the emphasis, we can see those trains on a collision course. All we have to do [in Rome] is say that Commodus is throwing games."

DreamWorks and the producers went to work coaxing Crowe back into the fold. Crowe's misbehavior over the years has been thoroughly documented, but when *Time* ran an article on his "bad-boy" antics on *Gladiator*, that was still news. Franzoni read the article but was basically sympathetic to his star. "His ass is on the line. He's got to carry a hundred-million-dollar movie. Of course he's got to be concerned if there are problems with the script. I don't find that to be a problem."

Crowe also wanted some elements from Franzoni's original script put back in, including a scene where Maximus spared a defeated gladiator and threw his own sword to the crowd as a souvenir. The conversation put Franzoni in an awkward position.

"I said, 'Look, I'm not the writer anymore, but you're the star. You can coherently sit down with Ridley and Walter and John and make this work, if this is what you want. It's not because I wrote it. I want to get the movie made, man. If we get the movie made, I'll feel good about it. But if you feel strongly about these issues, you've got to get out there and say so.'"

Soon Bill Nicholson became the third writer on the project. Later, as shooting began, Ridley Scott began to change the story on the fly, bringing it ever closer to Franzoni's original structure.

Franzoni is unabashed in his admiration for Scott, who he believes saved the picture. "When he's got the camera in his hands, he's writing," he said. "He began understanding why all these choices didn't work, and he reversed them.

"He had Bill Nicholson write the Elysian Fields scene at the end, totally out of the blue. He made the decision to have Maximus whip off the mask because he knew it would work. Organically, he understood, finally, that it would work.

"You have to give Ridley credit. A man who's got the balls to go against decisions of other people, even against his own choices at times, when he sits down with a camera in his hand, to go, 'Oh, I get it. This is how it has to be.' And he was dead right."

That's not to say that all went smoothly during shooting. At one point, said Franzoni, Richard Harris refused to leave his dressing room because he hated the script so much. "The truth was, for a while we really lost sight of the movie, in my opinion," said Franzoni.

Nor did it help that Oliver Reed, playing Proximo, died during production before some of his climactic scenes were filmed. (They were created using a body double, some digital compositing, and some clever nipping and tucking of the scenes.)

Franzoni even wound up helping Scott with some last-minute rewrites, almost by accident. "I went to Morocco on my own money to have a vacation and watch the movie get made with my kid and my wife," he explained. Instead, he was drafted into some all-night rewrite sessions.

Scott's changes completed what Franzoni calls a "Great Circle route" in development. After wandering far from Franzoni's story, *Gladiator* became something much closer to Franzoni's original idea. Though both Logan and Nicholson contributed much of the final script, especially the dialogue, it is Franzoni's structure that audiences see on the screen.

Not even Franzoni, though, was sure what to expect when he went to see the director's cut. "I was really nervous," he remembers. Some of his old concerns were still bothering him. "I was going to say, 'We have to see the family on the German front,'" he remembers, "'I don't know how we're going to do it.'

"He has [Maximus] praying to his ancestors. Ridley designed that. It wasn't written. He decided he had to do it. I'm sitting there going, 'I can't believe he did all this.' And I was blown away."

Ironically, Scott and company had solved the family-on-screen and death-of-the-hero problems at a single stroke. Maximus has a clear, simple "through-line" that anyone can relate to—he just wants to go home to his family. Once his wife and child are dead, he can get what he truly wants only by dying.

Commodus's lose-lose situation, where his popularity depends on keeping his bitterest enemy alive, is mirrored by Maximus's win-win situation. If Maximus lives to kill Commodus, he has his vengeance. If he dies, he gets his family in the afterlife. It's simple, it's clear, and audiences get it. Maximus's death becomes the happy ending we've wanted all along.

"It's perfect," said Franzoni. "Ridley really is the genius that made this work. It's like he had clay in his hands, and he said, 'I have to work with these colored blobs of clay, but I know how to change them and have it work.'"

Despite the torturous rewrites, *Gladiator* turned out remarkably coherent. Audiences loved the film and turned it into a smash. It launched Russell Crowe from respected obscurity to major stardom.

Not all critics liked the film; Elvis Mitchell of the *New York Times* called it "silly," and Roger Ebert gave it a contemptuous thumbs-down. By and large, however, the reviews were positive. The script, which caused so much tension in the making, seems simple, clear, and logical in retrospect. It even became a somewhat unlikely Oscar winner, taking Best Picture honors for Wick, Franzoni, and Branko Lustig; Best Actor for Crowe; and the Oscars for Visual Effects, Sound, and Costume Design. Franzoni, Logan, and Nicholson were nominated for Original Screenplay, but were beaten out by Cameron Crowe and *Almost Famous*.

With an Oscar on his mantel and a box office smash in the books, Franzoni went on to write another revisionist take on history, *King Arthur*, produced by Jerry Bruckheimer and directed by Antoine Fuqua. That film didn't catch fire at the U.S. box office and didn't get much attention at award season but did well in the rest of the world, so Franzoni's career didn't suffer much. By 2006 Franzoni was at work on another Roman-times epic: *Hannibal the Conqueror*, with Vin Diesel as the Carthaginian general who threatened Rome with elephants. He also bought rights to remake a Korean hit, *Joint Security Area*, with plans to direct it himself. So he was still atop the Hollywood mountain.

If *Gladiator* had turned out as badly as Franzoni feared, he might not have been at such lofty heights. "The serendipitous nature of this film is unbelievable," said Franzoni. "It's like twenty-five cars ran into each other and the Mona Lisa emerged."

American Beauty

CREDITS

DIRECTED BY Sam Mendes
SCREENPLAY BY Alan Ball
PRODUCERS: Bruce Cohen, Dan Jinks
STUDIO: DreamWorks SKG
PRODUCTION COMPANIES: DreamWorks SKG, Jinks/Cohen Company
ORIGINAL MUSIC BY Thomas Newman
CINEMATOGRAPHY BY Conrad L. Hall
FILM EDITING BY Tariq Anwar, Christopher Greenbury
CASTING BY Debra Zane
PRODUCTION DESIGN BY Naomi Shohan
ART DIRECTION BY David S. Lazan
SET DECORATION BY Jan K. Bergstrom
COSTUME DESIGN BY Julie Weiss

MAJOR AWARDS

ACADEMY AWARDS: Best Picture; Kevin Spacey—Actor; Sam Mendes—Director; Alan Ball—Original Screenplay; Conrad L. Hall—Cinematography
GOLDEN GLOBES: Best Picture, Drama; Sam Mendes—Director; Alan Ball—Original Screenplay
BAFTA AWARDS: Best Film; Kevin Spacey—Actor; Conrad L. Hall—Cinematography; Tariq Anwar—Editing
SAG AWARDS: Best Ensemble Cast; Kevin Spacey—Actor; Annette Bening—Actress
DGA AWARDS: Sam Mendes—Director
WGA AWARDS: Alan Ball—Original Screenplay

Kevin Spacey . . . *LESTER BURNHAM*
Annette Bening . . . *CAROLYN BURNHAM*
Thora Birch . . . *JANE BURNHAM*
Wes Bentley . . . *RICKY FITTS*
Mena Suvari . . . *ANGELA HAYES*
Chris Cooper . . . *COL. FRANK FITTS, USMC*
Peter Gallagher . . . *BUDDY KANE*
Allison Janney . . . *BARBARA FITTS*
Scott Bakula . . . *JIM OLMEYER*
Sam Robards . . . *JIM BERKLEY*
Barry Del Sherman . . . *BRAD DUPREE*

ESTIMATED BUDGET: $15 million
RELEASE DATE: September 8, 1999
U.S. GROSS: $130 million
FOREIGN GROSS: $218.6 million

"Consistently provocative and devilishly amusing . . . *American Beauty* is a real American original."
—TODD McCARTHY, *VARIETY*

"[A] justly celebrated look at what gets lost in life when we numb ourselves to feeling."
—PETER TRAVERS, *ROLLING STONE*

"*American Beauty* is a comedy because we laugh at the absurdity of the hero's problems. And a tragedy because we can identify with his failure—not the specific details, but the general outline." —ROGER EBERT, *CHICAGO SUN-TIMES*

"Ball's script is underwrought with revelation as the people in this neighbor-hood oscillate between a razor-sharp caricature study and an automatonic thriller, staid in its inability to decide precisely how much it hates what it sees." —WESLEY MORRIS, *SAN FRANCISCO EXAMINER*

"Unsettling, unnerving, undefinable . . . a blood-chilling dark comedy with unexpected moments of both fury and warmth, a strange, brooding and very accomplished film that sets us back on our heels from its opening frames."
—KENNETH TURAN, *LOS ANGELES TIMES*

2 | SCRIPTER: LONG ISLAND LOLITA WAS MY MUSE!

AMERICAN BEAUTY • ALAN BALL

One bromide young writers hear ad nauseam is "Write what you know." There's nothing exactly wrong with that advice—it's just that "What you know" isn't what you *think* you know.

On the surface, "Write what you know" seems to mean write about the people, places, and things you've experienced. That's roughly what David Franzoni meant when he said, "One, get a life." The more experiences you have, the more you have to draw on.

Too many young filmmakers, though, take "Write what you know" too literally. As a result, the indie movie scene seems perpetually glutted with autobiographical God-my-childhood-in-the-suburbs-was-awful-because-my-family-was-crazy movies, most of them about as interesting as a fourteen-year-old's lament about how his parents won't buy him the latest PlayStation. A lot of them are doughnut movies—grease wrapped around an empty hole where the protagonist should be—because, as playwright Jeffrey Sweet once told me, "We think of ourselves as acted upon, rather than acting."

Of those rare films in the autobiographical coming-of-age genre that seem to work, many are notable for making the filmmaker's alter-ego character just as responsible for any domestic chaos as the family members around them. Noah Baumbach's 2005 film *The Squid and the Whale* is a good example. So is Michel Gondry's *The Science of Sleep*.

"Write what you know" is great advice when it means "Write about what you've felt." No one alive knows exactly what it is to be a Roman gladiator fighting to the death in the Colosseum, for example, but we've all felt triumph and defeat, rage, friendship, and the longing for family. Even children can relate to those feelings. By the age of twenty-one, almost everyone has been on the

receiving end of parental love (and parental anger); experienced loneliness; enjoyed romantic love and success; suffered pressure, rejection, and disappointment. Many have experienced a serious illness, the divorce of their parents and a struggle to adjust to stepparents, or more profound tragedies, like the death of a family member. In short, we all know a lot about what it is to be human, even if we're lucky enough to have lived sheltered, uncalamitous lives.

That's why Alan Ball was able to write *American Beauty*.

When he started working on the story, he was living in New York City—hardly the suburban enclave where the story was set. Later, when he resumed work in Los Angeles, he was a successful TV writer, not a stifled trade-paper writer like his hero, Lester. He was not married or father to a teenage daughter. He is openly gay. So where does "Write what you know" come in? Well, Ball knew what it was like to seethe at a job that didn't use his talents, and to wonder what it means to be a man in contemporary America. And he was disinclined to make his hero a passive victim. On the contrary, he conceived the character as a man waking up to reclaim his life, only to be murdered at the moment he succeeds.

Even at the very beginning, when the germ of the story first emerged in his mind, it took the form of a surge of compassion for a public figure of the early 1990s who was getting little such sympathy: the "Long Island Lolita," Amy Fisher.

For those who don't remember her story, Amy Fisher (that's *FISH-uh*, for those not from Lawn Guy-Land) was a tantalizing teenager who had an affair with one Joey Buttafuoco, a married mechanic more than twice her age. The media circus began after Miss Fisher came to the Buttafuoco house packing a pistol and popped Mrs. Buttafuoco in the head, apparently aiming to become the next Mrs. Buttafuoco. Happily, Mrs. Buttafuoco survived, and the Buttafuocos stayed together, at least for a while. As for Fisher, the jilted sixteen-year-old pleaded guilty to reckless assault. She served seven years in jail; her lover did six months for statutory rape. (The story was eventually told in three TV movies, one with Drew Barrymore playing Amy, one with Alyssa Milano, and one from Fisher's point of view starring Noelle Parker.)[1]

[1] Mary Jo later publicly forgave Amy and even wrote a letter asking for her early release from prison. Fisher eventually married, became a mother, and became a columnist for a newspaper, the *Long Island Press*. She wrote not one but two books about her experiences, *Amy Fisher: My Story* (with Sheila Weller, Pocket Books, 1993) and *If I Knew Then . . .* (with Robbie Woliver, iUniverse, 2004), and achieved the ultimate media redemption: an *Oprah*

The case was a sensation, especially in New York City, where it graced the front pages of the *New York Post* and *Daily News* for months. Ball, then a young playwright, was living in the city at the time. "I was working at a magazine in midtown," Ball told me over a cup of coffee outside a movie theater in Hollywood. "I was on my lunch break, and there were street vendors selling this comic book version of the story." The comic book had two opposing cover illustrations: "One cover had a very specifically evil-looking Joey with a virginal Amy, and then you flip it over and the other cover was just the reverse. He looked like a good, nice Catholic husband and she was a scary little psycho tramp."

Seeing the cover, Ball remembers reflecting that the public would probably never know the whole truth behind the story. "What really happened is probably much more interesting and much more tragic than any version that we're ever going to get." He was also struck by how "underneath all the jokes and the comedy about it, there were real lives that had been tragically altered. That sort of was the germ of the idea, was the notion of a media spectacle."

Ball's spec script certainly starts differently from the film. It opens with the young Ricky Fitts in jail, charged with the murder of his middle-aged neighbor, Lester Burnham. The case is a tabloid sensation, inflamed even more when TV stations mysteriously obtain videotape of teenage Jane Burnham hiring her boyfriend, Ricky, to kill her father. Ricky's father, Colonel Fitts, is furious at the leak and blames prosecutors.

While Ricky sits in his cell, chanting the Talking Heads' "Psycho Killer," we cut to one year earlier and the deceased Lester Burnham, flying like Superman over his former suburban neighborhood.

What follows from that point until near the end of the story is astonishingly close to the film that arrived in theaters. In fact, other than some changes at the beginning and end of the script, few spec screenplays have been so faithfully rendered, down to specific images in the scene descriptions. Yet those few critical changes exposed a profound, tender story that had been obscured at first, even from Ball himself.

One change was a simple but important cut. The spec includes a flashback

show devoted to her. Meanwhile the Buttafuocos split up and Joey moved to Los Angeles to try acting, getting as far as a part in the Sean Connery drama *Finding Forrester*. The two faced off again for *Entertainment Tonight* in 2006. It started well but ended badly. However, press reports and photos in the summer of 2007 had the pair canoodling in public. The saga of Amy and Joey, it seems, ain't over even when it's over.

in which we see the colonel, Ricky's father, making love with another man in Vietnam. The encounter is interrupted by an enemy attack, and the colonel's lover is killed. That scene is gone from the film.

The next major change comes near the end of the story, when Lester is alone with Angela, trying to seduce her. In both the spec and the film, Angela—who has been bragging about her many conquests—admits that she is a virgin. In the film, Lester decides not to have sex with her; in the spec, however, they make love.

In both versions, Les is soon shot in the head. As he dies, he flashes back on his life. In the spec, the flashbacks are dominated by Angela; in the film, his wife, Carolyn, and Jane are central.

When the script returns to the trial, Ricky is convicted. We learn that the colonel had leaked the tape to ensure his own son's conviction. Both Ricky and Jane go to prison. Angela ends up as an actress on a *Melrose Place*–style prime-time soap. Lester's widow, Carolyn, goes into business with her lover, Buddy; they become "the king and queen of real estate." The spec ends with Les flying above the clouds again, talking in voice-over about his gratitude for "every single moment of my stupid little life."

It's an angrier, darker story than the version audiences saw on-screen, despite the relatively small number of changes. To understand how that story got written, and why it changed, it's important to understand where Alan Ball came from.

Though he has never taken a writing class, Ball is a natural playwright. He wrote his first play in first grade, and he was a confirmed actor and playwright by the time he left Florida State University. By the 1980s and early '90s he was living in New York and pursuing life in the theater. When his play *Five Women Wearing the Same Dress* was produced at the Manhattan Class Company, he caught the attention of Carsey-Werner Television, which offered him a deal as a term writer. So he moved to Los Angeles and became a writer on the Brett Butler sitcom *Grace Under Fire*.

He called the experience "a real eye-opener." Like her TV contemporary Roseanne Barr, Butler was famous for being difficult to work with—so much so that agents reportedly demanded higher-than-normal "hazard pay" salaries for their writer clients working on the show. If the show becomes a hit, the pay keeps coming, so their shows never lacked for writers.

"In a lot of ways, it was the best first job to have, because nothing will ever be that bad," said Ball. "I worked with some really smart, talented writers. It was just the situation [that was difficult]. It was really infuriating to me,

because I came out of the theater, where writers have a certain amount of respect and people have a certain amount of reverence for the text."

He was not asked back for another season with *Grace Under Fire*, which upset him for "about ten minutes." Instead, he moved on to work on the Cybill Shepherd sitcom, *Cybill*, becoming co–executive producer. Working on *Cybill*, the show, was far more pleasant than working on *Grace Under Fire*, but working with Cybill, the actress, wasn't so good.

"The star had absolute creative control. And so in a lot of instances, I would have to work ten-, twelve-hour days. [I was] basically taking dictation from someone who really looked at the show not from the point of view of an actor, but from the point of view of someone who considered it to be PR for her life." Another job, another maddening experience.

It was against that background of anger and frustration that Ball started writing *American Beauty*. He had been haunted by the characters for years, at one point even trying unsuccessfully to develop the story as a stage play. Lester, Ricky, and Jane would not go away. "I just allowed them for years, on a very subconscious level, to gestate."

Another inspiration—immortalized in Ball's Oscar acceptance speech—came from an eerie encounter with a plastic bag at the World Trade Center subway stop on a weekend afternoon. Today the WTC complex is an object of blessed memory; in the 1990s, though, it was still a forbidding superblock that created odd swirling winds on the surrounding streets. Ball found himself standing on the sidewalk as a plastic bag swirled around him.

"I had been to brunch with my friends," he said. "I wasn't drunk, I wasn't high, but there was something very profound and enigmatic and almost spiritual about this moment. And I kept waiting for the bag to fly away, and it didn't; it just kept slowly circling me. Whether that was an accident of physics or whatever, it was a profound thing for me. And that stuck with me."

By 1997, Ball had done a couple of studio assignments, including a film adaptation of another play of his own, and he was determined to break out of television and get into features. He even changed agents, looking for representation that would push him for movies.

His new agent insisted he would need a new spec script, and *American Beauty* was one of the ideas he brought in. Combining the Fisher/Buttafuoco story with an encounter with a plastic bag didn't seem like the formula for a salable spec script, though, and Ball knew it.

"I pitched three ideas to [my agent], two of which were really standard romantic comedies, and one of which was *American Beauty*, which is really

hard to pitch. I expected his eyes to glaze over and for him to say 'Write the first one, because you can get Julia Roberts to do that.' But instead he said, 'I think you should write that last one.' I said, 'Why?' He said, 'Because that's the one you obviously have the most passion about. I can hear it in your voice.' That's the best advice I ever got."

So in his spare time during his third season on *Cybill*, mostly late at night, Ball wrote his first draft of *American Beauty*. It took him eight months to turn out a rough 150-page draft. "I didn't outline it. I tend not to outline, because I think my best work is done when it's sort of like a journey of discovery. Of course there's a lot of stuff you have to throw out later, and you end up writing a lot of stuff that ends up being subtext."

He gave the script to a couple of trusted friends, took their notes, cut twenty-five pages, and gave it to his agent. He didn't really expect the script to sell, only to help him get some attention for his work. But it was bought by DreamWorks, caught the eye of several A-list directors, and moved quickly toward production.

One thing Ball's script had going for it was that every one of its characters, even the bit parts, is very vivid on the page. For that, Ball credits both his acting background and his experience in television.

In sitcom work, he notes, "even when you have a day player, you want to give them a joke, because if they just come in and set up the stars, it always [feels] like sloppy writing. So you learn how to write for [certain actors and capture them] in one line, even if they don't have a joke or anything. [That way] they have a voice, they have a presence. It's not just boring, it's not just pretty, there's a person there.

"I think there's a tendency around town to look at sitcom writing as hack writing, and I would disagree with that. I think when it's done well, it's some of the hardest writing there is. It's certainly taught me about the nuts and bolts of storytelling. I've always had sort of an instinctive understanding of character and tone and dialogue, but just in terms of telling a story, each scene having a purpose, each scene progressing the plot, I owe that to television."

But there was a downside to that television background, too. Ball found that his frustration with the job was infecting the tone of the script. "I think the first draft of the script is a little too angry," he said. "What I was able to realize later is the heart of the movie is not angry at all."

He used one unusual technique to make sure the reader understands his idea of line readings: boldface and italics.

Alan Ball on Writing Visually

This is one of the most visual screenplays I've ever read. The scene descriptions are very detailed and specific.

I've always written that way. To me, that's one of the great [virtues] of writing in the screenplay medium. You do tell a story visually. It's not a play. It's not based on dialogue. And there are so many points in this movie where important information is revealed visually. I just saw it that way when I wrote it. When I'm writing for the medium of film, which is a visual medium, I write visually. I see the shots. I see the way it should be. In order for me to clearly tell the story, I put them on paper. I think one of the reasons people responded to this script as strongly as they did when it first came out is that you can see the movie.

A lot of beginning writers get bogged down creating the details of the performance on the page, trying to do the actor's job.

I've been an actor. I think that actually is a strength that I have as a writer, because I sort of perform the roles in my head. But I'm very aware, also, that actors are going to bring their own choices, a lot of which are going to be better than the ones you make when you're writing, so I try to stay away from that.

I look at a screenplay that's going to go out to the town as almost a presentation. It's not really the script of the movie, it's a presentation that hopefully will allow the people who read it to see the movie. So sometimes I go a little overboard in stating clearly what's going on in the characters' minds. I hope I err on the side of "He looks at her and realizes what he hasn't known for all these years," because even if you were to write it in terms of performance details, that information might elude the reader.

I use italics and boldface in my dialogue so that you can hear the dialogue when you're reading it—you can hear those inflections. Then, when it comes time to produce the movie, I go back and remove all of that, so that the actors will be free. But I feel that for that first read, you almost need to spoon-feed. I'm not saying that a lot of people in the industry aren't savvy enough to get it; it just helps if you're really clear.

Some scenes were cut immediately after the script sold, including the colonel's Vietnam flashback. "The flashback stuff with the colonel is an example of [writing] something that is subtext," he said. "I needed to know that backstory to understand why that man behaved the way he did and to be able to write him and not have him just be a cardboard villain. But it didn't belong in the script. It totally tipped where you're going in the story."

He also changed the end of Lester's pursuit of Angela, so that they would no longer have sex. His original idea had been that their lovemaking would be just that—making love, as opposed to sex. "But that's a little subtle," he admitted, "and because he's forty-two and she's sixteen, it does raise a lot of red flags for people." After the script sold, Walter Parkes, a DreamWorks senior executive, suggested that Lester ought not to sleep with Angela. "Once I really heard that idea and really understood it, I realized it wasn't about the sex—it was about him becoming the parent he was unable to be with his own daughter."

Ball replaced the lovemaking scene with one of the film's most powerful moments, when Les and Angela talk in the Burnhams' kitchen. Finally, Les is at peace, and by *not* having sex with Angela, he becomes the man he has wanted to be. As Ball notes, Angela gives Les the chance to be that man simply by letting him in emotionally. "His wife and daughter have completely shut him out of their lives. It's a basic tenet of so many spiritual disciplines to be selfless, to love something outside of yourself and to give to that, and he can't really do that with Carolyn or Jane because they've dismissed him. He's dismissed himself.

"Angela is like the 'call to action,' in Joseph Campbell terms, and he assumes that she is the goal. He gets sort of obsessed about her, but then he just sort of forgets about her. It becomes all about freedom and reclaiming his authority over his own life, and doing what he wants to do for once, instead of just being this beaten-down automaton who brings home the paycheck. She sets him on this journey, but he sort of loses sight of her. Then, when she comes back, it's like, 'Oh. Oh, yeah.' He thinks that's what he wants, but it isn't.

"She awakens this passion for living that he had forgotten about, that had been so dormant in him, and he focuses it all on himself in very adolescent ways. But in the end he realizes that it is not all about him. It's about something else entirely."

Les's pursuit of Angela is actually mirrored in Carolyn's affair with Buddy, the real estate king, though that parallel became clear only as Ball and director Sam Mendes rehearsed with the actors before shooting started.

"It was pointed out to me, during that whole rehearsal process, [that] Carolyn didn't really have . . . as much of an arc as Lester. She really needed to go on her own journey as well. We talked at length during that time about their history and their life together, and how it had been really good once, how they had really loved each other in the beginning."

The result was a memorable scene in the Burnhams' living room, where Lester is almost able to reawaken that passion with Carolyn, who has just re-

turned from a tryst with Buddy. "She's reawakening a part of herself that had been long dormant, and she's kind of fresh and alive. That's why, when she comes in, he goes, 'Have you done something? You look great.' The notion of him reaching out to her and trying to pull her back in, and her just not being able to do it, felt really right."

Another attempt to connect with Carolyn also came out of the rehearsal process. In the script Carolyn confronts Les in their bedroom, taunting him that he may not be the only one who's sexually frustrated. "I just remember saying, 'Why doesn't he just go, "Well, come on, climb on. I'm ready"?' And everybody just seemed to like that. So we put it in."

Some critics have commented on how Carolyn has pruned away Lester's virility, his very manhood, just the way she prunes her roses. But Ball doesn't blame Carolyn personally. "It's that whole American preoccupation with success and appearance. That eats away at manhood, because then you feel like you have to perform. You can't be an authentic person if it's all about your image and success and everything. That's not what real manhood is about.

"A lot of people see her as the castrating woman, and I never saw her as that. I saw her as this woman who got lost. [Les's] problem is not that he's whipped, it's that he's given up. It's that he's lost. . . . We live in a society in which it is very difficult to be an authentic person, to be a soulful person, and I think that's tragic. I think so much energy and money and attention is spent on appearances and hype and distraction. And as a culture, I think we're in trouble."

Ball himself is a very soulful person. His emotional connection with his characters is palpable. He identifies with them strongly, and he talks about them with a passion many people might be hard-pressed to muster for real-life friends. Writing Lester's death scene affected him deeply. "I got depressed for like three days," he remembered. "Over the course of writing the script I had really grown to love this character. [After writing that scene] I walked around in a funk."

He was also moved by the plight of Barbara Fitts, played by Allison Janney. "She's so sad, that woman. She's so lost. She's so shut down," he said. One source for that character was Ball's own mother. "When I was an adolescent my sister was killed in a car accident and my mom went into a deep depression that she stayed in for many years. She was sort of shut down, walking around the house like a ghost. So there was a little bit of that."

Once it was decided that Les should abstain from sex with Angela, and his efforts to reconnect with Carolyn were brought to the foreground, the last

moments of Lester's life had to change as well. In the film, just before Les is shot, he contemplates a picture of his family, saying only, "Man. Man oh man."

Ball says that Les is "realizing, *I had that. I still have it*. I think he's thinking, *What an asshole I've been. I have got to get this family into therapy. I've got to do something. I've got this thing, and it's so precious, and I almost lost it*."

Les's flashbacks in his moment of death also changed. It was Mendes who suggested that his mind should dwell mostly on his family, not Angela. "It's one of those instances where once you hear it, you think, *Of course*. You feel like an idiot for not having thought of it," said Ball.

Overall, Ball and his script got far more respect from Mendes and Dream-Works than Franzoni got with *Gladiator*—and Ball was writing his first produced feature. That is likely because *American Beauty* was also Mendes's first feature. An award-winning stage director, fresh from a Tony for his Broadway revival of *Cabaret*, Mendes treated Ball with a respect that is more akin to how writers are treated in the theater than in the film world.

"Sam is used to working with writers and allowing them a certain amount of [leeway], really listening to their input. The really good directors in theater, of whom Sam is one of the best, look at the script and say, 'How do I bring this to life? How do I illuminate this script?' As opposed to, 'How do I bend this script to my concept of what it should be?' The writer is very much a part of the process and [there are no] changes to the script without the writer's consent. The flip side, of course, is that you can't make any money as a writer in the theater.

"I disagreed with Sam on a couple of occasions. He disagreed with me. But we both are used to working in that collaborative way. If there was something that I felt really strongly about, I would articulate it, and if I did a good enough job, he would go, 'Huh, okay, I see what you mean.' And vice versa."

When the script went out for casting, it still carried the prologue with Ricky in jail, and the epilogue that followed the fates of the characters. One actor who responded strongly was Annette Bening, who would eventually play Carolyn.

"I thought it was very special," Bening told me some months later. "I thought it was unusual because of the juxtaposition of moments. And these private moments in *American Beauty* are so unusual. When I was in acting school, we had an exercise where we had to come in and bring in a private moment from your life, where you were doing something that you would never imagine someone seeing you do. *American Beauty* had those moments where you have the characters, and you kinda think you know who they are,

and suddenly you have this moment and you think, *Oh my God!* There's something very satisfying about watching that."

As Bening says, such moments of revelation touch a universal chord. "We're all known in a certain way by the way we present ourselves, either understood or misunderstood in a certain context by the way we carry ourselves, but we know there's a whole part of ourselves that nobody really sees or knows. And the movie is interested in that. And I remember thinking, when I first read [the script], *I don't know how this works, but I know emotionally it makes sense to me.*"

Bening especially appreciated the scene early on where Carolyn is trying to sell the house. "What happened was so surprising. I thought, *My God! That's just so right, and yet it's so crazy, and yet it makes sense and is funny, so, so sort of tragic. All these things together.*"

Bening got to make her own small contribution to the script in the moment after Lester's death, when Carolyn runs to their closet, sobbing, and embraces Lester's clothes.

"Ninety-nine-point-nine percent of the script is his," she's careful to say, "but that moment, the way it was cut, is different from the way it was shot. I felt it was very important, even with all of this dysfunction and stuff, that everyone was basically deeply loving, which is really how I think most of us are in our dysfunctional families. There's incredible love, incredible desire to have these relationships have some sort of meaning to us, but it often gets distorted. So I thought it was really important that, even though she was so angry at this guy that in a way she wanted to kill him, she was madly in love with him."

But how to convey that on the screen? Bening says she wanted to show that Carolyn took no pleasure in his death. "I had a friend whose father committed suicide and the mother never took his clothes out of the closet. Everything was still there. You know how it is if you miss someone and you smell a piece of their clothing; it so brings them back." She suggested adding such a moment to *American Beauty*, a contribution Alan Ball welcomed.

Ball did clash briefly with Mendes, though, over the trial sequences that framed the main story. Mendes cut them in editing, leaving only a glimpse of the incriminating videotape to tease the audience.

"The first time I saw it I was a little bit upset," remembers Ball. "I said, 'It goes against everything this movie's about, every reason I wrote this movie.' And he got very passionate and said, 'The movie's trying to let us know what it needs to be, and you can't see that!'" After his anger died down, Ball says, he realized that Mendes was right.

"Hopefully one of my strengths is that I can realize when things are better," he says. "I don't hold on to things from a proprietary place. I've been collaborating with people long enough to realize that I don't always have the best idea. Other people are going to have other ideas and they're going to be better, and they're going to make the work better, and that's what's important, the work. Not me, not my ego, not everything being done exactly the way I saw it."

Ball suggests that there is a very specific but finite role for the creative ego in a collaborative process like filmmaking. "As the writer," he says, "you have a very clear picture in your head of the way things should be done when you write. That exists to get the piece on paper. The minute it's on paper, you need to let go of that."

Mendes convinced Ball that it was simply too cruel, too cynical, to have Ricky convicted of Lester's murder. "It felt at odds with the heart of the movie that was taking shape. You see this really tender love story that's really innocent and sort of pure, even though he's a drug dealer. To punish them for the crime they didn't commit [was] so cruel, and the movie's not about the world being a cruel place, it's about the world being a beautiful place."

Ball's experience with Mendes, then, was entirely positive, despite their occasional disagreements. "I really hit the jackpot," said Ball. "I don't know if it will ever be this good again."

Maybe that's why Ball returned to TV after *American Beauty*, to launch the acclaimed HBO series *Six Feet Under*. (Or maybe he saw series television as a medium where writer-producers, not directors, have the final say.) By late 2005, he was preparing another HBO series and developing a feature to be his directing debut, *Towelhead*, based on a novel by Alicia Erian. According to *Variety*, he also had two spec scripts in hand and had workshopped a stage play, *All That I Will Ever Be*.

All that suggests a craving for creative control that few screenwriters ever get.

"If I were to write a movie now that was as personal and meant as much to me as *American Beauty* did," Ball told me, "and then I saw somebody turn it into something completely different or subvert it or something like that, I'd go crazy. I'd jump out of my skin."

He also said he'd learned a hard lesson about writing for the studios. At one point, he says, he took a job rewriting a romantic comedy for Warner Bros. "I had taken every single studio note. I thought, *You just do what you're*

told and that will get them to like it and that will get them to do it. And that's not the case."

Instead, he urges writers to follow their own instincts. "Just write what you feel. Write what moves you. Write the movie you would go see and you would like, not the movie you think would sell or you think that other people want to go see. For me, I've been most successful when I write the movie I would want to go see. Because I don't go see the big blockbusters; I don't go see the mainstream movies. I prefer the more independent, foreign, less generic stuff, and I think that's what I write best. I can write that other stuff, but it's never paid out for me. This one did."

Random Hearts

CREDITS

DIRECTED BY Sydney Pollack
SCREENPLAY BY Kurt Luedtke
NOVEL BY Warren Adler
PRODUCERS: Sydney Pollack and Marykay Powell
EXECUTIVE PRODUCERS: Warren Adler and Ronald L. Schwary
PRODUCTION COMPANIES: Columbia Pictures, Mirage Enterprises, and Rastar Pictures
ORIGINAL MUSIC BY Dave Grusin
CINEMATOGRAPHY BY Philippe Rousselot
FILM EDITING BY William Steinkamp
CASTING BY David Rubin
PRODUCTION DESIGN BY Barbara Ling
ART DIRECTION BY Chris Shriver
SET DECORATION BY Susan Bode
COSTUME DESIGN BY Bernie Pollack

MAJOR AWARDS

None

CAST

Harrison Ford . . . *SERGEANT WILLIAM "DUTCH" VAN DEN BROECK*
Kristin Scott Thomas . . . *KAY CHANDLER*
Charles S. Dutton . . . *ALCEE*
Bonnie Hunt . . . *WENDY JUDD*
Dennis Haysbert . . . *DETECTIVE GEORGE BEAUFORT*
Sydney Pollack . . . *CARL BROMAN*
Richard Jenkins . . . *TRUMAN TRAINOR*
Paul Guilfoyle . . . *DICK MONTOYA*
Susanna Thompson . . . *PEYTON VAN DEN BROECK*

Peter Coyote . . . *CULLEN CHANDLER*
Dylan Baker . . . *RICHARD JUDD*
Lynne Thigpen . . . *PHYLLIS BONAPARTE*
Kate Mara . . . *JESSICA CHANDLER*
Ariana Thomas . . . *SHYLA MUMFORD*
Bill Cobbs . . . *MARVIN*
Susan Floyd . . . *MOLLY ROLL*
Edie Falco . . . *JANICE*
Kathleen Chalfant . . . *SHIRLEY MAGNUSON*
S. Epatha Merkerson . . . *NEA*
Brooke Smith . . . *SARAH*

BUSINESS DATA

ESTIMATED BUDGET: $64 million
RELEASE DATE: October 8, 1999
U.S. GROSS: $31.5 million
FOREIGN GROSS: $43 million

REVIEW HIGHLIGHTS

"There are so many good things in *Random Hearts* but they're side by side instead of one after the other. They exist in the same film, but they don't add up to the result of the film. Actually, the film has no result—just an ending, leaving us with all of those fine pieces, still waiting to come together. If this were a screenplay and not the final product, you could see how with one more rewrite, it might all fall into place."　　**—ROGER EBERT,** *CHICAGO SUN-TIMES*

"[*Random Hearts*] . . . is Hollywood hit-making at its efficient, formulaic worst. Technically, there's not much to fault—and yet it's so familiar, so predictable and so interchangeable with dozens of other overbudgeted, carefully packaged star vehicles that one might as well watch the trailer and fill in the blanks."

—EDWARD GUTHMANN, *SAN FRANCISCO CHRONICLE*

3 | "I DIDN'T THINK THIS WAS REALLY GOING TO HAPPEN"

RANDOM HEARTS • KURT LUEDTKE

ladiator and *American Beauty* are pretty good movies. You may or may not agree with the Academy that they were the best pictures of the years they were released, but few people would list them as out-and-out stinkers. *Random Hearts*, on the other hand? Well, it's bad. And by the time it was getting ready to open in the fall of 1999, everybody involved seemed to know it. The studio certainly knew.

How can I be sure? The cold cuts were a dead giveaway.

Scene from the life of an entertainment reporter: When I was attending movie press junkets, almost every one included some bit of swag for the reporters. The studio liked to call them gifts, some consider them bribes, but they were a fact of life on the junket circuit. I assume they still are. I gave a lot of mine to charity auctions, but years later I was still using my *Mission to Mars* overnight bag and my *You've Got Mail* laptop case, and to this day my wife looks mighty fetching in that white terrycloth *At First Sight* bathrobe.

Junkets themselves can also be a bit of a bribe, especially if they entail a couple of days at the Ritz-Carlton in Maui, all expenses paid, for thirty-five minutes of work (as was the case for me on the junket for *The Beach*). At the very least, a reporter attending a junket can expect a very nice buffet lunch. (Indeed, on my very first junket, I mentioned to a more experienced reporter that I'd grabbed a sandwich before driving over. Came the response: "My dear, you *never* eat before one of these things.")

When I arrived at the *Random Hearts* junket at the Four Seasons in Beverly Hills, a day or so after the press screening, the swag was a leather-bound organizer, embossed with the title of the film. Very classy, a tie-in with the story, a nice gift. But when I got to the waiting room, where there would normally be

a buffet of pasta, grilled vegetables, and hot entrees, all I found was a modest platter of cold cuts. There may have been some hot dogs, too. Later I called one of the publicists and floated a theory: The studio had ordered the leather organizers early, thinking this would be their prestige release for the fall, maybe a big Oscar contender. Then, after they'd seen the movie, they put out a cost-cutting directive to everyone involved with the film.

The publicist laughed. "You're probably right," he said.

Despite a formidable cast headed by Ford and Kristin Scott Thomas, Sydney Pollack directing, and a screenplay by his Oscar-winning *Out of Africa* collaborator Kurt Luedtke, *Random Hearts* really is a stinker. I can't say I was shocked, though, because in doing my due diligence on *Random Hearts*, I read the book. And there's no polite way to say it: *Random Hearts* is a bad book. Warren Adler's 1984 novel is a slight, sentimental potboiler, the kind that turns up on the bargain table at your neighborhood library's yard sale—and doesn't sell.

When I went to buy a copy at a mystery bookstore in West Hollywood, the clerk shook his head and chuckled, "Poor old Warren Adler."

Yet somehow this minor novel inspired a major motion picture. How does such a thing happen? How did this forgettable book become not just a movie, but a prestige project—or at least a stab at one? The answer: concept. Adler's book had a logline that hooked its producers, Luedtke, Pollack, and Ford, but somehow never worked—on the page or on the screen.

Luedtke was at home in the Detroit suburbs when his phone rang late in 1994. The caller was Marykay Powell, a producer for Rastar Productions, who had been trying to develop *Random Hearts* for the screen. "Marykay called and said, 'I've got a story about two people who meet because their spouses have been killed in a plane crash and the spouses were having an affair,'" Luedtke remembered. "I said, 'Oooh, that's interesting. Send me the book.'"

Inspired by the real-life crash of a jet into the icy Potomac river, Adler's novel opens with two lovers, Orson Simpson and Lily Davis, waiting at Washington National Airport. They are nervous but excited, sneaking away from their respective spouses for a romantic getaway in Florida. The couple are blissfully anticipating their time together when the plane falls into the river just after takeoff.

The plane crash is big news, and both Lily's husband, Edward Davis, and Orson's wife, Vivien Simpson, have a moment of fear when they hear of it, but then they both relax. The plane was Miami bound, but Lily was supposed to be headed for Los Angeles, and Orson had told his wife he would be in

Paris. Neither spouse thinks to contact the police for several days. In the meantime, the bodies are recovered from the Potomac and returned to next of kin, but two remain mysteriously unclaimed: "Mr. and Mrs. Calvin Marlboro." Only when their IDs are recovered does a local detective realize what really happened. Remembering his own wife's infidelity, the detective is furious at the dead couple.

The detective brings Edward and Vivien to identify the bodies, then sits them down together and breaks the news. He shows them that they each carry copies of the same key: Clearly, the two "strangers" had a love nest somewhere in Washington. Edward and Vivien are stunned. Later, they meet at a roadside restaurant and begin trying to find the love nest. As they join forces to piece together Orson and Lily's lies, the two lean on each other for support, and soon they fall in love themselves. At first Vivien feels too betrayed by Orson to move on, but the affair ripens, and Edward moves into her house. The pair attract suspicion when they receive a visit from the FBI; the agents suspect that their affair has been going on for some time and that they had something to do with the plane crash. Finally, however, the original detective surprises them when he announces that he's found the love nest. The two visit the apartment; Vivien realizes "We must forgive them," and they return to McCarthy's car, blissfully and unrepentantly in love. Vivien reveals she is pregnant and she hopes the baby will look just like Edward. The end.

In the words of my tribe: *Oy vey.*

When Luedtke got the call to adapt this story, he was already in his mid-fifties, with a couple of successful careers behind him and no burning itch to keep working in either of them. Born in Grand Rapids, Michigan, Luedtke attended Brown University and went into the newspaper business, working at the *Miami Herald* and eventually serving as executive editor of the *Detroit Free Press*. Restless, he moved west in 1979, hoping to get into the movie business.

"I went to Hollywood," he remembered, "thinking that I could afford to work cheap for a while, that if I could get myself apprenticed to a studio president or major independent producer, that I could do that for a couple of years and learn the business and then produce myself. The work I had been doing in the newspaper business was largely administrative—designing a mass-market product—so I thought of myself as pretty commercial. I went looking for that job, [but] I found that the job I had in mind for myself didn't exist—and even if it had, any kid from USC was a better candidate for it than I was."

At length, Luedtke realized that his best chance to make it in Hollywood was as a screenwriter. "To get a job as a screenwriter," though, "I was going to

have to write a novel first, and if Hollywood wanted the novel, then I could bargain for the right at least to do that draft." After settling on an idea for a novel, he was getting ready to leave Los Angeles to write it when he had a chance meeting with a distant family friend, an Orion executive named Chris Chesser. He mentioned his story idea and thought nothing of it until the next day, when he returned to drop off some scripts he had borrowed.

"Come on," Chesser said. "We're going to go down the hall and pitch Medavoy"—Mike Medavoy, the cofounder of Orion. Luedtke was floored. "I knew generically what 'pitch' meant, and I vaguely, vaguely, vaguely knew who Medavoy was, but not really." But off they went. "I started telling the story and one thing led to another. What they didn't tell me at the time, princes of candor that they are, was that they were trying to make a deal for a picture or two with George Roy Hill, and Hill had said to them, I've done this this, this, this, and this. Do you have anything political? Do you have anything like *Advise and Consent*?'

"Well, if you use a very broad definition, you can kind of call the story of *Absence of Malice* political. . . . So a meeting was arranged and I told the story, what I knew of it then, to George Hill, who was interested enough to say, 'Yeah, let's try it.'"

Luedtke then wound up with what he calls "one of the strange deals ever made." Orion optioned the film rights to his still-unwritten novel, conditioned on receiving a satisfactory treatment. "What they intended to do, of course, was get their hands on the treatment, give it to a screenwriter, and get on down the road. But I unintentionally outwitted them. I left town thinking I knew what a treatment is, but I didn't really. So I went off to my cabin in the woods in northern Michigan and wrote maybe fifty, sixty thousand words. In six weeks, I shipped off this big pile of paper to Orion. And they called up and said, 'We have this thing here. It's kind of interesting. What is it?' I said, 'It's a treatment.' They laughed and said, '*Nooo*. A treatment's four pages, five pages. Sometimes we get six pages.' I said, 'It's a long treatment.'"

Still, George Roy Hill was convinced that Luedtke was worth a try. He contributed some ideas about converting Luedtke's "treatment" into a screenplay, and in 1981 it became a successful film with Paul Newman and Sally Field. More important, it put Luedtke together with director Sydney Pollack. Four years later, Pollack and Luedtke would reunite for *Out of Africa*, and Luedtke would take home an Oscar for the film.

But then ten years went by—a decade in which Luedtke wrote no produced scripts—before he received the call about *Random Hearts*.

Long after their first phone conversation, Luedtke would learn that Marykay Powell had been trying to develop *Random Hearts* into a screenplay for some time, and at least one other writer had written a draft. In turning to Luedtke, Powell was starting over—but she had good reason to be persistent. Adler's *The War of the Roses* had been made into a hit film, and the logline of *Random Hearts* certainly looked like the stuff of a movie. And Luedtke's track record of adapting novels for the screen—most notably *Out of Africa*—made him seem the perfect match.

Like everyone who heard the premise, Luedtke was intrigued. The book, however, was another story. He declines to offer his opinion of the novel, but he remembers that after reading it he was "sort of interested" in the project. Luedtke was back living in Detroit, "and I was not hot to go to Los Angeles. So I said, 'You know, you'll be going to New York to do your Christmas shopping or something. Come through Detroit on your way, stop at the airport, and we'll have a meeting. It will be cheap and easy.' That was the plan. I kind of thought that at the end of the meeting we'd say 'It's good to see each other again' and get on with things. I didn't think this was really going to happen."

What Luedtke didn't know was that Powell was trying to hire Luedtke, at least in part, in order to entice Sydney Pollack and Harrison Ford to sign on for the picture. Several months after I spoke to Luedtke, at the same press junket where Columbia plied us with cold cuts and leather datebooks, Pollack filled in the blanks. "I am told [by Powell]," he said, "that the reason they hired Kurt was in an effort to get me, because he's only done three [movies]—he's only done the movies I've done." Powell and Ray Stark had tried to interest Harrison Ford in the story, but his interest was limited. "I think this is a great premise," Ford told them, "but I'm not crazy about the script." At the time, however, Ford was working with Pollack on the remake of *Sabrina*. "Maybe when we finish *Sabrina*, we could look at it again," Pollack thought at the time.

So Powell had more reasons to get Luedtke on board the picture than the writer could have known. Still, she never quite found her way to Detroit for that December visit. New Year's 1995 came and went, and Luedtke and his wife headed to their winter home in the Florida Keys. Then Powell called again, but Luedtke wasn't biting. "I said, 'You know, I just got to Florida and it's really swell here. I'm not getting on any planes and going to Los Angeles.'"

So Powell and Columbia executive Chris Lee suffered their way to Florida that January for a pitch meeting with Luedtke, who was still a bit dubious about the whole thing. "I don't know exactly what I said [to them], and it wouldn't have been very highly developed, because frankly I hadn't

thought about it that much." Luedtke remembers pointing out that he didn't like the idea of having Lily be pregnant when she dies on the plane. Worse yet, he told them, "the characters seemed to me to be too passive. An administrative assistant and a housewife aren't active enough for me." Much to his surprise, Powell and Lee offered him a deal. "At that point, of course, I felt, gosh, these people came all this way to talk about this thing, I'd better do it."

Deal or no deal, though, Luedtke wasn't about to drop everything for *Random Hearts*. "I didn't go to work right away. I think I told them we were going to Costa Rica for a while, that I wanted to lie in the sun."

Luedtke likes to write in his northern Michigan cabin or the Florida Keys, but finding the right place to write is the easy part. "I'll do almost anything to avoid writing," he admits, "so there's a lot of sitting around thinking about other things that need doing. But eventually I write something, sooner or later. I tend to take an awful long time thinking about the thing, even though I know I shouldn't.

"I know what I *should* do—that the most productive thing to do is to put a thing on paper and see. It takes on a momentum. It goes the right way, or it goes the wrong way, but it goes someplace that you can react to. I tend to want to work in my head for a very long time, trying to work out this little thing or that, trying to make it perfect.

"So when I finally *write*, you know, I write very, very fast. If people knew how long something really took to write, when they haven't heard from me in six months—if they knew that what they finally got [was] written in three days, Lord knows what they'd think."

Once he got going on *Random Hearts*, what Luedtke ended up writing was less an adaptation than an entirely new screen story, keeping little more than the premise of two people who meet and fall in love after they learn that their spouses, who were cheating on them together, have died in a plane crash.

Luedtke kept the story in Washington but jettisoned almost everything else. Luedtke combined the story's two most developed male characters—the cuckolded husband and the outraged local detective—into one composite character, a Washington internal affairs detective named Dutch Van Den Broeck.

"I think Dutch is sort of a blend of the cop and Edward Davis and other things," explained Luedtke. "As a matter of plot convenience, the cop was feeding them information, and I thought, *Well, I want them doing that for themselves*. I don't want them relying on some otherwise not-very-involved cop doling out nuggets of material when the story needs it."

"Don't Overreport a Good Story"

Reporters, like screenwriters, often find themselves looking for simple, clear conflicts in their stories. Luedtke cultivated that skill as a journalist, but carrying it over to screenwriting proved more difficult.

That talent—if talent it is—for simplification, which I certainly would have in a newspaper office, where I would cheerfully write a one-sentence, two-sentence description in a story budget, and even be pretty good about [it], I don't seem to have that where screenplays are involved. I think it's a good thing to have. It's a good discipline.

I used to laugh when I was told you ought to be able to summarize a movie or a screenplay in five or six sentences. And after a little more time with the process, I realized that not only is [that talent not silly], but . . . your inability to do it is telling you something you'd better pay attention to about the story. Doing that exercise, when you hit that point where you aren't able to do the next sentence, or you can't finish it, most of the time you're being told something about a story problem.

Luedtke spent so long on one assignment that it eventually slipped away from him: Schindler's List. *For more than three years, he researched his own adaptation, but was replaced by Steven Zaillian. Luedtke laughed as he looks back on the experience.*

I fell into an odd trap. I thought I should know more about Oskar Schindler than anybody else in the world. And almost did. Although I certainly enjoyed it at the time, I wasted a terrific amount of time to go running down information from that period generally and Oskar in particular. The reading I did was prodigious. Getting into previously unopened files, discovering this and that, all kinds of things.

There's a saying in the newspaper business: Don't overreport a good story—it may turn into not such a good story. And that happened to me with Schindler as well. You know, when they hire you to adapt the book, maybe what you ought to do is adapt the book, instead of reinventing the whole situation.

The Washington setting inspired the evolution in the female lead. Housewife Vivian Simpson became Representative Kay Chandler, a congresswoman in a tough reelection campaign. "I wanted to make her something other than a housewife, certainly. It appealed to me to have [her husband's] adulterous relationship [a big enough story to] make the papers." And the idea of a cop and a congresswoman joining forces—intellectually and

romantically—was also attractive to Luedtke. "A bit of a class and caste difference implied there, and I liked that."

Where Adler went to considerable lengths to put his characters into some kind of danger—having the FBI agents suspect Edward and Vivien of wrongdoing, for instance—Luedtke said, "We did nothing with that." The creative team on the film asked themselves, "Is there anything in it for us, if anybody [should see] our protagonists in a romantic situation [and] wonder, *Well, gee, how long has this been going on? Is it in any way related to the plane crash?* But it was nothing that we really wanted to deliver on. We didn't feel confident that we could put them in any real jeopardy, and since we couldn't do that, we just thought it was a blind alley."

Luedtke also decided not to give the story a villain, focusing instead on building conflict between the leads. Where Edward and Vivien both felt shocked, betrayed, and wounded, then came together to work through their pain, Dutch and Kay have very different reactions to the discovery of the affair. Dutch is shaken to the core by the fact that his wife was cheating under his nose, and by his failure to recognize it. "Dutch [thinks], *I get paid to know who's lying. I get paid to know this stuff.* So he really wants to know when it got started, and what their plans were, and was it a fling or was it serious?

"And [Kay] wants to know nothing, other than what she knows already. Her attitude is, *There's nobody to shoot; we can't even get a divorce. Put it behind you. Stop this, don't dwell on this. You'll hurt yourself and you'll hurt people around you.* In particular she has a teenage daughter she's trying to protect from this knowledge, and she's scared to death that this cop, who is running around trying to find things out, will start talking to friends and neighbors and business associates, and that the daughter might find out about her father's affair."

With the two leads at loggerheads, there was no need for a suspicious FBI agent or an enraged brother-in-law to create conflict. Yet making Dutch a cop opened the door for a different kind of danger. "He's an internal affairs cop, investigating corruption, which is kind of betrayal." Luedtke looked for a situation that would relate thematically to his main story, and focused on Dutch's new cynicism. "Now that he knows that he could not trust his wife, he kind of becomes somebody who doesn't trust anybody, and out of not trusting anybody, he blunders or rushes into a situation that proves to be a dangerous one for him."

Luedtke also ratcheted up the conflict by giving Kay at least a hint of knowledge of her husband's affair. Where Vivien was clueless, Kay is

suspicious, so when Dutch finds her and breaks the news, she's not shocked, and he can see as much.

Given their conflicting motives and attitudes, David and Kay's search for the "love nest" takes on a whole different meaning in the story. Rather than a shared obsession that brings them together, it's another bone of contention between them. Still, in order for these two wounded people to come together, Luedtke had to find *some* way to make them spend time together.

The answer was to send Dutch to Miami in search of the lovers' trail. "He's beginning to wonder whether [his wife] was regularly meeting this guy, and the congresswoman follows him to Miami trying to get him to drop it." In Miami the pair become intimate, but Luedtke has no answer to the question "Do they fall in love?" "I'm not trying to be coy," he says. "I believe that there is a degree of ambiguity there. . . . A reasonable, prudent [viewer might say] 'Yes, they did,' and another would say 'No, they didn't, they were reacting to the pain.' So I don't know."

It all sounds logical, well thought out. So how did *Random Hearts* go wrong?

Luedtke's involvement did revive Pollack's interest in the project. He felt that Luedtke's first draft "went a long way to solving the problems that were in the previous versions."

Still, there were challenges. "In Kurt's first draft," said Pollack, "he didn't write a love story. He wrote that they became very good friends in the process of trying to track down what had happened. So I spent six or eight months with Kurt trying to turn it into a love story and then sent the first fifty pages to Harrison." Pollack and Ford then met over breakfast. "Harrison said he thought it was promising, but he wasn't ready to commit."

So Pollack and Luedtke kept working—and their relationship protected Luedtke from having to take notes from the studio. In fact, perhaps because of his habit of working with Pollack, Luedtke rarely took studio notes directly. Like many working writers, he called the few notes he has received from studios over the years "kind of ridiculous. It wasn't something that would cause you trouble because it wasn't even in the ballpark. It was bizarre."

Pollack, though, had a different attitude. As Luedtke joked, the director welcomes input—from "anybody in the state of New York, the state of California, airplanes going between those two places, people met on the street . . . anybody [he] meets. Obviously I overstate, but he likes to get a lot of reaction.

"I think he's looking for the interesting small insight that could become

a suggestion: 'What if . . .' Or he's looking for 'Nobody gets it when . . .' Or 'Everybody likes it when . . .' Or 'All the women like it when . . . but the men are bored.' He's got his own set of filters, and he needs to stoke his process with a lot of reaction. When he's already made up his mind about what he thinks is right, it doesn't make any difference at all. But on everything else, on anything that's up for grabs, he likes to have lots and lots of reaction."

Luedtke, for his part, said he likes notes that reveal "real confusion." He laughed about one draft of *Random Hearts* where "I wrote a story movie—it wasn't fancy writing, it was just pure story—and it was clear that nobody knew what the hell was going on. So that's helpful. Once in a great while, a *great* while, you actually get a suggestion that's useful, and that of course is swell. It's rare, but it's swell."

Ford has said in interviews that he comes with a process, and everyone knows that. "My way of preparing to stand and deliver acting-wise," he told me, "is to become involved in the story and the script at a certain point, to test that material with the people I'm to work with and to have my questions and concerns addressed . . . so that I can have full confidence in the material when I step out to do the acting part of it. That is the process, if you will."

Did that happen on *Random Hearts*? "It always happens, yeah."

Word to the wise: If ever a star seemed uncomfortable talking to reporters at press junkets, it's Harrison Ford. Unlike many stars, he doesn't seem to much care for talking about himself, his process, or even his pet causes. In fact, he doesn't seem to much care for talking, period, at least to strangers. (During the *Six Days, Seven Nights* press junket, goes one story, a young reporter started the roundtable interview by chirping, "Who is Harrison Ford?" Ford's response: "Why the hell should I tell you?")

At the *Random Hearts* junket, happily, Ford was a bit more expansive. Asked what he related to in the character of Dutch, Ford said, "I always resent being lied to. I don't lie to other people unless it's absolutely necessary, and I don't like being lied to, so I expect truthfulness in my working relationships with people."

Dutch's feelings of betrayal appeared to have hit a nerve with Ford. "Every day he puts his life on the line, based on feeling that he can take care of himself, that he knows who's lying to him and who's not; that he's got a process that will help him find the truth. And, in this case, he finds out that there is no truth to find. It's a bit disquieting to him. And one of the geniuses of the screenwriting in this case, I think, is this parallel police story, where we see the effect of these circumstances on his professional life. We see him start

to make missteps and misjudgments, and to try and frame this guy he knows is guilty of the murder. But suddenly he's doing things in a way he'd never done before. I found that interesting."

By the end of this series of processes—Luedtke's, Pollack's, and Ford's—only one major thread remained from Adler's strong premise, or his weak novel. As Luedtke defined it, the film's real focus was "what happens after two people find out that their spouses were killed in a plane crash because they were having an affair that they didn't know about. It's how people react to adultery, and in particular, how they react when the adulterers are not available to be yelled at, or divorced, when they're dead."

The resulting film was not quite a love story, not exactly a thriller, not precisely a character-driven drama. "I'm not sure," said Luedtke, "given the limited vocabulary that one uses for labels in these situations, what words to use. Everything that quickly comes to mind, I say to myself, 'It's not exactly that, it's not exactly that.' So maybe we've invented a whole new genre here, I don't know."

The consensus after the fact, though, was that whatever they invented, it didn't really work. Reviews were bad, box office was worse, and Luedtke hasn't written another movie since.

By the time the cold-cut junket was upon us, everyone involved must have realized they had a dud on their hands. So maybe in this case, perhaps Harrison Ford, of all people, should get the last word.

"Were there any concerns you had about the material, going in, that you care to talk about now?" I asked him.

"No. No."

"No to which part of the question?"

"Any part. Any part. There's no sense going back. I mean, the process is . . . the process is complete, you know. There are things that I have less confidence in than other things, and some of those things are still in the movie and some of them aren't, you know. It's just, it's such a long and complicated process. It's real hard to go back and look at it and try and deconstruct it for other people, because you sort of had to be there."

Lost in Translation

CREDITS

DIRECTED BY Sofia Coppola
SCREENPLAY BY Sofia Coppola
PRODUCERS: Sofia Coppola and Ross Katz
EXECUTIVE PRODUCERS: Francis Ford Coppola and Fred Roos
STUDIO: Universal Studios
PRODUCTION COMPANIES: American Zoetrope, Elemental Films, and Tohokashinsha
ORIGINAL MUSIC BY Kevin Shields
CINEMATOGRAPHY BY Lance Acord
FILM EDITING BY Sarah Flack
PRODUCTION DESIGN BY K. K. Barrett and Anne Ross
ART DIRECTION BY Mayumi Tomita
SET DECORATION BY Towako Kuwajima and Tomomi Nishio
COSTUME DESIGN BY Nancy Steiner

MAJOR AWARDS

ACADEMY AWARDS: Sofia Coppola—Original Screenplay
GOLDEN GLOBES: Best Picture, Musical or Comedy; Sofia Coppola—Screenplay;
 Bill Murray—Actor, Musical or Comedy
BAFTA AWARDS: Sarah Flack—Editing; Scarlett Johansson—Actress;
 Bill Murray—Actor
INDEPENDENT SPIRIT AWARDS: Best Feature; Sofia Coppola—Director, Screenplay;
 Bill Murray—Actor
WGA AWARDS: Sofia Coppola—Original Screenplay

CAST

Bill Murray . . . *BOB HARRIS*
Scarlett Johansson . . . *CHARLOTTE*
Giovanni Ribisi . . . *JOHN*
Anna Faris . . . *KELLY*
Fumihiro Hayashi . . . *CHARLIE*
Catherine Lambert . . . *JAZZ SINGER*

BUSINESS DATA

ESTIMATED BUDGET: $4 million
RELEASE DATE: October 3, 2003
U.S. GROSS: $44.6 million
FOREIGN GROSS: $73 million

REVIEW HIGHLIGHTS

"What's astonishing about Sofia Coppola's enthralling new movie is the precision, maturity and originality with which the confident young writer-director communicates so clearly in a cinematic language all her own . . ."
—LISA SCHWARZBAUM, *ENTERTAINMENT WEEKLY*

"One of the purest and simplest examples ever of a director falling in love with her star's gifts. And never has a director found a figure more deserving of her admiration than Bill Murray."
—ELVIS MITCHELL, *NEW YORK TIMES*

"The joys of Sofia Coppola's *Lost in Translation* come from watching Murray modify his trademark passive-aggressive style into played-straight comic bewilderment. . . . This is a career worth watching and a movie worth watching, too."
—MIKE CLARK, *USA TODAY*

4 | "IT'S TWO PEOPLE; NOTHING HAPPENS"

LOST IN TRANSLATION • SOFIA COPPOLA

Over a few months during 2003, two movies opened about Americans abroad, getting very different receptions from critics and the public. The first arrived with a fancy pedigree: Merchant-Ivory's *Le Divorce*, adapted by acclaimed screenwriter Ruth Prawer Jhabvala from Diane Johnson's bestselling National Book Award finalist. It boasted a flavor-of-the-month actress, Kate Hudson, and a star on the rise, Naomi Watts, as American sisters in France. The story of their romantic misadventures and the underlying clash of cultures was timely, coming at a time when Americans were changing the name of french fries to "freedom fries" because of France's refusal to support American policy toward Iraq and the resulting war. Whether that hurt or helped the film at the box office is hard to say, but in any event the film met with tepid reviews and attracted little attention from audiences. By Oscar time it was forgotten.

Not long after, though, *Lost in Translation* arrived in theaters. This film's pedigree really belonged to its writer/director, Sofia Coppola, the daughter of *The Godfather* director Francis Ford Coppola. *Lost in Translation* also featured a star on the rise, Scarlett Johansson, and it paired her with a long-established actor loved by baby boomers, Bill Murray. Johansson played a young newlywed, Murray an aging movie star, both visiting Tokyo and both feeling disconnected from, well, pretty much everything. *Lost in Translation* went on to become both a rare crossover indie hit (grossing around $120 million on a production budget of around $4 million) and an award-season darling. Coppola eventually took home a Writers Guild Award and an Academy Award for Original Screenplay.

At a glance, the two films seemed to have a lot in common. Both started

as indie art-house releases, though *Lost in Translation* proved popular enough to get wider release. Both featured Americans in a foreign capital, grappling with the customs of a friendly but profoundly alien country. And both feature a relationship between a younger woman and an older man.

As anyone who saw both films can attest, though, the experience of watching them feels entirely different. In a time when the studios have all opened specialty arms to make and distribute "independent" films, "indie" has come to signify a style of filmmaking more than a financing method. By that standard, *Lost in Translation* is a true indie: an intimate, offbeat, intensely personal film with a unique style and point of view. It's almost all atmosphere and subtext, something no studio would have made, yet its fans found it tense and compelling—even though it's almost entirely plot-free. (To be fair, some critics found it slight and self-indulgent, and consider it overpraised.)

Next to *Lost in Translation*, *Le Divorce* seems very much the well-made play, filled with plot contrivances: a stalker, a suicide attempt, and a denouement featuring a well-timed murder and a conveniently discovered fortune. It all seems very old-fashioned, at least compared to Coppola's film. It's like comparing Ibsen to Chekhov: One's chockablock with melodramatic plot devices and twists, while in the other, on the surface, little seems to be happening at all.

Like Chekhov, however, Coppola doesn't tell her story through plot. "[Plot] is just not what I feel like writing," she said by phone from her New York apartment. "You just have to do what you're into. That's just not what I feel compelled to write." She set out from the beginning to write a script where what is left unsaid is far more important than dialogue. "That was part of the lost-in-translation thing, that people don't really say what they mean. There's just a lot of confusion, not just between the Americans and Japanese but between men and women.

"I just thought of everyone kind of missing each other, everyone's busy, or not speaking the same language—and then to have this brief moment of connection with someone you wouldn't expect, a stranger." It's almost the opposite of a high-concept premise. "It's hard for me to even pitch it," confessed Coppola. "It's two people; nothing happens."

Coppola's two Americans—the middle-aged movie star and the young wife of an up-and-coming photographer—find themselves staying at the Park Hyatt hotel in Tokyo. Both are in quiet crisis: Bob Harris (Bill Murray) is in a midlife crisis, while Charlotte (Scarlett Johansson) is drifting through her twenties, trying to find a direction. Neither really wants to be in Tokyo. Both

are jet-lagged and can't sleep, which gives them hours of silent nighttime with nothing to do but think. In time they strike up a friendship, each recognizing the same sense of utter dislocation in the other. And they quickly form a bond that isn't exactly a romance, but is somehow still deeply romantic.

It's a delicate film, mostly mood and atmosphere, a far cry from the elephantine, plot-heavy tentpoles that sweep through multiplexes like storm fronts all summer. It's certainly a far cry from the kind of spec scripts that most screenwriters learn to write in hopes of selling a script to a major studio—though its logline, "Two baffled Americans hook up for an interlude in Tokyo," sounds like the jumping-off point for a romantic comedy.

"It's such a specific genre, romantic comedy, and I don't feel like it's really like that," said Coppola. "It's romantic more in feeling and atmosphere. When you listen to a certain song, that kind of melancholic romance, just a brief connection or moment that doesn't last."

It's not *all* atmosphere, of course; things actually do happen. Bob makes a Suntory whiskey commercial and is bewildered by the direction he gets. A Japanese woman, apparently a prostitute, is sent to Bob's room to give him a "premium fantasy" that goes comically awry. Charlotte meets a vapid young movie starlet. An insipid jazz trio serenades the hotel bar, where Bob and Charlotte hook up. The two go out on the town a couple of times. Charlotte injures her foot and Bob takes her to the hospital. The real action is in the subtext: What's *not* happening and what's not said give the story its power.

Coppola said that the story is not strictly autobiographical, but when the film opened, the unkind portrayal of Charlotte's too-busy husband raised some eyebrows, and when Coppola split with husband Spike Jonze some months later it seemed to confirm the sense that Coppola was drawing on her own life. Coppola herself would say only that most of the events and people in the film come from her own memories of Japan. "Aren't all writers eavesdroppers?" she mused. Of course . . . but if a writer wants to draw on her experiences, it helps to have had some, as David Franzoni observed. And Sofia Coppola has had her share.

As Francis Ford Coppola's daughter, Sofia grew up around movie sets. (She's the infant who was baptized on-screen during the climactic sequence of *The Godfather.*) And from childhood on she absorbed storytelling lessons from her father. "He was talking to me about screenwriting as a little kid," she remembers. "He would talk about the three acts: 'In the first act you have to have this.' Just being around that, you're being encouraged, but also learning about writing."

Unlike some directors, the elder Coppola would take the whole family along with him on his shoots; Sofia's childhood included a stint in the Philippines during the shooting of *Apocalypse Now* and time in other locales away from the family's California home. "Maybe it was the Italian thing; it was so important to keep the family together. That's why we all went on location; otherwise we would never have seen him," Sofia recalls.

At first, she seemed destined to go into acting, like her cousin Nicolas Cage. She played small parts in several of her father's films, including *Peggy Sue Got Married* (with cousin Nic) and *Rumble Fish*. At eighteen, she got what looked like her big break: With filming about to start on the long-anticipated *Godfather III*, Winona Ryder dropped out of the key role of Michael Corleone's daughter Mary. The elder Coppola, needing an actress in a hurry, turned to his daughter, who had performed ably in those earlier films.

The rest is unhappy history: The movie was trashed by the critics, and much of the blame seemed to fall upon Sofia, who was lacerated by critics and fans alike. (Years later, even after *Lost in Translation*, she was still taking abuse for it: *Slate*'s 2006 review of her *Marie Antoinette*, a pan of the film and of her entire oeuvre, called her *Godfather III* performance "amateurish.")

A small handful of observers, this writer among them, felt her performance was not so much bad as wrong. The characters of the *Godfather* saga had been larger-than-life, even operatic; Sofia's Mary Corleone was underplayed and naturalistic. In *Lost in Translation*, Scarlett Johansson gives a similarly low-key performance; in a different context, the style works beautifully. Whatever the case, Sofia Coppola's *Godfather III* turn remains one of the famous misfires in American film history, her casting a symbol—unfairly or not—of misplaced Hollywood nepotism (though her father maintains that it was actually she who did *him* a favor by stepping in at the last minute so he could get his movie made).

Today, Sofia Coppola says she's too uncomfortable in front of the camera to imagine ever being an actor. As for *Godfather III*, she reflects, "I'm glad that people didn't like it, because then I might not have found something I liked doing as much." But she did not immediately follow her father's path into writing and directing films.

Instead she kept acting, with parts in *Inside Monkey Zetterland* and *Star Wars: Episode I*. She also hosted a show on Comedy Central and became a popular performer in music videos. (Her future husband, *Being John Malkovich* director Jonze, directed her in the video for "Elektrobank" by the Chemical Brothers.) She also started her own clothing line and designed the

costumes for the film *Spirit of '76*, produced by her brother Roman. It was this interest in fashion and clothing that first brought her to Japan.

She was still in her early twenties, in the midst of what she calls "that I-don't-know-what-I-want-to-do-with-my-life thing," when she was invited to Tokyo to produce a fashion show. When she started her clothing company with a friend, the trip to Tokyo became an annual event. "I loved the way the cities looked, and the feeling of it, and the isolation of being so far away from home.

"It's definitely inspiring just seeing new things and different things. And I think you are more reflective when you're away from your regular life, because you don't have the distractions."

A few years later, she also began writing and directing short films and collaborated with her father on a segment in *New York Stories*. On the strength of those shorts, she got the chance to write and direct her first feature, adapting the novel *The Virgin Suicides*. That film established her as a writer-director, if not a particularly commercial one. The question now was, what next?

She had long wanted to do a movie in Japan; something about those isolating Tokyo trips nagged at her, with the emotions they stirred and those memories of sleepless hours. "I love going to Japan, but it was at that time where I didn't know what I wanted to do. Having this jet lag, contemplating your life in the middle of the night—*What am I going to do?* It came out of being at that point in my life, and then in such a strange place."

There was more on her mind as well. "I wanted to try to write an original script, which seemed kind of scary, not to have a book to be working from. I wanted to make a romantic movie, something I would think was romantic. And I wanted to do something with Bill Murray. So I tried to piece together how to fit those things together.

"I was kind of curious about the whole midlife crisis—a man trying to figure out what he was doing. I thought there was something similar between that and being in your twenties—what are you going to do, rather than looking back on what you've done. That was just based on people I know, or friends who are in that phase of [their lives]. And I just pictured Bill Murray in Japan in a kimono that's too small. That's what I was thinking about when I was writing that. And I also liked the Humphrey Bogart–Lauren Bacall kind of romance."

She took the setting from her own visits. She'd stayed in the Tokyo Park Hyatt on a publicity tour for *The Virgin Suicides*, and that provided fodder for

her story as well. "There's something about how a hotel becomes its own world. You walk in one room and there's a press conference going on and in another room there's an ikebana flower class. It's all the things that go on in this hotel. . . . It is sort of surreal, [when you] walk into a room and that whole world is going on." She even drew on her press conferences there. "You find yourself giving these stupid answers about your favorite food. And it's always funny to hear the translation back, with partial English words in it."

Actually writing a script, though, is something of an ordeal for Coppola. "It's so hard. Writing and all the procrastinating involved, I find it really isolating, too. I think the thing that helped a lot was not writing it in a script form." She started with a suggestion from her brother Roman, who told her to try writing in the style of beat poet Richard Brautigan. "He writes these little paragraphs. It's easier to write a paragraph than a whole scene or a whole page." So she wrote down her memories of Tokyo, not worrying about how they'd fit together. "I find that helpful. It takes the pressure off to say I'm just going to write a couple of sentences about what I want the scene to be like.

"If you keep doing it, then you have a whole pile of pages with just a couple of sentences on each one. Then you put those in script form. As opposed to sitting down and saying 'I'm writing a script,' you're just writing little paragraphs." It worked, she said, "because there's no plot to chart out, it's more just these little moments, which hopefully add up to this feeling or atmosphere."

She works at home and prefers to write late at night, when there are no distractions. "When you're a little bit tired, you get better ideas when your brain isn't on all the way. My dad says to get up and do it first thing in the morning, but I'm just not a morning person."

She started working on *Lost in Translation* in spring 2001, but the script didn't come together very fast. "I think there was only one draft, because I don't like rewriting. For me that's like cleaning your room or something. I like to write and be done with it. Maybe I made revisions, a couple of different drafts, but I didn't rewrite the whole thing.

"I think I spent a year writing the script and finishing it up. But I started writing it in this other form. Whenever I get stuck I talk to my brother Roman, and he encourages me to not write it in script form—just to write these little scenes or little ideas."

Because she found writing so lonely, and to keep her from procrastinating, she even arranged for screenwriter David Russell (*Flirting with Disaster*) and his writing partner to come over for an informal "writing club."

"They were just in the other room writing, and we had lunch together. And that helped, because there was someone in the other room writing so you'd better be writing."

She would get stuck, but when she did, she'd talk to her brother and get back to basics. "I thought about this story in the back of my mind for a while before I sat down to write it, and then going back to Japan when I was working on it gave me ideas for little observations. It helped that I knew what the ending was going to be.

"I knew it was a simple story, more just about the feeling or the mood between these two characters. That's what I was trying to do."

On learning that we had read a draft of the screenplay (marked "Second Draft, April 12, 2002") she admitted being a little embarrassed, maintaining that what we read was "like notes for when you're making the movie." Certainly she didn't write this script to sell it: Punchy, it's not. On the surface, it looks like the collection of disconnected observations of Japan it started out as—and yet that ends up working perfectly for the film, since it forces the reader to feel as disconnected as Charlotte and Bob.

At length, some themes do emerge from the script: Bob and Charlotte's longing for connection, and the difficulty any two people can have communicating. What isn't clear from the screenplay, though, is just how funny the movie turns out to be. (In that respect, Coppola's writing really is a little like Chekhov's. There's plenty of humor, but it comes across in the playing, not always on the page.) In the script, Bob's encounter with his "premium fantasy" woman is odd; on-screen, it's hilarious. It also advances Coppola's themes: Any chance that this could actually be a turn-on for Bob is torpedoed when the woman can't pronounce the fantasy she wants him to play out with her. Even eroticism is lost in translation.

The film is also structured a bit differently from the script. The script spends many pages following Bob at the outset, not bringing Charlotte into the story for a long time. In the released version of the film, our first glimpse of Charlotte and her husband comes much earlier.

"We moved her story forward. My dad gives really good editing advice, when he sees the early cuts. He gives good writing advice, too. But I wrote it on my own and then I showed him the rough cut. He always tells young filmmakers to make it clear in the beginning. You think it's obvious because it's your thing. . . . You want to be subtle or mysterious, but I feel like if the audience is confused in the beginning they can't really get into it. So we added some narration there too, just to make it clear where they're coming from."

One scene that plays very differently on the screen is a scene where Bob and Charlotte lie on her bed, fully clothed, and simply talk. It's an honest and intimate conversation, shot from directly above, mostly in one static shot, so we see their entire bodies. On the page, it just seems like talk—good talk, but still talk. On-screen, the scene aches with tension; while they aren't touching, we feel the attraction between them, and the moment could turn sexual at any moment. And unlike such scenes in typical romantic comedies, that doesn't necessarily seem like a good idea.

"I like seeing their body language in that scene. But I guess it's sort of hard to describe on paper. . . . I wanted there to be that kind of tension. She's in his hotel room, and right there, something could happen. I like those moments where they're both aware of something but aren't really saying anything about it. They're talking about other things. In those situations, when you like someone, there's a lot of tension over simple things. I like these epic moments, which seem like nothing if you're not in the moment. Just those little things in life that seem like a big deal, though they [may not] sound like it to someone else."

When Coppola finally assembled her script, though, it was less than seventy-five pages long. That's not unheard of in a script with long stretches with little or no dialogue and where much of the action is meant to be improvised, but it's still uncomfortably short for a feature script. "I was always trying to make it longer because it was so sparse. I remember screenwriter friends telling me I could make it longer if I put the pages in a certain way, and this and that." It also became an issue with getting financing. Would someone put up money for such a slender script? Especially one that was virtually unpitchable? Having *The Virgin Suicides* to show helped, but it was still hard to get *Lost in Translation* financed.

The solution to the financing problem turned out to be foreign sales. "The Japanese distributor for *Virgin Suicides* was one of our early financiers. It wasn't super easy. It wasn't just like, 'This is what I want to do.' We had to work with my agent to go around and get it together." Some chipped in because they'd liked *The Virgin Suicides*. Others related to the details of *Lost in Translation*. "[They] said they could relate to it, that they'd had an experience like that, that they'd had this connection with someone."

Having Bill Murray attached might have helped, but at that point he hadn't signed on, so she could say only that he was the actor she wanted. "He was kind of elusive. He never signed a contract or anything. He just said he'd do it at one point. So I went to Japan not knowing for sure—wondering if he

was going to show up. But Wes Anderson had told me that when he worked with him, you don't know, you won't hear from him for a while, but if he says he's going to do something, he'll show up. And they didn't have any signed contracts or anything, so that put me at ease. But I really wanted him to play that part, and I couldn't picture anyone else doing it." Murray, of course, showed up.

She shot with a Japanese crew, which provided more than its share of lost-in-translation moments, and she kept finding moments to add into the picture even as she shot: One long shot of two women laughing at Bob in the hospital waiting area is actually two extras cracking up during the take. "Somebody [on the set] was worried. They said, 'Should we stop? They're ruining it.' But that's what would really happen in real life."

Yet as offbeat as *Lost in Translation* is, its disconnected protagonists hit a nerve with more people than the American sisters at the core of *Le Divorce*. Where *Le Divorce* is about expatriates trying to make the best of life in their adopted home, *Lost in Translation* is about travelers, people who are just passing through for a few days, far from home, cut off from everything they know and without hope of putting down roots where they are. It's an experience almost any business traveler can relate to.

Still, Sofia Coppola says she doesn't enjoy writing. It's directing, which lets her bring her visual sense and acting experience together, that she really loves. But after adapting *The Virgin Suicides* and now penning an original with *Lost in Translation*, she said she couldn't imagine directing someone else's script. And by spring 2006 she had completed another film about a culturally displaced young woman, this time with ten times the budget: *Marie Antoinette*. Once again, she wrote the screenplay, directed, and produced, and once again, the film was light on plot and long on atmosphere.

In 2003, though, she was happy to have her first original screenplay behind her.

"For me, writing's hard, to sit down and actually do it. I'm motivated to do it, because I want to make the movie.

"But I'm not looking forward to doing it again."

Black Hawk Down

CREDITS

DIRECTED BY Ridley Scott
SCREENPLAY BY Ken Nolan
BOOK BY Mark Bowden
PRODUCERS: Jerry Bruckheimer and Ridley Scott
EXECUTIVE PRODUCERS: Branko Lustig, Chad Oman, Mike Stenson, Simon West
PRODUCTION COMPANIES: Revolution Studios, Jerry Bruckheimer Films,
Scott Free Productions
ORIGINAL MUSIC BY Hans Zimmer
CINEMATOGRAPHY BY Slawomir Idziak
FILM EDITING BY Pietro Scalia
CASTING BY Bonnie Timmermann
PRODUCTION DESIGN BY Arthur Max
ART DIRECTION BY Pier Luigi Basile, Gianni Giovagnoni, Ivica Husnjak, Keith Pain, Cliff
Robinson, and Marco Trentini
SET DECORATION BY Elli Griff
COSTUME DESIGN BY David Murphy and Sammy Howarth-Sheldon

MAJOR AWARDS

ACADEMY AWARDS: Michael Minkler, Myron Netinga, Chris Munro—Sound;
Pietro Scalia—Editing

CAST

Josh Hartnett . . . *EVERSMANN*
Ewan McGregor . . . *GRIMES*
Jason Isaacs . . . *STEELE*
Tom Sizemore . . . *McKNIGHT*
Eric Bana . . . *HOOT*
William Fichtner . . . *SANDERSON*
Ewen Bremner . . . *NELSON*
Sam Shepard . . . *GARRISON*

Kim Coates . . . *WEX*
Tom Guiry . . . *YUREK*
Charlie Hofheimer . . . *SMITH*
Danny Hoch . . . *PILLA*
Zeljko Ivanek . . . *HARRELL*
Glenn Morshower . . . *MATTHEWS*
Jeremy Piven . . . *WOLCOTT*

BUSINESS DATA

ESTIMATED BUDGET: $90 million
RELEASE DATE: December 18, 2001
U.S. GROSS: $108.6 million
FOREIGN GROSS: $65 million

REVIEW HIGHLIGHTS

"The film manages to pull off the remarkable tightrope walk of remaining scrupulously noncommittal in its attitude toward the conflict.... In this respect; pic is unusually mature, in that it doesn't tell you what to think. Unfortunately, it also refrains from giving you anything to feel other than general revulsion for war.... The pummeling viewers get—which can be rationalized intellectually as 'putting them through' the firefight as vividly as possible—makes the film more rewarding to think about afterward than to actually experience." —TODD McCARTHY, *VARIETY*

"Films like this are more useful than gung-ho capers like *Behind Enemy Lines*. They help audiences understand and sympathize with the actual experiences of combat troops, instead of trivializing them into entertainments.... The movie avoids speechmaking and sloganeering, and at one point, discussing why soldiers risk their lives in situations like this, a veteran says, 'It's about the men next to you. That's all it is.'" —ROGER EBERT, *CHICAGO SUN-TIMES*

"*Black Hawk Down* wants to be about something, and in the midst of the meticulously staged gunfire, the picture seems to choose futility arbitrarily.... The lack of characterization converts the Somalis into a pack of snarling dark-skinned beasts, gleefully pulling the Americans from their downed aircraft and stripping them. Intended or not, it reeks of glumly staged racism.... The actors are mostly called upon for the kind of 'it's a man's man's man's man's world' sloganeering before heading off to fight that characterizes most Bruckheimer films: dated martial wisecracks of the 'Let's rock 'n' roll' variety." —ELVIS MITCHELL, *NEW YORK TIMES*

5 | "GOTTA STAY ON THIS JOB"

BLACK HAWK DOWN • KEN NOLAN

Ken Nolan wasn't really surprised to be fired from *Black Hawk Down*. He'd been warned to expect it and he'd worked like a dog to prevent it. Still, when the call came, he was angry.

"I had emotionally attached myself to this movie. I loved it as if I'd written a spec. And when they replaced me, to have that ripped away from me was very difficult to deal with."

It's a feeling familiar to many writers—just think of David Franzoni, who suffered the same fate on a story that was his own idea. Brought in with high hopes, Ken Nolan did the heavy lifting required to turn Mark Bowden's long, complex book *Black Hawk Down* into a workable screenplay. Now he seemed to have been tossed aside in favor of more experienced writers with big-name credits: *Thanks much, don't let the door hit you on the way out.* Unlike Franzoni, he wasn't even offered the chance to stay on the project as a producer.

In the end, though, Nolan got a happy ending . . . of sorts. A thirty-three-year-old with no produced credits, he was hired, fired, then later re-hired. And, in the end, the Writers Guild awarded him sole "screenplay by" credit for the film—despite the involvement of such writers as Bowden, Steve Gaghan (*Traffic*), Steven Zaillian (*Schindler's List*), and Eric Roth (*The Insider*).

Black Hawk Down was adapted from Mark Bowden's bestselling book on "the Battle of the Black Sea," the confrontation between U.S. Special Forces troops and tens of thousands of Somali fighters in the city of Mogadishu on October 3, 1993.

At first, the United States had sent troops to Somalia on a humanitarian

mission. The elite Army Rangers and Delta Force commandos were inserted later to capture warlord Mohamed Farrah Aidid.

The battle came after a lightning "snatch and grab" mission to arrest two of Aidid's lieutenants went awry. The mission was supposed to last an hour or less but escalated when two of the army's Black Hawk helicopters were shot down over a hostile section of Mogadishu. More than one hundred American ground troops spent eighteen hours pinned down and surrounded by thousands of enraged Somali fighters. It was called the longest such battle for American ground troops since the Vietnam War. By the time the trapped Americans were evacuated, one helicopter pilot was captured, dozens of troops were wounded, and eighteen Americans were killed. No one really knows how many Somalis were killed in the battle, but estimates range from one thousand to five thousand.

In the wake of the battle, the Clinton administration decided to withdraw American troops from Somalia. For years, the only public memory of the incident seemed to be the video of a half-naked American corpse being dragged through the streets of Mogadishu. Bowden's book, the only full account of the battle ever compiled, changed all that when it became a bestseller.

The film version, a Columbia/Revolution Studios release directed by Ridley Scott and produced by Jerry Bruckheimer, was slated for a fall 2001 release, but after 9/11 it was pushed back to January 2002 (with a limited release in December to make it Oscar-eligible for 2001). Many observers wondered how audiences would react to its graphic violence and the depiction of Americans dying in a fight against Muslim nationalists. But it proved a big hit, knocking *Lord of the Rings: The Fellowship of the Ring* out of the number-one box office slot.

When he was hired, the boyish Nolan might have seemed like an unlikely choice to pen such a big-budget, high-profile production. A Buffalo native, he attended the University of Oregon with hopes of a journalism degree, but when he couldn't pass the grammar test, he chose English instead. Nolan became the film critic for the school's newspaper, and soon after college he moved to Los Angeles. After trying his hand as a performer ("I sucked at acting"), he gave it up. "I'd always written," he says, "so I thought I'd try writing scripts."

From 1990 to 1994, Nolan completed every assignment in Syd Field's noted guide *The Screenwriter's Workbook*. By day, he supported himself as an assistant at production companies. "It was during the early-nineties spec

craze, the Shane Black era," he recalled. "I saw all these people earning huge money for selling these ideas, and I thought, *I totally can do this. I have better ideas than most of these scripts.* I started reading all these professional writers' scripts, learning what to do and what not to do."

Over four years, he wrote "seven really bad scripts." Bad they may have been, but his scripts improved with each new attempt: The seventh spec attracted some interest, and number eight finally sold.

In fact, Nolan sold three specs before booking the *Black Hawk Down* job, but none were ever made. The first was a "*Die Hard* rip-off" (Nolan's phrase) called *In Contempt*. In 1995 he sold a spec called *The Long Rains* to Imagine and Universal. After nearly going into production with John Frankenheimer directing and Gary Sinise starring, the project fell apart at the last moment. He even sold Universal and Imagine another high-priced spec, but again it stalled in development. Nolan had carved out a reputation as an action writer, but he began to fear that he was becoming one of those screenwriters who make a comfortable living in Hollywood but never actually get produced.

"I started to realize, *Oh my God, I've got to get a movie made*," Nolan said. "My agent told me I was doing great, but if I wanted to have a long career, I had to have a produced movie."

He wasn't happy with the opportunities he was getting, either. "I was being offered the trickle-down from A-list writers. I was very intent on getting a movie made and everything I saw stunk." He took an assignment adapting a book for Universal. "It's like the worst homework assignment in the world, but at least you don't have to write a spec and reinvent yourself over and over." Still, nothing he'd written was getting produced.

Then he had a meeting with Todd Garner, a Disney executive at the time. Garner reviewed the company's slate of pending projects, but to his own surprise, Nolan said flatly that none of the projects interested him. "I don't know why that popped out of my mouth," he laughed. Startled, Garner pulled out a galley proof of *Black Hawk Down*. He warned Nolan that the author would be writing the script, but asked him to read it anyway.

He took the book home and was hooked. "I called up my agent and told them, "I'll go in, I'll pitch it to Jerry, I'll do all those things I really hate. This is the one I want.'" Nolan's agent set up a meeting with Bruckheimer Films executive Chad Oman, who agreed to meet even though Mark Bowden was still slated to write the script.

"Chad and I met for an hour over a beer," said Nolan. "He said, 'How do

you see this movie?' I talked for about five minutes and he said, 'All right, I'm going to get you into this.' Then I was hired, and I was off to the races."

Oman had good reason to be looking for another writer. Bowden was a first-time screenwriter, so new to the medium that Bruckheimer felt compelled to send him "how to write a screenplay" books before he started. According to Nolan, not even Bowden thought his draft would be used. "He was doing it just for fun," said Nolan. (Bowden probably collected a tidy sum for his draft as well: Getting a book published, selling the movie rights, and getting paid to write the first draft is a well-known way to get paid three times for more or less the same material. Michael Crichton, for one, has made something of a science of it.)

Once Bowden's draft was delivered, Bruckheimer Films was free to bring in other writers, and they turned immediately to Nolan. He jumped at the chance but knew that this would be a trial by fire. Bruckheimer Films and its predecessor, Simpson-Bruckheimer, were notorious in Hollywood for replacing writers freely and for bringing in big-name writers to fix either specific scenes or specific aspects of a script. "My agent told me, 'Look, do everything you can to stay on this project, because these guys replace people quite often. They're serial firers. They're going to wring you dry, then someone else is going to come on. Know this before you start.'"

A Bruckheimer script typically might have had one writer who did a relationship draft, another who worked on tech, another who worked on action, and another who wrote dialogue for "the girl." Stories abound of "name" writers contributing bits of scripts; Quentin Tarantino is rumored to have contributed the Silver Surfer exchange in *Crimson Tide*, for example.

But Nolan was determined to stay on the project at all costs. Knowing a bad first draft could get him fired in a hurry, he decided to go beyond the requirements of his writing deal. He'd heard that James Cameron would write detailed fifty- to sixty-page treatments he called "scriptlets," including dialogue and action. That's a lot shorter than Kurt Luedtke's first "treatment" for *Absence of Malice*, but it's still a lot of work.

"I didn't care if it was in my contract or not. I was just continuing to write and trying to make it good. If I'd just gone off and written a first draft, I could have made all these mistakes, because it's much harder to rework a first draft than a treatment." He did three drafts of the scriptlet, taking notes from Jerry Bruckheimer and his lieutenants Mike Stenson and Chad Oman on each draft, before actually turning it into a screenplay. (Disney, which has

a first-look deal with Bruckheimer, eventually opted out of the project, feeling it was too violent for their family-oriented strategy. The film was made by Revolution Studios, headed by former Disney Studios boss Joe Roth, and distributed by Sony's Columbia Pictures unit.)

Nolan was convinced the story should be an ensemble piece with no real main characters. Gently, Bruckheimer, Stenson, and Oman convinced him that it simply wasn't feasible to make a film that way. "They said, 'We've got to find out who our five main characters are, who the next ten main characters are, and who the ten under that are,'" said Nolan. "That was a constant problem throughout the screenwriting process."

As predicted, the pace was grueling. He did three complete treatments in four months. He would turn in his draft and get notes within days. "They'd call me up and say, 'Okay, let's keep going, here's all our notes.' Writing these treatments left me really burned out, because it's like writing the first draft every time."

Once he started writing screenplay drafts, he faced a whole new set of challenges. Bowden's sprawling, often technical narrative was gripping but did not readily lend itself to a film adaptation. On the other hand, changing it would mean playing fast and loose with the real events of the battle. Nolan wanted to write the ultimate James Cameron–style action movie. Some wanted a more political story. The resulting process was largely trial and error.

"We didn't know what we were doing. We were blundering along from draft to draft. How much of an ensemble movie do we make? We went way overboard at one point and cut out all but twelve characters. We decided there were too many characters and it was confusing.

"We finally decided that no matter how you slice it, this was going to be a confusing movie. You're going to get guys mixed up, they look the same. It is what it is. We've just got to go with it and keep the integrity of the story. We can't just make it 'Ben Affleck and someone else—that's the movie.' It's not going to work."

Nolan would incorporate new ideas into each draft, trying each new approach to see if it worked. It was Simon West, then slated to direct the film, who suggested telling the story from Matt Eversmann's point of view. "I thought, *Oh, no, here we go*. It's going to be a Hollywood movie after all," said Nolan. "I was getting all artsy and strident. But I tried it and it actually worked well."

But there was a problem: The real Eversmann was out of the battle relatively

early; he had returned to base before nightfall. The filmmakers wanted to keep Eversmann in the action, so later Nolan combined him with several other characters.

Eventually Nolan settled on five major characters: Eversmann; the company clerk who goes into battle for the first time; two older, more experienced Delta Force "operators"; and General Garrison. Eventually, Eversmann emerged as the protagonist of the film, and Stenson suggested building up the relationship between the inexperienced protagonist and the "ultimate warrior" Mace, the Delta Force fighter played by Eric Bana. "We wanted him and Eversmann to have, maybe, three conversations, so Eversmann could learn something from Mace without it sounding pedantic."

For Nolan, the writing process was grueling. He followed a writing "method" he calls "ultimate self-disgust." "I was playing video games and sitting in my underwear, not having left the house. I was living like a vampire. Then, at eleven at night, I'd say, 'I've got to get to work.' I'd work till three, four A.M. Sometimes, when it got down to the wire, I'd pull all-nighters." To enhance the mood, he'd slip in a CD from his collection of three hundred soundtracks (*Gladiator, The Thin Red Line, The Fugitive, In the Line of Fire*), turn off the phone, and drink a lot of coffee. In addition to his three scriptlets, he wrote ten drafts—far more than the usual two-drafts-and-a-polish provided for in a WGA-signatory screenwriting contract.

"I didn't care," said Nolan. "I figured, this is the one that gets made. I'm working for Jerry Bruckheimer. I felt like the apprentice, making cabinets for the master cabinetmaker. Another drawer? Yes, yes, no problem."

His eighth draft got director Ridley Scott attached to the project, and Nolan wrote two more drafts for Scott. Eventually, though, the "serial firers" lived up to their reputation.

"I got a phone call from Mike Stenson and Chad Oman," he remembered. "He said, 'This phone call is really hard to make. We think you've done a great job, but the studio wants to move on. We're going to hire Mr. Big Shot hot writer.' I said, 'Who's that?' They said Steve Gaghan, whose movie *Traffic* was about to come out."

Interviewed as the film was nearing completion, Jerry Bruckheimer said he always prefers to keep the first writer on a project, but it rarely works out that way. "Sometimes they have other movies to go off to, sometimes they get burned out. We try to always keep the original writer as long as he delivers something we feel is in the ballpark. On this project, Ken was the second writer, after Mark Bowden took a crack at it, and Ken was on it till the end,

even though other writers came on. . . . Mark Bowden is involved even now, along with Ken in the editing room, writing some stuff we needed for captions."

As Nolan tells the story, however, Gaghan in turn was fired after writing only thirty pages for Scott. The director then turned to Oscar-winner Steven Zaillian, who'd just worked with him on *Hannibal*. Zaillian essentially did a page-one rewrite, taking the script in a darker, more realistic direction. But as shooting began in Morocco, Nolan's cell phone rang again.

Nolan didn't have a laptop or even a passport, but sure enough, four days later he was on set in Morocco. The pressure only intensified once he got there: Each day he had to rewrite scenes for the next day's shooting schedule, while also working on new "theme scenes" that would underline the film's message. Bruckheimer noted that these "themes" were "kind of unwritten in the book," so the filmmakers turned to the journalist for background. "We consulted Mark Bowden about the intentions of these soldiers—what they were thinking, what they were feeling. We wanted to express that in the movie."

Nolan had his own ideas about the story's themes. "How does a Vietnam-in-twenty-four-hours [experience] change these young soldiers? That was my general idea," Nolan explained. "I wasn't sure how that was going to come across. What Ridley kept teaching me was, less is more. Subtlety is better. I was hitting things way too hard on the head, which is why I got replaced." On that score, Nolan studied Zaillian's draft for tips: "He's so damn good at subtle dialogue," he says. "I learned a lot from that."

Eric Roth was hired to write some of the "theme scenes," including exchanges between Eversmann and his Delta mentor, while Nolan kept up the grind of turning out daily pages. "What you do is approach a scene from a lot of different angles," said Bruckheimer. "And if the writer who's on the project doesn't quite get the angle you're looking for, then you bring somebody in with a fresh point of view. In this case, that really worked. Eric came in on a couple of scenes and was sensational. Other writers had tried those scenes and just couldn't crack them."

Meanwhile, Nolan was saddled with the task of changing the names of many of the characters. Some of the original names belonged to active Delta fighters who didn't want their names used. Others were composite characters. "Names are so hard to come up with," said Nolan. "There was a Ridley-approved list of names. And he'd snicker to himself as he read each name. '*Deke Branchmate*? What the fuck is this?'"

"I called up my little brother and asked him to help me out. He gave

me the entire roster of the 1980 Buffalo Bills. So [actor] Bill Fichtner called me up and started reading the names, 'Joe Cribbs, Joe Ferguson, Reggie McKenzie . . . Are you from Buffalo?' Turns out we'd grown up ten minutes away from each other."

Even as shooting was under way, Nolan changed "Mace" into "Hoot Gibson" and Mark Howe into "Jeff Sanderson" (after a hockey player). Company clerk Stebbins was combined with other characters and reemerged as "Grimes," played by Ewan McGregor.

On the set, the technical advisors told Nolan and Scott a story that had gone unmentioned in Bowden's book—the tale of how Osman Atto, one of Aidid's key lieutenants, was captured by American troops. The filmmakers decided to include the incident to show how effective the Delta Force could be and to throw the battle that followed into contrast.

That opened the door for a scene between Atto and General Garrison (Sam Shepard). Eric Roth contributed the first draft of the scene, in which Atto represented the Somali perspective on the Americans' presence.

Bowden had gone to Mogadishu to interview Somalis who witnessed or fought in the battle, and had the luxury of presenting many points of view. The film, by contrast, was mostly told from the perspective of the American servicemen. That was a red flag for some on the project, including Ridley Scott, who had wanted to make a dark, antiwar film. "We've got to get the Somali perspective into this movie," Scott insisted, anxious to ensure that the story didn't slide into one-sided jingoism. "Otherwise they're going to come after you with a fucking meat cleaver."

Despite the writers' efforts, Scott's fears proved correct: Some critics attacked the final film for dehumanizing the Somalis. Andrew O'Hehir, writing for *Salon*, complained that the film "provides virtually no context for the famine and civil war in Somalia, and presents the citizens of Mogadishu as a teeming, vicious horde, an angry black tide that engulfs the lonely emissaries of civilization." In the *New York Times*, Elvis Mitchell was even harsher. "The lack of characterization converts the Somalis into a pack of snarling dark-skinned beasts, gleefully pulling the Americans from their downed aircraft and stripping them. Intended or not, it reeks of glumly staged racism."

The accusation of racism particularly pained Nolan, who protested that there was simply no way to do full justice to both sides of the story while keeping the film at a reasonable length. But most reviews were positive, including raves from such major critics as Roger Ebert, Kenneth Turan of the *Los Angeles Times*, and Gannett Newspapers' Jack Garner. Judging by box of-

fice grosses, audiences were largely unperturbed by whatever flaws the film may have had.

For Nolan, the experience looked like a success: He got the produced movie he'd wanted and its reception seemed to bode well for his career. He was nominated for a Writers Guild Award for adapted screenplay; the movie got four Oscar nominations—including one for Ridley Scott—and grossed around $160 million worldwide. (That's a lot of money, although, given its estimated $90 million budget, probably not enough to make the movie profitable for the studio.)

Yet soon Nolan wound up on the same treadmill he was on before: often hired but not produced. Not until the summer of 2007 did he get another produced credit, *The Company,* a miniseries for TNT. In the meantime, though, he was certainly well paid. *Variety* reported in 2005 that Sony would pay him $3 million for his seventy-five-page scriptlet for "The Grays," an adaptation of a science fiction novel. In 2007 he was announced as the writer of a planned remake of John Carpenter's cult hit *Escape from New York.* Still, though, his name had not been seen on movie screens since *Black Hawk Down.*

In the days after *Black Hawk Down* opened, Nolan had joked about being like the hero of the Christopher Nolan film *Memento*: He'd worked so hard on the film that he couldn't remember anything he worked on before that. With time, too, he also realized never to take it personally when he's replaced. "They have an eighty-five-, ninety-million-dollar investment," he said, "and they have to get the best thing they can get. If it means replacing you and getting someone else, they have to do it. If they replace you, it doesn't mean you're a bad writer or a bad person. . . .

"Well, of course, I say that now. But at the time I was pissed."

Troy

CREDITS

DIRECTED BY Wolfgang Petersen

SCREENPLAY BY David Benioff

POEM (*THE ILIAD*) BY Homer

PRODUCERS: Wolfgang Petersen, Diana Rathbun, and Colin Wilson

PRODUCTION COMPANIES: Warner Bros., Radiant Productions, and Plan B Entertainment

ORIGINAL MUSIC BY James Horner

CINEMATOGRAPHY BY Paul Bond and Roger Pratt

FILM EDITING BY Peter Honess

CASTING BY Lucinda Syson

PRODUCTION DESIGN BY Nigel Phelps

ART DIRECTION BY Julian Ashby, Jon Billington, Andy Nicholson, Marco Niro, and Adam O'Neill

SET DECORATION BY Anna Pinnock and Peter Young

COSTUME DESIGN BY Bob Ringwood

MAJOR AWARDS

None

CAST

Brad Pitt . . . *ACHILLES*

Eric Bana . . . *HECTOR*

Orlando Bloom . . . *PARIS*

Diane Kruger . . . *HELEN*

Brian Cox . . . *AGAMEMNON*

Sean Bean . . . *ODYSSEUS*

Brendan Gleeson . . . *MENELAUS*

Peter O'Toole . . . *PRIAM*

Rose Byrne . . . *BRISEIS*

Saffron Burrows . . . *ANDROMACHE*

Julie Christie . . . *THETIS*

Garrett Hedlund . . . *PATROCLUS*

BUSINESS DATA

ESTIMATED BUDGET: $185 million

RELEASE DATE: May 14, 2004

U.S. GROSS: $133.3 million

FOREIGN GROSS: $363.6 million

REVIEW HIGHLIGHTS

"Crisply edited combat sequences, tableaus of antique splendor, [and] a hugely muscled Brad Pitt modeling the latest in Hellenic leisure wear . . ."

—A. O. SCOTT, *NEW YORK TIMES*

"Based on the epic poem *The Iliad* by Homer, according to the credits. Homer's estate should sue. The movie sidesteps the existence of the Greek gods, turns its heroes into action movie cliches and demonstrates that we're getting tired of computer-generated armies." —ROGER EBERT, *CHICAGO SUN-TIMES*

"Spectacular battles and some fine actors in grand roles on the one hand; hokey dialogue, insipid romance and dull interstitial downtime between set-pieces on the other." —TODD McCARTHY, *VARIETY*

6 | "LET'S SHOOT BIG"

TROY • DAVID BENIOFF

Every reader knows the feeling of finishing a classic work of literature and thinking *This is great. Why hasn't it been made into a movie?* But many literary masterpieces, however rollicking they are, feature sprawling story lines, long cast lists, and considerable violence, making them tough to adapt and expensive to film while limiting their potential audience.

In the early years of the twenty-first century, though, *Gladiator*, *The Lord of the Rings*, *Saving Private Ryan*, and *The Passion of the Christ* proved that computer-generated effects would bring stories once considered unfilmable into the realm of possibility. They also demonstrated that audiences would not automatically reject long, complex, or violent movies. The question a screenwriter must ponder, then, isn't whether a great classic story can be filmed, but rather, "What do *I* bring to the table?"

That was the question facing writer David Benioff when he decided to pitch an adaptation of one of the seminal (and most violent) stories in the history of Western literature: Homer's *The Iliad*, based on the myths of the Trojan War.

Like Ken Nolan, Benioff was still in the early days of his career when he took on the project: His novel *25th Hour* had just been filmed, on the strength of his own script. He had come far enough to have a good agent, who proved a good sounding board. When he asked his agent why no one had ever attempted an adaptation of *The Iliad*, Benioff recalls, she said it would be a tough adaptation. "There are dozens of characters, and it would be a four-hundred-page script.[1] How would you do it?"

[1] Despite the stereotype of agents and other Hollywood types as rapacious philistines, Benioff's agent's informed response isn't actually that shocking: Major agencies today

His reaction? "I said I'd strip it down and I'd be really ruthless."

Stripped down it may be, but *Troy*, from Warner Bros. and director Wolfgang Petersen, is still a big-budget, two-hour, forty-five-minute "tent-pole" focusing on the legendary grudge match between Achilles and Hector, played by Brad Pitt and Eric Bana (*Hulk*).

Of course, anyone could have pitched *The Iliad*. Benioff had to sort through the vast mythology of the Trojan War to come up with a workable angle on the story, knowing that his pitch would sink or swim on the clarity of his own point of view, the strength of his characterizations, and his ability to mold a Trojan War story that contemporary audiences would relate to—not to mention his willingness to horrify classicists everywhere by tinkering with a 2,500-year-old masterpiece.

Benioff, a longtime fan of Homer and the Trojan War myths, had always dreamed of seeing them on the screen. "There was *Helen of Troy* back in the fifties, but there'd never been the grand version the story deserved," he said. For years, he and his friends had kicked around the question of who should play the great Greek warrior Achilles, his Trojan counterpart Hector, and the tragically lovely Helen.

But all of that was just idle talk until *Gladiator* opened the door to a return to sword-and-sandal films. *25th Hour* had put him on the Hollywood map, and he began to think about trying an *Iliad* adaptation himself.

In some ways, the challenge of sorting through the source material was more complex than even Benioff's agent had thought. *The Iliad* is not the story of the entire Trojan War. Homer's poem begins late in the Greeks' ten-year siege of Troy and ends after the death match between Achilles and Hector, well before the end of the war. Much of the mythology of the war—including the seduction of Helen, the story of the Trojan Horse, the destruction of Troy, and the generations-long fallout from the war—is famous from other myths, poems, and stories, including Homer's *Odyssey*, Aeschylus's *Oresteia* trilogy, Virgil's *Aeneid*, and others.

As he prepared his pitch, Benioff had to choose his story points carefully from among the elements of this vast mythos. It might have been an over-

are filled with elite-business-school grads with an eclectic background and a passable knowledge of both high and low culture. So they tend not to be philistines, even if they remain, as a rule, irredeemably rapacious.

whelming assignment, but Benioff knew from the start what piece he wanted to build the screenplay around.

"For me, the core story was always the conflict between Achilles and Hector," said Benioff. "You had these two great heroes on either side who are inevitably going to fight at the end, but you're not rooting for one or the other. It's not a good guys–bad guys story. You know one's going to die, but either way it's going to be tragic. That for me was always the essence of it."

Sideways Connections

DAVID BENIOFF ON ODD JOBS, IRISH LITERATURE, A TROJAN HERO, AND CREATIVITY

Many writers have a colorful history of day jobs. David Benioff's resume includes time as a nightclub bouncer, a high school teacher, and a DJ in Moose, Wyoming. We asked him whether any of those jobs were especially important.

Taking all those different odd jobs was probably a reaction to my adviser in college, who was a novelist. His author bio said that he'd been a taxi driver in New Orleans and an attendant at an insane asylum and all these other crazy jobs. Being an impressionable nineteen, I remember thinking, *If you're going to be a novelist, you have to go out and have these crazy experiences.* There was a self-consciousness: *This would be cool to have in an author bio.* But they were all great experiences. . . .

I think one year that was really important for me as a writer was the year I spent in Ireland, getting a master's in Irish literature. I'd always been really obsessed with the Irish writers and that cult of the beautiful loser that the Irish have perfected. Maybe the reason I was so drawn to Hector is that he is the beautiful loser. He's not going to survive the story. He's not going to win. He's going off to fight Achilles, and he knows he won't be walking home, and the fact that he still goes out there, that he still puts one foot in front of the other, is one of the great acts of courage in literature.

[Then again,] maybe I'm just making that up.

Creativity often amounts to making sideways connections between things.

Sometimes, when people ask you where you get your ideas, it's hard to give a really good answer. I don't think many writers say, "Every day I sit down and read the newspaper and come up with three good story ideas." I think ideas often percolate in their minds for years and years. It might be something they first heard as a child and partly forgot, and then it gets partly recalled by some other thing they see or hear. Inspiration is an odd and elusive creature; it's hard to pin down where it comes from, but thank God it does.

Benioff reread Robert Fagles's translation of *The Iliad* (he especially admires the introduction and notes by Bernard Knox) and worked up a pitch, beginning before the seduction of Helen by Paris. He tried his pitch on his agents, who were enthusiastic enough to set up a meeting for him with Jeff Robinov of Warner Bros. (An executive vice president at the time, Robinov later become the studio's president of production.)

It was Benioff's first-ever pitch meeting, and Benioff remembers it as an uncomfortable experience. "He has this huge office and he's got a great poker face," the writer recalls. "He's just staring at me. I tell him the story as I see it. I start off pretty enthusiastic, but I'm not feeling a whole lot of excitement in there, and soon I'm feeling more and more nervous. I'm starting to feel like I've come into this room with the great epic of all time, the mother of all Western epics, and I've somehow blown it. I'm expecting to be thrown out of the office at any moment."

Later, as the movie was getting ready to open, Robinov recalled that Benioff began by saying, "Well, it's the greatest love story, the greatest story about brothers and family, it's one of the greatest war stories, and it's a big epic great tale." Benioff didn't know it, but from that point on Robinov was hooked. "I think he thought I was asleep, but I was really caught up in the story," said Robinov.

At the end of the meeting, said Benioff, Robinov shocked him by asking, "Are you ready to start writing?"

"Yes, *yes*, I'm ready to start," Benioff responded.

With support from his colleagues at the studio, Robinov soon gave the go-ahead for Benioff to start a draft. Of course, Robinov was only committing to a draft, not green-lighting the movie. Economics played a part in the decision, too: Robinov said he knew Benioff's fee wouldn't be prohibitive. "David was a fairly new screenwriter at the time, so if I was wrong, there wasn't a huge downside, like there would be today." (That is, after Benioff had written a hit epic for Wolfgang Petersen and Brad Pitt.)

Once he gave the okay to start writing, Robinov gave Benioff little in the way of further instructions. Robinov recalled telling him to "write the same story you pitched me." Benioff remembers him saying, "Let's shoot big."

"It was a long shot for all of us," said Benioff. "It was a long shot that this movie would ever get made, clearly, but from his point of view, [I think he felt,] 'If it's going to happen, let's take a real shot at this.'"

Benioff wrote "maniacally" for the next two months. All those years of thinking about the story had served him well; he knew the story he wanted to tell. His take was decidedly contemporary: Homer's poems describe a violent

world defined by war, and Benioff pitched *Troy* in October 2001, just weeks after 9/11. With war once again in the air, he found that his long-treasured story now spoke to today's times.

"In *Troy* we're talking about this idea that people are all human. There's a kind of respect for the enemy that I think is missing in [today's] war. I don't think there's a lot of respect on the other side for civilian life here, as the terrorists showed plunging jetliners into the World Trade Center. Without getting political about it, there's something almost nostalgic about this idea that you have people fighting not with technology, but man to man. There seems to be a kind of nobility about it. No one's hiding behind anything. It's skin to skin and bronze against bronze.

"It's not humans versus orcs, it's not an epic battle of good and evil. It's two human sides, and both sides have good and evil mixed among them."

Benioff wanted to preserve the violence of Homer's story, which abounds with gory battlefield deaths, but also to reflect Homer's respect and compassion for the fighters and their suffering. "All the people who get killed—Homer always takes a moment to be with them. He tells you who the father was, exactly how they died, what the spear does to their bodies. You see the pain of that violent death and a life being cut short."

Setting the tone was one challenge; another was choosing a starting point and an end point for his plot. In his conversations with Robinov, they'd agreed that the story should carry through the Trojan Horse and the fall of Troy. But where to start?

Benioff chose to launch the story by introducing his main heroes, Achilles and Hector. He began with Achilles on the battlefield, fighting not Trojans but another Greek army. He is the champion of the army of the Mycenaeans under the command of their king, Agamemnon.

The movie's Agamemnon, like Homer's, is a fairly despicable character, but Benioff sees him as more than a tyrant. "Agamemnon will be slotted by most people as the bad guy, but Agamemnon is the nation-builder. It's hard to admire the man because he's so ruthless and so power hungry, but at the same time, he's the one who's leading Greece out of being this conglomerate of warring tribes and bringing them into nationhood."

Achilles, too, is far from the Hollywood ideal of a hero, said Benioff. "He's not likable. You're not going to have a pet-the-dog scene with Achilles. It's something I had to resist. There were certainly notes coming after the script was turned in saying, 'We think Achilles might be a little too arrogant.' It's Achilles! Of course he's too arrogant. He's defined by his arrogance.

"The thing to me that's interesting is not 'Let's make him less arrogant.' [Instead,] let's *admit* that this man is arrogant. Achilles believes he's the greatest warrior on Earth—and he *is* the greatest warrior on Earth. What's interesting to me about the character is: Is there a way into him? Is there a way for us to understand why he is that way, without minimizing the fact that he can be a real bastard?"

Benioff was mindful that it had been prophesied that Achilles would die at Troy. The great warrior knows that he'll leave no family, build no nation. For the writer, this was the key to Achilles' character—that he lives every moment with the knowledge of his own imminent death.

"He's made this decision that he wants eternal glory. He wants to be remembered as the great warrior. So everything he does is meant to ensure that his legacy is preserved. So he marches forward with one eye on eternity at all times."

By contrast, Benioff finds Hector much easier to warm up to. "I think Hector is the most likable character in *The Iliad*," said Benioff. "The funny thing is, I had this idealized memory of Hector as the noble leader of Troy. He's noble, but in *The Iliad* he's also shown killing people and gloating over their bodies. That wasn't my conception of Hector. My adaptation was closer to my faulty memory of him than what was actually on the page."

Benioff chose to introduce Hector on a peace mission to the court of Sparta, where, unbeknownst to Hector, his younger brother Paris is falling in love with (and bedding) King Menelaus's wife and queen, Helen. "Achilles is the great warrior, but I envisioned Paris as the great seducer and the great lover, this very, very handsome man who women just swoon for, which makes Orlando Bloom very appropriate casting."

Hector's peace mission ends in success, but then he's shocked to find that Paris has spirited Helen on board their ship home. By then it's too late to return her, for to do so would spell death for his brother. Hector will defend his brother to the death, so the die is cast.

Perhaps the most problematic character in the story is Helen, whose infidelity launches this disastrous war. Benioff simply worked to give her the same humanity he gave the rest of the characters. "She's trapped in this loveless marriage, which was basically a marriage of convenience to uphold the power of this king. [Then she meets] this man who for the first time makes her feel truly loved—this incredibly charming, beautiful young man who comes and almost literally sweeps her off her feet. And she goes with him. For me it's beyond good or evil, it just is what it is. She went with her instinct.

"The nature of great tragedy, and what's drawn me to this story, is that tragic inevitability: Helen just has to leave, she has to [in order] to survive. She *has to*. She was dead in Sparta; she was basically the walking dead. Paris is also complicit in this. He knows probably even better than Helen what this means for Troy and for his brother and for his father and for all his countrymen. But he's fallen for this woman and he's not going to leave her behind. And then that leads to Hector, who makes the decision, knowing that defending his brother means war. It's the last thing he wants: He wants to protect his people, he wants peace, he came over to bring peace, but he's the kind of man who will never turn his back on his brother."

This is the setup that occupies most of the first hour or so of *Troy*. The incident that kicks off *The Iliad*—Agamemnon appropriating Achilles' slave, a young Trojan priestess named Briseis whom Achilles counts as war spoils—is included in *Troy*, some eighty pages into the script. And just as in Homer, the action infuriates Achilles (the first book of *The Iliad* is titled "The Rage of Achilles") so much that he sits out the fighting for a while, with results that only bring death and tragedy closer to Achilles.

And while Benioff expanded the story to events not found in mythology, he also compressed the time frame of the events in the myth. Instead of a ten-year siege, the war appears to last just weeks. In part to speed things up, but also to keep the focus on the human drama, he also jettisoned the Greek gods and goddesses who are so prominent in Homer and the myths. There would be no "And Sean Connery as Zeus" in Benioff's movie. Instead, he wrote as if he were chronicling the real events that gave rise to the myth.

He also took license to alter the events of the myths in ways that some scholars might find disorienting. Notably, Benioff's Agamemnon meets his end as Troy burns—at the hands of Briseis, no less—rather than bringing home the enslaved prophetess Cassandra and dying with her at the hands of his wife Clytemnestra, as in Aeschylus's *Agamemnon*. In fairness, Benioff points out that there are many variations of the Trojan War stories, some with radically different endings, but several of his major characters have fates far different from those they met in myth.

"I didn't want to have a rolling scroll, *American Graffiti*–style, saying 'This is how the characters end up,'" said Benioff. "It was really about wanting to tell the story on-screen and to see the fates of the characters."

Troy follows the story through the end of the siege. We see Paris's famous arrow strike Achilles in the heel (though that shot alone does not fell him); we see the fate of Helen and Paris; there's even a cameo from Aeneas. For

Achilles, though, the fall of Troy is an anticlimax. His moment of truth comes when he takes on Hector in a man-to-man duel that proves one of the script's highlights.

"The way that it was shot, there were a hundred thousand people out there watching in this natural amphitheater, and he slays the greatest other living warrior out there—and that will never be forgotten," said Benioff.

Benioff managed to write his first draft very quickly. "This is a story that had been in my head for a long time. Once I started writing I felt like I really knew where I wanted to go. There weren't a lot of moments where I said, 'Okay, now what's the next scene?'" Fueled on junk food and a beer or two ("I've never been able to write successfully drunk, but one or two drinks relaxes me and gets me into the mood"), he prefers to write from around midnight to five A.M., when it's quiet and the phone doesn't ring. "It's just me and my dog farting beside me," he said. "I like having my dog around. He's not very helpful in the writing of the script—he's never had any good suggestions—but his presence there makes me feel good."

Working without an outline, Benioff was able to deliver a first draft quickly, less than three months after the first meeting with Robinov. His first draft was 173 pages on his own computer, and turned out to be considerably longer when reformatted in Warner Bros.' house style. But Robinov was as impressed with the script as he had been with the pitch. "It was great," Robinov remembers. "It doesn't happen very often. You don't often meet someone, hear a story, and it turns into a movie two months later."

Nonetheless, once director Wolfgang Petersen came on board the script fell prey to many rewrites. "There were days when I felt like I was married to Wolfgang, going to his office all the time," said Benioff, who counts some thirty drafts on his computer. Some scenes, inevitably, had to be sacrificed for length, including a sexy scene between Paris and Helen and an introductory blood-match scene for the mighty Greek fighter Ajax.

A bigger obstacle was Achilles' long absence from the story after the early scenes. "There was a lot of back and forth with Wolfgang and the studio about ways to see [Achilles] earlier," Benioff explained. At one point he tried writing a gathering of the Greek kings, just to bring Achilles back into the story, but the scene didn't work. "I think I was able to persuade them that it wasn't such a good idea, but there is this long break [between Achilles' appearances]. Having these extended scenes with Ajax and all, while I think it would have been fun for the movie, would have just dragged out that opening."

Even with such wrestling over structure, Benioff remained the only

writer on the project throughout. "I think I would have had to strangle some-
one else [if] they brought them in. But you're always prepared. You always
know the odds are that somebody else is going to rewrite you. I got lucky."

Troy wasn't a big hit in the United States, but it was a smash elsewhere in
the world and cemented Wolfgang Petersen's reputation as a master action
director (though Petersen would take a step backward with his next film,
Poseidon—not a Greek myth this time, but a money-losing reinvention of
The Poseidon Adventure). Benioff would go on to forge a relationship with
director Marc Forster (*Monster's Ball*), who directed Benioff's script *Stay* and
worked with him again on an adaptation of the bestselling novel *The Kite
Runner*. In fact, Benioff became a very busy writer and producer, with nu-
merous projects in development. He was tapped to work on the *X-Men* pre-
quel *Wolverine* and even got to take on a project with an Irish theme, *Appian
Way*, about the British moles in the IRA.

Troy, though, was something special, and not just because it sent him on
his way to a prosperous Hollywood career. "Being able to use the characters,"
he said, "being able to walk around with Achilles and Hector and having
them speaking lines—it was just a privilege."

Hero

CREDITS

DIRECTED BY Zhang Yimou
SCREENPLAY BY Li Feng, Wang Bin, and Zhang Yimou
PRODUCERS: Bill Kong and Zhang Yimou
EXECUTIVE PRODUCERS: Dou Shoufang and Zhang Weiping
PRODUCTION COMPANIES: Bejing New Picture Film Co. and Elite Group Enterprises
ORIGINAL MUSIC BY Tan Dun
CINEMATOGRAPHY BY Christopher Doyle
FILM EDITING BY Angie Lam, Vincent Lee, and Zhai Ru
PRODUCTION DESIGN BY Huo Tingxiao and Yi Zhenzhou
ART DIRECTION BY Huo Tingxiao and Zhao Bin
COSTUME DESIGN BY Emi Wada

MAJOR AWARDS

None

CAST

Jet Li . . . *NAMELESS*
Tony Leung Chiu Wai . . . *BROKEN SWORD*
Maggie Cheung . . . *FLYING SNOW*
Chen Daoming . . . *THE KING OF QIN*
Zhang Ziyi . . . *MOON*
Donnie Yen . . . *SKY*

BUSINESS DATA

ESTIMATED BUDGET: $30 million
RELEASE DATE: January 14, 2003
U.S. GROSS: $53.6 million
FOREIGN GROSS: $126 million

REVIEW HIGHLIGHTS

"A dazzlingly lensed, highly stylized meditation on heroism and the point at which individualism conflicts with the common good. . . . Taking its inspiration from several real-life attempts to assassinate China's first emperor . . . [*Hero*] is more a cinematic fantasia melding music, color and combat than a traditional . . . narrative." —**DEREK ELLEY**, *VARIETY*

"The extravagant visual beauty of *Hero* is, in a way, its own reward. . . . The cast is a parade of action stars in full charisma . . ."

—**LISA SCHWARZBAUM**, *ENTERTAINMENT WEEKLY*

7 | THE ANTI-*TROY*

HERO • ZHANG YIMOU

O kay, it may not be quite fair to call *Hero* the anti-*Troy*. There must be some low-budget documentary or character-driven Dogme film out there that better deserves that title. Maybe it's better to think of *Hero* as *Troy*'s bookend. Or its mirror image.

Hero, like *Troy*, is a big action movie, in a historical setting, based on the founding myths of one of the world's great civilizations. The source material is an oft-told tale that every schoolboy in China would know and has been fodder for storytellers for more than two thousand years. Like *Troy*, the film even got a summer release in the United States, though America was the last major market in the world to see it.

When acclaimed Chinese director Zhang Yimou and cowriter Li Feng decided to adapt this legend for the screen, though, they took a very different tack from the approach David Benioff and Wolfgang Petersen took on *Troy*. Where Benioff stripped the Trojan War myths of gods and magic, Zhang and Li made their story larger-than-life—in part by making it in kung fu, or *wuxia* (WOO-she-ah), style.

"I made this change consciously, to make it feel more like a legend," Zhang said through an interpreter. The result is one of the most breathtakingly beautiful epics ever filmed, but one that touched off a controversy that still simmered long after the film's surprise box office success in wide release in the States.

Hero was also a mirror image of *Troy* from a business perspective. Where *Troy* was a Warner Bros. "tentpole" that got massive promotion and marketing support, *Hero* was a Miramax production whose North American release didn't come until many months after its sensational initial run in the Far

East. Miramax's marketing campaign was so sluggish that Zhang himself complained to the press about the long wait for the American premiere.

Miramax got the last laugh, though, when *Hero* turned into a surprise hit with U.S. audiences. That mollified Zhang, but by then it may have been too late. He'd made a deal with Sony Classics for distribution rights to his next film, *House of Flying Daggers*, shutting out both Miramax and the Weinstein Company.

Hero tells the story of an encounter between the King of Qin (Chen Daoming), who will go on to become China's first emperor, and an obscure country sheriff (Jet Li) who claims to have killed the three greatest assassins in all of China. The trio, named Sky, Flying Snow, and Broken Sword, had been sworn to kill the king, and the sheriff, known only as Nameless, arrives with proof of their deaths and is brought before the king to claim his reward.

But the king soon deduces that Nameless's story is false and tells Nameless what he thinks really happened. The meeting becomes an exchange of flashbacks, each retelling of the story coming one step closer to the truth. Before their meeting is over, it is revealed that Nameless is on a secret mission and he holds the fate of the king in his hands.

The cast also includes Hong Kong stars Tony Leung and Maggie Cheung as Broken Sword and Flying Snow, *Crouching Tiger, Hidden Dragon* star Zhang Ziyi as Broken Sword's protégé, Moon, and rising star Donnie Yen as Sky.

For those familiar with the story, there was little suspense about the king's fate: the real-life king of Qin survived and went on to unify the warring kingdoms, becoming, in effect, the founder of China. The story that *Hero* is based on is familiar to almost everyone in China—a legend of a killer who tried and failed to assassinate the King of Qin. *Hero* is a revisionist version of that legend.

It's impossible to understand how audacious the film really is, however, and why it touched off such a furor, without some background on Zhang Yimou, the underlying legend, and the *wuxia* genre. *Wuxia* is a beloved genre in China, one that dates back hundreds of years and remained popular even after Mao Tse-tung's Chinese Communist Party conquered the country in 1949. Born in 1950, Zhang grew up reading *wuxia* novels the way American boys grew up reading pulp novels or comic books. But in the mid-1960s, during the Cultural Revolution's reign of terror, Mao's young Red Guard protégés declared war on China's past—and *wuxia* novels were among the sacrifices they demanded.

"If you were caught [with one], you'd be arrested," Zhang recalled. "So I read those novels in hiding. I was sixteen at the time. Sometimes I was very ner-

vous. You know, hiding a book like that, at that time, it was like committing a theft. It was very difficult, and we were terrified. Our group of friends passed those books secretly between us. It was like doing underground work."

Like millions of young Chinese his age, Zhang was sent by the government to work in farms and fields at an age when his contemporaries abroad were attending high school and college. Then, in 1977, a year after Mao died, China's colleges reopened and Zhang applied to the Beijing Film Academy as a cinematographer. He graduated in 1982, in a class that included director Chen Kaige and other future luminaries.

After shooting a few films as cinematographer for other directors, Zhang turned to directing in the mid-1980s. A series of stunning historical dramas—*Red Sorghum*, *Ju Dou*, and *Raise the Red Lantern*—established him as one of the foremost directors of China's "Fifth Generation."

Zhang has worked in many genres, with both historical and contemporary settings, but never thought seriously about making a *wuxia* film until Ang Lee's *Crouching Tiger, Hidden Dragon* became a smash outside China.

"I always liked *wuxia* novels, and I read some *wuxia* novels almost every year," he said. "[After *Crouching Tiger*] the market for *wuxia* movies was improving. And getting the funding for making *wuxia* movies is easier than it used to be. So I felt this was a good chance to make *wuxia* movies."

Crouching Tiger struck a nerve with Western audiences, but it was a much-derided flop in China. Chinese audiences felt they'd seen the wirework and fighting done better before. Mandarin speakers also found the heavily accented Mandarin of Hong Kong stars Chow Yun-Fat and Michelle Yeoh, both native Cantonese speakers, laughable. (Think Arnold Schwarzenegger and Milla Jovovich as George and Martha Washington.) So when Zhang announced plans for a *wuxia* film, that was big news for Chinese movie fans. The excitement only grew when he announced the story he'd shoot.

In Mandarin, the original legend is called *Jing Ke Ci Qin Wang* ("Jing Ke Stabs the Qin Emperor"). Set during the third century B.C., it tells the story of an assassin, Jing Ke, who tried to kill Ying Zheng, the king of Qin (pronounced *chin*). Qin was one of the seven "Warring States" whose constant conflicts had left China's people in misery; of their seven kings, Ying Zheng was the most ruthless and brutal.

Ying Zheng defeated Jing Ke, went on to conquer the other six states and, in 221 B.C., become the first emperor of China, taking the name Qin Shi Huangdi. He is remembered in China today for permanently uniting the seven states, standardizing Chinese writing, building the Great Wall on the

country's northern border, and generally paving the way for the flowering of China's civilization. His dynasty, the Qin, even gave China its name. He was also, not coincidentally, a ruthless despot whose rule took a terrible toll on China's populace.

The story of Jing Ke's failed attempt to kill the first emperor became legend, much as the tales of the Trojan War became legend in the Western world. The story had already been the basis of a number of films, including Chen Kaige's recent *The Emperor and the Assassin*. But Zhang's version turns the story on its head.

"In the past, in all the versions of this story the assassin had failed—he was killed by the emperor," said Zhang. "In our story, the assassin failed at his task because he didn't want to do it anymore. He gave up his plan. This ending is quite different from the others." So the hero of the title is not the king who defeats the assassin and goes on to unify China, but the assassin who sacrifices himself and lets the king live so that he can rescue the land from chaos.

At this point, a short language lesson is in order. The word "assassin" is commonly used to describe Jing Ke, as in the title *The Emperor and the Assassin*. In English, the word has a decidedly negative connotation. But the Chinese term is *ci ke* (pronounced *tsih kuh*), which literally means "stabber guest." A *ci ke* is a fighter for hire who's typically asked to kill someone evil. While there's no equivalent in English literature, a *ci ke* is a kind of combination gladiator, samurai, and Clint Eastwood spaghetti western hero, with a touch of comic-book superhero thrown in.

"*Ci ke*, in Chinese, has a certain mysterious meaning to it," said Zhang. "People actually admire them. Nobody really knows who they are, because *ci ke* are so mysterious, and the targets that *ci ke* are killing aren't necessarily good people. *Ci ke* stories don't necessarily have that negative connotation to them. So I wasn't thinking about how in Western countries it would be strange for the assassin to be the hero."

Zhang wanted to put his own stamp on the *wuxia* genre; changing the tale of Jing Ke was one way to do so. Another was dropping the typical building blocks of a *wuxia* story.

"In my own opinion, the rules and traditions for *wuxia* novels and films come down to two things. First is promoting harmony, kindness, and peace, and rejecting evil and bad behavior. The second rule is that the conflicts are always between the sects of different kung fu or *wuxia* schools, where one thinks it's better than the other. The conflict is between the martial artists.

"In my movie, I don't have those rules. I'm not promoting good people

versus evil people, and the conflict isn't between kung fu schools. I did that deliberately, to make it the opposite."

For Zhang, those conventions were never the heart of *wuxia* anyway.

The Philosophy of Action

ZHANG YIMOU EXPLAINS WHAT SEPARATES TRUE CHINESE WUXIA MOVIES FROM WESTERN-STYLE ACTION FILMS.

In my opinion, the difference between Chinese *wuxia* and Western action is that in Chinese *wuxia* or kung fu, they're not only talking about speed, power, and skill, they're also talking about the feeling, the pose, the beauty, and the poetic feeling of the movement. It's not just how powerful and skillful the movement is, it's how beautiful. There's an old saying in Chinese: "Standing as a pine tree, sitting as a big bell, moving as the wind." That's what Chinese *wuxia* is.

When I was little, I loved to watch kung fu tournaments and competitions. In watching them, I realized that when the judge gives points to the performers, he also looks at how they present their performance, not just how skillful they are. They have to be very graceful as well. Even in Chinese elementary school textbooks, they talked about a famous kung fu *wuxia* master from our history. There's a famous poem that says, "Watching her practicing her sword made him think of calligraphy." That's the difference between simple Western action and Chinese *wuxia*. *Wuxia* has a certain elegance. Therefore, when I was making *Hero*, I wasn't only thinking of the actions, I was thinking of the surroundings, the environment, the wind, the water, the trees. And completely using the characters' relationships with nature to create the movement, make the combat as if you were watching a painting.

Because of this, I think *wuxia* kung fu should be a combination of action and poetry. So something might only take a few seconds of film on the screen, but it might take me a few days or even weeks to shoot it, because I'm trying to find that feeling. The result is that it's especially beautiful, especially pleasing visually. The highest achievement in *wuxia* is not about power or skill anymore, it's about feeling, a comprehension or realization, a self-realization or self-discovery. When one can reach that stage, the kung fu master, the *wuxia* master, becomes a poet. The philosophy of action. Only *wuxia* movies made this way are true *wuxia* movies. Otherwise it's a simple Western action movie.

Abandoning them, though, allowed him to adopt the flashback structure, which he freely admits he borrowed from *Rashomon* and master Japanese director Akira Kurosawa, Zhang's favorite director.

Zhang wasn't content to imitate *Rashomon*. In Kurosawa's black-and-white film, the story of a murder, the action differs according to which witness tells the story, and there are also subtle differences in visual details. *Hero* goes farther, giving each flashback its own color palette. When Flying Snow and Moon fight to the death in a forest, they face off in a a swirl of yellow autumn leaves. Other stories are in red, blue, and white.

"When I was writing, I was thinking about these colors and images all the time. I always take color seriously in my movies. Since this story was told in three different ways, I was hoping I could use different colors to tell the different stories. Because of this structure, I felt I had a good chance to utilize different colors."

For Zhang, that use of color helped capture the sense of wonder he'd felt as a boy reading *wuxia* novels, but the real key was the wirework and fight choreography, which brought to life the images of *ci ke* he'd seen in his head.

"[*Ci ke*] are miraculous," he says. "They all have the powerful kung fu and magical abilities. Therefore when I was making the movie, I hoped to make it more mythic, not very realistic, and be more imaginative."

It took Zhang and Li three years to write the script—Zhang paces while Li types—and they went through several dozen drafts. By the time he was ready to begin shooting, it was clear this would be an enormous epic. By some accounts, *Hero* was the most expensive film ever made in Asia up to that time. Shot in China for $30 million, it would almost certainly have cost more than $200 million if made in the States.

Enter Miramax. The company's founders, Harvey and Bob Weinstein, were nearing the end of their association with Disney. Since selling their company to the Mouse House, Miramax had evolved from a specialty division and art house distributor into a mini-major, eventually funding even expensive period pieces like *The Aviator* and *Cold Mountain* with Disney's money—to the enormous displeasure of Disney management, especially CEO Michael Eisner.

The original Miramax might have waited until the film was completed to buy North American distribution rights for *Hero* or acquire it after it was completed. Perhaps emboldened by the success of *Crouching Tiger*, Miramax instead invested in the film up front. "It could be seen as a pre-buy," said Miramax's Matt Brodlie, senior vice president of acquisitions. The funding helped the perfectionistic Zhang realize his vision.

For Zhang, though, it proved a not-entirely-happy bargain. After he delivered a 110-minute cut, Miramax tested the film with American audiences.

Brodlie was sent to Beijing to ask Zhang, a notoriously meticulous auteur, for cuts and changes based on the audience feedback.

"I had a little difficulty accepting the way they dealt with me," said Zhang. (Chinese culture does not encourage confrontation; Zhang's comment might be taken as the equivalent of an angry tirade.) He was none too happy to have to change his film, especially on the basis of notes from Americans who didn't know the *wuxia* genre or Chinese culture.

"I always respect the audience very much; I think the movie should be understandable to the audience. But when you are in that kind of screening, you will find that the audience gives you all kinds of suggestions. Sometimes their questions completely didn't make sense. It is very difficult to make changes according to such suggestions."

But Zhang is also a practical businessman. "My boss told me, 'The U.S. market is the biggest market, so you'd better cooperate with them,'" he said with a laugh. "Therefore I did my best to cooperate with them."

As a result, he cut some twenty minutes from the film, including extended fight scenes—material that Zhang believes may be gone for good. "I didn't keep them. Though it seems in China there's a longer version on DVD."

By the time it opened in Asia, *Hero* had become perhaps the single most eagerly anticipated film in China's history, and it was a box office smash. Among American critics, the film's reception was also quite warm. At one U.S. publication, the chief critic told his colleagues that *Hero* was the first great movie of the year.

Unfortunately, that year was 2003—more than a year after the Asian release. Zhang and his fans have chafed at the delay, but Brodlie said it was necessary to give the film the kind of launch it deserved. "This is a big movie," said Brodlie. "We're going to release it wide, on eight hundred to a thousand screens." Miramax had the subtitles redone and put the trailer on the *Kill Bill* DVD (Quentin Tarantino is billed as a "presenter" on *Hero*) to lure fans of martial arts and genre films.

Zhang's frustration with Miramax drove him back to his previous American distributor, Sony Pictures Classics, for *House of Flying Daggers*, which opened in the States just a few months after *Hero*.

Hero is a more coherent film than *Crouching Tiger* but less of a crowd-pleaser, so Miramax may have figured it needed the time to build audience interest. In the meantime, though, a political controversy emerged around *Hero*.

The furor centered on the decision of Nameless not to kill the king. Qin Shi Huangdi did succeed in ending the wars that were tearing the country

apart, but he killed millions. When Nameless decides not to kill him in the name of the greater good, say Zhang's critics, it's an endorsement of the king's ruthlessness. This hit a nerve—not because of some academic debate among historians, but because the question of how to respond to the excesses of the Communist regime remains very current both inside and outside China, even if the PRC's darkest moments are now—hopefully—well in the past.

The debate over *Hero* broke down, roughly speaking, into two sides. One accused Zhang of being an apologist for the communists' excesses. The other argues that the film is really a plea for peace—that its point is that when both sides use the same methods, there's not much difference between them.

Zhang himself was diplomatic about the debate. "It doesn't matter to me," he said. "I'm used to it. Since the beginning of my film career, there have always been controversies over my movies. Some people will like it and some won't. That's not very important."

Perhaps a clue to his real intentions can be found in how he departed from *wuxia* rules. If, as he said, he's not promoting the good or condemning the evil, then he's not endorsing China's leaders, past or present.

In a larger sense, though, *Hero* probably represents something more enduring than an endorsement or rejection of any Chinese dynasty or regime. Communist China has produced many works of nationalist art—indeed, under Madame Mao and especially during the Cultural Revolution, most Chinese art was agitprop, the butt of jokes in the rest of the world. Even after Mao's death, Chinese films on patriotic themes didn't make much of an impact beyond the PRC's borders.

Hero, though, is one of the most visually beautiful films ever made—a fact that doubtless helped it find a worldwide audience. It's also an outstanding work of nationalist art, a celebration of China itself at a time when that country's people feel safer, more secure, and more prosperous than at any time in generations. For a nation that is stretching its muscles, *Hero* presents a vision of a past worth celebrating, served up in the form of a film that commands respect and adoration around the world.

It's a few thousand years early to put this movie in a league with Homer's epic poetry or China's best paintings and sculpture, but at the very least *Hero* is likely to become standard fare on national holidays in China. It may well end up being remembered as the first Chinese patriotic film to have the same kind of resonance around the world as the best films of John Ford.

Not bad for a kung fu movie.

Pay It Forward

CREDITS

DIRECTED BY Mimi Leder
SCREENPLAY BY Leslie Dixon
BOOK BY Catherine Ryan Hyde
PRODUCERS: Peter Abrams, Robert L. Levy, and Steven Reuther
EXECUTIVE PRODUCERS: Mary McLaglen and Jonathan Treisman
STUDIO: Warner Bros.
PRODUCTION COMPANIES: Bel Air Entertainment, Tapestry Films
ORIGINAL MUSIC BY Thomas Newman
CINEMATOGRAPHY BY Oliver Stapleton
FILM EDITING BY David Rosenbloom
CASTING BY Geraldine Leder
PRODUCTION DESIGN BY Leslie Dilley
ART DIRECTION BY Larry Hubbs
SET DECORATION BY Peg Cummings
COSTUME DESIGN BY Renee Ehrlich Kalfus

MAJOR AWARDS

None

CAST

Kevin Spacey . . . *EUGENE SIMONET*
Helen Hunt . . . *ARLENE MCKINNEY*
Haley Joel Osment . . . *TREVOR MCKINNEY*
Jay Mohr . . . *CHRIS CHANDLER*
James Caviezel . . . *JERRY*
Jon Bon Jovi . . . *RICKY MCKINNEY*
Angie Dickinson . . . *GRACE*
David Ramsey . . . *SIDNEY PARKER*
Gary Werntz . . . *MR. THORSEN*
Colleen Flynn . . . *WOMAN ON BRIDGE*
Marc Donato . . . *ADAM*
Kathleen Wilhoite . . . *BONNIE*
Liza Snyder . . . *MICHELLE*

BUSINESS DATA

ESTIMATED BUDGET: $40 million
RELEASE DATE: October 12, 2000
U.S. GROSS: $33.5 million
FOREIGN GROSS: $27.5 million

REVIEW HIGHLIGHTS

"The movie has its heart in the right place, but not its screenplay. It tells a story that audience members will want to like, but it doesn't tell it strongly and cleanly enough; it puts too many loops into the plot, and its ending is shamelessly soapy for the material."　　　　**—ROGER EBERT, *CHICAGO SUN-TIMES***

"With its smorgasbord of moralizings, *Pay It Forward* is a confusing welter of sentiment."　　　　**—PETER RAINER, *NEW YORK***

"As it stands now, *Pay It Forward* winds up making a very good case for never going out of your way to help anybody."　　　　**—RENE RODRIGUEZ, *MIAMI HERALD***

8 "CAN I WRITE *MIDNIGHT COWBOY*?"

PAY IT FORWARD • LESLIE DIXON

People who get past the scratching-and-clawing stage to succeed in the film business too often find that success has its own pitfalls. Typecasting, for one. No small number of actors have found their ambitions frustrated when they became too identified with a single role.

The same can happen to writers. One writer I know wrote a romantic comedy solely because he needed some money, sold it, and found himself inundated with offers to write romantic comedies. When he complained to his agent that he didn't really want to write romantic comedies, he was told, "This is Hollywood. People want you to do the same thing over and over again and pay you more for it each time."

Writers, though, do have more leeway to reinvent themselves. Where actors have to be cast, writers can simply write something different and let the work speak for itself. Still, such tactics demand a willingness to leave the comfort zone and risk failure, with all that implies for ego, reputation, and financial security.

For writers just getting started, like Ken Nolan and David Benioff, and for auteurs like Sofia Coppola, it's not an issue. The former are happy just to be working, while the latter can take on different genres as long as they continue to satisfy their backers. On the other hand, for someone like David Franzoni, who's succeeding making the projects he wants to make, there's no urgent reason to change.

For a writer in midcareer, such as Leslie Dixon, satisfaction can be harder to come by. Dixon was a successful writer of female-oriented comedies, with credits including *Outrageous Fortune* and *Mrs. Doubtfire*. She was

prospering, she was respected, and she could easily have carried on down that road for years without breaking stride.

"But I wasn't on anybody's A-list," she said. "The only things I ever got offered were comedies. They weren't even the prime ones. I didn't like the quality of the work I was doing. And I didn't know what was wrong, exactly."

The feeling was only aggravated when a friend gave her a copy of the PBS documentary *Waldo Salt: A Screenwriter's Journey*. Salt was a screenwriter from the 1930s through the '70s who generated countless Hollywood studio pictures—until an epiphany changed his course. "At some time during the early sixties," Dixon says, Salt "had a blinding vision that he was going to try to achieve some kind of greatness, and work in a whole other way and challenge himself, beat the shit out of himself and not speak to anybody. And out of that came *Midnight Cowboy* and other things. You would never know it's the same guy who wrote those other pictures."

As Dixon notes, Salt's story "speaks to all of us. At the moment you've been doing this for a few years, are you going to be a lazy hack or are you going to go to another level? It's very inspiring, but it's also chilling. Because you [think], *Could I do that? Could I write* Midnight Cowboy *if I really beat the shit out of myself?* That's a sobering question."

Dixon's efforts to answer that question would lead her to leave the world of comedy for more dramatic fare. In time, it also landed her one of the most unlikely writing assignments she could have ever received: *Pay It Forward*.

It was an peculiar pairing of story and writer: The preachy, earnest story of *Pay It Forward* bore a greater resemblance to *Touched by an Angel* than to anything Dixon had written or wanted to write.

"I'm such a cynical bitch," she said. "My actual taste in movies is quite dark." So how did she end up on *Pay It Forward*?

Dixon's efforts to drive herself away from disposable comedy and into something more ambitious began with a spec adaptation of an Edith Wharton novel. "It wrote itself in six weeks," she remembers. "I'd never had anything like that happen before. And even though it hasn't been made yet, it sold immediately." The Wharton experience taught her that she had a hidden talent for literary adaptations. "I was good at compressing and juggling and adding and yet somehow not violating the spirit of the book itself."

Her Wharton spec also turned out to be the writing sample that led to

her writing the remake of *The Thomas Crown Affair*, John McTiernan's big-ticket caper romance with Rene Russo and Pierce Brosnan. While other writers handled the film's tech/caper sequences, Dixon wrote the film's all-important relationship scenes—and, in the process, learned a whole new way of thinking and writing.

"One of the things that slapped me across the face a little bit was working with John McTiernan" on the film, she said. "Comedy is not a very visual form of filmmaking. In fact, too many camera tricks get in the way. And so a lot of it is just about behavior and dialogue. Then you're working with a director who makes pictures on a big canvas, and makes dynamic films and wants me to add a sailplane sequence and a catamaran wreck.

"He was good to me, by the way. He wasn't mean about it. But he made me realize that I wanted to be a part of *film* movies, as opposed to turn-on-the-camera, shoot-the-joke movies." She also came to feel she'd been depending too much on one trick in her writer's bag. "I just realized that taking refuge in dialogue was a trick I had down for a long time. But it was only that. It was just a trick."

After *Thomas Crown*, she landed *Pay It Forward*, a treacly modern-day Christ parable based on a novel by Catherine Ryan Hyde. She discovered *Pay It Forward* while reading five novels that were available as open writing assignments, then asked her agent to get her a meeting with the producer.

The book is naively indifferent to dramatic structure or even its own storytelling. It seems more interested in starting a real-life "pay it forward" do-good movement than telling a good story. "Paying it forward is not what attracted me to the material. I was really afraid of the premise," Dixon recalled. "I was terrified of the potential bad-Capra aspects of this piece."

Bad Capra? "Well, there are Capra people and Billy Wilder people, and I'm a Billy Wilder person. I think that was part of what drew me to this project, me walking into the heart of darkness of potential corniness. Anyone who knows me knows that I'm more likely to channel Bette Davis than Jimmy Stewart."

As Dixon concedes, "I was not a logical choice to adapt this material. I had done nothing but comedies for ten years. But I had adapted a drama. So I went and I swallowed my pride, because I do get offers, and I went and auditioned for this job."

As it turned out, Dixon's edginess was what won her the job. "[Producer] Steve Reuther actually said, 'I want to hire a cynical writer, rather than a

sweet writer. I don't want to hire a sweet writer because it will just get sweeter.'"

Dixon had reasons of her own for tackling the story. "I had just spent a lot of time inside the heads of these two pieces of work from *Thomas Crown*, these two amoral, predatory, wealthy sharks mating, and I didn't want to live there anymore. I wanted to live inside the head of people who really needed something in their lives. That may be as corny as I get. . . .

"My heart went out to these people. I felt sorry for them. I wanted to do the job because of the people. I did it almost in spite of the premise."

Still, she confessed to a basic uneasiness with the story and its characters. "I have nothing in common with any of these people. I am not like a single person in this movie. I have much more in common with the women on *Sex and the City* than I do with any of these people."

Dixon's adaptation is still sweet by Hollywood standards, but it's edgier than the novel. The screenplay begins with a jaded Los Angeles reporter seeing his car wrecked, only to have a total stranger hand him the keys to a Porsche and tell him to take it. There's only one condition: The reporter must "pay it forward"—that is, do three favors for other people who need them. The reporter soon discovers that other people are following the philosophy and begins tracing the favors back to find the beginning of the "pay it forward" movement.

Meanwhile, in flashback, we follow the story of a terribly scarred social studies teacher, Eugene Simonet (Kevin Spacey), an alcoholic single mother named Arlene (Helen Hunt), and her son, Trevor (Haley Joel Osment). Eugene is a cynical man who works hard to keep people at arm's length. Arlene's drunken husband has abandoned her, but she continues to cling to the hope of his return. She is nearly broke, barely making ends meet as a waitress, and still drinking despite having entered Alcoholics Anonymous.

On his first day of school in Las Vegas, Gene gives his class an assignment: "Think of an idea for world change, then put it into action." Most of the class does "perfunctory" work on the assignment, but Trevor comes up with the idea of "pay it forward." In "pay it forward," a person finds three people in need of help and gives them the help they need. There are no strings attached, except to tell the person who's received the help to do the same for three other people. The class ridicules Trevor, but Gene tells them that he's the only one who has taken the assignment seriously.

Trevor begins his own pay-it-forward plan by helping a down-and-out

bum get back on his feet. Trevor's efforts seem to fail, but he turns his attention to his own mother and Gene, deciding that they should get together as a couple. This is the real heart of the story, as these two damaged people, both wounded by life, edge painfully toward love and intimacy.

Meanwhile, unbeknownst to them, Trevor's pay-it-forward idea is beginning to seep out into the world. People are doing those favors for each other— sometimes for the wrong reasons, sometimes long after they've been helped themselves, but the idea is spreading. Lives are being touched, even saved. As people move around, it catches on in other cities, including San Francisco and Los Angeles.

The story of Gene, Arlene, and Trevor is intercut with the story of the reporter's quest for the origins of "pay it forward." Eventually, the reporter traces the story back to Trevor and Gene, who is amazed to learn that his social studies assignment has had such an effect on the world. Even as Trevor, Gene, and "pay it forward" stand on the edge of fame, however, Trevor's third favor leads to tragic consequences.

Hyde's novel, which Dixon read in galleys, provided plenty of challenges for any adaptor. It uses multiple narrators, including the reporter, and some of the narration comes in the form of letters and diaries. In fact, structuring the story was the biggest single challenge for Dixon—beginning with the problem of the reporter, who does not appear until halfway through the book.

"I discovered that you can't introduce a character halfway through the film," she remembers. "No one gives a shit. They don't want to be with that guy, they want to be with the leads. So I got halfway through on my first draft and I went, 'Uh-oh.' I was goddammed if I was going to go to narration. That's the lazy writer's out. I could not figure out how to do it. And I was stuck for two weeks. I almost gave the money back. That had never happened to me before."

Then, as Dixon was lying in bed one day, she lit upon a potential solution. "I realized, *What if we start with him and do the investigation backward?* Introduced first by the people who are the forwards, and then [have them] join up later in the book?" That structure made the more mundane story of Gene, Arlene, and Trevor more dramatic, because the audience would know that it would lead to something bigger.

So effective was the solution that, after talking with Dixon, Hyde decided to change her book before publication to follow the screenplay's structure. "That was the first time I know that the screenwriter had affected

something in the novel," said Dixon. "Everything else went in the other direction, of course. We talked about it later and we laughed."

After years of writing specs, Dixon is always excited to have a starting point. She said that it took years for her to learn what she calls the most depressing thing about writing for the stage and screen. "At the end of the day, the idea of the scene, and what occurs in it, is more important than the dialogue. And that is such a bitch to find out. But it's true.

"I call it heavy construction. Breaking the ground. Figuring out who the people are, how they feel about each other, what the dynamic in every scene is. Telling the story, what occurs in each scene, any writer who's been around will tell you, [that's] the bitch of it all. And dialogue is frosting. I didn't understand that for a long time. And I took refuge in dialogue."

As she faced the heavy construction of *Pay It Forward*, she had to find the movie inside Hyde's novel—a process she likens to archaeology.

"Once in a while a novel is just lying around that's a movie waiting to happen, like *Gone with the Wind*. A movie screaming to get out. Then there are movies that have to be excavated screaming and kicking from the material. This one was somewhere in between. It was tough."

Dixon's screenplay has around thirty-five significant speaking roles. That's a large number for a "small" movie, but the book had more. "I knew that a larger tapestry of people had to be preserved in order to get some sense of this idea that this child had leaked out into the world."

There was another, more basic problem: "There were not a lot of *scenes*," she explained. Much of the book took the form of diary entries, letters, and inner monologues. "There were references to the fact that [Gene and Arlene] had a couple of dates, but no scenes. There were references to how cool Trevor thought the teacher was, but no scenes with the teacher and the child. So many, many of these ideas come from the book, but I had to invent the scenes. Sometimes I had to bring to life what would just go by in a fleeting line of description."

Dixon compressed the book's timeline and took out some later sections where Trevor becomes famous and even meets the president. She also had to replace the book's final scene, where people give speeches praising Trevor and his efforts. Her earliest drafts even included a similar scene, with Gene giving a speech about Trevor, but once Kevin Spacey was on board he politely told her, "I can't see myself saying these things."

"I laughed," she said. "He was so right. I said, 'I can't either.'" The scene was replaced with a more visual tribute to Trevor.

Spacey was the first actor approached for the role of Gene. When he took the part, the rest of the cast fell into place, including Helen Hunt as Arlene. For Dixon, that meant having to address the needs of two powerful stars who weren't interested in keeping the material as edgy as Dixon wanted it to be. Spacey wanted to make Gene less cynical and more of an inspirational teacher.

"I don't know whether I was right about this," said Dixon. "[In the early drafts] Gene was a more cynical burnout teacher who didn't really connect with kids all that well. It was unusual that Trevor saw something in him and saw something in this rote assignment he gave every year, and touched off something in the story. I always liked that. Now he's just an inspirational teacher from the very first scene, although some of the bitterness and cynicism and some of [his] emotional removal from other people is all still exactly the same. It was really [only] the first scene that changed. Maybe he made a better emotional connection with the audience right away."

For her part, Hunt wanted the story to explore Arlene's alcoholism more deeply. In the book, Arlene is mostly sober and has one slip. In the film, Arlene is still drinking and struggling to stop. Hunt wanted "to go into the depths" of her character's addiction, said Dixon.

"The alcohol issue was just one of many things that the mother had to struggle with. I didn't have time to delve into her awful financial situation, how Trevor's father had left her. There was equal weight on a lot of problems. This became the forefront problem of the script."

Dixon had also originally "child-proofed" the script by focusing on the love story, keeping Trevor in the background. "The problem with child actors is two-shots, because they have to hold up their end in the same shot as the lead. You'll notice when you see kids on-screen, it's generally single shots of them, because the editor is picking and choosing the moments the kid actually pulls off. So you start writing short lines, writing punch lines. I even started constructing scenes where the kid has his back to the parents through the whole thing, in case you have to loop it later."

Then she saw Haley Joel Osment in *The Sixth Sense* and realized there was an actor the perfect age for Trevor who could handle the challenges of the role.

"I not only knew that he could, I knew in my gut that he *would*. I got excited. I just felt in my gut that it would happen." After Osment signed, she recalls, "I started to give Trevor more weight, more meat, more screen time.

It was okay to write a paragraph of dialogue, because I knew he'd be able to get through it in one take. It was okay to write big emotional moments.

"And then at the end, and when I found that Haley was really a light little spirit, and not a sad, morose kid like the kid in *The Sixth Sense*, I added a lot of humor. I think I had made a mistake by making the script too grim, just to really show people 'I'm really not a comedy writer, goddammit! I'm a serious pretentious drama writer now.' So I went back through the whole script and put in a lot of little moments. I'm so glad I put those in, because I think they mitigate that seriousness a lot."

Dixon herself has a dry sense of humor and a sharp wit. She is a slight woman with shoulder-length blonde hair, and physically she's quite unimposing. But she has some admitted "eccentricities" that have helped her as a screenwriter.

"Utter lack of shyness," she mused. "Flamboyance . . . an obnoxious degree of literacy, which is inappropriate when you're a groveling subordinate . . . firm opinions . . . an almost European sense of wanting to go through life and have a good time . . . and very occasional histrionics." The histrionics, she said, "have been a decreasing factor with age and wisdom. I can't remember the last time they've come." Still, they have apparently served her well. "I mean, if you're just a bend-over writer, you're probably not as good as you can be. A bend-over writer is a writer who'll do anything they're told—[who's] so anxious not to get fired that the idea of whether it's good or not has long since receded from the picture. And there are many people with mortgages and ex-wives and ex-children who have to be that way. But you also don't want to be a difficult, arrogant asshole who digs in your heels intractably and may be wrong."

Dixon has had to learn to compromise at home, too. Having a husband and a child requires her to surrender her preferred writing schedule, which involves working late at night. "There's no way a word is going to go on paper before ten thirty in the morning," she said flatly. "I can talk, I can try to make phone calls, but no inspiration is going to come. The later in the day, or the later in the night, the better for me. I would actually like to move to Manhattan at some point just to live in a city that's as alive as I am at one A.M."

Dixon works at an "ugly computer stand" next to a giant rolltop desk that belonged to her great-uncle. She loves having everything she needs close at hand, in the desk's many cubbyholes, but generally likes a boring physical

environment. She can't listen to music as she writes; as a musician herself, she gets too distracted by the details of the music.

"I did some pretty serious time as a guitar player's girlfriend. In fact, everything in my life went right once I stopped hanging out with musicians. And in the process of the various boyfriends, I learned to play pretty solid backup guitar for just about anything."

She doesn't play much guitar anymore, but she said that being musical has helped her writing. "I think a lot of dialogue is rhythm. Particularly humor. Any guy from the Catskills will tell you it's about pointing the rhythm of what you're saying. Mel Brooks can make [the] mundane into something extremely funny—[like] the 2000-Year-Old Man—just by the snap of his delivery. I discovered, too, that [if] you point up your sentences in a certain way, where they're going to end with a certain rhythm, it's going to have a lot more [dramatic] impact."

Even so, she says, polishing the dialogue this way is still "frosting the cake with high-class buttercream. You still have to bake the cake."

Dixon measures her workdays by the number of "quality pages" she completes. Once she's finished the "heavy construction" phase, she can do as many as ten to twelve quality pages a day. Without the structure in place, however, it's a different story: "Starting from nothing—that's a lot slower. You can spend a lot of days not writing at all, because you're outlining and plotting and figuring out what happens next. Once you do that, I think the actual writing is rather short." Earlier in her career, she outlined every script in its entirety before writing. "I think you almost have to work that way to learn to be a screenwriter," she says. "But I'm beginning to be more of a high-wire act now. I'm beginning to sort of tap into my unconscious and find things."

Dixon sees this change in approach as part of her growth as a writer—a shift in priorities that began before she began work on *Thomas Crown*. "I [had] developed a boring competence at structure and at character arcs. Frankly, that's something a lot of screenwriters are never able to achieve, but I always knew how to do a beginning, a middle, and an end, a plot. And ultimately, so what? Are those the kind of movies I want to pay eight-fifty or nine dollars to go see? Would I get in my car, drive to the theater, park, pay the babysitter, pay nine bucks to see this? I just decided I wouldn't do anything where that wasn't the case."

Writing predictable films, she says, "was frighteningly limiting. [So] I just

made this emotionally crushing decision to try five times as hard and to care ten times as much. Which will probably lead to me not being a screenwriter anymore. I'll probably end up being a director or a novelist."

What inspired such a radical change in perspective? "I really think it's for venal reasons," Dixon claims. "It's just ambition and competitiveness. I just wanted to be better. I just wasn't good enough. I'm still not. I can still get better at this.

"I'm not proud enough of anything I've done. There's nothing I've worked on that I can say, 'That's up there with *Godfather II* or *L.A. Confidential*.' It's extremely pretentious to say for a minute that you could do something like that, but I'd feel a lot better about spending millions and millions of studio dollars in negative costs for films if I thought there was a chance."

In the fall of 2000, Dixon was determined that *Pay It Forward* not start a trend. There would be no "sensitive, squishy, female-appeal films" in the future for her, she said. "This was the left-turn anomaly of all time for me." She was looking forward to working on "the sickest, most twisted kind of black comedy. Something with impalings and decapitations." But things didn't work entirely as she'd planned.

Pay It Forward wasn't a critical or box office success; many found it too sweet after all. The offers that followed were for what she calls "vagina movies," but her interest in writing earnest dramas had long since disappeared. Three years would pass before her name appeared on another film, and that was Disney's *Freaky Friday*—hardly an edgy project, though Mark Waters's take on the family chestnut garnered good reviews. Two years later, she shared credit on *Just Like Heaven*, a melodrama about a man who falls in love with the spirit of a woman in a coma, then discovers that her family is about to take her off life support. (The movie suffered from comparisons with the real-life Terri Schiavo case, a political lightning rod at the time.)

But her next effort brought many of her talents together: an adaptation of *Hairspray*, the hit stage musical—which, in turn, was adapted from the film by John Waters.

Yes, it's a comedy, and yes, it's based on a family-friendly musical, but it has a decidedly edgy undertone to its family comedy. It may not be exactly what Dixon set out to do, but it's a nearly perfect combination of her personality and proven talents.

No, it's not *Midnight Cowboy*. But there's always that next script.

Getting Down to Basics

LESLIE DIXON ON "DO THEY WANT TO TURN THE PAGE?"

I write scripts completely differently from the way I did three years ago. And I think it's good as a writer to try to write different ways. Write with a partner you've never written with before. Adapt a novel and don't use an outline. When you've done this for a while, you can begin to break rules and take chances, so these are all completely new to me. My criterion now is, do I want to flip the goddamn page to the next page to see what's going to happen? That is the only rule.

I'm here to tell you, if the reader does not want to flip the page to the next page, the audience is not going to want to keep their butt in the seat to the next scene. It's a total correlation. You're telling the story. If there's a bunch of thirteen-year-old kids sitting around a campfire, and you're telling a story, and their eyes start to glaze over, you're not doing it right. You're not keeping butts in seats. You see all these movies that break conventional screenwriting rules, like *Pulp Fiction*, which jumps all over in time and kills off one of its heroes two-thirds of the way through. But do you want to know what's going to happen next every minute in that movie? Yes. And that's the only rule.

Somebody gave me a copy of Robert McKee's *Story*. I said, "This is like trying to understand a human being by looking at DNA." Maybe we could put the McKee book on the shelf, and right next to it could be the Leslie Dixon book, which would be a flyer saying "Do they want to turn the page?" That would be my screenwriting manual, and we could put his four-hundred-page tome next to it.

Erin Brockovich

CREDITS

DIRECTED BY Steven Soderbergh
SCREENPLAY BY Susannah Grant
PRODUCERS: Danny DeVito, Michael Shamberg, and Stacey Sher
PRODUCTION COMPANY: Jersey Films
ORIGINAL MUSIC BY Thomas Newman
CINEMATOGRAPHY BY Edward Lachman
FILM EDITING BY Anne V. Coates
CASTING BY Margery Simkin
PRODUCTION DESIGN BY Philip Messina
ART DIRECTION BY Christa Munro
SET DECORATION BY Kristen Toscano Messina
COSTUME DESIGN BY Jeffrey Kurland

MAJOR AWARDS

ACADEMY AWARDS: Julia Roberts—Actress
GOLDEN GLOBES: Julia Roberts—Actress
BAFTA AWARDS: Julia Roberts—Actress
SAG AWARDS: Julia Roberts—Actress; Albert Finney—Supporting Actor

CAST

Julia Roberts . . . *ERIN BROCKOVICH*
Albert Finney . . . *ED MASRY*
Aaron Eckhart . . . *GEORGE*
Marg Helgenberger . . . *DONNA JENSEN*
Peter Coyote . . . *KURT POTTER*
Cherry Jones . . . *PAMELA DUNCAN*
Jamie Harrold . . . *SCOTT*
Mimi Kennedy . . . *LAURA AMBROSINO*
Tracey Walter . . . *CHARLES EMBRY*
Veanne Cox . . . *THERESA DALLAVALE*
Gina Gallego . . . *MS. SANCHEZ*
Conchata Ferrell . . . *BRENDA*
Erin Brockovich-Ellis . . . *JULIA THE WAITRESS*

BUSINESS DATA

ESTIMATED BUDGET: $51 million
RELEASE DATE: March 14, 2000
U.S. GROSS: $125.6 million
FOREIGN GROSS: $132.3 million

REVIEW HIGHLIGHTS

"Director Steven Soderbergh has blown a great opportunity to make the movie that the real Erin Brockovich calls for. Susannah Grant's by-the-numbers screenplay sees the characters as markers on a storyboard rather than flesh-and-blood humans." —ROGER EBERT, *CHICAGO SUN-TIMES*

"Writer Susannah Grant and director Steven Soderbergh, while recognizing the Cinderella aspects of the true tale they are telling—there's even a love scene in which this ex-beauty-queen-turned-activist gets to wear her crown—also manage to keep valid the everyday aspect of the story without getting bogged down in earnestness or resorting to shrill preaching." —BRIDGET BRYNE, *BOX OFFICE*

"On paper, the story of *Erin Brockovich* might seem smugly pat—knee-jerk anti-corporate. But the director, Steven Soderbergh, keeps the menace vague, the horror intangible." —DAVID EDELSTEIN, *SLATE*

"An exhilarating tale. . . . Well done . . . *Erin Brockovich* is everything that 'inspirational' true-life stories should be and rarely are." —TODD McCARTHY, *VARIETY*

"EVERY GOOD STORY IS A LOVE STORY"

ERIN BROCKOVICH • SUSANNAH GRANT

rin Brockovich, the movie, gave a lot of things to a lot of people. Universal Pictures got $259 million in worldwide theatrical gross—more than enough to put the movie in the black even before its DVD release. Julia Roberts got the best reviews of her career and an Academy Award for Best Actress. After two acclaimed but little-seen films—*Out of Sight* and *The Limey*—director Steven Soderbergh got a commercial and critical hit.

For her part, screenwriter Susannah Grant got Hollywood heat, and lots of it. *Variety* itself called Grant "red-hot" in a front-page, above-the-fold story announcing that she would write and direct a romantic comedy for Sydney Pollack's Mirage Enterprises—a deal that wasn't even new at the time.

Yet *Erin Brockovich*, the movie, could easily have gone unmade. The true story of the beauty-queen-turned-broke-single-mom-turned-ace-legal-investigator had not been a bestseller. There were no banner tabloid headlines touting her accomplishments. There was no rush to snap up her life rights, not even an agent to pitch them. This story's voyage from script to screen began with a producer in need of adjustment—and the chiropractor who straightened her out.

The producer was Carla Santos Shamberg, wife of Jersey Films partner Michael Shamberg. Santos Shamberg had been at Jersey Films since 1992, beginning as an assistant to the producer on *8 Seconds* and working her way up to vice president of special projects. By 1996, she was looking for a project to produce for Jersey.

She found one while lying on her chiropractor's table. Santos Shamberg, it turned out, has the same chiropractor as Erin Brockovich. As the chiropractor explained the story, Brockovich had been in a car accident in the early 1990s.

Her lawsuit against the other driver went badly, but afterward she talked herself into a job with the personal injury lawyer who had represented her. Within a few months, through her own efforts, this untrained novice had uncovered one of the most serious cases of toxic contamination ever found in California—not to mention a cover-up by Pacific Gas & Electric. Brockovich discovered enough information to compel PG&E to pay what was then the largest settlement in a direct action lawsuit in U.S. history: $333 million. Now she had become the key investigator on a string of major water contamination cases, with damages that could top $1 billion.

"I couldn't believe it," Santos Shamberg remembers. "It seemed incredible that this twice-divorced woman with three young children, who had no money, no resources, and no formal education, had single-handedly put this case together. I thought she seemed like the perfect role model for the new millennium."

Picturing Julia Roberts as Erin Brockovich, Santos Shamberg brought the idea to Jersey Films. Jersey quickly got behind the project, optioning life rights from Brockovich and attorney Ed Masry, who helped uncover the case. Later, after the script was under way, they optioned the life rights of Brockovich's former boyfriend George Halaby.[1]

With the rights secured, Jersey started looking for a writer. At the same time, Susannah Grant, who had just finished the Cinderella fantasy *Ever After*, was looking for a new project. "I was just looking for something to do. I was either going to write a spec or do something for someone else." A graduate of Amherst College and the screenwriting program at the American Film Institute's Center for Advanced Film and Television Studies, Grant had received a 1992 Nicholl Fellowship in screenwriting from the Academy of Motion Picture Arts and Sciences. She established herself as a television writer, producer, and director during three seasons on *Party of Five*, winning a Golden Globe in 1995. Her reputation as a feature writer was solidified by work on Disney's *Pocahontas* and *Ever After*, on which she shared credit with director Andy Tennant and Rick Parks.

[1]Halaby would later be charged with extortion, along with Brockovich's first husband Shawn Brown and an attorney, John Reiner, after Reiner threatened to tell the tabloids that Brockovich and Masry had had an affair and that Brockovich was an unfit mother unless they paid $310,000. Reiner was convicted of two counts of attempted extortion and one of conspiracy to commit extortion in April 2001, and was sentenced to 120 days in jail and three years' probation.

It was a good resume, but none of Grant's credits could exactly be called gritty. She got her name in contention for the project, even having lunch with Brockovich and producer Gail Lyon of Jersey Films. "It was great!" she remembers. Still, she did not leap to the top of Jersey's list. First Jersey approached *Thelma & Louise* scribe Callie Khouri; she passed a few weeks later. Then they offered the job to Paul Attanasio (*Quiz Show, Donnie Brasco*).

But Grant did not give up. "I said, 'If he passes . . .' Finally my persistence won out. [Lyon must have] figured that anybody who wants to do the story that much must be able to do a semi-good job," she said with a laugh, "because I hadn't done something that was a perfect writing sample for it. She knew what kind of writer I was, but not for this kind of material. So I told them what I thought the movie should be like, and what I liked about the story."

Grant isn't certain, but she's fairly sure Brockovich had approval on the writer, so it was helpful that they'd hit it off. "She just has a really firm sense of what's decent and what's not, but she's not a Pollyanna. When somebody is not nice, she can be as angry as the next person. She's a lot like the character in the movie. I found her irresistible. Just on a personality level, we laugh at the same stuff, we became friends really easily. It wasn't a force-fit at all. We had lunch and she said, 'Yeah, let's do this.'"

The film, as it arrived in theaters, begins with with a somewhat desperate Erin Brockovich interviewing for a job—and not getting it. Moments later a car smashes into hers at an intersection. The accident brings her to a San Fernando Valley personal injury lawyer, Ed Masry, whose firm takes her case without much enthusiasm. Masry promises her a big settlement for her injuries, but his efforts fall short.

Now even more desperate, with three children to support and no job, Brockovich talks Masry into hiring her at the law firm. Most of her coworkers hate the loud, profane, outrageous Erin, but she sticks with the job anyway. Meanwhile, she slowly, tentatively, begins a romance with her biker neighbor, George.

Then she begins to work on a real-estate case for a family in rural Hinkley, California. It seems that Pacific Gas & Electric wants to buy this family's home. Yet there are some medical files along with the real estate information.

Puzzled, Brockovich goes to Hinkley to visit the family. Working on her own—and deftly displaying her physical endowments to charm men she encounters on the way—she soon assembles frightening evidence of contaminated

groundwater and a PG&E coverup. When she returns to the law office, however, she finds she's been fired: While she was working the case in Hinkley, everyone at the office had assumed she'd taken off to have fun. Only when Masry gets a message from a toxic-waste specialist telling him that there are carcinogenic wastes in Hinkley's water does he approach Erin to find out what really happened.

After Ed rehires Erin, she becomes his key investigator on the Hinkley case. She plunges into the work, finding self-esteem and a sense of accomplishment that she has never known before. She pays a price for her work: Her children resent the time she spends away from them, and even George eventually loses patience. Still, Brockovich presses on, eventually finding the key evidence that forces PG&E to admit everything. In the end, Ed gives Erin a bonus of $2 million—finally leaving her speechless.

Some critics made the obvious comparison between *Erin Brockovich* and *A Civil Action*, a John Travolta film based on a similar case, that came out about two years earlier. Both films revolve around contaminated water litigation, and some of the legal details are remarkably similar. Still, this probably says less about movies than it does about how polluters behave and the means by which lawyers can beat them.

"They're very different, the two movies," said Grant. "The John Travolta character is going through a completely different life experience from Erin Brockovich—which is something Stacey Snider at Universal saw right off the bat from the first draft. [She] said, 'It doesn't matter, it's irrelevant, we're undeterred.' Because there were people who thought you can't make this in the wake of *A Civil Action*."

In one respect, Grant had more freedom than Steven Zaillian did when he adapted *A Civil Action* for the screen. *A Civil Action* was based on a bestselling book; author Jonathan Harr had already stamped the material with his own take. Grant found her own take on the Erin Brockovich story and even avoided reading Harr's book, which she'd received as a gift.

Grant did see Zaillian's movie—which, like Harr's book, focused on the lead lawyer in the case—and she could see the similarities in the stories. Like Zaillian, however, Grant knew she would have to focus more on people than on science or law.

"It's really hard to get people to sit down and watch a movie about contamination," she said. "So you need an engaging personal story. If somebody had said, 'Do you want to do a movie about contamination, hexavalent chro-

mium leaching into groundwater?' I would have said no. But somebody said, 'Here's Erin Brockovich. Would you like to do a movie about her?' How can you say no? She's fantastic."

Once she had the go-ahead, Grant "just started hangin' with her, hanging out at her house. I went through her entire life in photographs and memorabilia, went out to Hinkley, hung out with Ed, hung out in the office." In fact, writing Brockovich's story for the screen took quite a bit of hanging out. Grant talked, observed, and did a huge amount of research. Much of the work involved interviewing the real-life figures behind the case: "What happened when, who did you have when—it was very complicated. A lot of it is in their memories, so you just have to sit down and say, 'Okay, there's a gap here.' That stuff was like math. No fun." On the other hand, she recalls, "there was the dynamic between them and the character stuff—which was just irresistible."

Ed Masry remembers Grant getting into meticulous detail as she filled in those story gaps. As she did, Masry came to realize what an unlikely accomplishment the Hinkley case had been. "When it's over, you look at it and say, 'Oh my God, how did we ever do this in the first place?'" he said. "Every little bit had to have fallen into place or none of it would have happened."

Grant didn't start out with a strong take on what the story should be, so during her research she was looking for an angle on Brockovich's life. "I knew that I liked Erin. I knew that I liked the things she stood for, admired the choices she'd made. I understood the decisions she was forced to make, and I thought they were compelling and universal and incredibly challenging.

"So I didn't start out saying, 'This is the story.' But as I spent time with her . . . I decided that I was interested in the story of a woman's struggle for success completely on her own terms. Which doesn't happen very often. It doesn't happen to men either. Once I figured out that's what it was, that's what I was trying to tell, I tried to figure out which parts of the story I couldn't leave out and stay truthful, and then which parts of the story I also wanted to incorporate to tell, to get that larger theme."

As a writer with experience in romantic comedy, she also brought an unusual sensibility to the script. "I have a theory that for me, every good story is a love story. I really looked at this [as] a love story between Erin and Ed. It's not a romantic love at all, but it's a true love, and they complete each other in a wonderful way. And it's kind of structured classically along those lines. Boy meets girl, boy loses girl, you know? It's classic love story structure, which helps."

Ed Masry agrees that—even though he didn't really like Erin at first, when she was his partner's client—they have developed a deep, close relationship. "She's a great companion to travel with; she's always got something funny to say. She does her job extremely well, very competent." The two grew so close that Masry actually gave Brockovich away at her wedding. "And I guess that was appropriate," he said, "because I was getting to be like [a] father-brother to Erin. . . . Definitely that more than an employer and employee."

Grant's script actually emphasizes the bond between Erin and Ed more than the finished product, including several scenes that were cut from the film. One such scene shows the two of them driving to Hinkley together. Ed makes a cell phone call to his wife and drifts out of his lane while talking baby talk. Erin orders him to pull over, scolds him for talking baby talk in front of an employee ("It really undermines your authority!"), and orders him to let her drive.

Grant recognizes that this scene did not advance the film's main story, the contaminated water case. "It's about getting from one place to another. It's about a character thing. And all that was pretty much done about the case. So the storytelling pretty much stopped there, and there's the rule in screenwriting that if you can take a scene out, you should."

The subtle shift away from the Ed/Erin "love story" may also reflect Steven Soderbergh's take on the story. Soderbergh, like Grant, knew this would not be a movie about a lawsuit. But he looked at it somewhat differently than Grant. To Soderbergh, the story was about "a person who cannot seem to reconcile how she views herself with how others view her," he said.

Soderbergh joined the project in late 1998 and he proved essential to locking in Roberts for the part. "Who wouldn't want to work with him?" said Grant. "Everybody does their best work in his movies."

Soderbergh said that he was drawn to the project because "the screenplay was very linear. It was performance-driven and had a female protagonist who was in every scene in the film. I had never done a film like that before, and it really appealed to me."

Grant, too, enjoyed the direct quality of the story. "The movie's a pretty straight line. And I think it works as a straight line. It's been criticized for that—for not being experimental or something—but I really like that. It reminds me of an old-fashioned movie. It tells one story."

With the relatively powerful Jersey Films producing, Grant was already insulated from most of the typical development pressures, not least the usual

pressure from the studio to make the star's role more likable. "They've changed it now," said Grant. "Now they say 'relatable,' because they don't want to say 'likable.' But they mean 'likable.'"[2]

Jersey's protection was especially important because Grant was trying to capture a difficult personality. "She's tough," said Grant. "But drama is conflict. It's a lot harder to write a character who's nice to everyone and doesn't get in fights. Because what are you writing? What's the scene about? What do they want? [In terms of craft,] it's just more difficult if it's a difficult person. Because there's a lot going on in any scene, and that's great. You get to a scene, and you think, *Oy.* If you're thinking *This isn't complicated enough,* then you don't have enough to work with."

Grant also wanted to avoid painting Brockovich as a passive victim. For example, in the latter part of the film, Brockovich has a series of confrontations with a prim lawyer named Theresa—a polite and professional, but significant, antagonist for Brockovich.

"Erin's response to her is inappropriate," said Grant. "She reacts quickly when she feels disrespected, but sometimes she perceives more disrespect than is actually there. I really wanted it to be clear that it's not just that the world is against her. She's also itching for a fight herself."

For Ed Masry, there is one big difference between the film's Erin Brockovich and the woman he works with: The real woman is a lot smarter. "Erin is one of the most intelligent persons I've ever met. I don't care whether it's a Harvard lawyer or a brain surgeon or whatever. She is an extremely intelligent woman."

Grant's first draft impressed enough people that she never heard any notes about making Brockovich more "relatable." But she and Carla Santos Shamberg still wrestled with how much dramatic license to take with the story. "I remember talking to Carla and having that 'What matters more—drama or truth?' conversation," said Grant.

Aside from Brockovich, Masry, and boyfriend George, most of the characters became composites. Masry actually partnered with two outside lawyers, but in the film they were combined into a single character, Kurt Potter (Peter Coyote). Even Ed became something of a composite in the movie: In

[2]Likability. It's a Tinseltown bugaboo. I suppose that "relatable" is an improvement, at least in theory. You don't have to like the characters, you just have to relate to them. But I can't shake the feeling that George Orwell is snickering at this from beyond the grave.

actual fact, it was Ed's partner Jimmy Vititoe who represented Erin in her accident case and who initially hired her to work at the law firm.

Grant and Santos Shamberg also faced an ongoing question about whether the real events of the case would be dramatic enough. For example, the film depicts a meeting between the plaintiffs and Ed Masry. In reality, most of the plaintiffs at the meeting signed up for binding arbitration, but more than a hundred remained unsigned, and Brockovich obtained the missing signatures alone. Grant's initial draft followed the facts, but there were doubts about the scene. "All of us were thinking, *Well, was that heroic enough?*" In Grant's second draft, the Hinkley plaintiffs all refuse to sign, and Brockovich alone convinces the entire group.

But that wasn't the end of the story. Once Soderbergh came onto the project, the "truth versus drama" conversation shifted. "Steven was adamant about truth," said Grant, and he made it a point to steer the script away from dramatization.

Soderbergh said, "When I came on board, I felt that part of my job was to become as familiar as I could with all of the facts in regards to the case and make sure that there wasn't anything in our script that was unnecessarily provocative or created solely for dramatic effect.

"Basically, I was going through the movie and accentuating the things that I was drawn to. I asked questions about everything. I wanted to know what had really happened." Soderbergh helped tip the balance toward the real events, and the signature-gathering sequence returned to its earlier, truer form.

"Now that the movie's all done, we can see that that scene is obvious," said Grant. "But when you're developing it, you think, *How am I going to feel?* You can't really *tell* how you're going to feel. You can't really tell if it's going to feel like she did a great thing by herself. It's my instinct that it would work, but you don't know, so you play around with it a little."

Despite Soderbergh's desire to stick to the facts, some nuggets of truth were omitted from the final product. The film implies that Erin loses her lawsuit against the doctor who slammed into her car; in truth, the lawsuit was settled before going to the jury. Ed Masry said "she got some [money,] but it wasn't enough to talk about." Later, they learned that the jury was going to give her a large award. Also, the real Erin Brockovich was never fired from the law firm, though some of Masry's staff did push to get her fired when she was inconsistent about punching in and out of work.

One of the film's more memorable moments, already in place in Grant's

early draft, comes when a lawyer challenges Brockovich to recite from memory the phone number for one of the plaintiffs in the case. Brockovich not only has the number memorized but also expounds at length about a wealth of detail.

Grant's draft reveals a true detail that explains Brockovich's remarkable feats of memory: She is dyslexic. She memorized the numbers because she had to. The film only mentions that she is a slow reader.

"I think it was too much, ultimately, in the movie for her to be dyslexic," said Grant. "Dyslexia's interesting, but the movie works without it, and it's not a handicap that's insurmountable for this job. It's just a little off-point."

Likewise, later in the film Brockovich gets sick. There is no particular information about what she has or what caused it. In Grant's early draft, Erin collapses and is rushed to the hospital with what turns out to be acute meningitis. Masry was convinced that Brockovich's illness was the result of their visit to one especially toxic house, but that detail was left out of the film as well.

Roberts had script input, too, of course. She insisted that *The Fisher King* writer Richard LaGravenese do a "polish" of the script. For an uncredited writer, LaGravenese has been mentioned in an unusual number of reviews of this film. Yet, though many details and bits of dialogue changed before the final product, the vast majority of the script is Grant's.

Moreover, some of the changes came not from LaGravenese, but from conversations on the set, as always happens on a film. There were some re-shoots, including the pivotal bar scene where Brockovich is offered the final piece of evidence that clinches the case against PG&E. Soderbergh himself added the opening scene of Brockovich interviewing for a job. He also asked for the character of Pamela Duncan (Cherry Jones), because he wanted to have a holdout in the story.

Another character changed as well: the "man in the cap" who seems to stalk Brockovich when she is in Hinkley. The man in the cap turns out to be a former PG&E employee who had saved some incriminating documents and wants to pass them to her. In the film, the whistle-blower at first seems to be a simple lecher, and Brockovich misreads his motives in exactly the way most people misread her. (In earlier drafts, the character was a "man in dark glasses," who seemed more menacing.) Either way, though, one element stayed the same. Brockovich misread the man and only succeeded when she let go of her preconceptions.

Grant was nominated for a WGA Award, a BAFTA, and an Academy

Award for Original Screenplay for *Erin Brockovich*, but was beaten out by Kenneth Lonergan and *You Can Count on Me* at the WGA, then Cameron Crowe and *Almost Famous* at the BAFTA Awards and the Oscars. The Las Vegas Film Critics Society did give her their Original Screenplay award—splitting it (rather rudely) with LaGravenese, despite the fact that he received no screen credit on the film. Julia Roberts, of course, took home a Best Actress Oscar—no small thing for the screenwriter. When actors want to go for Oscar gold, they like turning to writers who have plowed that ground before—writers such as LaGravenese, whose *Fisher King* script gave Mercedes Ruehl an Oscar-winning turn.

With *Erin Brockovich*, having written leading roles for Drew Barrymore, Julia Roberts, and Sandra Bullock, Grant had established herself as a solid writer of women's roles—the kind that can help an actress earn her serious-actress bona fides. That status was enhanced when she penned the 2005 adaptation of Jennifer Weiner's novel *In Her Shoes*. The story of the complex relationship between two sisters earned a Golden Globe nomination for Shirley MacLaine and acclaim for stars Toni Collette and Cameron Diaz as well. With *Hitchhiker's Guide to the Galaxy* screenwriter Karey Kirkpatrick, she also penned the screenplay for *Charlotte's Web* (2006)—starring the voice of none other than Julia Roberts as Charlotte.

That directing assignment for Sydney Pollack's Mirage Enterprises turned out to be, well, something of a mirage. But she did write and direct a drama, *Catch and Release*, starring two actresses of note: Jennifer Garner and Juliette Lewis. Sooner or later, it seems, even Hollywood hype can amount to something.

For her part, Grant laughed off the attention a hit movie brings.

"It probably matters more to my agent than to me. I frankly don't have a whole lot of interest in the business part of the business. So I have a very smart agent. I just tell her what I want to be able to do creatively, and she arranges it so everything just falls into place. But I mistrust any business where perception is so important."

Supermom

After writing Erin Brockovich *and* 28 Days, *Susannah Grant found herself with a writing/directing deal, a husband, and a young baby. Her struggles to balance family life and a demanding career mirror those of her on-screen heroine, the real-life Erin Brockovich-Ellis.*

When do you like to work?

I like to write in the morning before I've talked to anyone or done anything. Six A.M. But now I have a baby, so I can't start right away, which has put a little wrinkle in my workday. Because I have to actually engage something other than my work and then shift into work. And I used to just go right from sleep to work, and not have all that life-stuff in between. Now I have all that life-stuff in between, so I have to really refocus. And it takes more work to refocus than it used to.

I like working late at night for the same reason. Because the day's over, there are no calls you can make, there are no errands you can run. Put on your pajamas and go to work. Maybe you'll work half an hour, or maybe you'll work four hours.

What's a good day's work?

It depends on how far into the project. Now? Three hours, four hours. In about a month? Five hours. Once I've called the studio and said you're getting it in three weeks or four weeks or two weeks? Ten hours. Once you're really in it, it's easy to stay in it. It's hard when you don't really have the thing, you're [still] playing around with it. You have to build the thing before you can play with it. Playing with it I can do forever. But the building takes a lot of work.

What's the hardest thing about having a life and being a screenwriter at the same time?

Maintaining concentration. Maintaining your focus. And protecting the creative part of your brain. When you have a baby and a husband and an extended family and friends, not letting those aspects of your brain overwhelm the part of your brain that writes. Just getting some mental privacy.

I run—that helps a lot. I don't let any light in my office. I think that just cuts out the outside world. I just have a big blank wall in front of me. I just try to get rid of the things that will make me think of something else. I don't have very good concentration, really, so I need a lot of help in concentrating. If I had a desk in front of a window, there's no way I could work.

(Continued)

Do you have breakthroughs while you're running?

Always. Every time. [When] I can't figure something out, I get about a quarter mile in and I've figured it out. I also try not to wrestle with those problems at my desk, because I don't want to have a lot of negative, difficult associations with my desk. I have to spend a lot of time there and I have to feel like 'Oh, this is the place where all the good stuff happens.' Not 'This is the place where I have all those problems.' So I try to get up and bake some bread or something if I'm trying to wrestle with something.

How do you know when a scene isn't working?

You can't write it. You can't write it.

So what do you do?

Figure out *why* you can't write it. Go to the basics, sort of like the acting basics. What does each character want? Are they going to get it? If there's no drama, why not?

The Hitchhiker's Guide to the Galaxy

CREDITS

DIRECTED BY Garth Jennings

SCREENPLAY BY Douglas Adams and Karey Kirkpatrick

NOVEL BY Douglas Adams

PRODUCERS: Gary Barber, Roger Birnbaum, Jonathan Glickman, Nick Goldsmith, and Jay Roach

EXECUTIVE PRODUCERS: Douglas Adams, Derek Evans, and Robbie Stamp

STUDIO: Walt Disney Studios

PRODUCTION COMPANIES: Touchstone Pictures, Spyglass Entertainment, Everyman Entertainment, Hammer & Tongs

ORIGINAL MUSIC BY Joby Talbot

CINEMATOGRAPHY BY Igor Jadue-Lillo

FILM EDITING BY Niven Howie

CASTING BY Susie Figgis, Marcia Ross

PRODUCTION DESIGN BY Joel Collins

ART DIRECTION BY Alan Cassie, Daniel May, Phil Simms, Andy Thomson, Frank Walsh

SET DECORATION BY Kate Beckly

COSTUME DESIGN BY Sammy Sheldon

MAJOR AWARDS

None

CAST

Stephen Fry . . . *NARRATOR/THE GUIDE*

Martin Freeman . . . *ARTHUR DENT*

Sam Rockwell . . . *ZAPHOD BEEBLEBROX*

Zooey Deschanel . . . *TRILLIAN*

Mos Def . . . *FORD PREFECT*

Alan Rickman . . . *MARVIN*

Bill Nighy . . . *SLARTIBARTFAST*

Warwick Davis . . . *MARVIN*

Anna Chancellor . . . *QUESTULAR RONTOK*

John Malkovich . . . *HUMMA KAVULA*

BUSINESS DATA

ESTIMATED BUDGET: $50 million

RELEASE DATE: April 29, 2005

U.S. GROSS: $51.1 million

FOREIGN GROSS: $40.9 million

REVIEW HIGHLIGHTS

"[The] filmmaking style is unrushed and—for a film stuffed with special effects—not overly busy. . . . [The] narrative bagginess is partly what makes the film feel true to Adams, if not in precise letter then certainly in mellow spirit." —**MANOHLA DARGIS,** *NEW YORK TIMES*

"[A] movie that spills over with visual gags, puppet monsters and a digital John Malkovich. . . . The script by Karey Kirkpatrick and Adams himself delivers the goods in inspired lunacy." —**PETER TRAVERS,** *ROLLING STONE*

"Studiously harmless, Disney's long-in-development film rendition pasteurizes the book's renegade verve with typical means: special effects and gooey romance. (Adams had recently completed a second draft of the screenplay at the time of his death.) Pinballing around the universe with rumpled Englishman Arthur Dent (Martin Freeman, a/k/a Tim from *The Office*), the movie is amiable and eager to please, but its puppyish energies still rack up Hollywood overkill." —**JESSICA WINTER,** *VILLAGE VOICE*

10 | SITH, SCHMITH. THANKS FOR ALL THE FISH

THE HITCHHIKER'S GUIDE TO THE GALAXY •
KAREY KIRKPATRICK

Spring 2005 was a season of good news and bad news for science fiction fans. On the one hand, the sixth, and probably last, *Star Wars* film opened. On the other, *The Hitchhiker's Guide to the Galaxy* made its appearance.

The question is: Which was the good news and which was the bad? The answer depends on your hopes and expectations. (And no, the answer is not "42," smart alecks.)

Personally, I'm a fan of both . . . sort of. I was eighteen when the original *Star Wars* appeared; it was the first movie I ever paid to see twice. At twenty-one I was astonished by *The Empire Strikes Back*, which boasted a deeper, richer story than its predecessor and was gorgeous to look at to boot. But at twenty-four I was frustrated and angered by *The Return of the Jedi*, which seemed a redundant anticlimax.

When George Lucas started his prequel trilogy, I was cautiously optimistic, but *The Phantom Menace* proved my caution was more justified than my optimism. By the time *Revenge of the Sith* was on the horizon, I was looking forward to it the way I look forward to a dentist appointment: hoping things turn out all right, but expecting more pain than pleasure.

There was a certain symmetry, though, in seeing the last *Star Wars* movie premiere just a few weeks after the first, and probably only, *Hitchhiker's Guide* movie. The two properties have been in the public consciousness, one way or another, for about the same length of time, and one was probably instrumental in the creation of the other.

Each property has a global base of fans who anticipated these movies with a mixture of excitement and dread. That's every bit as true for *Hitchhiker's*

Guide as for *Star Wars*. Douglas Adams fans—and count me among them—may be fewer in number than George Lucas's legions, but we're every bit as passionate. If you're a fan of either, you probably had some of these thoughts: *What if it's terrible? Will I be disappointed? If it's great, will I be left wishing for more, knowing I won't get it? Can it possibly live up to our hopes?*

And that, in a nutshell, was the challenge facing *Chicken Run* screenwriter Karey Kirkpatrick when he accepted the task of completing the screenplay for *Hitchhiker's Guide*. Adams already had a working draft of the screenplay, but when he died in 2001 it was left unfinished. For Kirkpatrick, completing it meant assuming the legacy of a beloved author's most beloved book—a task he took quite seriously. "I was in service of what Doug was trying to do, and my job was to be in the background as much as possible," Kirkpatrick said. "If nobody could tell where Doug left off and I took up, I was successful. When the director came on board, I was in service of his interpretation. So I was a craftsman on this as much as a creator."

That's not to say Kirkpatrick made no creative contribution. In fact, he may be selling himself short. Kirkpatrick won't say so himself, but many of the key players behind the film admit that Adams, brilliant as he was, had become an obstacle to the film's completion, and it was Kirkpatrick's work that brought the movie to fruition after almost twenty years of development.

For those who haven't had the pleasure of reading *The Hitchhiker's Guide to the Galaxy*, here's an attempt at a synopsis—as much as it's possible to synopsize something that has more in common with Monty Python than Obi-Wan Kenobi.

On an ordinary English day, an ordinary Englishman named Arthur Dent awakens to discover that his house is about to be demolished by an officious and bureaucratic construction crew to make way for a highway bypass. As he attempts to stop the bulldozers, his friend Ford Prefect comes round to tell him that they should go to a pub right away, because the world is going to end in ten minutes. Ford, it turns out, is being quite literal: In ten minutes, the Earth is demolished by a particularly ill-tempered and bureaucratic alien race, the Vogons, to make way for a hyperspace bypass.

Just before the implosion, however, Ford hitches a ride aboard a Vogon ship and takes Arthur with him. Ford, we learn, is really an alien, a galactic hitchhiker who's been stuck on Earth for fifteen years doing research for the ultimate reference book, *The Hitchhiker's Guide to the Galaxy*. This tome, whose text is entirely electronic (think the Internet in a box), has on its cover one always-appropriate bit of advice: "Don't Panic."

Thereafter, Arthur finds himself a reluctant adventurer as he and Ford are thrown off the Vogon ship and, improbably, caught up in the quest of the galaxy's rogue president, Zaphod Beeblebrox, to find the legendary planet of Magrathea and its vast hoard of gold.

Along the way, Arthur learns that he's not quite the last survivor of Earth. The planet's two most intelligent species escaped: the dolphins and the mice. (Mice, he discovers, are not at all what they've appeared to be all these years.) In an improbable twist, also among the survivors is a girl named Trillian whom Arthur had fancied. To Arthur's frustration, Trillian shows up on the arm of President Beeblebrox. The president's spaceship, the Heart of Gold, is powered by the new Infinite Improbability Drive, which permits near-instantaneous access to any point in the universe, but also causes wildly improbable things to happen with disturbing regularity.

Arthur also learns that some millions of years earlier, the second-greatest computer of all time had delivered the answer to the meaning of life, the universe, and everything: 42. Unfortunately, that computer could not deliver the question that "42" answered. That would require the *greatest* computer of all time. Arthur is surprised to discover that he holds the key to finding the output of that computer: the Ultimate Question.

By Adams's own account, the idea for *The Hitchhiker's Guide to the Galaxy* came to him while "lying drunk in a field in Innsbruck, Austria, in 1971." He was traveling with a copy of *The Hitch Hiker's Guide to Europe*, and as he watched the stars come out, "it occurred to me that if only someone would write a 'Hitchhiker's Guide to the Galaxy' as well, then I for one would be off like a shot. Having had this thought I promptly fell asleep and forgot about it for six years." In those years, Adams attended Cambridge University, where he appeared in the school's Footlights troupe, following in the footsteps of one of his heroes, Monty Python's Graham Chapman. After Cambridge he became a freelance writer, and in 1977, when he was twenty-five, a BBC radio producer approached him about writing a science fiction comedy project.

It was the year of *Star Wars*, and lighthearted science fiction seemed just the ticket. The following year, March 8, 1978, saw the debut of Adams's BBC project, a radio production called *The Hitchhiker's Guide to the Galaxy*. Adams was modest about its success, but the show was a hit. Not that it made him rich: he went to work on the long-running British TV sci-fi hit *Doctor Who* before he was approached about turning *Hitchhiker's Guide* into a book, and when he said yes it was largely because he needed the money. The book hit stores in September 1979 and promptly rocketed to the top of the bestseller lists.

Things snowballed from there: more radio episodes, a BBC TV series, and more novels: *The Restaurant at the End of the Universe*; *Life, the Universe and Everything*; *So Long and Thanks for All the Fish*; and *Mostly Harmless*. But the idea of a film adaptation loomed in his imagination. Adams's close friend Robbie Stamp, who became an executive producer on the film, said that "Doug had always, always wanted there to be a movie . . . almost from the moment that *Hitchhiker's Guide* was a big radio success."

Adams wasn't interested in a low-budget *Doctor Who*–style treatment of the story, either. "He always wanted it to be done in Hollywood," said Stamp. He sold the rights to Ivan Reitman in the early 1980s and moved to Los Angeles to write the screenplay. But the project bogged down. The story proved to be very episodic—no surprise, given its origins as a series of radio episodes. "A series of stuff just happens to this character," said Stamp. "It's a very picaresque novel in that sense. You needed to find some character arcs, which took some time."

Adams wasn't idle. He developed new characters and sci-fi devices, added scenes, let go of big chunks of the book. Even so, the script lingered for years without gelling, while Reitman went on to direct *Ghostbusters* and other popular comedies. Mike Nesmith, of *Monkees* fame, worked with Adams on it for a while, but their collaboration came to nothing. Adams never gave up on the idea, but it wasn't until the success of 1997's *Men in Black* that Hollywood's interest in the book revived.

At that point, Caravan Pictures and Disney Studios got involved, acquiring the rights and attaching Jay Roach, director of the *Austin Powers* series. Adams went back to work on the screenplay, still tinkering. As the years went by, the rights went from Caravan to a new entity, Spyglass Entertainment, formed by Caravan's Roger Birnbaum and a new partner, Gary Barber. Adams was still working on the script—but by the late 1990s those working with him had begun to realize that he was as much a part of the problem as of the solution.

"We needed to edit ourselves, and it was difficult to do that with Douglas in the process," said Birnbaum. "He wrote the book, it was his story, and he loved a lot of it. He wasn't a filmmaker. It was harder for him to look at his work and say, 'This part is not necessary in order to tell the story.' He loved it all. We loved it all, too, but eventually we had to make a movie."

Kirkpatrick defends Adams. "*Hitchhiker's Guide* was an organic, living, breathing, not-sacred thing for him," he says. "What plagued him more than his own [concern about] what to let go of was the fans saying 'You can't not

have this, you can't not have that.' Being loyal to his fan base—that's a conundrum."

Adams finally turned in a draft that was well over two hundred pages. The project was stalled when he collapsed from a heart attack during a workout and died in May 2001 at the age of forty-nine. "When he passed away, he froze us all," said Birnbaum. "We were stunned by the loss. He was the creator of that beautiful book and the reason we were all doing this."

It was Robbie Stamp who called Adams's widow and asked whether the project should go forward. If it could be done, she said, then it should.

But there was still that script problem. "The biggest challenge was bringing this wonderful story and making it contemporary," said Birnbaum. "It was written twenty-five years ago. How do we make it relevant to audiences today and keep Douglas's voice alive?"

The year before Adams died, Roach had seen and enjoyed *Chicken Run*, a Claymation feature by Nick Park of *Wallace & Gromit* fame. He sent the existing script of *Hitchhiker's Guide* to the screenwriter, Karey Kirkpatrick.

An actor turned writer who'd graduated from USC Film School in the early 1980s, Kirkpatrick had heard of *The Hitchhiker's Guide* but never read the book. "My first thought was, *I don't think I can do this, this guy's too good. I don't think my words can mingle seamlessly with his words.* I was a little intimidated."

But the chance to work with Roach was irresistible, and Kirkpatrick signed on. He inherited not just the published material, but access to Adams's computer hard drive: a treasure trove of notes, new characters, new devices, and other elements Adams had invented to fill in the gaps in the story.

Kirkpatrick was highly aware of the importance of preserving the book's spirit and tone. He saw his primary goal as "just to keep it satiric and not take anything too seriously . . . retaining its quirky, understated British sensibility, and its irreverence." At the same time, he needed to find the strong linear story and character arc that had been missing all along. "That was Question Number One," he said, "how do you create a strong, emotional story?"

The answer, it seemed, would be to focus on the growth of the hero. "We settled on this idea that Arthur's journey is learning to become a hitchhiker. [At the start of the story,] the hitchhiker spirit is everything he's missing. Trillian is looking for someone who gets her but who can also hang with her spontaneous spirit, and Arthur has everything except that."

In the book, Arthur mentions in passing that he'd met a girl at a party, but she'd gone off with someone else. The girl turns out to be Trillian, the

"someone else" Zaphod Beeblebrox. Yet the book is hardly a love story: At the party, as it's depicted in the film, Trillian (then going by the more conventional name Tricia McMillan) sparks to Arthur, but when she asks him to go to Madagascar with her, he flunks the test.

"Arthur's very rooted to his job and his cups of tea and his house," said Kirkpatrick, "so he goes on this adventure that frees him from that choice, which prevents him from getting any happiness."

That adventure, then, became the story's controlling idea. The story had a strong start—nothing beats having the Earth demolished while the audience is still settling in—and a satisfying ending, but what came between them was still episodic. Kirkpatrick still needed a middle. "[All that] happens in the book is [that we] meet four characters, learn that they're going to Magrathea, go to Magrathea, and have a long scene there," he said. Part of his solution was to introduce a new villain: a cult leader named Humma Kavula, played in the film by John Malkovich. Kirkpatrick also added scenes of the Vogons pursuing Beeblebrox's spaceship, and Trillian being kidnapped and taken to the Vogons' home planet. As Kirkpatrick said, "All [these] things were created to strengthen the narrative drive."

Everyone knew, though, that inventing new material had its pitfalls. As Robbie Stamp explained, "We were always careful after Douglas had died to invent as little as we could. The world Doug created was so incredibly rich, [our approach was,] don't invent unless you've got to. That's why Karey's done such a stand-out job on this. . . . If we did need a piece of plot or something to [bring a] character across a scene, he did it. But it's very, very seamless."

To be true to the book, Kirkpatrick also had to keep in long sections of voice-over—quotations from the reference book *The Hitchhiker's Guide to the Galaxy*, which Arthur consults through the course of the story. Those sections were absolutely indispensable to keeping the tone and voice of the original story, but they created a headache for Kirkpatrick.

"When you're in development and pre-production, script length becomes the god you're serving, and when you have a *Guide* entry, that gives you pages and pages of additional page count." This posed money problems for the production. "When you're budgeting, they go by page count," he explained. "They break down a script into eighths of a page. How many eighths of a page do you get a day? How many setups?" Of course, the budget people understand that there's a difference between an action sequence and two people sitting at a table, but length still proved problematic—"especially [for] a comedy," said Kirkpatrick. "My first draft was one hundred fifty-two pages.

Brevity truly is the soul of wit. Comedies just don't play beyond ninety min-
utes. I think at the end the script got down to about a hundred and twelve
pages." But every step of the way, he says, all he heard was "It's too long, it's
too long, cut it down."

Kirkpatrick always maintained that the movie wouldn't play as long as
the budgeters claimed, because the voice-over material played over action,
meaning that several pages of script would overlap. At one point he even pro-
duced a draft without the *Guide* entries—not because he was considering
dropping them, but to show the true length of the script.

Money was a particular problem on *Hitchhiker's Guide* because Disney
wasn't entirely sold on the project. The studio chiefs who had bought it for
Caravan, Joe Roth and David Vogel, were gone, and their replacements—
worried that they were backing a $120 million art film—grew wary of fund-
ing the project further. Spyglass eventually put up its own money to get to a
finished script. Only when Disney saw Kirkpatrick's script did they agree to
go forward, and at that point, they offered to finance the movie entirely.

By the time the movie was ready to go, though, Jay Roach had moved on
to other projects. Spyglass approached Spike Jonze, who told them, "You need
me five years ago." He sent them to a little-known British team, Garth Jen-
nings and Nick Goldsmith, that called itself Hammer & Tongs. "They said
they didn't want to give their answer until they talked to the writer," said
Kirkpatrick, which proved just how un-Hollywood they were. Kirkpatrick
told them the old joke about the actress who was so naive she slept with the
writer. They wanted to meet him anyway.

Jennings and Goldsmith were fans of the book and liked the script, but
were worried about an American writing such an iconic British story. "I told
them I was trying to do the un–*Star Wars*. Whatever *Star Wars* would do,
we'd do the opposite. They said they were thinking the same thing."

Jennings was so determined to work on the film that—even before he got
the job—he showed up to his first meeting with Disney's president of pro-
duction, Nina Jacobson, with almost the entire movie storyboarded. He came
in with a strong take on how to give the film an appropriately rough-edged
indie feel while keeping the budget down. Jacobson and studio chairman
Dick Cook liked the approach; relieved to find a relatively inexpensive way to
make the picture, they gave it a green light.

Even so, the studio didn't know what to think until the movie's first test
screening. They were flabbergasted at the positive response. In the lead-up to
the movie's London premiere, Disney brass was calling the Internet buzz on

the film the best they'd ever seen on any title. The movie opened strongly, winning its opening weekend with more than $21 million—hardly a big number, but good considering the film's relatively cheap budget. But the following weekend the grosses fell off sharply. The fanatical core group of Adams fans had turned out to see the movie early, but thereafter the movie never found a broad audience. It topped out at around $51 million in the U.S. and $92 million worldwide—significantly short of the numbers the film needed to make much money for Disney.

In that battle of the 2005 space-opera debuts, then, George Lucas got the last laugh. *Revenge of the Sith* was hailed as probably the second best of all the *Star Wars* movies, behind only *The Empire Strikes Back*, and while it didn't gross as much as some of its predecessors, it probably dropped nine figures' worth of profit into Lucas's coffers.

With Disney slashing its live-action film slate in recent years, we may not see a film version of Adams's sequel, *The Restaurant at the End of the Universe*, any time soon. But *Hitchhiker's Guide* fans consoled themselves with the fact that the initial story was made at all—and that many of the surreal, fantastical, bizarre, and wildly improbable features of the book survived the transition to the screen. "If we, in a big Hollywood movie," said Stamp, "can have a missile that turns into a whale that meditates on the nature of its existence and language as it falls and ends with a big funny joke—'I hope the ground and I will be friends'—then you certainly have *Hitchhiker's Guide*."

Despite his excitement about the finished film, Stamp spoke for many when he said, "So many of these moments are so bittersweet. Every time we achieve something I'm desperately proud we've achieved it—and desperately sad Doug isn't here."

My Best Friend's Wedding

CREDITS

DIRECTED BY P. J. Hogan
SCREENPLAY BY Ronald Bass
PRODUCERS: Ronald Bass and Jerry Zucker
EXECUTIVE PRODUCERS: Gil Netter and Patricia Whitcher
PRODUCTION COMPANIES: Predawn Productions, TriStar Pictures, and Zucker Brothers
 Pictures
ORIGINAL MUSIC BY James Newton Howard
CINEMATOGRAPHY BY László Kovács
FILM EDITING BY Garth Craven and Lisa Fruchtman
CASTING BY David Rubin
PRODUCTION DESIGN BY Richard Sylbert
ART DIRECTION BY Karen Fletcher Trujillo
SET DECORATION BY William Kemper Wright
COSTUME DESIGN BY Jeffrey Kurland

MAJOR AWARDS

None

CAST

Julia Roberts . . . *JULIANNE POTTER*
Dermot Mulroney . . . *MICHAEL O'NEAL*
Cameron Diaz . . . *KIMBERLY WALLACE*
Rupert Everett . . . *GEORGE DOWNES*
Philip Bosco . . . *WALTER WALLACE*
M. Emmet Walsh . . . *JOE O'NEAL*
Susan Sullivan . . . *ISABELLE WALLACE*
Paul Giamatti . . . *RICHARD THE BELLMAN*
Carrie Preston . . . *MANDY NEWHOUSE*
Rachel Griffiths . . . *SAMANTHA*
 NEWHOUSE
Christopher Masterson . . . *SCOTTY*
 O'NEAL

BUSINESS DATA

ESTIMATED BUDGET: $46 million
RELEASE DATE: June 20, 1997
U.S. GROSS: $127.1 million
FOREIGN GROSS: $172.1 million

REVIEW HIGHLIGHTS

"The summer-date-movie supreme for pretty women and the gay men they love. . . . Aussie director P.J. Hogan makes a funny, touching job of it . . ."

—*ROLLING STONE*

"One of the pleasures of Ronald Bass' screenplay is the way it subverts the usual comic formulas that would fuel a plot like this."

—**ROGER EBERT**, *CHICAGO SUN-TIMES*

"[The movie] employs the infamous green-eyed monster to propel the action. The bedrock of base instincts is unsettling but nonetheless holds one's interest, and Ronald Bass' script concocts an unusual resolution that's unexpectedly satisfying." —**LEONARD KLADY**, *VARIETY*

11 | ROLL OVER, CARY GRANT

MY BEST FRIEND'S WEDDING • RON BASS

I didn't know it when I settled in to watch *My Best Friend's Wedding* in 1997, but I was about to reach the end of a long, long wait.

I'm not sure of the exact date it started, but I remember the day. It was some time in the mid-1980s, when my roommate and college pal Jill sat me down in our Chelsea apartment to watch *His Girl Friday.* Jill had been raving about the movie for years, but in those days, before DVDs and digital cable, you had to wait for it to show up at a revival house or catch it on late-night TV, and somehow I'd never managed to catch it. I was primed to like the movie, and there was laughter in the room as we watched Cary Grant ingeniously sabotage Rosalind Russell's engagement to nice-but-boring Ralph Bellamy. But all that laughter was coming from Jill, not me. "Some friend!" I complained. "He's doing a terrible thing to these people. He's a total jerk."

Jill, gaping at me in disbelief, replied with four words that certified the film as a classic and me as a clueless philistine: "But he's Cary Grant!"

Touché.

More than ten years later and three thousand miles away, I thought of Jill when *My Best Friend's Wedding* emerged to reject the old-fashioned he/she's-marrying-the-wrong-gal/guy-and-he/she-really-belongs-with-me-so-I've-got-to-stop-the-marriage romantic comedy plot—if not forever, at least in a way that reassured me that I'm not the only one who finds that plotline, well, kinda stupid.

My Best Friend's Wedding, which began as a (rare) spec script by Oscar-winning screenwriter Ron Bass, only pretends to be a normal romantic comedy. In fact, it turns the "rom-com" genre on its head. True, it has a wedding and plenty of laughs, but the tone is more bittersweet than comic. Here is a

movie where the star behaves badly and doesn't get the guy. And she's Julia Roberts.

"That's the whole reason for making the movie, that she doesn't get the guy," said Bass. "If you don't have that, I don't know what you have. You have a cliché. And what's the message in someone going in to break up the marriage of nice people and succeeding? In order to do that, you have to make the bride an arrogant dimwitted bitch, so it's okay that we break up her marriage and take the guy. And [then] you've got a movie that I don't want to watch."

The film opens with New York restaurant critic Julianne Potter (Julia Roberts) having dinner with her editor and friend George (Rupert Everett), who is openly gay. Julianne gets an urgent message to call her long-ago college boyfriend Michael O'Neal (Dermot Mulroney). After a month-long relationship nine years ago, Julianne had broken up with Michael; they've been best friends ever since, though they rarely see each other. They have a deal to marry each other if they're still single when they turn twenty-eight, and with her twenty-eighth birthday coming up, Julianne expects to turn down a proposal from Michael.

Instead, Michael stuns her with the news that he's getting married in three days to a twenty-year-old college junior and asks her to come to Chicago to help him through the wedding. The next morning, Julianne is off to the airport, confessing to George before she leaves that she's in love with Michael and is going to stop the marriage and steal him back.

Michael's fiancée, Kimmy (Cameron Diaz), turns out to be all but irresistible, even to Julianne. Though she's racked with guilt about it, Julianne creates a crisis and gets Michael to break off the engagement. But the gambit fails and Michael and Kimmy reconcile, using Julianne as their go-between. Julianne finally takes Michael aside, confesses her love for him, and kisses him. Kimmy sees the kiss and runs off, Michael chases her, and Julianne chases both of them. After a car chase, Julianne finds Michael in the train station and admits that she's been trying to break them up. "I'm the bad guy," she said. Michael forgives her. Julianne then finds the furious, hurt Kimmy in the women's room at Comiskey Park, and Julianne tells her, "You won . . . I want to take you to the church so you can walk down the aisle with the man of our dreams."

The wedding is glorious and Julianne makes a beautiful toast. She kisses Michael good-bye and sits alone at the reception. She calls George on her cell phone, but as they talk she realizes that he's actually there at the reception. "There may not be marriage, there may not be sex, but by God, there will be dancing," he tells her. The film fades out on the two of them dancing together.

It was an unlikely story for a Hollywood film and it began life in an unlikely place: a meeting between Bass and his agents at CAA. "We used to talk about several story ideas I might consider, and [one agent] had some idea about a woman who hears her ex-boyfriend is getting married and regrets it," said Bass. "That wasn't nearly enough for something that interested me, but it stuck with me.

"Then I got married to a notion that I really *was* very interested in, which was the notion of people who begin their relationship as platonic friends, and then it turns into lovers and husbands and wives. I have a theory that when you meet someone you're attracted to, there's an immediate pigeonholing—either 'My interest in this person is romantic' or 'My interest is not romantic.'" People in the latter category, he said, can lead to relationships with "a much better chance to grow in a natural way, because all of the expectations and the gamesmanship and the rules and the agendas and the desires that go with relationships that are labeled romantic aren't involved, and you're able to just like somebody, and be with somebody, and open yourself up to somebody. So that was an idea that kind of interested me."

That started Bass's wheels turning. "I asked myself, what if it wasn't an old boyfriend, it was a current platonic friend, a best friend, someone you hadn't thought you were romantically interested in, but then when you hear they're getting married, suddenly you're interested?"

Bass then started joining this idea with another one he'd had on his mind for a while—the idea of the "crisis moment," a sudden event that promises to "define your life forever." As Bass noted, many of us are prone to this kind of magical thinking: "'If I just can do this one thing right in these next three days, the rest of my life I'm going to be happy for it every day. And if I screw it up, the rest of my life I'm going to regret it every minute.' That kind of pressure cooker made me think of the beginning of the story."

Even in the 1990s, when spec scripts were hot in Hollywood and seven-figure spec sales were fairly common, Bass generally pitched his ideas and wrote on assignment. Not this time, though. "I decided to spec this because I hadn't written an all-out comedy before. For me, what's funny is a very, very idiosyncratic and delicate thing. I just wanted to live by what was funny in my own ear and not be looking over my shoulder at some studio executive who was paying me to do this and saying 'I don't know about that.'"

His spec got competitive bids immediately. "Jerry Zucker was my producing partner the first day, and Julia was there the first day, and there was a period when we considered several people who wanted to direct the movie."

Ron Bass on Writing for Stars

Do you keep specific actors in mind when you're writing the script?

No, I really don't. When I think of an idea, I might think it might be good for [a particular actor], or that I'd like to write it for someone. But unless I actually have that actor in hand when I write the script—which was not the case here—I don't really write it thinking of that actor.

I was thrilled to have Julia in the part, but I wasn't really visualizing [her] in my mind. When I was writing I was visualizing Julianne Potter, who's a character I created in my mind; I know what she looks like and how she moves and how her face moves and what her voice sounds like. I think creating characters [around] actors is a mistake, because you wind up compromising what you really want that character to be to comply with the specifics of who that actor is.

If the actor's already on the project, [on the other hand,] then you make all the efforts in the world to write for that actor. You're better off just being flexible.

Do you have any advice on writing star parts?

Well, I write star parts all the time, and I think the first piece of advice is, don't try to write a star part. Once you're thinking, *Boy, a star would enjoy doing this*, or *This is a big turn that a star's going to want to play*, you're not telling a story anymore. You're painting by numbers, and what you [write] won't have any breath of life in it .

The reason a lot of my things turn into star parts, I think, is that my stuff is always character-driven rather than plot-driven. Even though I spend a lot of time on structure, and I care about it, I'm more of a dialogue writer than a structural writer. I'm really more into the scene-by-scene, into unpeeling and revealing and living with that person. Because, to me, every film is about us. It's about who we are and how we deal with this life we're in. The characters are more important than the plot they're dealing with. So if you start with "Who's the access character? Who's the audience coming into this movie to be? Who am I in this story?" and that's your focus more than the details of the plot, I think you wind up telling a story that stars want to play, because they don't always get that. Frequently there's a lot of lip service to character, but people are so concerned with plot twists that the characters [end up] servicing that—and then the character's not really driving the plot. The plot's acting *on* him or her, and his or her reactions are reactions to whatever's happened in the plot, and the writer tries to keep them "in character," so they don't jar you—but they're not what drives the plot.

I'm more likely to say, "Okay, this is a story about a woman who thought she was never in love with anybody. She had this best friend who she thought was on the string, who she thought she could always rely on to marry her or be her lover on a moment's notice if she ever changed her mind. She had that security blanket. And then he fell in love with somebody else. Jealous, devastated, she sallies forth to try to

get him back, and she has to learn everything that's been screwed up about her and about her vision of love and friendship and trust and betrayal and what's important in life. And she'll have the ally of the best friend, who's her editor, and she'll have the enemy of the bride, who's a very poor enemy because she's adorable and wonderful and nice to her and she can't really get angry at her. Those are the building blocks I'm going to use to teach this character something about life that I'd like us all to examine. Now, what plot turns service that?" As opposed to "Here's a plot. Now, let's see, what kind of character do I need to service my plot?"

Before long, director P.J. Hogan (*Muriel's Wedding*) signed on, and the collaborative process began. "When P.J. was settled on, we started to talk about how he'd like to change it, what opportunities he saw, what his concerns were, and the script developed from there." At the time the film came out, a number of articles referred to the difficulties the filmmakers had finding an ending. No wonder: Bass said the version most of us saw, with Julianne dancing with her friend George, "was sort of the way I had really wanted to do it." But he'd fought an uphill battle to get that moment.

Bass was challenging one of Hollywood's most persistent core assumptions, something so deep and pervasive that most of the town takes it as much for granted as the smog they breathe: The highest form of happiness, the thing that makes the happiest happy ending, is romantic love. The guy must get his girl, the girl her guy. So deep does this idea run that years later one Hollywood wag observed that even in *Gladiator*, where the question of whether they could kill the hero plagued the project throughout development, the answer was, "He can die, but only if he gets the girl." Which, of course, he does: Maximus is reunited with his wife, *on-screen*, in the Elysian Fields. A few years later, *The Constant Gardener*, a much more serious-minded film, hit on essentially the same finale. Ralph Fiennes's Justin Quayle adores his wife, Tessa, but only after she is murdered does he learn all her secrets. Their newfound intimacy is cemented when he is reunited with her in death.

Bass's entire story, though, depended on Julianne's (Julia Roberts, for crying out loud!) not getting the guy. He wrote an ending in which Julianne sits alone at the reception, talking to George, who's in New York, on the phone. It's a quiet, philosophical, almost downbeat moment.

Now, imagine yourself a studio executive. You've inherited responsibility

for shepherding this big-budget spec purchase through development. You have Julia Roberts. You have a script in which she doesn't get the guy. You're already feeling like someone's making you hold your breath underwater. For a really long time. Now you have an ending where she doesn't get *any* guy.

How does that feel? A little like drowning?

"It was decided that they didn't want her on the phone with somebody" at the end of the film, said Bass. "They wanted her actually dancing with somebody. I said, 'Well, then, George has come back, and he surprises her by being there.'"

At that point, though, the studio told Bass that they wanted Julianne to latch up with a guy. This was absolutely not because it would be inconceivable to end such a movie without the girl's getting the guy, they insisted. They wanted her in the arms of a man from the wedding party, recounted Bass, "to make the point that she had recovered from her loss—to show that she was open to loving again and open to the world and wasn't crushed or broken-hearted."

Sound bogus to you? Well, Bass wasn't buying it either.

"My idea was that to be with her best friend would make a more interesting point than just [showing] that she was available to love again. Because who the hell doubted that she would be available to love again? She's Julia Roberts. She's going to be besieged by a million guys. I never thought she needed that validation."

Nonetheless, the Julia-gets-a-guy ending was shot, cut, and shown at the movie's first preview—where it went over like last week's sushi.

"We all met in the lobby after the first preview, and one person after another said, 'I know, I know, okay. George should be there in the end,'" said Bass. "I was wrong about a lot of stuff, but I was right about that thing."

Bass's instinct was validated. "I thought it was an interesting comment, to make the point that friendship and important relationships and love and caring come in a lot of different packages. Sometimes movies make it seem like no one else could comfort you at a moment like that except the next boyfriend. And that just wasn't true for her. That had been my theory—more than simply getting Rupert on the screen some more. But it was nice getting Rupert on the screen [again], because he's pretty good."

That meant a reshoot, which is often taken as a sign of trouble on a film. However, as *Variety* editor in chief Peter Bart often observes, reshoots are a sign that the studio has confidence in a film and is willing to spend the money to get it right. In this case, the audience vindicated the writer and

proved the development pros wrong, and the studio was quite willing to get the ending right.

Despite all the hand-wringing over the final scene, though, Bass said that the ending wasn't really what got the most attention in development anyway. It was the middle that got most of the retooling.

The script had gone out at 128 pages, long for a spec. Hollywood doesn't make two-and-a-half-hour romantic comedies (or even anti-rom-coms), so cuts were inevitable. To be sure, a great deal of dialogue was cut during development—and some of the cuts and changes weren't to Bass's liking.

The first act isn't much different from the film. The spec opens as the film does, with Julianne having dinner with her gay friend, called "Digger" in the original script. Bass's spec features much more banter between the pair, and Julianne comes across as quick-witted and slightly acerbic. The cuts made Julianne less edgy and a little easier to like, though perhaps less formidable. Few of the conversations Bass had written were cut entirely, but sometimes they became more focused. At one point, Bass had Michael comment to Julianne that Kimmy doesn't pull away from his hugs in public; the remark gets no reaction from Julianne in the script, but in the finished film Julianne does react and they discuss it.

The spec also had plenty of broad physical comedy; most of that was toned down or cut, especially Julianne's broader moments. But it was Kimmy, not Julianne, who changed the most from Bass's original conception.

In the spec, Kimmy seems every bit a match for Julianne. In fact, she seems like a near Julianne-clone, which makes it harder for Julianne to pry them apart. In the film, as played by Cameron Diaz, Kimmy is sweeter and more vulnerable than Julianne—which paved the way for Julia Roberts's Julianne to look edgier and harder by comparison, even though she was much toned down from Bass's spec. As a result, at least at first, Julianne seems to be taking advantage of Kimmy—though eventually Kimmy turns out to be formidable in her own way.

With Kimmy and Julianne thus differentiated, one scene was shifted in the film's sequence to allow Julianne to exploit the differences. In the spec, Mike, Kimmy, and Julianne go out to an off-the-beaten-track blues bar and Kimmy is thrilled to be there. In the film, the scene is set instead in a karaoke bar. Knowing that Michael loves karaoke—and Kimmy hates it—Julianne makes sure the microphone ends up in Kimmy's terrified hands. But the scheme backfires: Kimmy rises to the occasion, Michael embraces her, and in the end Julianne is the only one in the room not having fun (one of the movie's motifs).

The script's second act got the most work as Bass developed the screenplay with director P.J. Hogan and producer Jerry Zucker. Bass originally had Julianne conceive an elaborate scheme to use Michael's job situation as a wedge to break up his engagement. Instead, the team evolved a new approach, in which Julianne would rope George into making an appearance as her "fiancé"—a simpler strategy. "When we came up with that," said Bass, "and P.J. sort of rolled up his sleeves and we began to look at all the fun we could have with that—that made for a lot of change."

These were important changes, but many of the film's most memorable moments appear almost verbatim in the original spec. One of my own favorites takes place at the airport, when George leaves after his appearance as her fiancé.

> JULIANNE
> What's going to happen?

> GEORGE
> He'll choose her. You'll stand at the wedding.
> You'll say good-bye. That's what you came to do.
> Now do it.

It's an ingenious moment. George is a wise and sympathetic character; as much as we may like Julianne and want her to be happy, we can see, as he does, that she's making a mistake. It takes Julianne a little longer to come to the same realization. There were other scenes drawn almost exactly from Bass's script, such as the moment when she sits in a hotel hallway, guilt ridden, smoking a cigarette and musing aloud, "I'm a terrible person." Bass's spec even includes Julianne's gift to the newlyweds (Julianne and Michael's "song") at the wedding reception, and other details—including Julianne not catching the bridal bouquet.

If the development process focused on the second act, many changes came about during the reshoots and editing. One major alteration occurred in the train station scene, where Julianne confesses to Michael. In the spec, she admits that she's been trying to sabotage the wedding, tells Michael that she wants him to marry Kimmy, and makes him promise never to tell her which one he would have chosen. "That was shot, and [it] was in the scene till just before the very first preview and the director wanted it out," said Bass.

"I did take his point . . . that she had clearly made her choice. It was clear

that, [with] her confession and apology, she was no longer asking him to marry her. She had realized that Michael had chosen Kimmy, and that therefore her insisting he marry Kimmy, instead of [seeming noble], could play a little stupid, [because] she wasn't really his to give. What was important was her acknowledging, confessing, apologizing, and taking responsibility for what she had done, rather than pretending that she could be the one to make the decision for him."

In the spec, Michael and Julianne split up to look for Kimmy, with Julianne carrying Kimmy a message. Then, in the Comiskey Park women's room, Julianne tells Kimmy that she was giving Michael a congratulatory kiss—and reveals that Michael is taking the job after all.

"That changed at the very end," recounts Bass. "That was significant to me, because if the piece is about what love really is, that was the journey that Michael had to make. Even though the woman he was marrying was loving enough, flexible enough, or even immature enough to permit him to ignore what she needed from life, he needed to learn that that wasn't the way he needed to be married to her. But not everybody agreed with me."

Instead, the scene was replaced with a scene that reveals a "spunkier," more assertive side of Kimmy—a scene about which Bass had some reservations. "There was a feeling that Kimmy had taken too much from Julianne lying down, and she needed to stand up for herself and duke it out. And I think that made sense, but it still didn't resolve that issue for me. I must have been interviewed more than thirty or forty times [about this film], and nobody has ever asked me, 'Did Michael take the job and did Kimmy get to live in Chicago?' So it must have meant less to people than I thought."

The reception scene was especially heavily cut. In the film, Julianne's toast to the happy couple is much shorter than in the spec. For Bass, though, the most painful cut was Michael's speech at the wedding, which was shot but edited out. "That was my single favorite part of the script, and it wasn't in the movie," confessed Bass. "It was sort of a soliloquy on [the question of] why should two people who are attracted to each other, who are living in a day and age when people living [together] in an unmarried status is completely acceptable and very common, decide to get married anymore—to make that kind of commitment? To me, that was what the movie was about. The movie was about what love really is, not what Julianne thought it was, which was something based in selfishness. Love really lies in the joy of commitment, in someone who feels it's not a burden to say yes, not a burden to

give. My belief is that that truth was really at the heart of the movie, rather than being some extraneous soliloquy."

Rupert Everett, as George, was a huge hit with audiences; there was speculation that he improvised his dialogue, though it seems more likely that Bass's voice just fit Everett's persona perfectly. The original character, Digger, is a small role in the spec—Julianne often phones him, but we don't see his side of those conversations—but his basic function in the story is critical: He's the audience's voice in the story, telling Julianne to tell the truth and let go of Michael.

The film's success surprised even the studio, though not all critics liked it or even understood it. "I got some bad reviews from people who said, 'Mr. Bass doesn't really understand the genre, because a short while into the movie, you don't know who you're supposed to root for.'" Bass laughed off the thought. "For a critic not to understand that's what the movie was about, like it or not, and to chalk it up to not having a grasp, it's almost like the guy was saying, 'He's too naive to realize that the star's supposed to get the guy in the end.'"

Take that, Cary Grant.

Mona Lisa Smile

CREDITS

DIRECTED BY Mike Newell
SCREENPLAY BY Lawrence Konner & Mark Rosenthal
PRODUCERS: Elaine Goldsmith-Thomas, Paul Schiff, and Deborah Schindler
EXECUTIVE PRODUCER: Joe Roth
PRODUCTION COMPANIES: Columbia Pictures, Revolution Studios, and Red Om Films
ORIGINAL MUSIC BY Rachel Portman
CINEMATOGRAPHY BY Anastas N. Michos
FILM EDITING BY Mick Audsley
CASTING BY Ellen Chenoweth and Susie Farris
PRODUCTION DESIGN BY Jane Musky
ART DIRECTION BY Patricia Woodbridge
SET DECORATION BY Susan Tyson
COSTUME DESIGN BY Michael Dennison

MAJOR AWARDS

None

CAST

Julia Roberts . . . *KATHERINE ANN WATSON*
Maggie Gyllenhaal . . . *GISELLE LEVY*
Kirsten Dunst . . . *BETTY WARREN*
Julia Stiles . . . *JOAN BRANDWYN*
Marcia Gay Harden . . . *NANCY ABBEY*
Dominic West . . . *BILL DUNBAR*
Ginnifer Goodwin . . . *CONNIE BAKER*
Topher Grace . . . *TOMMY DONEGAL*
Juliet Stevenson . . . *AMANDA ARMSTRONG*

BUSINESS DATA

ESTIMATED BUDGET: $65 million
RELEASE DATE: December 19, 2003
U.S. GROSS: $63.7 million
FOREIGN GROSS: $78.6 million

REVIEW HIGHLIGHTS

"An appealing female cast gives the hollowly formulaic *Mona Lisa Smile* more dignity than it perhaps deserves." —DAVID ROONEY, *VARIETY*

"If Ms. Roberts is the undisputed star of *Mona Lisa Smile*, she graciously allows her acolytes plenty of opportunity to sparkle."
—STEPHEN HOLDEN, *NEW YORK TIMES*

12 | LIFE'S TWO TRAGEDIES

MONA LISA SMILE • LAWRENCE KONNER
& MARK ROSENTHAL

I n this world there are two tragedies," George Bernard Shaw wrote a century ago. "One is not getting what one wants, and the other is getting it. The last is much the worst." The movie industry didn't even exist when Shaw penned the line, but it's hard not to think of that quote when watching *Mona Lisa Smile*.

On one level, that's the lesson the characters are learning, each in her own way. The film's heroine, Katherine Watson, is a "bohemian" art history teacher from a working-class background who journeys from California to Wellesley College in 1953 to teach art. A sort of protofeminist whose ideas are at least ten years ahead of her time, she arrives excited to be at the best women's college in America but is disappointed at the school's emphasis on preparing its students for life as corporate wives. Some of her students are learning, too, how bittersweet it can be to get what you've dreamed of, as they march into their designated roles as helpmates, only to discover that they're miserable in that life.

That image applies just as surely to *Mona Lisa Smile* itself. This is a project that no studio would have made without Julia Roberts: In 2003, no other actress had the box office appeal, charisma, and clout to get a studio to greenlight a movie about a feminist art teacher in an elitist 1953 girls' school.

Lawrence Konner and Mark Rosenthal knew as much when they first conceived the project; they knew that even spending their time putting a pitch together was a risk. "It's very dangerous to create a pitch when only one star can be in it," Rosenthal said, "because your odds are like winning the lottery. But we went to see her partner, Elaine Goldsmith-Thomas, and before we finished the second sentence of our pitch, she said, 'I love it. I want to do it.'"

Unlike David Franzoni on *Gladiator*, though, Konner and Rosenthal didn't see victory snatched from the jaws of development. It turned out that Roberts's clout, especially her box office appeal, makes getting her to star in your film something of a Faustian bargain. Though she's had a few box office flops (remember *Mary Reilly?*), every movie she stars in is a potential blockbuster, and that brings temptation. With hundreds of millions of dollars' worth of box office grosses dangling within reach, every commercial instinct kicks in: *Trim here, compromise there, soften throughout—and make sure Julia's fans will like it.*

It was that kind of thinking that led to the wrongheaded ending audiences saw at the first previews of *My Best Friend's Wedding*. It also probably contributed to softening her character in that film. But softening Roberts's character in that film didn't undermine the basic story. On the contrary, the movie became a hit in large part because of Roberts's likability and because Ron Bass's basic story is intact. On *Mona Lisa Smile*, though, the opposite turned out to be true: Softening the film made it fuzzier and less convincing.

It's not a question of whether Roberts herself gives a good performance, but of what kind of movie you wind up with once you've ground the edges off a script in pursuit of those extra dollars. Watching the movie after hearing what Konner and Rosenthal had in mind, you may well wonder if getting Julia Roberts was really such a happy thing for *Mona Lisa Smile*.

A glance at Konner's and Rosenthal's credits doesn't suggest writers who'd care to write about an elite women's college in the 1950s; they've worked in many genres, from science fiction (*Star Trek VI*) to action (*Jewel of the Nile*) to comedy (*The Beverly Hillbillies*—the movie, not the TV show). Their history, though, makes sense of it all.

"We call ourselves a high-concept writing team," said Rosenthal. "I have a doctor of arts in Chaucer and Middle English, and Larry is a high school dropout from Brooklyn." They became friends almost thirty years ago, while Rosenthal was at the University of Vermont. "We'd meet and just talk about movies. That was a rare thing then."

Rosenthal moved to California and finished his doctorate at the University of the Pacific, but he calls himself "basically a fraud as a scholar." Instead, he wanted to go into movies, though he didn't know how to do it. "I didn't know what jobs were available; I didn't know what a screenplay was. But one night, after I finished my doctorate, I drove down to Los Angeles. I moved into the garage of some relatives and stumbled into a job at the newly formed Orion Pictures, all because a very nice lady named Sara Altshul took pity on

me. I didn't know how to read screenplays; she should have fired me after I took the first few scripts and reported on them, because I had no idea how to evaluate them. But I managed to hang out there, and after a year or so I became a reader for Mark Rydell, who was working on the Bette Midler movie *The Rose* at the time."

Rosenthal's I-can-do-better-than-that moment came around that time, when he decided "we could write as badly as the scripts I was reading." Konner followed him to Los Angeles and they met regularly in the food court at the newly opened Beverly Center shopping mall (which got its own fifteen minutes of screen fame when it was inundated with lava in *Volcano*) and wrote a screenplay they called *Legend*. It was eventually retitled *The Legend of Billie Jean*.

Rosenthal made a trip east to visit a sick family member. While waiting in the hospital's intensive care unit, he got a call from Konner: The screenplay had sold. "To make it a true Hollywood tale," said Rosenthal, "by the time I got back, a director had been hired, [Peter] Guber and [Jon] Peters were the producers, and the first thing the director did was to fire us so he could rewrite it. So I got my complete baptism in how Hollywood works. It was Christian Slater's first movie and Helen Slater's first movie, and it didn't do that well, but it taught us what to do. And from there Michael Douglas hired us to write *Jewel of the Nile*."

In the years that followed, the duo flourished as genre writers. "Our career has nothing to do with who we are," said Rosenthal. "Larry and I are both serious literature devotees. We stumbled into a career, [and] we have no idea how. I think it's because we were in the last gasp of the screenwriter-as-honorable-working-profession. We just took jobs as they were available, rather than the new sort of self-aware filmmaker/screenwriter, which came as film schools exploded across the country. Had we been ten years younger, I think we would have chosen different careers. We were just delighted to be hired by studios who knew we could do lots of different genres."

In Rosenthal's own view, he and Konner came from an all-but-vanished zeitgeist, the world of "the working-class Jewish urban eastern guy who grew up treasuring books, who then fell in love with pop culture. That sort of icon has disappeared pretty much," he said, "as the culture's become more suburban and film schools have grown up. We took movies more seriously because it was the world of American movies in the 1970s, the last great era of American moviemaking. It comes out of a more literary tradition, the tradition of the blue-collar city kid who went to college and fell in love with art in general.

And I don't think that's a world you can be part of if, from age eight, you decided you just wanted to make movies—because if you don't read literature, you're going to have a different relationship with it."

So it's not a huge shock to learn that these two East Coast Jewish intellectuals read the *New York Times* Op-Ed page. It's just odd that they got the idea for a Julia Roberts movie there.

The spark for *Mona Lisa Smile* came from a *Times* article by playwright Wendy Wasserstein. Rosenthal remembers the title as "Hillary at Wellesley," but he is most likely talking about a 1998 piece called "Hillary Clinton's Muddled Legacy," written in response to the Clinton-Lewinsky sex scandal. Wasserstein's article led off with a quote from Hillary Rodham's 1969 Wellesley commencement speech: "We're searching for more immediate, ecstatic and penetrating modes of living. . . . Every protest, every dissent, is unabashedly an attempt to forge an identity in this particular age," Miss Rodham had said.

Wasserstein lamented that the loss of this Hillary Rodham, replaced by a dutiful, supportive first lady standing by her husband, was one of the most destructive consequences of the scandal. But she also offered some insight into the women's colleges that had shaped the last three first ladies, Hillary Clinton, Barbara Bush, and Nancy Reagan. "Like their Seven Sisters classmates, all three women were trained to develop an independent intellect as well as the grace to serve living room teas," wrote Wasserstein.

"I had no idea where this graduate of Yale Law School and children's rights advocate could possibly have picked up such a skill. But then I remembered dressing for 'Gracious Living,' a semi-weekly ritual at Mount Holyoke that consisted of formal dinners, complete with waitresses and folded cloth napkins. I'm sure Wellesley had its equivalent when Hillary Rodham was a student, too."

In 1967, Wasserstein recalled, it was not uncommon for women at these schools to say they were "hoping to marry Harvard." By 1970, however, feminist writers were part of the regular curriculum. "Women like Hillary Rodham suddenly had the same career opportunities as the men they were supposed to wed. Marriage would be for love or companionship, but would no longer be a substitute for individual destiny."

The column got Konner and Rosenthal talking. "Our joke was, 'Imagine making a movie about this. It'd never happen.' But as we got more interested in it, we [realized that] Hillary was at Wellesley more as a child of the 1960s. We started to do research into Wellesley a generation before her.

"I went up to Wellesley and the first copy of the *Wellesley News* I saw had a picture of a woman in a Donna Reed–type dress, with pearls, at an oven, with a frying pan in one hand and a book in the other, saying 'Married Women Make Best Students.' And we found these statistics that in that school twenty-five percent of the students got married every year, and seventy-five percent of them never used their training in any professional way. We realized that a generation before Hillary, Wellesley was essentially the world's most intellectual finishing school, a school for corporate wives. We began wondering, what if Hillary were in that school? What would have happened? Even though the vocabulary of feminism wasn't around, her personality and intellectual nature would have clashed with that. And that prompted the idea of, what if there were a premature feminist there?

"We said to ourselves, that would make a great movie—but it would never get made by a studio. There's only one person who could get that movie made, and that is Julia Roberts." That led to their successful pitch meeting with Elaine Goldsmith-Thomas. "Elaine took a risk with her big star, who usually does big popular movies, to do a drama set in a 1950s women's college about feminism." As Rosenthal recalled, Goldsmith-Thomas took a stand. "We're going to go out on a limb. We're not going to do this as an independent movie. We're trying to do a big-budget Julia Roberts movie on a subject that studios don't do anymore." This kind of story wasn't natural studio fodder, Rosenthal noted. "It's something they have to be forced to make, and Elaine and Julia forced them to make it."

Konner and Rosenthal started with a "one-step" deal, where they would be paid for a first draft with no guarantee that the project would continue or that they'd be paid anything more. As Rosenthal notes, screenwriters often aren't happy about such deals. Still, "If you want to get something that's not *The Hulk* going at a studio today, odds are they're going to make a one-step deal, where they can cut you off after the first step. But she liked the first step and things went pretty quick after that."

Getting to that first draft meant plunging into historical research, but Konner and Rosenthal weren't obsessive about getting every detail exactly right. "When you write historical projects, in most cases you're not writing to be true to the historical period. You're writing to let the historical period play to a contemporary audience. So [you ask], how can I interpret this historical period so that the contemporary audience will feel the same emotion without making it unfaithful to the period? How do you let a contemporary audience into this world of Wellesley without either boring them to tears or making

these people so weird that they can't assimilate the emotions? That's really the problem."

With *Mona Lisa Smile*, that meant finding a way for the lead character, Katherine, to represent the feminist values of the future without making her a complete anachronism. "What we tried to do is not have her rely on any feminist vocabulary," said Rosenthal. "We wanted it to be about [her] premature feminism, manifested dramatically as someone who's making it up as she goes along. Today there's a preexisting structure you can plug into, an ideology, if you want to get into feminist agitation. [Katherine] doesn't have that. She's flying by the seat of her pants."

The movie also touches on a problem confronting feminism today, a problem that no one could have imagined at 1953 Wellesley: Is it all right for a woman to choose *not* to have a career? When one of Katherine's students chooses to marry and live as a housewife, instead of pursuing a promising career, she insists to a disbelieving Katherine that this really is what she wants. As far as we know, she lives happily ever after.

For Rosenthal, there was even a further question: If women *must* work out of economic necessity, is that really an improvement over a world where women *couldn't* work?

"America has evolved from a place where you had to fight to allow women to get into the job force and have a career, to [one] where you have to fight to allow women to stay at home," he said. "The middle class is so squeezed that most families can't make it on a single salary. There are women who want to stay home, but they have to work." That gives the story a certain dramatic irony: The audience may admire Katherine as she bravely struggles to break the status quo, but we also know that she doesn't fully understand where this struggle will lead. It makes her look a little naive.

Sexuality would normally seem the like the least of a writer's problems in modern movies. Today, almost anything goes . . . or does it? In fact, an honest portrayal of the sexuality of the period was impossible in a modern movie, said Rosenthal.

"Despite nudity and pornography, sexuality has become Victorian today, because you can't allow a serious discussion of sexuality," he explained. "Audiences are uncomfortable with an adult treatment of sexuality. For instance, one of the great adult dramas in the history of American cinema is *Gone With the Wind*. In *Gone With the Wind* you have lead characters, movie stars, who ain't that faithful, who fool around. The lead guy essentially rapes the lead

girl in the middle of the movie and that starts their romance. It's a very frank, adult movie in its sexuality.

"Today, a studio would never let you have characters who have that kind of adult sexuality. They have to be good and they have to be sexually honest. They can't fool around and still be heroes—or, if they fool around, they have to be punished for it. Sexuality has become infantilized in American movies today."

In *Mona Lisa Smile*, that affected how Katherine starts an affair with a hunky fellow teacher. "In the original script we had them meeting and fucking, but audiences didn't like it," said Rosenthal. Instead, the affair had to be shifted to later in the story, after they'd known each other for months.

In a larger way, the writers found themselves constantly toning down the students' sexual banter. One scene that survives into the final film, in a dorm "smoking room," shows four senior girls hanging out: the aristocratic Betty (Kirsten Dunst), budding scholar Joan (Julia Stiles), good-natured Connie (Ginnifer Goodwin), and the school's token Jew, Giselle (Maggie Gyllenhaal). Connie discovers that Giselle keeps a diaphragm in her purse.

"Originally, Connie takes out the instructions and starts to read them and mime them, then [the diaphragm] squirts out of her hand and hits Betty. We had done it with with the smart-alecky sexuality that existed in the period. And it got cut way back. . . . We actually had her read instructions that came with a diaphragm at the time. It may have been too much for a modern audience, but we were trying to shock them a little bit. These were smart-aleck college girls."

Much of that smart-alecky quality was cut even before the late production draft the studio released for this article, but one moment stands out: Charlie, a Harvard boy, comes to Wellesley to visit Connie, with whom he's been on one date. He interrupts her as she's practicing her cello and kisses her. It's a very romantic moment, and in the film it ends there. In the script, though, after they break from the kiss she says, "I bet you've never kissed a woman with something big and hard between her legs before." Then, off his look, she adds, "I am so sorry, did I wreck the moment?"

The script also opened the story up more than the film does. Where the final film is set almost entirely at Wellesley, the original script showed Katherine with her boyfriend in California, before she comes to Wellesley. It also included scenes of the girls playing sports, which was an important part of

campus life. That kind of athletic lifestyle, Rosenthal notes, "came with being an aristocratic corporate wife. . . . She played golf and swam—that was part of that culture, and we wanted to show that."

The original script also included a scene where Katherine escorted one of her students to Yale Law School for an interview. "They get to Yale and there's no bathroom for women, which was true—until recently there was no bathroom for women in the main part of the law school. So Julia kicks the men out of the men's room so Joan can go to the bathroom." It's a scene Rosenthal missed.

One other aspect of the original script was drastically toned down: the women's braininess. "The women at Wellesley are truly the brightest women in the United States," said Rosenthal. In those days, he said, it was common for Wellesley girls to make fun of Harvard boys. "Boys went to Harvard because their fathers did; girls went to Wellesley because they were smart. They were much smarter than [the men]." Once a feature of the script, only a hint of that remains in the script, when in the diaphragm scene the girls ask Joan if she did her boyfriend's Harvard homework. (She did.)

Nearly all of the film's intellectual banter was cut out, said Rosenthal. "The studio was worried that the audience wouldn't get it. Our position was that it doesn't make a difference if they get it. They would know that something was being spoken about, that these girls like to show off their intellectualism the way that some girls like to show off their midriffs. That's who Wellesley girls were."

One scene had Betty being teased about being the product of B. F. Skinner–style behaviorist programming; Skinner was a hot topic on campuses at the time. The teasing led to an argument, but the Skinner reference was cut—as were a mention of J. D. Salinger's *The Catcher in the Rye* and other literary references. "There was a beat where the classes say to [Katherine], 'Your boyfriend's in California and you're here.' Katherine says, 'Well, even Persephone got six months off from hell.' When they were shooting they said, 'Oh, we can't do that, people won't know who Persephone is.' We said, 'That's how those girls talked.' But there's nothing you can do about that as the writer."

With all the banter and braininess cut out, a movie that wanted to celebrate women's intellects turned into a rehash of that old Tinseltown canard, a story of regular folks teaching stuck-up smart people how to be "real." Katherine's brains, independence, and ideas aren't what define her in the film; instead she's marked by her less-than-elite background and down-to-earth

style. The protofeminist intellectual heroine instead turns out to be something of an anti-intellectual. Her classroom scenes, in which she is supposedly teaching art history, mostly ended up as vague art appreciation discussions, in which Katherine tries to impress upon her hidebound students the value of modern art. More important, her conflict with the Wellesley establishment, instead of coming across as a toe-to-toe intellectual battle of ideas, turns into a fight against snobbery. It's a Hollywood cliché that flatters the audience without challenging them—a good commercial choice if you're trying to attract the largest possible audience while making absolutely no one feel uncomfortable.

My Best Friend's Wedding didn't suffer for such commercial-minded changes, in part because the story was never about how smart Julianne was; from the beginning, after all, Ron Bass had made Kimmy her equal. *Mona Lisa Smile*, though, set out to be *primarily* about how smart the girls were, and by the time the changes were complete, that fundamental idea had been lost.

If the movie had been made as a small independent—with, say, Catherine Keener in Roberts's place—the final product might have been very different, and much more interesting. That's not to blame Roberts herself; Rosenthal is quick to praise her for courageous choices. "She did not let them doll her up, like they wanted to," he said. Roberts wears her hair in a plain style throughout the film; she plays her age and wears little makeup. For a movie star who makes her living by feeding fantasies, that really is a brave choice.

Still, when you sign Julia Roberts for your picture, you get a Julia Roberts picture. Those nine-figure grosses start whispering in the executives' ears, and careerism takes hold. If you help make a $200 million grosser, people notice. On the other hand, if your Julia Roberts movie grosses only $40 million, um . . . What's your name again?

So it's mighty tempting to dumb a picture down and pretty it up in pursuit of a larger audience. And, to be fair, studios are for-profit companies. They exist to make money, and in 2003 Sony was facing tough times worldwide. Why should they make an art film if they could make a smash hit instead? The script for *Mona Lisa Smile* was never decapitated, exactly; instead, it died the death of a thousand cuts. The trouble is, in the end, it's just as dead.

Oddly enough, the thousand cuts to *Mona Lisa Smile* included most of the references to the Mona Lisa itself that inspired the title. In the film there's

a scene between Betty and her rigid mother that touches on the painting. It's not a bad scene, but it feels tossed in. The scene wasn't in the production draft I read. Instead, in that script, Katherine's teacher boyfriend likes to call her "Mona Lisa," and there's a classroom scene in which Katherine lectures about why she doesn't like the painting.

"Maybe it's because I'm expected to," she says. "Or maybe it's because of her smile ... I can't even see the painting. ... To appreciate anything, we need to put aside expectations and ask ourselves, are we seeing with our own eyes? Or do we define beauty according to what others think?" In the end, she urges the students to think for themselves and not let anyone else define beauty for them. "Even, and most especially, me."

That's certainly more thought-provoking than anything left in the final film.

Which is not to say that *Mona Lisa Smile* is unwatchable. Some people liked it as a middlebrow "chick flick." It certainly garnered attention for its stellar cast; even its minor supporting roles are filled with terrific talent, including Marcia Gay Harden as a woman quietly shattered by her failed romance, and a rare film appearance by Broadway legend Marian Seldes. The 1950s soundtrack, and the images of young people living the swing-dancing, pipe-smoking, martini lifestyle embraced by hipsters around the turn of the twenty-first century, helped it along, too, though even that was starting to feel a little passé by the time the film opened.

In the end, *Mona Lisa Smile* did middling business, earning some $64 million in U.S. box office receipts and more than $100 million overall. On an estimated budget of $65 million, however, that made it hardly the big moneymaker Sony hoped for. It may even have lost money for them. The sadder fact, however, is that *Mona Lisa Smile*—which started life as an ambitious story about feminism in a time of conformity—was transformed into a female version of *Dead Poets Society*, a film few would say deserves such imitation. *Mona Lisa Smile* may have needed a star of Julia Roberts's caliber to get made—but getting her seems to have proved its own kind of tragedy.

Hollywood's Main Problem

Mark Rosenthal has high praise for Mona Lisa Smile *producer Elaine Goldsmith-Thomas, whom he calls one of the last true producers in the movie business. He also blames the dearth of strong producers for many of the story problems afflicting Hollywood.*

If you talk to writers—or even to studio executives—[they all say that] the main problem in Hollywood today is [that there are] no producers. There are people who call themselves producers, who at the first sign of a studio pushing back give up. But the kind of producer who actually says, "I'll put this project on my back and carry it across the goal line"—there are [only] a few of them. Everyone is just a deal maker, a glorified agent.

The exceptions are the obvious guys: Bruckheimer, Scott Rudin, a couple others. With most producers, when you talk to them, [you hear], "Oh, the studio said this and they won't do that, and I'm so frustrated working here." [On the other hand,] we once worked for Dino De Laurentiis. De Laurentiis says, "I'm making this movie. Nothing's going to get in my way." You never hear any doubt. He screams and yells and pushes. When Elaine says she's making the movie, it means she's making the movie. That's what's disappeared from the business. It's a horrible thing, but it means two things: It means the studio develops the project, so you're at the mercy of studio notes, which are always dumber than producer notes, and there's no one to protect the screenplay. The other thing it means is that when a big shot director comes on, because the studio is anxious to get a director and star, and the director starts to take the project in a wrongheaded way, it used to be that the producer said, "No no no, this is not the way I've set up this project." He would both protect the director from bad studio notes and protect the project from bad director tricks. Now, with that strong producer gone, eighty percent of directors are morons and they don't make good movies out of the script. There's no one there whose only allegiance is to the project, and that's what a producer used to be.

Bounce

CREDITS

DIRECTED BY Don Roos
SCREENPLAY BY Don Roos
PRODUCERS: Michael Besman and Steve Golin
EXECUTIVE PRODUCERS: Bob Osher, Meryl Poster, Bob Weinstein, and Harvey Weinstein
PRODUCTION COMPANY: Miramax Films
ORIGINAL MUSIC BY Mychael Danna
CINEMATOGRAPHY BY Robert Elswit
FILM EDITING BY David Codron
CASTING BY Sharon Klein and Patrick J. Rush
PRODUCTION DESIGN BY David Wasco
ART DIRECTION BY Daniel Bradford
SET DECORATION BY Sandy Reynolds-Wasco
COSTUME DESIGN BY Peter Mitchell

MAJOR AWARDS

None

CAST

Ben Affleck ... *BUDDY AMARAL*
Gwyneth Paltrow ... *ABBY JANELLO*
Natasha Henstridge ... *MIMI PRAGER*
Edward Edwards ... *RON WACHTER*
Jennifer Grey ... *JANICE GUERRERO*
Tony Goldwyn ... *GREG JANELLO*

BUSINESS DATA

ESTIMATED BUDGET: $35 million
RELEASE DATE: November 15, 2000
U.S. GROSS: $36.8 million
FOREIGN GROSS: $17.3 million

REVIEW HIGHLIGHTS

"Comparable in its craft to *Jerry Maguire* and *As Good As It Gets*. . . . Gywneth Paltrow and Ben Affleck emerge from the movie as the most romantic coupling to animate a Hollywood film in quite some time . . ."

—STEPHEN HOLDEN, *NEW YORK TIMES*

"Lovely and all-too-rare. . . . The two actors hold you with the matching gentleness and vivacity of their spirits. —Rating: A-"

—OWEN GLEIBERMAN, *ENTERTAINMENT WEEKLY*

13 | "IT'S DIFFICULT TALKING TO IDIOTS"

BOUNCE • DON ROOS

I f the drive to make the characters nicer and more likable inflicted a slow death on *Mona Lisa Smile*, *Bounce* is a movie that almost, but not quite, suffered the same fate.

Writer-director Don Roos, fresh from selling his screenplay *The Opposite of Sex*, set out to tell the story of a narcissistic, arrogant, dishonest, barely recovering alcoholic who changes as he woos a young widow. No problem—except that once the script got into development, there were a lot of people who didn't like the hero, because he was, well, a narcissistic, arrogant, dishonest, barely recovering alcoholic. They wanted to like him, of course; more to the point, they wanted to know the audience would like him. Even if that meant turning the script into the story of a nice guy who, um . . . gets a little nicer?

Roos doesn't think much of Hollywood's obsession with likability, which emerges as an issue in all three of the Julia Roberts movies surveyed here. "I don't think it's important, necessarily, for a character to be liked by the audience," the screenwriter said. "I think it's important for a character to be understood by the audience, and for the audience to empathize with that character's point of view. But likability, which generally means the character only does nice things—I find that to be a very useless concept.

"But it's very, very prevalent. It was even prevalent at Propaganda [the company that bought *Bounce*], and it's prevalent among actors and directors. We're all infected with that. It's kind of a disease we have here in Hollywood, [this fixation on] likability. It makes for much duller movies if the character always has to behave nicely."

Roos was able to back his movie away from the precipice, though, where the writers of *Pay It Forward* and *Mona Lisa Smile* were not. That may be

because Roos has an advantage they lacked: He directs his own scripts. Directing not only gives him a chance to protect his script but lets him enlist the stars as allies—and stars, by virtue of both their influence and their craft, can be the best allies a writer can have. Then again, they can be his worst enemies.

Bounce is the story of Buddy Amaral (Ben Affleck), an arrogant Los Angeles advertising executive who thinks of himself as supremely lucky until he is stranded in Chicago's O'Hare Airport during a Christmas Eve snowstorm. There he meets a failing playwright and TV writer, Greg Janello (Tony Goldwyn), who is trying to get home to spend Christmas with his family. The patronizing Buddy gives up his first-class seat to get Greg on the plane so that he can spend the night with a beautiful woman he's met in the airport bar.

Later that night, Buddy learns that the plane has crashed, killing Greg and every other passenger. It's another stroke of luck, but instead of celebrating, Buddy spirals downward. A year later, he is fresh out of the Betty Ford Clinic and barely holding on to his sobriety. Haunted by the memory of Greg, he looks up his widow, Abby (Gwyneth Paltrow), and tries to set things right in her life. Expecting simply to throw her some financial relief, he instead finds himself falling in love with her and her sons, all while hiding his role in Greg's death.

Roos wrote *Bounce* between the time he sold *The Opposite of Sex* and the the start of shooting on that film. That may make Roos sound terribly prolific, but if so, it's not because he loves sitting down to work. "I hate writing," he admits. "But I have a terrible day if I don't write, so I make myself."

Yet Roos found writing *Bounce* the easiest experience he'd ever had as a screenwriter. "I thought, *You know what? I should write something that's more commercial,*" Roos said. "The idea for [*Bounce*] came into my head literally on a Monday night, and by Friday I had thirty pages of the script, a complete outline and thirty pages of the script. Within four weeks, the entire script had been written.

"It was a very exciting process, because I usually write with a lot of reluctance and dread and procrastination, and [this time] I was actually eager to get up in the morning and write, because I seemed to know where I was going. It was the only time in my life where I couldn't wait to get back to it. It hasn't happened since and it hadn't happened before."

Reading two drafts of Roos's script—his sale draft from January 1997 and a revised draft from May 1999—reveals the results of that process. The plot is basically the same in each case, but the focus of the story shifts quite a

bit from one draft to the next. Roos was discovering that *Bounce* wasn't about exactly what he thought it was.

"The sale draft is essentially the story of a man who is competing, always, with the ghost of a man who died in his place," said Roos. "The entire story is an evaluation of himself, compared to this real man who had real family and connections and affection and ambition and hopes and dreams and failures. [Buddy is comparing] his own empty, shallow, conceited life to that man's. And in some way, over the course of a hundred and twenty pages, [he's trying] to become that man who died."

Of course, *Bounce* is also a love story between that "empty, shallow" man and the widow of the more virtuous man he admires. As Roos notes, "there is an element of Buddy becoming a man worthy of this widow." In the process of refining the script, however, the deceased husband, whom Roos calls "the invisible third character in the movie," receded from center stage. Among the casualties of this process was one of the sale draft's more unique scenes, a moment roughly halfway through the film where Greg's ghost appears to Buddy and taunts him.

"A ghost appearing can be very powerful, but it didn't seem to be the story I was telling. He only appeared one time, and it seemed out of place somehow. I let it go quite easily. I just said, 'Oh, you don't like the ghost? Okay, I can do without that.'"

Instead—and probably inevitably—the emphasis shifted to Abby and her romance with Buddy. Of course, an on-screen relationship between two movie stars is bound to be more compelling than any relationship between an on-screen character and an offscreen one. But Roos also points to his leading lady, Gwyneth Paltrow, as the key to the change.

"If there were a lesser actress in the part, you wouldn't be as invested in the love story. But she's a very riveting presence, and her story is very clean. You can't help but admire her. She's an enormously powerful character. And, [when you're] watching it, that is what you decide it's about. Even myself."

Roos also noted that downplaying Greg's character made the storytelling subtler. "It's an interesting thing for Ben [Affleck] to play—that he's constantly judging himself against this man. But [this way] it becomes a subtextual thing, rather than what the story is about."

For the writer, the transformation took some adjustment. "Sometimes I regret it. I think, *Wow, I intended to make a different movie.* But that's moviemaking. Once you have flesh and blood and eyes and faces, your movie changes. It has to change—otherwise you're not being responsive to your materials. The script is one element, and the players are another."

Perhaps it's no surprise to hear Roos talk so admiringly about his leading lady. Her father was one of the men who introduced him to screenwriting. Roos grew up in upstate New York and Washington, D.C., before attending the University of Notre Dame. Notre Dame had no film department, but alum Tony Bill, producer of *The Sting*, returned in the mid-1970s to teach, bringing along a then-unknown writer pal named Bruce Paltrow. Twenty-five years later, a scene of *Bounce* was shot in a restaurant co-owned by Tony Bill and Bruce Paltrow.

Bill encouraged Roos to come to Los Angeles, but when he arrived on the West Coast in 1978 he had no idea what he was getting into. "I literally showed up at Tony Bill's office and asked for a job as the writer of his film. I suppose I thought they had writers during the film, to write extra stuff. That's now naive I was."

"There really aren't jobs like that," Bill told him. "All I can tell you is, keep writing."

After a few years of writing typical beginner's screenplays, "where the adults are crazy, and the young twenty-two- or twenty-three-year-old guy is really wiser than everybody," he decided to go after a ready-made market: episodic television. "In those days, 1980, 1981, there were a lot of freelance episodes produced. It's not that way anymore. So I wrote a couple of *Hart to Hart* scripts and got in the door that way."

His first produced screenplay was *Love Field*, but when Orion went bankrupt, the film's release was held up for two years. In the meantime, he wrote *Single White Female*. Both arrived in theaters in 1992.

Like many screenwriters, he soon became interested in directing as well. "When you see what directors do to your material, you decide to direct out of self-defense. Not that I have anything against the directors who directed my material, but very often their interpretation was not mine, or not what I intended, or what they thought was important, I didn't. What I did think was important, they neglected. I'd rather be angry at myself. I'd rather mess it up myself than watch somebody else mess it up."

After roughly a decade, Roos finally got his chance by writing his least commercial screenplay, *The Opposite of Sex*. "It wasn't about stars, it was an ensemble story, and that's always more difficult," he said. "It was about the love life of a gay man, and that's always more difficult. I never really thought that it would get made. I knew that if it was to be made, I would direct it, but I never really thought that anyone would buy it. It was more of an exercise for me to write a non-studio picture."

The Opposite of Sex did sell, even with Roos attached to direct. That might have encouraged him to try to do the same kind of thing again, but Roos was savvy enough to guess that his next script should not only be more commercial, but have a straight male protagonist. He had written stories focused on straight women and gay men, but never a straight man. "I thought that would be a good task to tackle," he said.

As it turned out, writing for a straight man proved no problem. Instead, Roos found it much more difficult to surrender the ironic writing style he had used to such great effect in *The Opposite of Sex*.

"*The Opposite of Sex* was a great, easy script to write, because the main character in her voice-over could always take a different position to the actual script, to what was actually happening on-screen. So, if there was a boring part of the story, I would just have my lead character say, 'Oh, God, this is a really boring part, but what I have to do is get from here to there.' That constant commentary on what I was writing about [gave the film] a built-in sense of irony, and I could hide behind that."

Bounce, on the other hand, was "very nonironic, very sincere," and consequently more challenging. "The discipline of actually having to tell a story and letting it live and die by its own merits was difficult," Roos says.

After getting through his first draft, Roos put the script down for a month before giving it a polish. In January 1997, a week after it was sent out, the script was bought by Propaganda Films.

Then things slowed down. While Propaganda searched for a director for *Bounce*, Roos went on to direct *The Opposite of Sex*. That led Propaganda to call off their director search and ask Roos to take the reins himself. It took months to negotiate that deal; when Propaganda's parent company, Poly-Gram, was acquired by Universal, it held up the film still further. The logjam finally broke in January 1999, when Miramax's Harvey Weinstein read the screenplay and decided to buy it from Propaganda.

Many of the changes in *Bounce*, though, came from a revision Roos did in January 1998, after receiving notes from Propaganda's Steve Golin. As Roos recalls, the changes made the story cleaner and simpler. For example, in the sale draft, Buddy had a girlfriend and an ex-wife; both were cut. Abby's character was strengthened and became more active. A new scene showed that Abby was actually very good at her job, even though she wasn't very successful. She also became more active in pursuing the romance with Buddy, so that the responsibility for the relationship would be split between them.

The most important shift, however, came in Buddy's character. "I don't

like Buddy for not telling the truth," Roos remembers hearing. "Can you make him nicer? Can you have more opportunities where he's about to tell her and then something she says makes that impossible?" As Roos says, "It was a pervasive note from everybody who read the script: 'Oh, my God, I hate this guy because he's lying.'

"It's difficult, because that's the story I wanted to tell—the story of a guy who lies and becomes more and more invested in the lie and more and more afraid of the lie coming out. It's hard to softpedal that. I did the best I could to make him more sympathetic, but ultimately he begins the movie as a very narcissistic, self-involved character, and it's hard to turn him into a sweetheart from page one. That's not the story."

As Roos notes, rewriting often involves this kind of "cleaning up" for a film's main characters—sanding down their rough edges to make them more palatable for a wider audience. He inserted a scene where Buddy moves toward telling Abby the truth but is interrupted. He also removed scenes where Buddy proposes to Abby and the pair go house-hunting, out of concern that audiences wouldn't want Buddy taking the relationship too far while he was still deceiving Abby. "Fortunately, in the actual [execution], we were able to get a lot more edge and darkness back into it."

After more than twenty years in Hollywood, Roos knows how to play the game. He knows who will be reading his scripts and what kind of notes to expect. "Very often in a script session they'll say, 'We have to have a scene that shows why the lead character is in love with the other lead character.' And you can write many, many of those scenes, and none of them will probably survive into the movie theater. I mean, a main character, a star, loves another star because they're the stars of the movie, and they bring so much history with the audience to that."

More than their association with previous starring roles, of course, actors also bring their talents for character portraiture and emotional nuance. "Most of all they bring eyes," Roos says, "and if they're good actors they [can] really bring out the subtext of the scene."

Roos's writing stresses subtext quite a bit. His dialogue is especially rich and compelling, in part because his characters almost never say what's actually on their minds. He writes his scripts knowing that actors will bring these characters to life—but he also knows that not every development executive will account for that before giving notes.

"It's hard for people to read subtext," he admits. "It's hard for people to understand that while a guy might be lying with his mouth, his eyes may be

clearly saying 'I love you, and I care about you, and I'm worried about you.'"
Many industry readers prefer to see their emotional nuances spelled out on
the page. "A love scene in Hollywood development circles is where one char-
acter says 'I love you. And here's why I love you. And here's how I'm going to
love you.' That's very often not what a love scene will look like on-screen."

To Roos, this overliteral approach often dampens creativity within the
industry. "It's why so many movies are by-the-numbers. When characters
come in and start talking their subtext, I check out. [In real life,] usually
people talk to *conceal* how they feel, not to express it. And when we do ex-
press how we feel, it's often extremely ineloquent in real life.

"So I can tell a movie that's been overdeveloped. I can tell a scene whose
only purpose is to state where the character is at [emotionally]. We had such a
scene in *Bounce*, but it's not in the movie. We had a scene where the Ben Affleck
character says, 'I want to tell her. I should have been on the plane, and I really
love her, and she's really really special to me.' It's not in the movie. I never ex-
pected it to be." Roos admits he only wrote the scene to placate the develop-
ment people who were giving him notes. "You try to do it cleverly. You never
write anything that you know won't be in the movie. You try to make it work.
You [think], *This is sort of against how I would do it, but if I have to do this scene,
this is a good version of it*. And you spend a lot of time and money putting it on
film, working with the actors and hoping for the best. [And then,] finally, when
you see the movie, the scene falls right out, because it's unnecessary."

For Roos, such overexplicit writing is "really why movies are so dull. Be-
cause we get it. We understand. Everything we need to know about the charac-
ter is displayed in front of us. When you [in the audience] work to understand
a character and to try to figure out what they really mean and what they want,
then you identify with the character, and it's a stronger movie."

On the other hand, Roos said that such on-the-nose exposition scenes
are perfect for trailers, because they summarize the plot in a few lines.
"They're usually 'so far' scenes."

"So far" scenes?

"'So far,'" he said by way of illustration, "'I've fallen in love with this
woman, and yet I am the man responsible for her husband dying. That's
what's happened so far, Seth.' And then Seth says what the audience is feeling,
'You need to tell her.' So it's a silly scene, really. It's never going to be in the
movie. But I tried."

Roos's dialogue is interesting precisely because his characters are so inar-
ticulate. "Real drama is in seeing people hide or struggle to express how they

feel. You really have to look at the underpinnings of where the characters are and what each action that they do means. There's a code that each character has developed over the course of the movie."

Unfortunately, screenplays have to sell off a read, and the readers and buyers are often the people who want everything spelled out in the dialogue. As Roos explained, few of them really grasp the power of film. "There are very few film enthusiasts in Hollywood, really, at those levels. Very few people who have favorite films, who are moved by films or understand remotely what film does. It's difficult talking to idiots, it really is."

How, then, to get the subtext across to those "idiots," when they're responsible for deciding whether or not to buy your script?

"You put it in the action lines," Roos responds. "Here's a scene: two characters, Linda and Steve. Linda comes in, she says hi.

"Steve says hi.

"Linda says, 'I'm going upstairs to bed.'

"Steve says, 'I'll follow you.'

"That's the actual [dialogue] that will be in the scene. [But let's say] I mean it to be a love scene. I have to put all of that subtext in the action lines:

> Linda enters the room. She sees Steve. It's the moment she's been waiting for, but she can't trust herself to speak.

> LINDA
> Hi.

"You do it that way, so that people understand what you're trying to do, but you don't commit the sin of putting it into your actor's mouth. Because I guarantee you, by the time we get to that Linda/Steve scene, we know how Linda feels about Steve. We know how she feels when she comes home and he's sitting there. It's everything she hoped for. So we don't want her to say, 'Hi, Steve, it's everything I've hoped for to see you here.' We don't need her to say that. We want her to *cover* that. It will be much, much more powerful."

Writing this way, Roos said, can be "very liberating. And it's very simple. It's a novelistic approach. In the action lines, you can actually be the director, conveying the subtext of the characters. That's what they're for—subtext."

Roos learned this approach long ago, even before he became a director. "I would get notes very early on: 'Your main character is unlikable.' And literally, I would put in the action line, 'Sam enters. Although abrasive, there's

something strangely likable about him.' And then Sam's dialogue would be, 'You fat bastard, go fuck yourself.' But it doesn't matter. Because I've put that 'strangely likable,' they know that even though he says something awful, he's a likable character. It's obvious, but it works."

But isn't that cheating? No, Roos said. "Because what those action lines are supplying is the actor's face, the direction, the way that somebody says something. It *is* cheating to put it into dialogue, because then you're pretending it's a radio play, instead of a movie."

Roos is also expert at establishing character quickly. "It comes very naturally to me. That's just one of your jobs as a writer, to quickly tell the audience who these people are. And leave room for surprises. How do you want them to see this person instantly? What is it important for them to get about him?" Usually, he notes, the writer finds an activity that helps suggest something about the character. "Because there's a wonderful voyeur quality to watching a movie. The audience is titillated by finding something out, by watching somebody do something. That's much better than listening to them talk about themselves. To see a character do something is much more powerful than to have a character tell you he did something."

This audience-as-voyeur philosophy is a core part of Roos's worldview. "We grow up feeling, in our lives, that we're not exactly where the most interesting things are happening, that in another room there are other voices talking, and there's something fascinating going on. Movies are a way to look into those other rooms, and it's really very powerful."

Through all the changes, Roos always took care to ensure that *Bounce* let the audience spy on Buddy's personal spiritual journey. Those sensitive to recovery issues—and Roos himself is a recovering alcoholic—will recognize that Buddy arrives at a very "twelve-step" kind of spiritual awakening. He begins his rocky romance by jumping to Step 9 of the Alcoholics Anonymous twelve-step program ("We made direct amends to [people we had harmed] wherever possible, except when to do so would injure them or others") without bothering to do the first seven preparatory steps.

"When he first starts to help Abby, it can't be just that [he wants] to be a good guy," explained Roos. "It's a selfish reason: 'I have to help her if I'm going to stay sober.' I mean, I couldn't take the selfish guy and then just have him approach Abby because he's a great guy and wants to see if she's okay. He's protecting his sobriety. He's an idiot, because he hasn't sincerely worked an AA program. He's jumping. [Buddy thinks], *I can do this. I'll check up on her, I'll throw her a few bucks. I'll be sober, and I won't feel guilty.*"

At the start of the story, Roos says, "Buddy thinks he's God. He has incredible hubris. . . . He thinks he's powerful enough to make planes fall out of the sky—that that's his fault. And that he can fix it. That's the true hubris: that [he thinks] he can show up and make it better. And what he fails to realize is that he can't make that better. It's a huge loss, and he's too small to make that better. He has to let go of his control and let go of his idea that he can be God.

"So even in his trying to help her, he's being egotistical. And he really has to be humiliated at depth. And then he becomes the man that Greg was at the beginning of the movie. At the beginning of the movie, Greg couldn't be less powerful. He's a mediocre writer eking out a living writing bad television. He is a humble man. He has been humbled by life and he is humble, and he is a worthy object of love. And that's basically where Buddy has to be by the end of the movie. He has to be humbled by life and to learn his true station. . . .

"That's the whole process. The whole thing is humiliation and depth."

Roos finds his own true station when he forces himself to sit down and write every day. "It was very important to me to feel successful as a writer, and the only way to do that is to fulfill your appointment to write. Because who knows if what you're writing is any good or not? And I can't do a page budget—like, 'If I write three pages a day, then I'm a success.' I really have to say, 'If I keep my appointment to write, and I spend the time at the typewriter or the computer for that hour or two, then I'm a success.' I can sit there from nine to eleven and not write a word, and at eleven turn the computer off and say, 'I was a success as a writer today.' It's important for me to have something concrete like that."

Often, Roos admits, he starts out typing gibberish: " 'I hate writing. Last night was terrible. I ate too much. I'm too fat.' Then eventually you get bored with that. And after twenty minutes of a diatribe on your internal feelings, or how much you hate your life and other people in it, it's actually preferable to [start] writing rather than continue that kind of internal monologue. So in an hour, you'll get half an hour of actual work on a project."

He spends an hour a day while he's working out an idea, two when he's writing a first draft, then up to four hours a day while rewriting. "But I find writing exhausting," he said. "An hour of asking yourself what is in your brain, and what you want to create, is tough work."

He's also careful not to read over his work too quickly. "I never reread.

"No One Helps a Writer Do Anything"

Don Roos may hate writing, but it's still his favorite job in the business.

Writing is a great job. It's the only job in this business where you can perform your craft without anybody hiring you. I could write a movie today. So could you. I can start a job today without being hired. You're completely self-contained, or can be. So that's an enormously powerful thing.

But the [lack of] respect for the writer, it's really painful. And I honestly feel it's up to us as writers to insist on it. To not let actors improvise and to work hard on our dialogue so it can stand scrutiny, to understand our work so that we can explain it to other people, and to direct if we have to. To not make the big sale and wait for no money but a chance to direct it too.

You know, directing is very easy compared to writing. No one helps a writer do anything. A writer is alone. A director has a hundred people working for him whose only job it is to make the director look good. They succeed or fail, and get rewarded with pay or promotion, if they make the director look good. It's an ideal situation for somebody like me who doesn't know what he's doing. "Let me help you. No, you can do it this way. This will be better." You have all the help in the world. So I think directors have got the populace hoodwinked. It's so easy to be an okay director—where[as] it's so hard to be even an okay writer.

The one job a director can do, that no one else can do, is to talk to the actors. And I say, if that's the essential and unique job of a director, that's what I'm going to do. My DP will take care of the shots, and my script supervisor will take care of the continuity, and the production designer will take care of the sets. I will worry about performance. That's how I direct, and you can get by that way. I don't think I'm a great director, but I think I'm good. It's pretty easy to be a B director. I think I'm an A writer and a B director, and that's how it has to be. Because I'm not interested in putting the time and the work in to be that kind of visionary. I'm not Scorsese, I'm not Woody Allen. There are five, maybe, American directors that are truly extraordinary. That's not me. That's not my job. . . .

You just have to come to [an understanding] of what you can do, and do it. And that's what I can do: I can help the actors with a performance, because I love actors and always have. One of the great things about direct[ing] is that you finally get to talk to the people who are bringing your characters to life. That's a great privilege.

Ever. Because there's a little disgust involved with every artistic enterprise. You know, when you first go to a play, and you sit down, and everybody sounds phony, and you can see their spit in the footlights, and it's just awful and fake and phony and stagy—and then, ten minutes in, it carries you away.

"The thing you need to avoid when writing is that initial glance at a work. If I reread the previous day's output, I may never get over my feeling of disgust. I just have to soldier on and not be diverted by my own disgust at what I've managed to achieve. I'm a very self-critical person. My job is to spend that two hours a day, and eventually to type 'The End.' Then I let it sit, and *then* I reread it, and that's always a very painful day." For Roos, that day rarely comes less than two weeks after writing a new passage. "I very often don't even get through it the first time. I get to page thirty, and I think, *Oh, man, I'm in such fuckin' trouble here. Maybe I have to re-outline, I don't know.* That first encounter with your own work of art—I find [it] very tough."

Though *Bounce* was Roos's easiest experience as a writer, he points to the evolution of the story as the the most exciting part of the process. "Watching something change, something that you think you know everything about. It's just the magic of humanity, really." He's especially interested in how the process enhances his work—even when the dialogue remains the same. On *Bounce*, he noted, "None of the actors changed any of my lines. I'm not the kind of director who says 'or say something like that.' I've spent time on this dialogue, and I expect them to say it as written. And they do. But [even if] you think you know everything [about a scene], even [when an actor is] saying the exact things you wrote, a scene is different" when it goes before the camera.

"Directing something that you've written, you've got to pay attention and listen to what actually is there. That was very exciting, because things you thought were important aren't, or things you maybe didn't pay enough attention to are suddenly much more important to an audience—and to you—than you thought. That's what happened with this story. It started out as the story of a man's redemption, a man's descent and climb out of it and eventual salvation. And it became a love story and it happened very naturally, right before my eyes."

Eternal Sunshine of the Spotless Mind

CREDITS

DIRECTED BY Michel Gondry
SCREENPLAY BY Charlie Kaufman
STORY BY Charlie Kaufman & Michel Gondry & Pierre Bismuth
PRODUCERS: Anthony Bregman and Steve Golin
EXECUTIVE PRODUCERS: Georges Bermann, David Bushell, Charlie Kaufman, and Glenn Williamson
PRODUCTION COMPANIES: Anonymous Content, Focus Features, and This Is That Productions
ORIGINAL MUSIC BY Jon Brion
CINEMATOGRAPHY BY Ellen Kuras
FILM EDITING BY Vladis Oskardottir
CASTING BY Jeanne McCarthy
PRODUCTION DESIGN BY Dan Leigh
ART DIRECTION BY David Stein
SET DECORATION BY Ron von Blomberg
COSTUME DESIGN BY Melissa Toth

MAJOR AWARDS

ACADEMY AWARDS: Charlie Kaufman, Michel Gondry, Pierre Bismuth—Original Screenplay
BAFTA AWARDS: Charlie Kaufman—Original Screenplay; Vladis Oskarsdottir—Editing
WGA AWARDS: Charlie Kaufman, Michel Gondry, Pierre Bismuth—Original Screenplay

CAST

Jim Carrey . . . *JOEL BARISH*
Kate Winslet . . . *CLEMENTINE KRUCZYNSKI*
Elijah Wood . . . *PATRICK*
Thomas Jay Ryan . . . *FRANK*
Mark Ruffalo . . . *STAN*
Jane Adams . . . *CARRIE*
David Cross . . . *ROB*
Kirsten Dunst . . . *MARY*
Tom Wilkinson . . . *DR. HOWARD MIERZWIAK*

BUSINESS DATA

ESTIMATED BUDGET: $20 million
RELEASE DATE: March 19, 2004
U.S. GROSS: $34.1 million
FOREIGN GROSS: $38.9 million

REVIEW HIGHLIGHTS

"Going to the movies would be an eternally wondrous experience if more movies were as smart, ambitious, offbeat and emotionally rich as *Eternal Sunshine of the Spotless Mind*."　　—CLAUDIA PUIG, *USA TODAY*

"[Gondry] can define contradictory emotions with extraordinary clarity and alacrity. It's why he's so suited to handling much of this particular Kaufman script."　　—ELVIS MITCHELL, *NEW YORK TIMES*

"Gondry and the pitch-perfect actors have crafted a remarkable film that can coax a smile about making the same mistakes in love and then sneak up and quietly break your heart."　　—PETER TRAVERS, *ROLLING STONE*

14 | GREAT SCIENCE FICTION— BUT DON'T TELL ANYONE

ETERNAL SUNSHINE OF THE SPOTLESS MIND • CHARLIE KAUFMAN

T ry to name Hollywood's notable science fiction film writers. It's easier to think of the movies than the writers, isn't it? *Blade Runner*? Hampton Fancher and David Peoples. *The Truman Show* and *Gattaca*? Andrew Niccol. Ronald Shusett and Dan O'Bannon have done pretty well, with *Total Recall* and *Alien* between them. *Stargate* and *Independence Day*? Roland Emmerich and Dean Devlin. Maybe Joss Whedon. James Cameron. George Lucas and Steven Spielberg, I guess.

Charlie Kaufman? He probably doesn't jump to mind as a science fiction titan.

That's because *Being John Malkovich* doesn't often get lumped in with *Blade Runner*, *Alien*, or *The Terminator* in the SF pantheon. Yet Kaufman likes to play with elements of the fantastic as much as any science fiction writer. And, in his most honored film, *Eternal Sunshine of the Spotless Mind*, he works from a premise that's quite familiar to SF fans: protagonists who have had their memories erased.

It's familiar sci-fi territory, explored in such Philip K. Dick–inspired films as *Total Recall* and *Paycheck*, and in episodes of *Star Trek: The Next Generation* and *Star Trek: Voyager*—for that matter, even back to the original *Star Trek* story lines of the mid-1960s. But Kaufman seems to tense up when I ask him if he thinks of the story as science fiction, as if he's been anticipating the question—and dreading it.

"You know, *Malkovich* and this, both of which I think have supernatural kinds of elements . . . I try not to think of that," Kaufman said. "I'm interested in downplaying that aspect of it as much as possible. You just kind of present it and then get on with it, you know. So, no, I don't think of it as science fiction.

But I recognize that there's fantasy stuff in it. I just want to try to make that as real as I can, so that it's not an issue for the audience."

If that was his goal, Kaufman basically succeeded. *Eternal Sunshine* has none of the bigger-than-life trappings of Hollywood sci-fi. The memory-erasing machine has no overstuffed dentist's chair with ominous restraints; there's no menacing apparatus attached to the subject's head. Kaufman's fantasy hardware seems as pedestrian as a Dell laptop. Nor are there dark conspiracies to erase his characters' memories; the characters have freely chosen to have their memories of their bad love affairs erased. The fate of Earth (or another planet) doesn't hang in the balance. The concerns are at a more human scale: What makes a love affair good or bad? Would we be better off without our painful memories, or do we need them to learn? And what, in the end, makes us fall in love anyway?

Like the very best science fiction and fantasy writing, *Eternal Sunshine* uses its fantasy elements to conjure a situation that illuminates something important about the human condition. So the question isn't whether *Eternal Sunshine of the Spotless Mind* is science fiction, it's why more science fiction isn't this ambitious.

Maybe the answer is that Hollywood science fiction, for the most part, is a big-stakes industry, dependent on big sets and big special effects. It's turned into a spectacle genre, built around dazzling visuals and can-you-top-this action sequences. Films that expensive simply have to sell a lot of tickets, so they have to appeal to a pretty low common denominator. They're the movie equivalent of a super-sized meal at McDonald's.

Kaufman, however, isn't writing tentpoles, so he gets to write pretty much what he wants. His films may not generate half-billion-dollar grosses or record-breaking opening weekends, but they don't cost $200 million either. He's writing movies that people will be watching and talking about for a long, long time. To push a metaphor too hard, he's creating the cinematic equivalent of a rich offal stew—the kind of slow food beloved by chefs like Anthony Bourdain but rarely found on American dinner tables.

Eternal Sunshine of the Spotless Mind stars Jim Carrey and Kate Winslet as seemingly mismatched lovers who opt to erase each other, with unexpected results. Tom Wilkinson, Mark Ruffalo, Kirsten Dunst, and Elijah Wood play the staff of Lacuna, the memory-erasing company. Kaufman wrote the screenplay and shares story credit with Michel Gondry, who directed the film, and Pierre Bismuth. Like Kaufman's earlier films, *Being John Malkovich* and *Adaptation*, it's a challenging film, one that inspired flat-out

hatred from some viewers. But it has more fans than detractors, even in the somewhat stodgy Academy of Motion Picture Arts and Sciences, which gave it an Academy Award for best original screenplay.

The story is told out of sequence; large parts of the film take place entirely in the mind of its protagonist, Joel Barish (Carrey), as his memories are being erased. In the midst of the procedure, Joel realizes that, despite his painful breakup with his lover, Clementine (Winslet), he really doesn't want to lose his memories of her. But he's already been immobilized and thus can't tell the technicians to stop, so a desperate chase ensues within Joel's mind as he tries to hide his memories of Clementine in remote corners of his own memories, while the technicians struggle to obliterate every trace of her in his mind—just as Joel hired them to do.

Kaufman doesn't give a lot of interviews; a bad experience with a print interview has left him somewhat press-shy. The publicists at Focus Features had to coax him to talk to me, and he waited until the last possible moment, just before he had to leave on vacation, to make the call. I was shaving when he called, and when I asked him for a few minutes to finish, he tried to beg off the whole thing. So maybe his tension about the "science fiction" question had more to do with his basic discomfort about talking to a reporter.

He did, though, manage to soldier through our conversation, though no one would accuse him of being a natural storyteller like David Franzoni.

He told me that he and Gondry had been tinkering with *Eternal Sunshine* in one form or another since 1998, when Pierre Bismuth, a conceptual artist, thought of the idea of receiving a card in the mail telling you you've been erased from someone's memory. "Michel thought that was an interesting sort of starting point for a movie," said Kaufman. "So we talked about it and developed the idea of it being a relationship movie, and then that the story [was] taking place in this guy's mind, and [that] at a certain point he'd try to stop the erasing."

Though they didn't think it was a very marketable idea, the team came up with a short pitch. It was Kaufman's longtime agent, UTA's Marty Bowen, who recognized the commercial potential in it. "[He] thought it was a very marketable idea and he turned out to be right," said Kaufman. "We pitched it around town, and there was a bit of a bidding war on it."

It was another be-careful-what-you-wish-for story: "Then I got stuck having to write it, which was a lot harder. It's very easy to tell the initial story in a five-minute sound bite, but the practical problems of memory erasing, and having this person in their memory as it's being erased, and having the

story being told from the end of the relationship to the beginning—all that became very complicated."

He didn't spend all of the next five years on the project, of course. He was pitching *Eternal Sunshine* at the same time he was up for the job of adapting the book *The Orchid Thief*. As luck would have it, he got both jobs and was committed to writing *The Orchid Thief* first. That proved no easy task, as he documented in the screenplay that eventually emerged from the assignment: *Adaptation*.

Gondry and Kaufman also collaborated on the feature *Human Nature*, and Kaufman also took a few months out to write *Confessions of a Dangerous Mind*. But *Eternal Sunshine* was always simmering, even when it was on the back burner.

Having to pick up *Eternal Sunshine* after *Adaptation* made Kaufman's writing life difficult. "There were a lot of distractions, and I had an enormous struggle with the script. I remember being stymied a lot, which came right after being stymied a lot on *Adaptation*, so it was kind of a lot of stymie going on."

To Kaufman, writing the script was a lot of "dogged work." He encountered two major logic problems as he tried to work out the story. "One was, I wanted [to show] the memories and Joel's reaction to the memories and Joel's interaction with Clementine outside of the memories in the memories. And how do you do that? How do you actually have someone in and out of their memories at the same time? It was very complicated." Eventually, he and Gondry decided that Joel would experience his memories, *know* he's in a memory, and be able to comment on the memory, like someone who is having a lucid dream.

The second problem, which was particularly tough for Kaufman, was that if Joel is having his memories erased, then as each memory disappears he should be unable to refer to it in the ensuing scenes. "How can he still remember what happened previously if it's been erased?" They decided that Joel's memories would be degraded—a effect illustrated through surreal visual effects—but that they wouldn't vanish altogether until Joel awakens after the procedure.

Even with those problems solved, *Eternal Sunshine* is not a simple film. It rewards close attention. This is a film for moviegoers who enjoy figuring out the puzzle as they go. Kaufman said he always tries to write that way, because that's the kind of film he likes to see. But he also thinks about a bigger issue.

"There's a hurdle," he explained, "that it's difficult for a movie to over-come: It's set in stone. It's done when you see it. It's not live. It's not changing. It's just there. What I find is interesting is trying to create a script that makes you need to go back and look at it again, [so] that the second time you look at it, you'll see things you didn't see, that you *couldn't* have seen the first time, because you didn't have the information that you have by the end of the first viewing. And so the second viewing becomes the viewing of a different movie, even though it's exactly the same movie." *Eternal Sunshine* was an exercise in that kind of storytelling: "There are things you don't know until the end of this movie, and/or later in the movie." Indeed, because we first encounter Joel and Clementine after they've had their memories erased, there are many moments in their early scenes that only take on full meaning after we see what came before.

For Kaufman, though, it's important that what he calls the "gimmick" of memory erasure not overshadow the relationship aspect of the story. There's no doubt that Joel and Clementine aren't a perfect couple, and they've had a stormy relationship, but is that a *bad* relationship? They've had a painful breakup. Are they really better off without that pain? It's an open question.

Kaufman's script offers a very different picture of love from what we usu-ally see in movies. Films tend to like romance: pretty couples meeting cute and overcoming a few hurdles (big ones in dramas, smaller ones in comedies) to get together, usually to live happily ever after. In real life, of course, love and happiness don't always go hand in hand; the fact that two people are in love doesn't mean they won't grate on each other, or even make each other downright miserable. To some degree, *Eternal Sunshine* is a rebuttal of Hol-lywood love stories, even of sci-fi predecessors that covered similar ground, just as *My Best Friend's Wedding* was a retort to Hollywood rom-coms.

"You don't see a lot of movies that show the stress of [a] relationship," said Kaufman. "I am always trying to fight that kind of thing in my work, because I feel there's a fantasy world that's presented to people when they go to the movies. Speaking for myself, I've been very frustrated trying to find in my life what I see in movies, in terms of relationships or anything. Life is not like that. So I set out in my screenplays to try to write something that seems real to me, or true. I guess this is what's true to me."

"The Film Is What the Film Is"

CHARLIE KAUFMAN ON THE MEANING OF HIS SCRIPTS

Here in Los Angeles, during the fall-and-winter awards season, we're bombarded by commercials with clips from junket interviews telling us what the award-nominated films are about. The more I see them, the less I want to ask filmmakers what the film is about, because I think a good film speaks for itself.

I've never and I will never talk about what anything I write is about. I've never done it at any interview, and I won't do it, because I agree with you. The film is what the film is, and what is most exciting to me is that people have different ideas about what the film is about. I've consciously designed it so that hopefully people will come out and say, "It's about this" or "I got this from it" or "It touched me in this way." If I, as the writer, say "This movie is about this" then that's the end of the discussion, and I think that's a disservice. I mean, that's not why I write stuff, you know?

I've heard that somebody once asked Samuel Beckett what Waiting for Godot *means, and he said, "I don't know."*

Aha. Well, I'm a big fan of Beckett.

But does that mean it has no meaning? Of course not.

You know, it may have been sort of a cute answer; who knows? But I think the point is that you write something so that people have their own experience. I'm not a politician, you know. I'm not trying to get people to think a certain way. That goes back to what we were talking about before about what Hollywood movies do. You know, they tell people, "It's important to be nice to people," or, "Love is a wonderful thing," and that "War is bad," or whatever the hell it is that people want to say, and that's not interesting to me. You can say that in one sentence, you know.

During the early stages of writing *Eternal Sunshine*, Kaufman didn't have to take studio notes on his script. Propaganda Films, the same company that had bought *Bounce*, had bought the pitch—but Propaganda was soon bought by Universal, which in turn became part of Focus, so the corporate stewardship of the project changed several times. It wasn't until the end of the process that he had to deal with studio input.

There were changes along the way, though. When I spoke with Kaufman, he and Gondry were still working out whether to use a voice-over narration by Joel, and if so, how much. (They didn't.) Kaufman wrote scenes showing Joel with his previous girlfriend, Naomi, whom Joel left to be with Clemen-

tine. Her scenes were filmed but didn't make it into the final cut. "I was against cutting her out," Kaufman said, "and I fought for her, [but] she was cut out completely. Then part of it was brought back and then the decision was made that there wasn't enough of her, and coming at the end of the movie as she did, at that point it was too little too late.

"I really like having her there, so we understand a little bit about where Joel came from, who he was with and how she contrasted with Clementine. Also the fact that he had to make a decision that was monumental—which is not clear now, because there's an allusion to her but you don't see her. The idea was that he actually left his long-term relationship, which was a very risky thing for him to do."

Kaufman, a onetime actor and playwright, had originally conceived the memory-erasing scenes so that Clementine, who is being erased, would begin to behave like an automaton or a "husk" of reality. It's very much a stage device, as opposed to a film device, in that it puts the burden on the actor to create a "special effect" strictly through her performance.

In the film, though, the scenes are played straight; the degradation of memories is established visually, as the settings disintegrate around them, with elements from one set often intruding into another. "I think that Michel's concern was that there is a lot of emotional stuff happening in these scenes at those moments, and that making them robotic would be taking away some of the experience of the emotion. He may have been correct about that."

The film features some harrowing scenes showing the Lacuna staff treating Joel pretty much as a piece of meat during the time he's unconscious. We know he's in a desperate fight to hold on to his most important memories, but at the same time, the technicians party, get high, and use his bed—with him in it—as a trampoline. Gondry made those moments bigger and broader than Kaufman had written them, and Kaufman worried they had become too comic. "I wanted it to be insidious," he said.

There's even a little bit of identity-snatching, à la *Being John Malkovich*, when one of the Lacuna technicians (Wood) uses Joel's journals and words to seduce Clementine. "I liked it, as a nice sort of counterpoint to Joel and Clementine's relationship, to see this other person doing it, and the question of whether or not Clementine would feel the inauthenticity of this other version of it interested me. And I liked the character. I like characters who do kind of crappy things like that and betray people. I tend to put them in my scripts. I don't know why, except that it interests me, and it's a nice little twist to play with. I like twists and curves and stuff."

Kaufman is a rarity, especially today: a "brand name" writer who is almost always the defining creative sensibility on his films—as much as writer-directors David Lynch and Jim Jarmusch are on theirs—and yet doesn't direct his own scripts.

Eternal Sunshine clearly bears Kaufman's stamp. It moves confidently from past to present, from Joel's mind to the real world, from memory to reality, all the while daring the audience to figure out what's going on. It did make the studio a bit nervous, said Kaufman, but they stuck to their concept. "We liked the mystery of it; we thought that was effective and exciting. I think they were nervous about it, but I feel like I'm in a sort of fortunate situation. I'm kind of allowed to do [what] I want to do, for the most part, when making these things. I'm not sure why, but it seems to be that way right now."

Who's the ideal audience for a Charlie Kaufman film? "I'm essentially writing for myself, because that's the audience I know and that I'm interested in. I'm assuming or hoping that there are other people who have similar feelings or problems to mine, and that they would enjoy seeing something that I would enjoy seeing."

A few months after our nearly aborted telephone interview, I did get a chance to speak to Kaufman in person, briefly . . . in a way. A few months later, when I was covering the Oscars for *Variety*, I was backstage in the interview room where the winners come to speak to a room full of reporters from around the world. When Kaufman, Gondry, and Bismuth came in, Oscars in hand, few reporters had any questions for them. So I raised my hand and offered my congratulations. If Kaufman realized we'd ever spoken before, he didn't show it. I asked Bismuth about his part in the process, but he said very little. A few moments later, after an awkward silence, they retired from the podium.

I'm not certain, but I could have sworn Kaufman looked relieved.

Happiness

CREDITS

DIRECTED BY Todd Solondz
SCREENPLAY BY Todd Solondz
PRODUCERS: Ted Hope and Christine Vachon
EXECUTIVE PRODUCERS: David Linde and James Schamus
PRODUCTION COMPANIES: Good Machine and Killer Films
ORIGINAL MUSIC BY Robbie Kondor
CINEMATOGRAPHY BY Maryse Alberti
FILM EDITING BY Alan Oxman
CASTING BY Ann Goulder
PRODUCTION DESIGN BY Thérèse DePrez
ART DIRECTION BY John Bruce
SET DECORATION BY Nick Evans
COSTUME DESIGN BY Kathryn Nixon

MAJOR AWARDS

None

CAST

Jane Adams . . . *JOY JORDAN*	Elizabeth Ashley . . . *DIANE FREED*
Dylan Baker . . . *BILL MAPLEWOOD*	Louise Lasser . . . *MONA JORDAN*
Lara Flynn Boyle . . . *HELEN JORDAN*	Camryn Manheim . . . *KRISTINA*
Ben Gazzara . . . *LENNY JORDAN*	Rufus Read . . . *BILLY MAPLEWOOD*
Jared Harris . . . *VLAD*	Anne Bobby . . . *RHONDA*
Philip Seymour Hoffman . . . *ALLEN*	Dan Moran . . . *JOE GRASSO*
Jon Lovitz . . . *ANDY KORNBLUTH*	Evan Silverberg . . . *JOHNNY GRASSO*
Marla Maples . . . *ANN CHAMBEAU*	
Cynthia Stevenson . . . *TRISH MAPLEWOOD*	

BUSINESS DATA

ESTIMATED BUDGET: $3 million
RELEASE DATE: October 9, 1998
U.S. GROSS: $2.8 million
FOREIGN GROSS: $1.6 million

REVIEW HIGHLIGHTS

"*Happiness* is a film that perplexes its viewers, even those who admire it, because it challenges the ways we attempt to respond to it . . . In a film that looks into the abyss of human despair, there is the horrifying suggestion that these characters may not be grotesque exceptions, but may in fact be part of the mainstream of humanity." **—ROGER EBERT,** *CHICAGO SUN-TIMES*

"In his hands, passive aggression is a deadly weapon, right there in the arsenal alongside perky suburban décor and easy-listening songs . . . Yet kitschy Americana does not apparently interest him as a target for sardonic potshots. It interests him as a matter of proportion. There are people out there who are more bothered when a child's Tamagotchi dies than when a clean-cut relative turns out to be a serial pederast." **—JANET MASLIN,** *NEW YORK TIMES*

15 | SLAVES TO DESIRE

HAPPINESS • TODD SOLONDZ

Todd Solondz and *Happiness* may be the most problematic story in this book. The movie is problematic in itself, though in my opinion its virtues far outweigh those problems. The story of how the film was dropped by its distributor under a "morally objectionable" clause—apparently under pressure from its parent company—illustrates yet another obstacle facing risk-taking writers and filmmakers. Certainly Solondz said all the right things about the film and his intentions in making it, talking about compassion for the outcast and the challenge of recognizing ourselves in anyone else's story—even that of a pedophile.

That's the story you're about to read. But first, let me confess something: While I believe Solondz, especially on the factual things—about his painful childhood and even why his distributor dropped *Happiness*—and he certainly wants the audience to empathize with a pedophile—I can't shake the feeling that that's a way of sticking it to us, of making us squirm, even degrading us a little. I guess I also wonder whether Solondz is really the gentle, empathetic soul his musings suggest—or whether he's actually a driven man whose ample stores of anger fuel both his professional drive and his story choices.

None of which keeps me from liking *Happiness* very much, or admiring his courage for making it, or holding deep respect for the sentiments he voiced in our interview. Maybe I'm just so jaded after fifteen years in Los Angeles that I can't recognize sincerity when I see it.

I met Solondz at a very upscale Beverly Hills hotel, where he was meeting the press to promote his film. He was slender and frail looking, and on the day I met him he had a backache and a stuffy nose, so he was limping and his

voice was even more nasal than usual. But dominating everything were his trademark eyeglasses, with their huge, nerdy frames.

Solondz wasn't just nerdy, though, he was deliberately, aggressively unfashionable. Everything about him was so uncool, it was cool. Even those black eyeglass frames were an in-your-face fashion statement, almost a mask. ("Nineteen eighty-nine L.A. Eyeworks, and they don't make them anymore," he lamented.) "I'm not a model," they seemed to say; "deal with it."

He told me he'd grown up dreaming of being not a filmmaker, but a musician, only to discover he had no talent for it. His interest in movies blossomed only when he went to Yale in the late 1970s.

"I was so miserable, I had such a horribly pathetic social life," he recalled, "that I spent all my evenings going to the movies." In those days, before the VCR and its successors made every living room a revival house, Yale's film societies screened movies nightly. While getting a degree in English, he haunted Yale's theaters and auditoriums, soaking it all in. "I just saw everything. That's how I spent my four years, just watching movies."

He went on to NYU film school, made some short films, and afterward even secured deals with Fox and Columbia. But he walked away from the studio world to pursue more personal projects.

It was *Welcome to the Dollhouse* that brought Solondz back to the attention of the studios. The film made a big splash at Sundance and made him lots of fans inside and outside the film business. Suddenly, Todd Solondz was a hot writer.

Typically, he remembered the days after *Welcome to the Dollhouse* with a certain irony. "Every door was open to me," he said. "Too many doors. All I had to do was show them this script and they [the doors] would all close. And they did—except for October [Films], which eventually did close as well."

"This script" was *Happiness*, a film that won awards and critical acclaim but was nevertheless refused distribution by October Films, the company that had financed it.

It's important to understand that while all this was going on, October was owned by Universal, which in turn was owned by Seagram. Though the project held all the necessary cards for an indie hit (strong cast with name recognition, good reviews, controversy, plus more than a touch of sex), and October itself was eager to send *Happiness* to art houses around the country, the corporate powers-that-be exercised a rarely invoked clause in its contract allowing it to drop the movie if they found it "morally objectionable."

Solondz had the last laugh, though, at least creatively. The controversy

drew more attention to the film and it did find an audience. Yet Solondz's experience is a reminder that the path from script to screen doesn't end when the film is in the can. True, he didn't have to submit to Hollywood-style development, with its endless notes from stars, directors, and marketing-driven studio execs. He got to make the film he wanted to make. But Solondz still found his vision nearly suppressed by a major corporation that decided that *Happiness* did not serve its interests—interests that go far beyond the fate of a low-budget art film.

By turns funny, gross, and disturbing, *Happiness* tells several stories, loosely connected through the lives of three New Jersey sisters, Joy, Trish, and Helen Jordan. The film opens with Joy (Jane Adams) in a fancy restaurant, in the midst of breaking up with the man she's been dating, Andy (Jon Lovitz). It all seems quite civilized until Andy erupts, telling her, "You're shit! And I'm champagne." As the dazed Joy soaks this in, the screen goes to black and one word appears in elegant white script: "Happiness."

The story continues with Joy's two younger sisters. Trish is a housewife who "has it all." Her husband, Bill Maplewood (Dylan Baker), makes a good living as a therapist, coaches Little League, and is a loving and warm father to their children, especially eleven-year-old Billy. Yet we soon learn that Trish's world isn't quite as perfect as she likes to think: Bill is actually a pedophile who is obsessed with Billy's male classmates.

Helen Jordan (Lara Flynn Boyle), the youngest sister, is a successful writer of poems titled "Rape at 11," "Rape at 12," and so on. Helen is beautiful and famous but bored with her succession of hunky lovers; she also feels like a fraud, having never actually been raped. Helen's neighbor, Allen (Philip Seymour Hoffman), is sexually obsessed with her and vents his lust with random obscene phone calls.

The story interweaves these characters and others. In Florida, the Jordan sisters' parents (Ben Gazarra and Louise Lasser) are breaking up after forty years of marriage. In New Jersey, young Billy Maplewood, worried that he can't "cum" like his classmates, approaches Bill for good fatherly advice. In scenes that seem like a surreal version of *Leave It to Beaver*, Bill helps his son understand his emerging sexuality, fighting back his own urges (almost) completely.

Allen makes an obscene phone call to Helen, who, rather than shrinking from the call, terrifies Allen by star-six-nine-ing him and insisting "I have to see you." As Allen drinks himself into a stupor, unable to gather the courage to reveal himself to the expectant Helen, another neighbor, Kristina (Camryn

Manheim), tries to reach out to him. Kristina, who seems even more lost than Allen, turns out to have a secret of her own, though.

Joy crosses a picket line to take a job teaching English at a Manhattan immigrant assistance center and quickly falls into a disastrous affair with Vlad, a Russian thief. Most disastrously of all, though, Bill compulsively pursues Billy's classmates, leading to his own destruction.

"You have to get beyond the surface shock value of some of the stuff that goes on and recognize what the film's about," explained Solondz. Of course, some of that "surface shock value" is pretty strong stuff by most social standards. There are two "cum shots"—normally a mark of hardcore porn—and an unlikely portrayal of a pedophile as an almost (though not quite) sympathetic character.

Yet the film is far less graphic than the furor around it might suggest. Bill's pedophilic acts are always offscreen, though perhaps that's because depicting sex acts with minors would violate federal child pornography laws. The on-screen sex scenes are no more explicit than in most Hollywood films, and there is no frontal nudity.

Arguably, though, the most disturbing thing about *Happiness* is the way it compels the audience to relate to these suffering, marginalized outsiders.

"It's about understanding, about exploring these minds," he said. "To not be able to be dismissive about these people we would rather be dismissive of. It's much more comforting to reduce someone to his other: *The* Pedophile, *The* Obscene Phone Caller. Then it becomes an us-and-them kind of a scenario." More edifying, Solondz argues, is "to acknowledge—to be able to understand that fact, [that] he is one of us, that in his own twisted way there is a common denominator, that there are universals here. There are loneliness and desire, alienation and the struggle to connect. These are what tie us all together, and these are what make us all more fully human."

Even Solondz admitted that few in the audience would be able to relate to Bill Maplewood, despite his very conventional house, car, wife, and family. At a time when the Clinton-Lewinsky sex scandal had made "sexual addiction" a household term, Solondz had created a frightening picture of a man tormented by a sexual compulsion he is powerless to control.

Yet Bill Maplewood also seems familiar. In the film's most subversive conceit, Solondz plays tricks with the movie audience's natural empathy with the characters on the screen. Anybody can have fun identifying with Luke Skywalker in *Star Wars*, but it's very disquieting to find yourself identifying with an obscene phone caller, let alone a pedophile on the prowl.

"I put the audience there in the mind-set of Bill Maplewood," said Solondz, citing one scene where Bill frantically tries to find a way to slip Billy's friend a sleeping pill so that he can have his way with the boy. "Of course, we're all horrified, but we understand, because we all know what it means to be a slave to desire. That doesn't mean we would do such a thing, but we all understand this. I mean, what he does is unequivocally unforgivable, but what makes him tragic is that he's a great father, he loves his son, his wife, his family. He's not a monster. He struggles with a monster within, and he succumbs to that demon, he fails.

"People say it's misanthropic, but I would argue that no, it's only by embracing all these flaws and foibles and failings [that] we can even embrace who we are. To not accept that is to not accept the *all* of us. We all have the capacity for cruelty as much as we have the capacity for kindness, but that capacity for cruelty is something none of us want to acknowledge, it's too painful. But I don't think that this capacity evaporated after seventh grade. I think the best of us have learned as we get older to suppress and channel and sublimate these baser instincts, but they are all there. It's only at extreme crises and circumstances that make us all learn what we are fully comprised of."

After *Welcome to the Dollhouse*, Solondz deliberately decided to take an even bigger risk with his next script, where others might have gone for a big paycheck and a play-it-safe studio deal. "You're fortunate to have that kind of success, and you want to take advantage of it because you might never have that kind of success again. That was the time to try and do something I might not otherwise be able to do. Certainly, if I made another movie [that got] just a lukewarm reception, there was no way anybody would give me the money to make this."

Like most screenwriters, Solondz typically has several ideas competing for his attention. Usually the choice is clear. "I just go with whichever one is pulling on me first and then follow it. You just have to sit in your room, you write, you have to force yourself and just sit there and do the work. It's horrible for me. I don't unfortunately get very much in the way of pleasure from it. I just want to be there on the set with a lot of people and have fun, lots of people around. Of course, then when I get on the set, I can't wait to get back into my room and be alone again."

In the fall of 1996, Solondz found several stories pulling on him at once but was uncertain about which one to write. "I had a thing about an obscene phone caller. A thing about a marriage unraveling after forty years. I had a thing about a Russian. And I couldn't make up my mind. So I thought,

maybe there's a [way to] combine all of this. Is there some sort of common theme I'm not conscious of? Or are they all discrete stories that don't really connect? So I made [a] leap of faith, that there is a kind of glue that makes all of this coherent. I came up with the idea of three sisters who [wind] through all of these stories and interconnect. Once I had come up with that idea, I could get to page one and write to the end. But until I figured out structurally that that was what I was going to do, I was at a bit of a loss."

Solondz never definitively articulated the story's themes. Instead, he just kept writing. "I start with character and story, find a story to work with the character. All these themes, which for me are loneliness and desire, alienation and the struggle to connect—I think these become much more lucid after you've made the movie. It's all a process of discovery, you know. It takes time to really figure out what you've done or what you're doing."

Given all the attention that was focused on the story of Bill Maplewood, both at the time and since, it may surprise some that Solondz insists he "certainly didn't want to make a movie about a pedophile. I have no interest in pedophilia, per se. I did no research on the subject."

He did find inspiration in news accounts of a Russian serial killer who was alleged to have killed as many as fifty children. The serial-killer story itself, he reflected, was "a standard boilerplate thing we're all somewhat numb to. But at the end [of one article] it said he had a wife and two children. And it just struck me, God, what does that mean? How does that exist? And I thought about [Fritz Lang's] *M*, and [Alfred Hitchcock's] *Shadow of a Doubt*, which is so funny and suspenseful, and [Vladimir Nabokov's] book *Lolita*, which is a hilarious tragedy."

By the spring of 1997, it was time for his own hilarious tragedy to see the light of day. "The script elicited a strong response as well. Probably [people in the industry] found the script even funnier. But you know, when people were reading the script, I said, 'You may laugh now, but when you see this, you won't be laughing quite so easily.' When you have the actual reality up there—when you're suddenly confronted with what this means—it's just not so easy.

"But it of course retains a certain kind of humor. I am moved very much by these things that I often find funny, and vice versa. And that's probably what draws me to these kinds of characters and stories."

Some readers may have found the script funny, but those doors did slam shut all over Los Angeles. But one New York–based company, October Films, quickly became interested, signing a deal with Solondz during the Cannes

Film Festival. October knew the material was challenging, but they even allowed Solondz to retain final cut. "I really do credit Bingham Ray and the people at October for having the courage to finance a movie as troubling as this script."

He smiled as he remembered casting the film. There were "people with names, A-list actors" lining up for the role of Allen, he recalled, even flying in from Los Angeles just to meet him. "'That character, that is me, that is my life,' they would say about this character." Phillip Seymour Hoffman, then an on-the-rise character actor who had been in *Twister* and *Boogie Nights*, landed the part of Allen, but October Films wanted an A-list actor for the role of Bill Maplewood. None would even consider the role, and it eventually went to the talented character actor Dylan Baker.

Solondz said October never even tried giving him story notes. "They really left me alone. They were always very supportive of me." Where conflicts arose, they concerned not content but money. *Happiness* was budgeted at a tiny $2.5 million, which forced Solondz to fight for extra shooting days and a trip to Florida to shoot scenes of the elder Jordans and their breakup. "There's never enough money. One hundred million dollars and they still can't get the film shot. I understand that." But Solondz won his arguments and ultimately made the film he wanted to make. "There were [only] a couple of scenes we couldn't afford to shoot. We didn't have enough time. We already went over enough days, but it was stuff I felt I could live without."

That's not to say that the final cut has everything that was in the screenplay. "The first cut of the movie was three and a half hours, so [on] my own I cut more than an hour out of it. Some of my favorite stuff is not in the movie. You kill your babies in order to get the whole to work. My goal is to direct a movie from a script that I write and end up not dropping anything from the script. Then I'd be really happy as a screenwriter."

Knowing that the movie might provoke hostility, Solondz was nervous before its Cannes premiere. But *Happiness* won the International Critics Award and was widely praised. October, which had known the content of the film from the start, was looking forward to promoting the movie and recouping its investment. The first hint of trouble didn't come until several weeks later, when the *Hollywood Reporter* ran a story saying that four movies on the October Films slate, including *Happiness*, would be NC-17.

Solondz was still unhappy about that story when I met him. Two of those films wound up with R ratings, he noted, and his own was never submitted to the ratings board. "But when Seagrams/Universal [October's parent company]

saw this article, they kind of freaked out. They have an image. They have to pass things through Congress, so I'm told. They just don't need this. To get all this controversy from a movie as teeny as this is not worth it to them. It's like a gnat. So therefore they [decided to] call it morally objectionable and say all sorts of hateful things about it.

"Certainly, if they believed the movie would gross a hundred million dollars, I don't believe the 'morally objectionable' clause would really have been raised. In fact, quite the contrary: They would say 'This is a morally courageous film' and so forth. So it's naive of anybody to believe that morality had anything to do with Universal's decision to drop the movie."

So the company that had dared to finance *Happiness* when no one else would, seeing it from inception to its award in Cannes, was suddenly forced to condemn it. "October loved this movie; they championed this movie," said Solondz. But it was a hopeless fight. Universal was having none of it. Unlike battles over some studio films, which are trimmed to accommodate the sensibilities of the studio or the MPAA ratings board, there was never even any pressure to cut *Happiness* to salvage its distribution deal. "I think everyone realized that it [wasn't] about cutting this shot or that shot." The problem, he said ruefully, was "the *all* of it." (October Films declined comment to this writer and has consistently refused to comment on *Happiness*.)

So Solondz found himself with an award-winning movie and no distributor. The solution came when production company Good Machine stepped in with its new distribution arm. They got a boost when *Happiness* won an award at the Toronto Film Festival and when rave reviews began to roll in from national media. The film's continued critical success may have made Universal look bad, but Solondz is philosophical about the matter. "Do they look worse than any other studio? They're all the same. I mean, you can't have any illusions. Would any other studio have done any differently? Supposedly Sony Classics wanted to distribute it, but really, ultimately, could they have? Would Sony have allowed them to?"

One of the ironies of the controversy is that while the subjects of *Happiness* may be no more outrageous than an episode of Jerry Springer, it is the very compassion Solondz showed toward his characters that seemed to offend his critics. By contrast, Solondz pointed to the phenomenon of tell-all celebrity biographies, with their frank discussion of childhood molestations. "On one hand, you have to [ask], 'Is this helpful? Is this healing? And at what point is it exploitation?' And there is a cheapening, a kind of growing crassness to our culture."

History, meanwhile, gave the controversy another ironic twist. Soon after the film's release, the nation plunged into a presidential impeachment trial, driven in part by questions of the exact definition of "sexual relations." The U.S. Congress found itself distributing explicit accounts of fellatio, cigars used as sex toys, and semen-stained clothing. The whole thing made *Happiness* seem almost discreet by comparison. Almost.

"That sort of stuff is [now being] discussed in polite conversation that never would have been discussed before in the not-so-distant past," Solondz said at the time. "Some moderator at Telluride introduced me by saying, 'Ten years from now, we'll remember this as the year of *Happiness, There's Something About Mary,* and Monica Lewinsky's dress.' I think the films tend not to be forecasters so much as they are reflectors of who and where we are. I don't think I could have, or would have, embarked on such a movie if I were not a product of my times. I wrote it in the fall of 1996. I had no idea Monica Lewinsky was going to happen. I had no idea any of these movies were going to be made. But there [was] something in the air."

Those who actually got past the more shocking surface details in *Happiness* often found something moving about this sad and alienated collection of characters. That, of course, is what really interests Solondz. "If there is a message to anything I do, I think ultimately [it's] 'You are not alone.' In reality, of course, we are all alone, we were born and die alone, and no matter how close and how intimate we are with our loved ones, ultimately we are alone. But for the duration of this movie, for the two hours you're watching it, if you feel you recognize certain things, you respond emotionally and intellectually, in a certain sense [you become] a kind of kindred spirit. You can feel you're not alone, that we're all part of the same world. We can live and share this."

A Dirty Shame

CREDITS

DIRECTED BY John Waters

SCREENPLAY BY John Waters

PRODUCERS: Ted Hope and Christine Vachon

EXECUTIVE PRODUCERS: Merideth Finn, Fisher Brothers, Mark Kaufman, Mark Ordesky, John Wells

PRODUCTION COMPANIES: City Lights Pictures, John Wells Productions, Killer Films, and This Is That Productions

ORIGINAL MUSIC BY George S. Clinton

CINEMATOGRAPHY BY Steve Gainer

FILM EDITING BY Jeffrey Wolf

CASTING BY Kerry Barden and Pat Moran

PRODUCTION DESIGN BY Vincent Peranio

ART DIRECTION BY Halina Gebarowicz

COSTUME DESIGN BY Van Smith

MAJOR AWARDS

None

CAST

Tracey Ullman . . . *SYLVIA STICKLES*
Chris Isaak . . . *VAUGHN STICKLES*
Selma Blair . . . *CAPRICE STICKLES*
Johnny Knoxville . . . *RAY RAY PERKINS*
Patricia Hearst . . . *PAIGE*

BUSINESS DATA

ESTIMATED BUDGET: N/A
RELEASE DATE: September 24, 2004
U.S. GROSS: $1.3 million
FOREIGN GROSS: $307,000

REVIEW HIGHLIGHTS

"This raucously gritty and high-spirited film could scarcely be bluer in terms of the language, but from Waters it comes as a gust of fresh air."

—KEVIN THOMAS, *LOS ANGELES TIMES*

"The film could have been ha-ha funny. Instead Waters is content to give us one ridiculous scene after another of people getting 'sexcussions' and running around with their hormones out of whack, apropos of nothing."

—ALLISON BENEDIKT, *CHICAGO TRIBUNE*

SEX AIN'T WHAT IT USED TO BE

A DIRTY SHAME • JOHN WATERS

Todd Solondz could learn a thing or two from John Waters.

Solondz was still a kid in school when Waters began making his own sexually charged, often outrageous films. Even before his breakout film, *Hairspray*—and the hit Broadway musical that was adapted from it—made him safe for the mainstream, Waters had become an icon in the indie film world, always in demand as a speaker because of his insight and quick wit—a kind of indie Groucho Marx whose absurd sensibility and tendency to take nothing seriously throw the earnest concerns of Todd Solondz into high relief.

On the day I interviewed Waters about *A Dirty Shame*, however, he was perplexed. (Not necessarily an unusual occurrence: Waters claims to be perplexed by everything from personal computers to intolerance to certain sexual fetishes, some of which figure prominently in *A Dirty Shame*.) On that July 2004 day, though, what had Waters dumbfounded was the film's NC-17 rating.

"There's not a mean bone in its body. I think it's joyous," he said from Provincetown, Massachusetts. He knew that the summer of 2004 wasn't an ideal political climate for a movie about a sex-addict cult whose messianic—yes, even Christlike—leader performs sex miracles, and whose disciples enjoy a variety of fetishes most Americans have never even heard of. This was just a few months after a glimpse of Janet Jackson's nipple during the Super Bowl halftime show provoked such outrage that Congress, apparently not busy enough with health care, homeland security, and a war, made a crackdown on media indecency a top item on its to-do list.

"Certainly all that happened harmed me," he said. "I think that's why we

got an NC-17 rating. I personally think a year ago it wouldn't have gotten that. But others say, 'Are you kidding!?'" When he asked what I thought, I had to laugh: I saw no way this movie would ever garner less than an NC-17 rating, with or without the Janet Jackson controversy.

"That really shocks me," Waters admitted. "Because there's no explicit sex in it. And if you look back—and you're never allowed to argue [for a rating on the basis of other movies], even your own—comedies like *Hot Wet Summer* [sic] or *Scary Movie* or all those really rude comedies, to me seemed no less harmful than this. [In *A Dirty Shame*] there's no violence, there are no acts against women, and it's a comedy. But I guess I was wrong."

Waters conceded that the cards seemed to have been stacked against him. "I don't think it helped that the week we screened this movie was the week the Iraqi torture pictures [from Abu Ghraib] were released. I think a couple of [the soldiers in the photos] were from Maryland. I'm glad they didn't find *Pink Flamingos* in their unit."

Welcome to Waters's world, where there's nothing odd about discovering that there's a stripper locked up above the garage, the neighbors are into group sex and "bear" love, and the fate of our heroine hinges on the timing of a David Hasselhoff crap.

Yet Waters's fans might be surprised to find out that when it comes to the characters in *A Dirty Shame*, he's not entirely on the side of the libertines. For Waters, the question at the heart of this movie is "Can tolerance go too far?" And even for Waters, who's been testing indecency laws for decades, it's not entirely certain what his answer might be.

A Dirty Shame is the story of working-class Baltimore housewife Sylvia Stickles (Tracy Ullman). Sylvia's too busy cooking scrapple to have sex and too busy keeping her sex-obsessed stripper daughter Caprice (Selma Blair) under lock and key to pay much attention to the odd characters moving into the neighborhood. Caprice, it seems, has become a local legend as a stripper, thanks to beach-ball-sized breast implants, but now that Caprice is under house arrest for indecent exposure, Sylvia is determined that "Ursula Udders" will never perform again.

But when Sylvia gets whacked in the head during a traffic accident, she's overwhelmed by sexual urges she can barely comprehend—but which are quickly gratified by a passing mechanic, Ray Ray (Johnny Knoxville). Ray Ray explains to her that she's become a sex addict and invites her to come see him when she's ready to explore her nature. By the time Sylvia gets to the store, run by her mother-in-law Big Ethel, all she can think about is sex. Soon

Sylvia is swapping her "neuter" outfits for tight spandex and pursuing orgasms with single-minded obsessiveness.

While she's visiting Ray Ray, Sylvia learns that she's the long-awaited twelfth disciple of Ray Ray's sex addict cult. The other eleven, all of whom became sex addicts after concussions, each have their own favorite fetish: dirt eating, group sex, exhibitionism, and sploshing (spilling food on the body as foreplay). There's even an adult baby. Caprice, it turns out, is one of them—the victim of a childhood maypole accident. But Sylvia is the one they've all been waiting for: She's going to lead them to invent an entirely new sex act.

Meanwhile, Big Ethel and the other "neuters" in the neighborhood band together to fight the indecency around them. Another blow to the head switches Sylvia back to neuter, and the whole family makes a trek to a Sex Addicts Anonymous meeting. But Ray Ray's addicts storm the meeting, and from then on it's open war, as the sex addicts try to take over the neighborhood and the neuters fight to bring back decency and put an end to sex.

By this point, as Waters himself put it, the film has begun to feel like "a Three Stooges sex education movie." Yet the director also says that the film really came out of something deeper and sadder than all the slapstick suggests.

"This is a movie about sex, made after AIDS, and I want to be careful, because half my friends died of AIDS. So basically, it's not about real sex. It's making fun, and celebrating, what you have to do these days to think of something new.

"When AIDS came along, people, gay and straight, had to figure out new ways to have sex, if they weren't with one partner all the time. It's a movie that celebrates sex, but sex has been injured by AIDS in our lifetime. And it's never going to go back to being like what it was before. And there's good things and bad about that. The bad thing is—well, when I was young, I had a chance to really experiment and try everything, and I think those days are gone."

Waters was careful in the film to make sure his "sex addicts" limit themselves to acts among consenting adults, safe acts with little or no risk of STDs that don't harm anyone. "Almost every act in this movie you could do," said Waters. "Not that you'd want to! But you *could*."

For Waters, the movie's comedy comes from exaggeration. "It's sex made into compulsion, into comedy," he explained. "It's not saying that sex is bad. It's saying we have to think of new ways to do things. Even sex had to be

reinvented in my lifetime. That's what gave me the idea of trying to think up a new sex act. Everybody wishes they could. We *need* some new ones. Think of it: If there was a new one, that would be hot news."

Still, Waters's take on all this sex was not so simple. "In real life, I'm somewhere in the middle on all the issues in this movie. I think people should be free to do what they want. Do I think there should be more adult babies around? I don't know. I guess [they're exercising] equal rights they are allowed to have, but I still think I should be able to say I think it's fucked up."

Surprisingly enough, the outlandish story of concussion victims who suffer from super-enhanced libido wasn't entirely fictitious. "I read somewhere [that] a tiny minority of brain injuries have a carnal lust they can't control. I just exaggerated it."

He also got to thinking about some of the more out-there fetishes he'd heard about over the years. "I didn't make any of them up," he said. Among the most memorable is the phenomenon of "Roman showers." "I don't think I know anyone who's admitted to being into Roman showers, which is vomiting on each other for foreplay," he says. "I read [about] that, though. I did a lot of research. The dirt licker—I saw that in a sex club in the seventies. And it does stick with you," he laughed. He borrowed a similar image from an underground porn mag called *Straight to Hell*. "A truck driver forced somebody to lick all the tires of his truck before they had sex. That made me laugh, [so] I used it."

For Waters, a fetish that might seem pathetic in real life can be the stuff of great comedy on-screen. "For me, when it gets really funny is when people narrow it down to only one specific weird thing that turns them on. And that's what these characters [do]. . . . I tried to [portray them] as outsiders, as people who would band together and celebrate this. And, in a comedic way, to ask the question 'Can tolerance go too far?'" When, in other words, does a fetish become a pathology? "My [film] editor always used to joke with me and say, 'I think you're secretly Big Ethel in this.' I'm not. But a few of the things she says, I am, a little bit."

John Waters on the side of the neuters? Say it ain't so.

Those who get past the outrageous sexuality of *A Dirty Shame* will realize that his "sex addicts" are just as ridiculous as his "neuters." "There's no middle," Waters says. "You can't be healthy about sex [in the film]. You're either a sex addict or you hate sex. And that's the comedy, that you have to choose sides, and eventually you have to become one or the other in this neighborhood."

Of course, Waters is hardly straight, but could he be a closet straight arrow? He's certainly learned to be strict with himself when it comes to moviemaking. He embodies a certain kind of go-for-broke daring, but first and foremost he is an independent filmmaker, subject to the discipline of low budgets and tight schedules.

"Basically, I don't want to film stuff I'm not going to use. I don't have the luxury of a budget that will let me do that," he said. "I want to get it so planned that we shoot exactly what we need."

That discipline spills over into his work life even when he's not shooting. He lives and writes on a rigid schedule. "I get up at six o'clock. I read seven newspapers. I have a piece of toast and about fifty pots of tea. Then usually I [write from] eight o'clock to twelve. If I'm really thinking up the narrative, I can only go to ten thirty. But the rest of the time I go to twelve or one o'clock. Everybody knows not to call me then. The people who work for me come to work at ten, [but] I don't see them until I'm done."

Waters has few writing rituals. "I just need to be by myself. Nobody else can be around." He writes in pen and doesn't type or use a computer. "I have pads all over my house, car, everywhere. It's corny—it sounds like a bad Hollywood joke in a movie, which it is—but I really do, to write down ideas so I don't forget them."

He starts a script by going to the neighborhood where his story will be set. "I have to find a neighborhood," he said. "First I have to think, *What kind of genre is it?*" Often the title comes first. Once that's in place he works on developing his characters, "which is the easiest thing in the world. The hardest part is the narrative—which is the only way you have a hit movie. That's the hard part, the story." Waters fills notebooks with details on his characters, devoting a page to each character; then he starts to plot out his story, literally cutting and pasting his longhand notes and scenes together and handing the result to an assistant who types it into a computer. Then Waters cuts up the printout and starts rearranging again. "I hate that you can't take scissors on airplanes," he says. "It's a nightmare for me. I need scissors when I'm cutting up paper."

He doesn't write spec scripts. Instead, he does a detailed treatment, complete with dialogue. For *A Dirty Shame*, the treatment was seventeen pages long. His agents then arrange pitch meetings for him with industry movers and shakers. "I'm not bad at doing it because I have a stand-up act," he said. "I give them a treatment, I give them an ad campaign, even though they're never going to use it, to show I'm thinking the same way they are. Which I am, in some ways." For *A Dirty Shame*, he devised the ad line "What happened to

Sylvia Stickles was *A Dirty Shame.*" "It was based on an ad I really loved," he recalls—a poster for the 1961 William Wyler film *The Children's Hour,* a "very arty kind of adult ad that just said [one word]: 'Different.' That was my role model for the cover of my treatment."

Producers Ted Hope and Christine Vachon heard the pitch for *A Dirty Shame* and gave Waters a development deal. Then it was time to turn the treatment into a script—which, for Waters, meant more cutting and pasting. "The first piece of advice I would give anybody," he said, "is never, ever turn in your first draft. What I turn in as my first draft is usually my fifth draft. It gets better and better when you rewrite it." Waters says he keeps rewriting until he finds himself putting things back in he'd already taken out. Then he knows the script is done. "Same thing when you're editing the movie. Then it seems to be done." On *A Dirty Shame,* the rewriting took three or four months.

While Waters, outré auteur that he is, doesn't go through the kind of development David Franzoni endured on *Gladiator* or Ken Nolan experienced on *Black Hawk Down,* he did take notes from his producers. "I'm *for* notes from producers," he says. "If they're good you use them, and if they're not you don't, and they don't say anything about it again." Ted Hope suggested that Waters bump up the religious side of the story by having Sylvia be chosen as the twelfth disciple. "It was a very good note," he says. Another important contribution came from New Line's co-CEO. "We shot the ending in the script, but it wasn't strong enough. Bob Shaye, who gave very good notes, said, 'You need one more punch.'" Without giving away the movie's ending, Waters decided the last beat should be a "cum shot," and so it is— though one unlike anything ever seen in porn.

Cum shot or not, *A Dirty Shame* isn't erotica. It's too farcical, too likely to gross out its viewers rather than arouse them. In fact, Waters was more concerned about catching flak for the film's satire of religion than for its fetishistic sex. "I said that throughout: What my mother is going to be mad about is [the film's religious element]. But you know I've always said that Catholicism makes sex better because it's dirty, and [it's] more theatrical."

Waters was warming to his subject. "If you believe sex is a gift from God, then if it's great, couldn't it make miracles happen?" he asked sincerely. "Couldn't there be sex miracles? I guess there are people who won't go along with my idea of the 'resur-sex-tion,' but those people aren't going to see my movie—a movie with Johnny Knoxville, an NC-17 movie—[anyway]. I'm a lost cause to those people."

So as chagrined as he was by the film's NC-17 rating, Waters admitted

that it helped in one way: It immunized him from prosecution by indecency crusaders. "*Pink Flamingos* came out for many years with no rating and we got busted a lot. And we always were found guilty, because if you watch that movie at ten A.M. in a court with a jury it *is* obscene. If you watch it at midnight stoned on pot it's not obscene, it's joyous. We always got busted until the [film's] twenty-fifth anniversary, when it [was reissued] and we sent it to the ratings board. We said, 'You don't have to watch it.' They said, 'We have to watch it.' It got an NC-17 and we were never busted again. And that had hardcore [sex]. *Pink Flamingos* deserved an NC-17. But 'joyous' is the word I would have added."

In a way, then, John Waters had come full circle with *A Dirty Shame*, another joyous picture exploring topics too far-out for studio films. He may not have been subject to arrest, but he was prepared for the fact that not everyone was going to like it. "My parents will be horrified," he said. "They won't walk out of the premiere, which is an AIDS Action benefit," said Waters, "but I'm hoping they won't get some of it."

Which raises a question: Is it worse, John, if your parents don't understand this movie, or if they understand all of it?

"Well," he answered, "they won't ask, I promise you."

"You Always Have to Read Between the Lines"

Once [a studio has] said yes to the movie, contingent on casting, they want stars. They want international stars. And they all want the same five [stars]. That's when it can fall through so easily. There's what they call a "blinking green light." There's no such thing in traffic, and there's no such thing in Hollywood either. It's a yellow light, really. Then there's the budget. You're always given less than you think you really need. It's just [a question of] how much less. Because then you have to convince the bond company, and nowadays the bond company is more and more nervous, because there are really only three of them. . . .

If you read the trade [papers], you'll see how that is manipulated. You announce a film that isn't really done yet, and then it [can fall] into place in the next couple of days if there are two or three people wanting it. If you're lucky enough. You have to have most of it set in stone if you want to get on the front page, which is the only time it really counts. Then things either happen because of the announcement, or it falls through. And if it falls through, there's never an article. Or rarely.

It's a very skilled negotiation. Good producers know how to do it. But you always have to read between the lines in the trades. You have to look at the end of each article, to see which agents and lawyers handle the people in the article—they're the people who leaked the article.

There are certain reporters who are fair, [and] there are others [who] put things out wrong . . . and it fucks the whole deal up. Those are the ones I avoid forever. I've had my movie almost fall through [because of reporters] who printed wrong information, and it looked like I planted it. [With] the ones I like, you have a relationship. You're using each other, but you're not lying to each other. ˙

Witness

CREDITS

DIRECTED BY Peter Weir
SCREENPLAY BY Earl W. Wallace & William Kelley
STORY BY William Kelley and Pamela Wallace & Earl W. Wallace
PRODUCER: Edward S. Feldman
PRODUCTION COMPANY: Paramount Pictures
ORIGINAL MUSIC BY Maurice Jarre
CINEMATOGRAPHY BY John Seale
FILM EDITING BY Thom Noble
CASTING BY Dianne Crittenden
PRODUCTION DESIGN BY Stan Jolley
SET DECORATION BY John Anderson

MAJOR AWARDS

ACADEMY AWARDS: William Kelley, Earl W. Wallace, Pamela Wallace—Original
Screenplay; Thom Noble—Editing
BAFTA AWARDS: Maurice Jarre—Score
WGA AWARDS: William Kelley, Earl W. Wallace—Original Screenplay

CAST

Harrison Ford . . . *JOHN BOOK*
Kelly McGillis . . . *RACHEL LAPP*
Josef Sommer . . . *PAUL SCHAEFFER*
Lukas Haas . . . *SAMUEL LAPP*
Jan Rubes . . . *ELI LAPP*
Alexander Godunov . . . *DANIEL HOCHLEITNER*
Danny Glover . . . *JAMES MCFEE*
Brent Jennings . . . *ELDEN CARTER*
Patti LuPone . . . *ELAINE*
Viggo Mortensen . . . *MOSES HOCHLEITNER*

BUSINESS DATA

ESTIMATED BUDGET: $12 million
RELEASE DATE: February 8, 1985
U.S. GROSS: $68.7 million
FOREIGN GROSS: $59 million

REVIEW HIGHLIGHTS

"It's not really awful, but it's not much fun. It's pretty to look at and it contains a number of good performances, but there is something exhausting about its neat balancing of opposing manners and values. . . . One might be made to care about all this if the direction by the talented Australian film maker, Peter Weir (*Gallipoli, The Year of Living Dangerously*), were less perfunctory and if the screenplay, by Earl W. Wallace and William Kelley, did not seem so strangely familiar. One follows *Witness* as if touring one's old hometown, guided by an outsider who refuses to believe that one knows the territory better than he does. There's not a character, an event or a plot twist that one hasn't anticipated long before its arrival, which gives one the feeling of waiting around for people who are always late." **—VINCENT CANBY,** *NEW YORK TIMES*

"An electrifying and poignant love story . . . it is a movie about the choices we make in life and the choices that other people make for us. Only then is it a thriller—one that Alfred Hitchcock would have been proud to make."

—ROGER EBERT, *CHICAGO SUN-TIMES*

17 | "IF YOU TALK TO EARL, TELL HIM TO CALL ME"

WITNESS • BILL KELLEY & EARL W. WALLACE

The amazing thing about writing teams is not that they break up, but that they ever succeed at all. Writing is a solitary activity by nature, and getting writers to cooperate on anything is like herding cats. Just ask anyone who's ever been active in the Writers Guild.

Some partnerships, like that of *Mona Lisa Smile* writers Laurence Konner and Mark Rosenthal, start as friendships between people with similar interests and backgrounds. Others are a match of writers with the same sensibility—or of contrasting but complementary talents. Sometimes, though, writers team up because they have to, and however well it works, that's the end of it.

So it was for the pairing of William Kelley and Earl Wallace. They must have seemed like a dubious team, even to each other. Kelley's family was prominent in eastern politics—as a baby, Billy once peed in Eleanor Roosevelt's lap—and he'd attended Harvard and Brown and studied for the priesthood before becoming a poet and novelist. Wallace was a self-made reporter who'd grown up on a farm in California's San Joaquin Valley, going on to cover crime and police work as a reporter for a Fresno newspaper. Both were strong-willed, tough, intimidating men who wrote for the same TV westerns in the 1960s and '70s. When they teamed up, neither had written with a partner before. Nor had either ever written a produced feature film.

Despite all that, though, their first screenplay turned out to be an American classic. *Witness*, which earned the pair the 1986 Oscar for best original screenplay, has become a favorite case study for screenwriting students and teachers. The team of Kelley and Wallace, it seemed, was off to a flying start.

Yet there it ended. They never wrote together again. In fact, after the

night they collected their Oscars, they rarely spoke again—a schism that left Kelley with a pang that lasted for most of the rest of his life.

Witness itself needs little introduction; the story of a tough Philadelphia cop who risks his life to save a young Amish boy who is the sole witness to a drug murder, only to fall in love with the boy's mother, has become an enduringly popular classic. But the full story of the screenplay's conception and development is a little-known and fascinating sidebar to the work itself.

In 1998, I visited Kelley at his home, a replica Frank Lloyd Wright house on the eastern slope of the Sierra Nevada. A mentor of young writers and a regular presence at screenwriting events, Kelley regaled me over dinner with the story of how this one-off partnership began, succeeded, and ended.

In the official WGA credits for *Witness*, Kelley shares a story credit with Wallace and his wife, Pamela. As Kelley explained, the film had its origins in a conversation between the Wallaces during the 1981 Writers Guild strike. Earl Wallace had been researching a cop drama in Philadelphia when his wife (who later became a novelist and screenwriter in her own right) suggested a logline: A contemporary cop falls in love with an Amish woman. Earl liked the idea and set to work outlining a plot. Later he called his old friend William Kelley, whom he'd worked with on *Gunsmoke*, to help with the screenplay.

But Wallace and Kelley had never written together before; why start now?

In fact, Wallace knew that Kelley had once written a very similar script: a story of a violent man taking refuge among the Amish and falling in love with a young mother. Kelley's script had even been produced, though by the time Wallace called Kelley it was virtually forgotten.

While working as a writer for *Gunsmoke*, Kelley had thought back to his years as a seminary student at Villanova, when he'd been introduced to the Amish of Pennsylvania. "I got an idea for this story," Kelley said, "about an Amish girl being ragged on this country road by three badasses, three brothers. Jim Arness is riding along and he kicks the shit out of them and one of them shoots Jim. He has to go back to the Bruderhoff with the girl and they fall in love, and then the badasses' father and the other two sons come back and he has to face them off, although [the Amish] have taken the gun away from him. The little boy goes and runs and finds the gun and brings it to him, and he's able to defend himself and defeat the badasses."

Gunsmoke was canceled before the script could be shot, but when executive producer John Mantley moved over to a new series, *How the West Was Won*, he brought Kelley and Wallace with him. Kelley's story was turned into

an episode of the new show, with Bruce Boxleitner's Luke Macahan replacing James Arness's Matt Dillon.

More than a decade later Wallace remembered Kelley's story and found himself working with the same ideas. "Earl called me from Fresno," remembers Kelley, "and said, 'I'm standing here plagiarizing your Amish story. My wife suggested we make it modern. We want to make it a modern policeman [who] gets involved with an Amish woman, and maybe it's through the son who sees a murder.'"

"'That sounds good to me,' I said. 'You don't have to worry about that, just go ahead and write it.' He said, 'I want to collaborate with you. I don't know dipshit about the Amish.' So we collaborated."

The two men were actually more alike than their backgrounds would suggest. Though a poet and onetime seminarian, Kelley was hardly an effete intellectual. He left divinity school before becoming a priest, joining the Air Force (and one of their boxing teams); by his own description, he was a hot-tempered, "obstreperous" man who enjoyed a good fight. He found in Wallace something of a kindred spirit, a gifted writer who had earned his way onto the *Gunsmoke* staff on the strength of a spec episode and quickly rose to the position of story editor. Both were "bad boys" who didn't suffer fools gladly. They also looked alike: Two large, bearded men, they were often confused for each other during the making of *Witness*.

The pair dove into the project feet first, Kelley remembered. "Earl did the first half of the script, which had most of the cop stuff in it. I advised him over the phone and gave him a book on the Amish. [After] I finished that first draft, we got together up at Fresno and did more or less a second draft, as fast as we could write, all in one long weekend."

Wallace was "very down-to-earth," Kelley remembered, "practical, excellent on dialogue. He's got a damn fine film mind. He would tell me, 'Bill, this is windy.' What the hell do you mean? It's only four lines. 'It's windy.' So I'd cut it back. I valued him enormously."

The pair went through as many as sixteen drafts over several years, under the title "Called Home"—the Amish term for dying. The early drafts were up to 140 pages long, and Wallace pushed Kelley to cut.

At one point, director Mark Rydell (*On Golden Pond*) showed interest in the project, but no deal was forthcoming. Then producer Edward S. Feldman, who had no major film credits, optioned the script for $20,000. Kelley and Wallace began pitching the story around town.

Kelley recalled a pitch meeting with James L. Brooks, the writer/producer of the *Mary Tyler Moore* show and *Terms of Endearment*. "He was sitting in a chair in the lotus position, with a big grin, listening. We get all done pitching, and he spins around twice in his chair and leans back and says, 'You know what I think we need?' I say, 'What?' He says, 'A comic ending.' I turned to Earl and I said, 'You hear that, Earl?' He says yeah. I said, 'What do you think?' He said, 'I think we better get the fuck out of here.' Which we did."

Finally, they pitched it to Paramount, meeting with David Kirkpatrick, Dawn Steel, and a young executive named Jeffrey Katzenberg. "Boy, did they want it. They wanted it exactly how we had it. They loved it." Paramount snapped up the script. John Avildsen was attached for a while to direct and worked with Wallace on rewrites, then dropped out. By sheer chance, Peter Weir and Harrison Ford were available at just that moment. They'd been doing pre-production for *The Mosquito Coast*, but their financing had fallen through. Paramount messengered them a script in Belize and they signed on within days.

Though much of the film's final script has sometimes been attributed to Weir, the script Paramount bought was very similar to the final film, down to some surprisingly specific details. From the outset, for example, Kelley's central image was the barn-raising scene. "I've always seen it is as a romantic interlude," he said. "Maurice Jarre called me and said, 'Bill, for this barn raising, what did you have in mind?' I said it's an idyll, a love idyll."

If John Book was going to be of any use at a barn raising, though, the writers would have to establish that he had some carpentry skills, and that led to one of the film's most memorable images. Kelley suggested to Wallace that Book's father was a cabinetmaker, but Wallace dismissed the idea at first, not interested in digging that deep into his backstory. When Kelley pointed out the importance of having Book be clever with tools—so that he'd be invited to the barn raising—Wallace exclaimed: "I know—he knocks the birdhouse over when he faints on the way out! Then he feels he has to fix it before he can go."

The partners did have some disagreements along the way. A major scene in the later part of the film, where Book breaks Amish rules and punches out a tourist bully, began life very differently. "Earl insisted that it ought to be an eighteen-wheeler coming over a hill [that] smashes head-on, drives the horse right back into the buggy, kills the mother and the father and two little kids right there on the side of the road. And that pisses him off so much that he gets out and kicks the shit out of the truck driver." Wallace wanted the truck

crash; Paramount wanted it; producer Feldman thought it was "marvelous." Kelley was against it, but never found an ally until Weir met with them about the script. Then the eighteen-wheeler went away for good.

"That took Peter" to accomplish, Kelley said.

Kelley also clashed with Feldman over how much to borrow from his old western version of the story. His original TV show had ended with the little "Simonite" boy getting the hero's gun, and Feldman wanted to reuse the idea in *Witness*. Kelley fought him. "I said, 'Nah, nah, that didn't work very well in *How the West Was Won*, and I just don't like that image.' He said, 'I love that image! The little Amish boy with the big hat on, with the big gun, running over.' Thank God Peter was on my side with that too."

Weir and Kelley eventually struck a deal on the boy-with-a-gun image. Weir wanted Samuel to find Book's gun early in the film; Kelley was still opposed. Weir offered a trade: If the writers would give him the scene he wanted, with Samuel finding the gun, he would put in a scene where old Eli Lapp would sermonize about the evils of the outside world and the Amish ethic.

Kelley wrote the second scene himself. "I gave it to Earl, thinking, 'Earl is going to change this all to hell.' . . . Earl would usually say, 'This is too pious. Can't we lighten this up a little?'" Instead, he said, "This is beautiful. Don't change a word." Weir shot the scene verbatim.

Weir, too, had his clashes with the writers. When he and Harrison Ford went east to begin shooting, Weir began rewriting the script, shooting scenes Wallace and Kelley had never written. "He was trying to make it his own, which I understand, but he didn't know the Amish." Kelley and Wallace flew to Pennsylvania, read Weir's rewrite—"awful," said Kelley—and began to put the script back the way it was.

Weir called Paramount's Jeffrey Katzenberg to complain about Wallace and Kelley, but Wallace had beaten him to the punch. Katzenberg promptly flew in from Los Angeles for meetings on location in Lancaster, Pennsylvania. After he met first with the writers, Kelley remembers, Katzenberg told them, "Bill, you can't direct it, Earl can't direct it, I can't direct it, Ed can't. We've got to go with [Weir]. But I'm going to put him squarely in his place and tell him exactly what we want." Then Katzenberg met with Weir and Ford and "read the riot act to both of them." To Kelley, Katzenberg was one of their greatest backers. "I've always felt very grateful to Katzenberg. People say 'Jesus Christ, writers are supposed to hate him.' I didn't hate him. I thought he was a damn good man."

What followed was a major story meeting on Good Friday, 1984, with

Weir, Kelley, Wallace, Feldman, and David Bombyk, the film's co-producer. Kelley kept a tape of the meeting, and a review of its contents reveals that the writers went in with nine major story points—and won eight of them.

One argument was over backstory. The film's main plot begins when a newly widowed Amish woman, Rachel, leaves with her young son to visit her sister in Baltimore. Kelley conceived Rachel as "a modern woman caught in this seventeenth-century trap," frustrated that her son would not receive more than an eighth-grade education. "She's a strong-minded woman who wants to see her child be able to study and learn about the world, and if he wants to be a doctor, become a Mennonite, that should be possible."

Through draft after draft, Kelley held on to the scenes explaining the importance of Rachel's trip to visit her sister, who had married a Mennonite. But Weir insisted it was enough for Rachel to say that after her husband's death, she wanted to see her sister. In the end, not even that detail made it into the film, and even Kelley conceded that the film plays well without it.

One of Rachel's major scenes never made it into theaters. It occurs early in the story, when Rachel and Samuel sleep at Book's sister Elaine's house. In the film, Book and Elaine mention briefly that Elaine has a man over, even though her children are in the house. In the script, there's a follow-up scene where Rachel gets Elaine's kids to help her clean up the kitchen, prompting a snide comment from Elaine's boyfriend and an argument between Elaine and Rachel. Rachel is amazed at how Elaine lives and how Fred treats her; Elaine is offended by Rachel's attitude. The scene was shot but later cut when the film came in over two hours. It was eventually restored in some television versions.

Kelley was determined that the Amish aspects of the film be authentic. "I got to know them, and I wanted with all my being to make sure they were properly presented," he says. So he hired a technical adviser named John King, who was raised Amish but left the community. Whenever Weir called with questions, hoping to fudge on the Amish details, Kelley would tell him to talk to King. "Boy, he did marvelous [things] for me." Kelley even showed King a script to make sure the Amish dialogue was believable. King approved it without a single change.

The truck crash was long gone from the script, but the scene wasn't quite done yet, either. The shooting script had Book getting out of Eli Lapp's buggy to approach the bullies. Lapp told him, "It's not our way," but Book continued on. In the film, Book's retort, "It's my way," is one of the film's "money moments." Kelley recalled that the line came out of a late-night conversation with Feldman, who called each evening to go over problem spots in the

script. Kelley would write up new material based on Feldman's notes, review it with Wallace by phone, then call Feldman with the new dialogue. "I remember so many times calling Earl and saying, 'Here's what I'm sending back. What do you think?' 'Fine, fine.' He was a little pissed that they were calling me and not him."

The way Kelley and Wallace saw it, once Book has attacked the bullies, he knows his enemies from Philadelphia will find him. It's time for him to leave, so he replaces the birdhouse. In the film, Rachel watches in silence; in the script, she confronts him angrily, saying, "You could have stayed . . . You could live this life if you wanted to . . . I could never love a man who was so little."

No movie star would stand for that last bit, of course. "Once we cast Harrison, that had to come out, and we knew that." It was another bit Kelley had disliked; even without her backstory, Rachel came off so strong and assertive on the page that even to Kelley she seemed shrewish.

In the film, Rachel's decision to give herself to Book becomes clear in the simplest of gestures: She takes off her hat. Kelley gave great thought to the hat and what it meant to the Amish. "She would never make love to him with that cap on. That's a symbol to them of virtue, the virtue of the woman, as a mother, as everything." He added that he'd never met a woman anywhere who didn't understand the image instantly.

The last part of the script may have changed the most. The third act chase/fight sequence through the barn and silo was not in the script. Kelley and Wallace had discussed the idea but never put it in until they found the eventual location. The details were invented as they sized up the real barn.

Kelley and Wallace also made a conscious decision to let Weir experiment with the ending. "We've been all over this poor guy," they thought, "let's let him do something his own way." In the script, Samuel runs to the neighbor's farm; Rachel goes to get Book's gun, but Eli stops her from loading it, saying, "It is not our way." Then, finally, Rachel rings the farm's bell, summoning help. In the film Samuel doesn't run to the next farm, Rachel doesn't go for the gun, and Eli signals Samuel to ring the bell.

Book's final confrontation with his nemesis, Schaeffer, was different in the script as well. In the written version, Schaeffer pistol-whips Book to his knees, and it is Eli who steps between them and says, "Will you kill all of us?"

According to Kelley, Weir shot four different versions of the climax. (Weir often shot two versions of a scene, Kelley says, and decided later which to use.) In one version, Kelley recalls, Book shot Schaeffer.

One version that was never shot was the one in the script, which finds Book on his knees and helpless until he's saved by Eli. Once again, there was no way Harrison Ford—or any action star—would accept an ending where he's helpless on the ground and saved by an old man, so Book became the one to step forward. Kelley doesn't remember who wrote Book's ensuing speech and suspects it was ad-libbed by Ford himself. "I think Peter called me and he said he didn't like [the scene], so I said, 'Peter, that final scene is a director's call.' And I believe in that. If I were a director I would insist on that kind of freedom. So that doesn't bother me in the least. It was probably more Harrison than it was Peter.

"I didn't know how the ending was going to be until I saw the director's cut. Maybe it's an awful admission, but it doesn't bother me. I just thought, *We've got to end it with the Amish and witnesses*."

Despite all the changes, Kelley considers the finished film remarkably close to the vision he'd hammered out with Wallace. "In a way, I look at it as a miracle, that it got made as well as it got made despite all the confusion." Even during dailies, he recalled, there was excitement about the film. "People came by and said, 'Jesus, this is a classic! This is a classic.' Nobody ever mentioned the Academy Award because that was a jinx."

Though the film is highly regarded now, not all the initial reviews were good. Vincent Canby of the *New York Times* and Pauline Kael in the *New Yorker* were notably unimpressed. But David Edelstein wrote an extended rave in the *Village Voice*, and his view eventually carried the day. The Oscar nominations that followed included nods for best picture and to Weir for best director, Kelley and Wallace for best original screenplay, Ford for best actor, Jarre for his score, and Thom Noble for editing. The film was nosed out for best picture by *Out of Africa*—the film that gave Kurt Luedtke his Oscar. But Kelley and Wallace won (as did Noble), and from the podium Wallace got off one of the more memorable lines in Oscar acceptance speech history: "I have the uneasy feeling my career just peaked."

As both an Oscar winner and a box office success, *Witness* was one of those films that changes a lot of careers. Harrison Ford proved once and for all that he could act; Kelly McGillis became a movie star; Peter Weir had his first certified Hollywood hit; and Edward Feldman left behind a career of films like *Hot Dog . . . The Movie* to become a producer of A-list projects including Weir's *Green Card* and *The Truman Show*.

Yet the writing team of Wallace and Kelley got no career boost from the success of *Witness*. They took a stab at collaborating on a novelization of the

movie, but Kelley rejected Wallace's first few pages and wound up writing the book himself. (At Wallace's insistence, they shared authorship credit.)

Then, in a phone call, Wallace broke things off with Kelley. "His business manager told him, 'Get away from Kelley as soon as you can. He's a poet and he's a novelist and they're all going to think Kelley did it all.' Which is exactly what they think. . . . Earl just refused to work with me again."

With their partnership behind them, Wallace went on to write the TV miniseries *War and Remembrance* with Dan Curtis and Herman Wouk, and several further TV movies with a new partner: his wife, Pamela Wallace. His solo credits include a movie adaptation of Longfellow's *Song of Hiawatha*.

Kelley got out of Hollywood, returning to his home in the mountains, where he wrote novels, poetry, and screenplays. He was outgoing and generous with his time, becoming a familiar face at writers' conferences, yet when I saw him he had not crossed paths with Wallace in years. "I think we could have done some fine movies together," said Kelley sadly.

As I prepared to leave, he told me he'd last heard from his onetime partner through a photographer who was doing a series of portraits of Oscar-winning screenwriters. The photographer told Kelley that Wallace wanted him to call—but the photographer had lost the number. "Earl was a dear friend," lamented Kelley, "and I miss him. If you talk to [him,] tell him to call me."

I did try to talk to Earl, but neither he nor Pamela Wallace responded to my interview requests. Some years later I reached out to Kelley again to get some information for the *Variety* obituary of one of his former TV cohorts. When his wife answered, she said in a strained voice that Bill was in the hospital. Less than two weeks later, I was writing Kelley's own obituary.

As far as I know, he never spoke to Earl Wallace again.

Monster's Ball

DIRECTED BY Marc Forster
SCREENPLAY BY Milo Addica & Will Rokos
PRODUCER: Lee Daniels
EXECUTIVE PRODUCERS: Michael Burns, Michael Paseornek, and Mark Urman
PRODUCTION COMPANIES: Lee Daniels Entertainment and Lions Gate Films
ORIGINAL MUSIC BY Asche and Spencer
CINEMATOGRAPHER: Roberto Schaefer
FILM EDITING BY Matt Chessé
CASTING BY Kerry Barden, Mark Bennett, Billy Hopkins, and Suzanne Smith
PRODUCTION DESIGNER: Monroe Kelly
ART DIRECTOR: Leonard Spears
COSTUME DESIGNER: Frank Fleming

MAJOR AWARDS

ACADEMY AWARDS: Halle Berry—Actress
SAG AWARDS: Halle Berry—Actress

CAST

Billy Bob Thornton . . . *HANK GROTOWSKI*
Halle Berry . . . *LETICIA MUSGROVE*
Heath Ledger . . . *SONNY GROTOWSKI*
Peter Boyle . . . *BUCK GROTOWSKI*
Sean Combs . . . *LAWRENCE MUSGROVE*
Coronji Calhoun . . . *TYRELL MUSGROVE*

BUSINESS DATA

ESTIMATED BUDGET: $4 million
RELEASE DATE: December 26, 2001
U.S. GROSS: $31.3 million
FOREIGN GROSS: $18.7 million

REVIEW HIGHLIGHTS

"*Monster's Ball* says that if we come from bigoted backgrounds, we have to cut ourselves loose from those bigots, even if they are family. It says that trauma may help us break free of our emptiness. It says that if we are ever to go beyond our terrible past, we may have to learn to forgive others who have changed just as we have to face our own pain if we are to liberate ourselves from the enslaving weight it can impose upon us. We rarely get such mature and truly human visions from contemporary American film."

—STANLEY CROUCH, *LOS ANGELES TIMES*

"The characters and the bond that develops between them are too complex for words. . . . Their economy and the eloquence of Mr. Foster's unshowily beautiful images give *Monster's Ball* the density and strangeness of real life . . ."

—A. O. SCOTT, *NEW YORK TIMES*

"*Monster's Ball* proves that Halle Berry had a spectacular performance inside her waiting to be unleashed and that Billy Bob Thornton still had a third one left in his stunning 2001 stockpile . . ." —MIKE CLARK, *USA TODAY*

"Written with the complexity of great fiction, avoiding obligatory scenes, cutting straight to the heart. . . . The best film of 2001."

—ROGER EBERT, *CHICAGO SUN-TIMES*

"Burning with a quiet intensity, *Monster's Ball* is bolstered by a poetic, intelligent sensibility." —ROBERT KOEHLER, *VARIETY*

18 | THE BEST SCRIPT THAT COULDN'T GET MADE

MONSTER'S BALL • MILO ADDICA & WILL ROKOS

Like Bill Kelley and Earl Wallace, the team of Will Rokos and Milo Addica came together to write a single script—but under very different circumstances. Kelley and Wallace were career writers who needed to work together on *Witness* because both had a certain claim on the material. By contrast, Rokos and Addica were struggling actors who hoped to launch their careers in front of the camera by writing themselves the roles of a lifetime. Perhaps if they'd written something as commercial as Matt Damon and Ben Affleck did with *Good Will Hunting*—or if they were as hunky as Damon or Affleck—that might have worked.

Instead, Rokos recalled, they found themselves on something of a treadmill, hearing the same thing over and over: "This is the best script that will never get made." Since neither was really looking for a screenwriting career, those were about the worst words they could hear—especially since their writing process had been so torturous that it consumed whatever friendship they'd had. Their own dreams of starring in the movie faded as famous names attached themselves to the script—but those names drove the budget high enough to stall the project. They persevered through notes and rewrites that threatened to undermine the things they valued most in their own script.

Yet somehow, three producers and a parade of departed stars later, *Monster's Ball* found its way to the screen with a high-powered cast, a suitably low budget, and even a couple of supporting parts for Addica and Rokos themselves. The writing team may not have received the acting boost that Affleck and Damon got from their Oscar-winning screenplay, but the story of *Monster's Ball* has much to teach actors who are thinking of trying their hand at writing—or anyone who writes with a partner.

Monster's Ball is a drama about three generations of executioners in a small Southern prison town. The protagonist is middle-aged Hank Grotowski (Billy Bob Thornton), a man caught between his own good instincts and the racism and misogyny of his father Buck (Peter Boyle). Buck is an aged bigot, slowly dying of emphysema, who spends his days collecting clippings about executions and watching bad TV.

Sharing the house with Hank and Buck is the youngest of the Grotowski men, Sonny (Heath Ledger). Sonny is just learning his father's trade as the prison prepares for the execution of a black prisoner, Lawrence Musgrove (Sean Combs). Musgrove gets a last visit from his young son Tyrell and long-suffering wife Leticia (Halle Berry). Hank and Sonny keep Musgrove company during his final hours, while across town Leticia flies into a rage at her son, an obese compulsive eater.

When Sonny falters during Musgrove's execution, Hank beats him and humiliates him. Sonny responds by threatening Hank with a pistol—then turning the gun on himself. Soon after Sonny's suicide, Hank quits his job at the prison. Meanwhile, Musgrove's widow Leticia struggles at her waitress job, trying to avoid being evicted from her small home. One rainy night, Hank passes Leticia on the roadside. Her boy has been hit by a car, but no one will help her. Something makes Hank stop and take the pair to the hospital. The boy dies at the hospital, and Hank takes Leticia home.

Over the next few days, Hank and Leticia begin an intense sexual relationship, fueled by their need to drown the pain of the deaths of their sons. But they have yet to discover the hidden links in their pasts, and the racist Buck still holds sway over Hank at home. As the truths are revealed, Hank and Leticia must face choices that neither of them could have imagined just a few weeks before.

Addica and Rokos met some fifteen years before *Monster's Ball* was released, while performing together in a New York production of *Fools in the West*, a spoof of the plays of Sam Shepard. Rokos was a twenty-one-year-old from rural Georgia; Addica, two years older, was a street-smart child of "hippies" who'd grown up in lower Manhattan. Somehow they hit it off.

Rokos had already started to edge toward writing with a stage adaptation of *The Ox-Bow Incident*, a film that had had a profound effect on him when he'd seen it as a boy. Impressed with his work, Addica passed the script along to Harvey Keitel, whom he'd known since he was fifteen, when Keitel was a regular in a Broome Street restaurant where Addica's mother was waiting tables. "I was always enamored with him as an actor," Addica remembered.

Rokos and Addica had hoped Keitel would direct them in *The Ox-Bow Incident*, but though Keitel liked the script, he never signed on to direct.

After their show ended, Addica and Rokos kept in touch; Addica also saw Keitel from time to time, and the established actor often mentioned Rokos and his good writing. By 1995, Addica and Rokos were in their thirties, both coming off relationships and nursing their struggling acting careers. They decided to take matters into their own hands and write a screenplay.

Holed up in Addica's tiny Santa Monica apartment, the pair set out to write a script for three major characters, hoping that Keitel would star opposite Addica and Rokos themselves.

As they started, they zeroed in on an area they had in common: troubled father/son relationships. "We both came from very dysfunctional homes," said Addica. "We both had difficult fathers we really didn't like. We didn't want to write something that would be indulgent and spiteful and take out our aggressions on our fathers, but we knew we wanted to write something about father-and-son relationships." They were especially eager to explore how a "cycle of violence" in such relationships might spin out of control.

They drew on their lives, basing characters on people they knew, especially characters from Rokos's hometown in the South. Looking to give their lead character an "interesting job," they soon decided to make him an executioner. "We were both interested in the Gary Gilmore story," Addica said, "the idea of an execution." This was before the release of *Dead Man Walking* (1995) and *The Green Mile* (1999), and the duo had never seen a contemporary film about executioners. Their research took them to a 1920s issue of *Collier's* magazine and a book called *Death Work: A Study of the Modern Execution Process.*

"Originally, Sonny, Buck, and Hank were just roommates who shared a house and worked together," Addica recalled. In the course of their research, though, they discovered that executioners traditionally pass their trade from father to son, and a lightbulb went off. "We said, oh, this is perfect. Once we changed it to his son, and he was getting his son onto the death team, the story really started to speak to us."

Their research into executions and executioners also led them to the title of their script: "monster's ball" was an old English term for the condemned man's last meal. The doomed man was the monster; the night before his death, his jailers would send him off with a party, or ball.

They started without an outline or a treatment, just a rough sketch of a father and son getting ready for an execution. "It was so far different from

what we have now," said Addica. "We didn't have an ending, we didn't even have a middle. We only had a beginning. The characters took different shapes. Hank was a much happier character. He was pursuing Leticia and she owned an art gallery in town."

Since neither was an experienced screenwriter, they turned to their acting as their main writing tool, improvising scenes and dialogue. It proved a fateful choice. "The experience of writing it was more than difficult," said Addica. "We had to dig into ourselves to get to some of the layers of the relationships that we were writing about, especially the son and the father. Will and I would improv a lot of these scenes, to get down to the essence of what we were trying to say and do.

"We were improv'ing things about father and love: 'What do I have from you, Dad? What did I ever have from you? Why don't you love me? Why didn't you ever love me? You never loved me, you never cared about me.' That touches on me and my own life and my own dad, and Will's as well. And it was hard." In such an intense writing process, Addica recalled, "you dig up a lot of stuff inside of you and reveal a lot to your partner. Afterward, when the smoke settles, the feelings haven't gone away, they're still there. Especially with guys like us, who are from dysfunctional families."

This went on for almost eight months, as the pair worked together—and flayed away at their own emotions—in Addica's ten-by-fifteen-foot apartment. They wrote "hundreds of pages" of dialogue, only to pare them back again and again. Eventually, they distilled the searing emotions of their improvs down to subtext, leaving much of the most painful emotion unspoken. It was an unusual insight for a pair of writers working on their first screenplay: Few young writers have the confidence to leave so much of the storytelling to the gestures and expressions of a not-yet-determined cast. As actors, though, Rokos and Addica shared an affinity for silences, and they deliberately chose to leave the script terse, almost underwritten.

"I know some actors like dialogue, want to add a line," Rokos said. "I know myself as an actor—I definitely prefer not to talk very much. I think that's what drew us together as artists when we first worked together. We like the inner stuff and the small moments." Sometimes, the two were convinced that dialogue would destroy the essence of a scene. "Sometimes less is best, you know?" said Addica. "But we didn't know if people would get that reading the script. We had no clue."

They completed their draft by March 1996 and started showing it to people they knew in the business. "The irony was, it never got to Harvey Keitel,"

said Rokos. Rokos, who'd been acting in a Swedish film, showed it to his producer; he liked it and passed it along to Michael Lieber, an executive producer on *Joe Gould's Secret*. "Mike got us our first writing agent," said Rokos, "and got the script around L.A. It took off pretty quick; we were lucky that way."

In fact, interest in the script was so great that Addica and Rokos never had a chance to play the lead roles they'd written for themselves. The script attracted the attention of such luminaries as Robert DeNiro, Tommy Lee Jones, and Marlon Brando. Oliver Stone and Sean Penn talked about directing.

Before too long, however, the pair of actor/writers found themselves stuck in the purgatory of development. Atlas Entertainment, best known for David Russell's *Three Kings*, took an option on the script and asked for some changes. One of them concerned a series of flashbacks in the first draft, which revealed that at the age of ten Hank had seen his father rape a small black girl. The scene was to pay off later, after Leticia innocently brings a gift to Hank's house, only to be verbally abused by Buck. "In our original draft," said Rokos, "Hank literally dragged his father out to the tombstones where his wife and his mother and his son are buried and asked, 'Why did you do that to that girl?' and physically beat him up, then put him in the home after that." The verbal abuse remains in the script, and afterward Hank decides to put Buck in a nursing home, but the explosion in between was cut.

The flashbacks and the resulting confrontation weren't the only elements that got trimmed when producers started giving notes. Atlas Entertainment eventually let the script go, and the option was picked up by Fine Line Features. The producers there wanted more dialogue and a happier ending. They also wanted Leticia's son to live.

"We were told it was too grim, [that] nobody would want to see the movie if the child died," said Rokos. "We were kind of surprised to get so much resistance on that, but the producers had the option on the script, so if they wanted the kid to live, the kid was going to live." They wrote a new ending, with Hank nursing the boy back to health and teaching him to box, so his classmates wouldn't be able to pick on him at school. "Neither one of us was very happy," said Rokos, "but we heard once that [the actor who played] Hank would win an Oscar if the kid lived."

Addica and Rokos knew this change could undermine one of the cornerstones of the script: the pain of loss that brings Hank and Leticia together. "The whole point of the relationship between these two people is that they're together because they both have lost sons," explained Addica. With that in mind, the script's sex scenes are so raw that they're almost painful to watch.

"We didn't want to write perfect, clean sex," said Addica. "Nothing to do with lovemaking. They're people who are fucking because they're desperate."

By this time, Addica and Rokos were having their own differences. By their own descriptions they are both opinionated, strong-willed people who had their own ideas of how the script should go. Their partnership, always tenuous, soon ended.

Rokos, for his part, said little about the breakup: "We never set out to be a writing team. That's all. We did one more script together. Warner Bros. hired us to write a science fiction action movie. It was while we were doing that that we figured we shouldn't be a writing team." Addica was more emotional about the experience. "It was like we were married, man, and when we broke up, it was awful," he said. "It was very difficult. But I have nothing negative to say about the guy at all."

Yet the two kept working together until *Monster's Ball* was made. At times the story was tantalizingly close to production. Fine Line gave the script to DeNiro, who wanted to play Hank; DeNiro passed it to Sean Penn, who wanted to direct. But that pushed the budget of the film far too high. Producer Lawrence Bender took an option on it next, but that led to another dead end.

Finally, producer Lee Daniels came into the picture. Daniels wanted to return to the writers' original ending, "a big selling point" to the writers. Daniels brought the film to Lions Gate Entertainment, and director Marc Forster was attached.

Though the acting in the final film is generally excellent, the most memorable performance came not from one of the male stars, playing the roles the script was meant to showcase, but from Halle Berry. The actress pursued the role of Leticia from the moment she read the script. "She came in and said, 'I know you guys don't want me in this movie, you think I'm just a big pretty face, but I want this part.' And she proved everybody who thought that maybe she couldn't do it wrong."[1]

In many ways, Leticia and Hank are unlikely lovers. Of course, they're an interracial couple in a small Southern town, and Hank has recently executed Leticia's husband. The differences also extend to their emotional makeup: Hank is repressed and inarticulate, while Leticia seems to go from outburst

[1] For a great illustration of what Don Roos means when he says "actors bring eyes," watch Berry in the final shots of *Monster's Ball*. The play of emotions across her face is remarkable, without a word being spoken.

to outburst. With so many overheated moments, yet so few words of dialogue to carry them, Berry's role demanded a lot of improvisation—including in the sex scenes. It's something that Addica heartily endorses. "Some of our dialogue is so sparse that it almost begged to be improv'ed at points. I was hoping they'd improv on it. I'm sure they made a lot of improvements where it needed it."

In the end, Addica and Rokos did get to act in their film, though you have to look closely to spot them: Rokos plays the prison warden, Addica a prison guard. And in the years that followed, both would get more work as writers than as actors. "I feel more like a failed actor than a successful writer," laughed Rokos. "I'm hoping it will help me get some acting work in the future. When *Monster's Ball* took off the way it did, I got so busy that I haven't really acted in the last couple of years." Rokos agreed, calling the turn of events "an irony of show business."

With the critical success of *Monster's Ball*—and Halle Berry's Academy Award—on their resume, Rokos and Addica could have become one of the hotter writing duos in Hollywood, favored by actors with dreams of Oscar. By then, however, they'd already resolved never to write together again. They speak highly of each other, but Addica puts it very clearly: "We're not working together, and we're not going to work together. We're not enemies or anything, but we don't hang out and we don't talk."

Nor was Addica certain that he could write many more dramas as intense as *Monster's Ball*. "It's just so difficult to bare yourself like that," he confessed. "To get to the depth of something that has any real meaning and weight, that can move people, you have to really be honest. Patrick Shanley said that an actor has to work from the darkest part of his soul, and I think that's true for all artists and all art forms. To get to that [place] can be very painful."

But the pair stayed together when it counted, working through the pain while *Monster's Ball* was in development, even as countless observers told them their script would never get made.

"Milo and I never accepted that," said Rokos. "If something fell apart, we didn't even once suggest chucking it and giving up. It was always, 'Let's call someone else.' We didn't give up. We were tenacious fuckers, and it paid off."

Monsoon Wedding

CREDITS

DIRECTED BY Mira Nair
SCREENPLAY BY Sabrina Dhawan
PRODUCERS: Caroline Baron and Mira Nair
EXECUTIVE PRODUCERS: Jonathan Sehring and Caroline Kaplan
PRODUCTION COMPANIES: IFC Productions, Mirabai Films, Key Films, Pandora Films, and Paradis Film
ORIGINAL MUSIC BY Mychael Danna
CINEMATOGRAPHY BY Declan Quinn
FILM EDITING BY Allyson C. Johnson
CASTING BY Uma Da Cunha, Dileep Shankar, and Loveleen Tandan
PRODUCTION DESIGN BY Stephanie Carroll
ART DIRECTION BY Sunil Chhabra
COSTUME DESIGN BY Arjun Bhasin

MAJOR AWARDS

INDEPENDENT SPIRIT AWARDS: Caroline Baron—Producer

CAST

Naseeruddin Shah . . . *LALIT VERMA*
Lillete Dubey . . . *PIMMI VERMA*
Shefali Shetty . . . *RIA VERMA*
Vijay Raaz . . . *PARABATLAL KANHAIYALAL "P. K." DUBEY*
Tilotama Shome . . . *ALICE*
Vasundhara Das . . . *ADITI VERMA*
Parvin Dabas . . . *HEMANT RAI*
Kulbhushan Kharbanda . . . *C. L. CHADHA*
Kamini Khanna . . . *SHASHI CHADHA*
Rajat Kapoor . . . *TEJ PURI*
Neha Dubey . . . *AYESHA VERMA*
Kemaya Kidwai . . . *ALIYA VERMA*
Ishaan Nair . . . *VARUN VERMA*
Randeep Hooda . . . *RAUL CHADHA*

BUSINESS DATA

ESTIMATED BUDGET: INR 7 million ($149,100)
RELEASE DATE: February 22, 2002
U.S. GROSS: $13.9 million
FOREIGN GROSS: $8.2 million

REVIEW HIGHLIGHTS

"An energetic and amusing drama about the power of love to make things whole ... *Monsoon Wedding* has an engaging warmth and an effortless sense of life ..." —KENNETH TURAN, *LOS ANGELES TIMES*

"One of those joyous films that leaps over national boundaries and celebrates universal human nature.... What strikes you immediately about *Monsoon Wedding* is the quickness of the comedy, the deft way Nair moves between story lines ..." —ROGER EBERT, *CHICAGO SUN-TIMES*

THE GOLDEN LION, SURE.
BUT DID SHE GET AN "A"?

MONSOON WEDDING • SABRINA DHAWAN

Before we visit the world of *Monsoon Wedding*, full disclosure is in order: In the winter of 2002, I was scheduled to write about a different studio release. At the last minute, however, the studio couldn't arrange the interview, and *Script* magazine was left with a great big hole and very little time to fill it.

As it happened, my brother was dating an Indian writer named Sabrina Dhawan, whose first movie, *Monsoon Wedding*, was getting great reviews and doing strong business. I volunteered that I could probably coax Sabrina to allow me to interview her about it, as long as everyone at the magazine knew she was my brother's girlfriend. Such an apparent conflict might be unacceptable in a more self-serious publication, but as Doc Brown said in *Back to the Future*: "What the heck." We did the interview.

Four years later, I found myself wearing one of the Dhawan family's heirloom turbans, dancing up a hill to the beat of Indian drums in Rajasthan, India. Astride a white horse, my brother led a group of friends, cousins, and parents through the ancient gate of the Neemrana Fort-Palace, while dozens of Sabrina's relatives showered us with flower petals from the battlements above. No, it wasn't a monsoon wedding—this was just after New Year's, months from the summer monsoon season—but my brother and Sabrina Dhawan were married after a glorious week of festivities, one that could have the makings of a comedy the couple may write together someday.

At the wedding I met dozens of Sabrina's relatives and friends, and spent some time wondering which ones might have inspired characters in *Monsoon Wedding*. But I never asked, and I probably never will—not least because upon its release the movie was considered quite scandalous in India.

When I interviewed her in 2002, though, Sabrina was fairly open about the origins of the script, and I'll rely on her to protect the innocent.

FOR the most part, 2001 was a pretty lame year for American movies. A late rush of quality films did give critics enough films to assemble a decent ten-best list, but the summer films were forgettable; for much of the year, the local multiplex looked like a big-screen adaptation of Bruce Springsteen's "57 Channels (and Nothin' On)."

Yet while Americans were stuck in the movie doldrums, *Monsoon Wedding* was causing a sensation in India. Far from the typical Bollywood musical, the small film was a more or less realistic look at the wedding festivities of an upper-middle-class New Delhi family. Amid the film's warmth and comedy, it touched on enough sexual taboos to earn India's equivalent of an NC-17 rating.

American critics mostly embraced the film as a feel-good crowd-pleaser. TV's *Ebert and Roeper* pegged it as the first Indian film likely to become a crossover hit in the United States, and they were right: American moviegoers— especially the art-film audience that's long been acclimatized to the work of challenging filmmakers like Todd Solondz and John Waters—seemed undisturbed by the themes of sexual abuse and infidelity that so shocked Indian audiences, and even today viewers who don't know the backstory may be hard-pressed to understand why *Monsoon Wedding* caused even the slightest controversy.

Yet screenwriter Sabrina Dhawan always felt the film's child sexual abuse story was the most important single thing in the script—even as she knew her hometown audience would find it so shocking.

"Growing up in India, hearing multiple stories, multiple times, about that happening to kids," she said, she still recognized that child molestation was almost unheard of as a topic of conversation, never mind cinematic storytelling. "In America, the issue of sexual abuse is totally open for discussion. In India, we prefer to believe these things don't exist. And if they do exist, they happen in other families, not like ours. [The assumption is that] if people do it at all, servants do it; respectable people don't do it. I have seen so much of that growing up in India. We never, never had a film about sexual abuse of a child by a family member in India."

By American standards, *Monsoon Wedding* is hardly a dark "message" movie. On the contrary, it seems to be an exuberant, lively look at modern

India and its growing middle class. The affection that both Dhawan and the film's director, Mira Nair (*Mississippi Masala*), hold for their home is unmistakable in every frame.

Born in England, Dhawan had a sheltered childhood in India's capital, Delhi. Both of her parents were doctors; her father is one of India's most esteemed surgeons and medical instructors. Dhawan was educated in convent schools, which are popular for educating girls even among Hindu families. "They tend to be really good schools," said Dhawan, "and because you're only hanging out with girls, it raises your value in the matrimonial market."

Her comment about "the matrimonial market" was not a witticism. Arranged marriages are still the rule in India; "love marriages" are unusual, and some Sunday papers carry pages and pages of matrimonial ads. Those seeking wives typically have some specific, predictable requirements. "About eighty percent of those ads, when people write them, they want someone who is 'fair,' as in light skinned," said Dhawan. "Fair is a big thing. You have to be fair, you have to be English speaking and convent educated."

Dhawan's parents weren't focused on whether she would marry well; they wanted her to follow the family tradition and become a doctor. After high school, though, she decided she didn't want to go into medicine. Instead she enrolled in Delhi University to study English literature. "My parents were convinced my life would amount to nothing at all, and since I'm an only child, they have a lot riding on me. Getting a degree in English literature is the kind of thing you do just to get a degree and get married. Traditionally, it's never led anywhere professionally."

But college was a defining experience for Dhawan. At Delhi she left her quiet life behind, encountering politically minded students, labor activists, and communists for the first time. "It just blew my mind. It was a completely different world. I felt like I grew monumentally in three years."

She took advantage of her newfound freedom to get as much exposure to Western movies as she could. Only the big American blockbusters get theatrical release in India, but one movie theater would host occasional retrospectives of Western films. "It might be Hitchcock or James Bond, but even that was more than we would normally get. My best friend and I would miss classes every time there was a retrospective on. We'd pool our meager resources. We couldn't take public transportation, because that

would take away from money for the ticket, so we'd hitchhike. Sometimes we'd only have enough money left over for one ice cream, which we had to share."

After college she moved to Mumbai and got a job in advertising, then got a master's in communications research from a college in England. Along the way she decided she wanted to be a filmmaker. With no connections in the Bollywood film business, though, she moved back to Delhi and became a television journalist. Three years later, it was time to either pursue filmmaking or commit to a career in journalism. She decided to apply to American film schools.

"But of course I was clueless about where to apply," she remembers. She'd heard of UCLA, so she requested an application from its film school, but a postal strike in Delhi waylaid the forms. Instead, she wound up enrolling at Columbia's graduate film program. "It really was not a considered choice," she admits. "I got lucky."

She arrived in New York determined to be a director, not a writer. In fact, she didn't think she could write at all. "I never had written short stories or plays. I had written journalistically, but I didn't think of myself as a writer." She looks back on her first writing classes at Columbia as "a disaster," though her teachers disagree.

After three years at Columbia, Dhawan was confident that she'd learned the craft of writing, but she was still focused on being a director. She wrote the script for a twenty-minute short film called *Saanjh—As Night Falls* and prepared to go to India to shoot it. Not long before she left, she was surprised to see Mira Nair in the hallway at Columbia.

"I recognized her, since she's a very famous face in India. I thought I should go up and say hello to her since she's also from Delhi, and she's a filmmaker and that's what I wanted to be, but I felt a little shy about doing that." Forcing herself to say hello, she was surprised again to get a warm reception. "She said, 'Oh, you're Sabrina, I've heard wonderful things about you from the head of the film division, because I was asking that they bring Indian students.'" Nair invited her to tea, and they two hit it off immediately. "We came from the same milieu, the same struggle of battling our parents to do film, the struggle of being females from India, assertive and aggressive, which Indian women aren't supposed to be." Dhawan gave the script of *Saanjh* to Nair, who promised to read it.

The next morning, Dhawan awoke to the sound of Nair's voice on her

answering machine. "She said the script was absolutely wonderful and amazing, and funny and sad, and she was so impressed with it, and we absolutely have to work together some time. Of course I got up and I grabbed the phone."

The two stayed in touch as Nair prepared to move to New York and Dhawan completed her film. *Saanjh* became quite a success in its own right: It was one of five New York regional nominees for a Student Academy Award and won a fistful of awards, including Best of the Festival at the Palm Springs International Film Festival.

Meanwhile, the seeds of *Monsoon Wedding* were being planted. Dhawan was determined to write a story set in the world she'd grown up in: Delhi's burgeoning middle class. "It's a world I'm familiar with, a world that has never been seen in film. [It's a place] where people use cell phones to live these lives," said Dhawan. "They're not that different from people living in cities all over the world, [except that] they do live in India. "But more than that, I was very, very keen to write a story of sexual abuse set within an upper-middle-class family in Delhi."

Nair maintained an e-mail correspondence with Dhawan, and one day the director mentioned that she wanted to do a film set around a Punjabi wedding. "She said, 'Let's talk about weddings and about how long and ostentatious they are.' All my family's gotten married that way, and all her family's gotten married that way." But the conversation moved on to something else; Nair was about to embark on a new Bollywood film, and for the moment, Dhawan recalls, "that was the end of that."

It was in one of her Columbia screenwriting courses that Dhawan finally got the push she needed to turn her ideas into a script. The course required students to write and then revise a full-length screenplay, but with the deadline only a week away, she was still without a script. Remembering Nair's wedding idea, and her own desire to explore family sexual abuse, Dhawan started a story of a wedding in an upper-middle-class Delhi family.

"I wrote the first draft over four very sleepless nights and days," she confessed. The script quickly took on a life of its own. "A lot of stories just developed that I didn't see coming at all. I'd write about the family who goes to the wedding; then I'd get stuck, so I'd start writing something else. And I'd get stuck with *that*, and I'd start writing something else. Just by the nature of having to do that with all these characters, it ended up being an ensemble piece."

Sabrina Dhawan on Hollywood vs. Bollywood

American politicians like to complain about Hollywood's influence on the culture, but India's "Bollywood" films arguably have a much greater impact on India's culture, which is much older. Sabrina Dhawan explains Bollywood and how the Bollywood style relates to what we see in Monsoon Wedding.

India produces seven hundred films a year, more than anywhere else. Almost all films to come out of Bombay are musicals. There's no other genre you can work in. Music is very important in Indian cinema. Characters will break into song and dance at any given excuse. Movies actually sell on the basis of their songs.

It's always a love story, rarely anything but. The camera is very fluid, with lots of zooms; it's very rich, very lush and beautiful. And Indian films are much more fantastic—as in having the element of fantasy—than American films. The suspension of disbelief is far, far, far greater in Bollywood than it could ever be in Hollywood. [Bollywood has] developed its own language, because it's so disconnected from world cinema.

It sounds like the closest thing we've seen to Bollywood from the studios is [Baz Luhrmann's] Moulin Rouge.

Moulin Rouge is very, very influenced by Bollywood; its final musical number is a song from a Bollywood film from a couple of years ago.

India has huge movie stars who are unknown in America.

Huge. And the whole movie star thing in India is incredible. Movie stars are deified, they're demigods. There are literally temples built to movie stars in India.

Did the Bollywood style creep into Monsoon Wedding?

It didn't. There's a lot of homage to Bollywood in the music and dance. But since Bollywood is such a huge influence on our lives, and it's the only kind of cinema Indians really watch, it's influential on our daily lives. Cinema is a national obsession in India. From the screen it enters into your life. In the last fifteen to twenty years, Indian weddings have become Bollywoodized. In the old days, you'd just sit around and sing folk songs created for weddings, like what happens in the henna scene in *Monsoon Wedding.* That's how it was when I was growing up. But today you'd have one of the girls dance like a certain actress from the newest Bollywood film. We never had weddings like that. So it wouldn't be possible to do a realistic movie about what happens at Indian weddings [today] and not use that influence. It was woven into the reality of the film.

The story explored the intrigues, secrets, and romances of an extended Indian family during the days leading up to an arranged wedding. While the "fair and lovely" bride's father frets that everything must be perfect, she sneaks off to resume an affair with a married ex-boyfriend. Others pair up as the story unfolds, including an unlikely romance between the coarse wedding-tent contractor and the household's shy maid. By the end of the story, the bride's cousin exposes a molester within the family, forcing the father of the bride to make a painful choice between paternal love and family obligations.

"I knew the sexual abuse story was going to be there, but I wasn't sure about anything else," said Dhawan. "I did think of the maid's love affair, but at first I thought it would be with the driver of the house. Then, when I was writing, I thought of this character I see at Indian weddings all the time—the tent contractor." Nearly all the story's main elements fell into place quickly, except for the bride's fey younger brother and his struggles with his father. "The young couple, the sexual abuse, the bride having an affair, the tent contractor and the maid were all there in the first draft. Not all of them were developed and fully written out, but they were there."

The love story between Dubey the tent contractor and Alice the family maid was especially important to Dhawan. "Dubey's utterly unapologetic, and he's very upwardly mobile," she said. "He, more than any other character, symbolizes the new middle class of India."

It was for Dubey and Alice that Dhawan invented one of the film's more memorable visual devices. Both characters have a habit of eating marigolds, the most popular flower at Indian weddings. It's the kind of visual motif usually attributed to directors, but it was Dhawan's idea, a kind of magical-realism device meant to establish a connection between Dubey and Alice.

"When I was little I used to chew on the little white core of marigold flowers all the time. It's very bizarre. You don't usually do that; it doesn't taste like anything." Dhawan decided to give her tent contractor the marigold-chewing habit. "It foreshadows what's going to happen, that unexpected love story between the contractor and the maid."

Dhawan took the script to class, where it got a great reaction. Still, she was nervous about showing it to Nair; it had been written so fast that she hadn't even proofread it. But her professor encouraged her to give the script to Nair, who liked it. "She said it had a wonderful energy and worked pretty well," recalled Dhawan.

Nair was eager to direct the still-untitled film and initially thought of

shooting it on video, following the Dogme movement's manifesto of no arti-
ficial lighting, props, or sets, and using a handheld camera. "Mira wanted to
do it as [a] quickie, before she made her next big film. Just for pleasure, just
for fun." But the director was scheduled to attend the Cannes Film Festival
that spring, so she asked Dhawan to write a treatment she could show to po-
tential financiers. At the festival, Nair soon found companies eager to fund
the project as a movie, including IFC Productions. She returned that May
with financing in hand but dropped a bombshell on Dhawan: She wanted to
shoot the film that very August.

"She didn't want to leave her young son, so she wanted to shoot it during
his vacation. And she was also keen to cast Naseeruddin Shah in the lead role
of Lalit, the father of the bride. He's one of our legendary actors. He's abso-
lutely fantastic, very highly regarded in India." But Shah could only do the
film in August, before heading off to another project with director Peter
Brook.

But Dhawan hadn't yet completed a second draft of the script, and she
was "freaked out" by the projected shooting schedule, which was limited to
thirty days. When her second draft came in at 180 pages, it was the producer's
turn to freak out. Dhawan was ordered to cut the script down drastically. The
next draft came in at an acceptable 124 pages.

She had one meeting with the financiers from IFC, who were nervous
about the sexual abuse story, which had inspired the script in the first place.
"They felt that the rest of the film was sort of romantic and fun and funny,
and then there was this abrupt shift in tone. They weren't sure if it would just
bring people down." Dhawan, of course, fought to keep the story in. "I
thought that dramatically it was very important to have it, because it's a story
about a family that's put through a test. You wouldn't understand that if the
family didn't go through some kind of major crisis."

In the end, IFC pledged to support whatever the filmmakers wanted to
do. "There wasn't much money at stake, so there weren't that many people
telling you what you should do and what you shouldn't do. Mira was very
respectful toward things I felt strongly about, so the sexual abuse story stayed.
And it worked out well. The shift in tone works out fine, and you still manage
to feel happy at the end."

Though Dhawan considered the abuse subplot the most important part
of the story, it was also the hardest for her to write, because she had so
many choices to make about how to structure it and weave it into the story.
How would it come to light? Should she include a new victim for the abuser,

or just stick to one victim, now grown? In the end, she decided she would have to have a young, new victim in the story, lest it seem mean-spirited for a grown woman to confront her abuser in the middle of her cousin's wedding.

An equally difficult problem was how Lalit, the father of the bride, would handle the revelation. In real life, the head of an Indian household would probably simply sweep the whole thing under the rug; it would be too painful to address even in private, and it would be unthinkable to take the issue outside the family. But "that would have been too hopeless," Dhawan said. She wanted Lalit to find a solution that would serve as an example for Indian families to follow in real life. The solution, as seen in the film, has indeed had a profound impact on Indian viewers. "When the film opened in India, people told me it was just wonderful, because where their own fathers in that situation didn't know how to deal with it, [the film showed them that] there was a way."

There were other changes along the way, too. A plotline involving the groom's alcoholic bureaucrat father and his abused wife was cut because there simply wasn't time to shoot it. "I was a little sad about that, too, because that pompous Anglophile bureaucrat character is such a part of daily life in India." So is political debate in India's capital city, and Dhawan's script includes far more such debate than made it into the film—another sacrifice as the script was condensed.

The August shooting schedule also meant taking a story originally set in India's winter, the traditional wedding season, and adapting it to include the monsoon rains and summer heat of August in India. Winter in India is "like spring here [in New York]," Dhawan said. "It's a beautiful time. But we were shooting in August. You can't put people in these fancy pashmina shawls and silks in August—it's way too hot and it's rainy and it's humid. So when I wrote the next draft, I had to include the monsoon, because there's no way to work against that kind of weather in Delhi; you just have to find a way to use it."

Up to this time, the script had no real title. Dhawan had wanted to call it "Shavi.com" ("Wedding.com"), as a reference to globalized India, but another company had already registered that title. "Monsoon Wedding" was meant as a working title, but by the time the film was ready for release, it had stuck.

One near-disaster gave Dhawan a final challenge. When five days' worth of footage was damaged by airport X-rays, the production was forced to mount a major reshoot—but some locations were no longer available, so Dhawan had to adjust the script to work around the limitations. Mira Nair

had liked the performance of Parvin Dabas as Hemant, the groom, and she asked Dhawan to write another scene between Hemant and his bride-to-be. Dhawan responded with a scene showing Hemant trying to engage with his betrothed, whose mind is clearly elsewhere.

Monsoon Wedding was shot between Dhawan's second and third years at film school. It became her thesis screenplay—the first in the history of the school to be bought and produced while the student was still in school. The film went on to win the Golden Lion at the Venice Film Festival, and was nominated for a Golden Globe for best foreign language film.

Dhawan said that only after *Monsoon Wedding* found such acclaim did she discover how hard screenwriting really is. Relatively speaking, *Monsoon Wedding* was "not that hard," she said. "Dialogue came very easily to me. I was literally hearing these voices in my head, because they were voices of relatives I'd grown up with." She remains acutely aware that she was lucky to have her script greeted with such acclaim on her first time out. "I'm happy that the movie's been received so well, because it was going to be a small, personal film made with no idea of whether an audience was ever going to see it."

The Aviator

CREDITS

DIRECTED BY Martin Scorsese

SCREENPLAY BY John Logan

PRODUCERS: Michael Mann, Sandy Climan, Charles Evans Jr., Graham King, and Matthias Deyle (IMF)

EXECUTIVE PRODUCERS: Chris Brigham, Colin Cotter, Leonardo DiCaprio, Aslan Nadery (IMF), Volker Schauz (IMF), Rick Schwartz, Bob Weinstein, Harvey Weinstein, and Rick Yorn

PRODUCTION COMPANIES: Warner Bros., Miramax, Forward Pass, Appian Way, and International Entertainment Group

ORIGINAL MUSIC BY "Papa" Charlie Jackson and Howard Shore

CINEMATOGRAPHY BY Robert Richardson

FILM EDITING BY Thelma Schoonmaker

CASTING BY Ellen Lewis

PRODUCTION DESIGN BY Dante Ferretti

ART DIRECTION BY Luca Tranchino

SET DECORATION BY Francesca Lo Schiavo

COSTUME DESIGN BY Sandy Powell

MAJOR AWARDS

ACADEMY AWARDS: Cate Blanchett—Supporting Actress; Thelma Schoonmaker—Editing; Kathryn Blondell, Morag Ross, Sian Grigg—Makeup/Hair; Dante Ferretti, Francesca Lo Schiavo—Art Direction; Robert Richardson—Cinematography; Sandy Powell—Costume Design

GOLDEN GLOBES: Best Picture (Drama); Howard Shore—Original Score; Leonardo DiCaprio—Actor (Drama)

BAFTA AWARDS: Best Film; Leonardo DiCaprio—Actor (Drama); Cate Blanchett—Supporting Actress; Kathryn Blondell, Morag Ross, Sian Grigg—Makeup/Hair; Dante Ferretti—Production Design; Howard Shore—Anthony Asquith Award For Film Music

SAG AWARDS: Cate Blanchett—Supporting Actress

Leonardo DiCaprio ... *HOWARD HUGHES*
Cate Blanchett ... *KATHARINE HEPBURN*
Kate Beckinsale ... *AVA GARDNER*
John C. Reilly ... *NOAH DIETRICH*
Alec Baldwin ... *JUAN TRIPPE*
Alan Alda ... *SENATOR RALPH OWEN BREWSTER*
Ian Holm ... *PROFESSOR FITZ*
Danny Huston ... *JACK FRYE*
Gwen Stefani ... *JEAN HARLOW*
Jude Law ... *ERROL FLYNN*
Adam Scott ... *JOHNNY MEYER*
Kelli Garner ... *FAITH DOMERGUE*
Frances Conroy ... *MRS. HEPBURN*
Brent Spiner ... *ROBERT GROSS*
Stanley DeSantis ... *LOUIS B. MAYER*

ESTIMATED BUDGET: $116 million
RELEASE DATE: December 14, 2004
U.S. GROSS: $102.6 million
FOREIGN GROSS: $111 million

"DiCaprio convincingly conveys the hard shrewdness and the petulance of the man. It's a make-or-break performance for the film, and it pays off."
—KENNETH TURAN, *LOS ANGELES TIMES*

"A magnificent DiCaprio fully captures Hughes' drive and intensity ..."
—MIKE CLARK, *USA TODAY*

"There's a sleek, almost tactile pleasure to be had in getting swept up in the gale force of a man who smashed through limits because he didn't see them."
—OWEN GLIEBERMAN, *ENTERTAINMENT WEEKLY*

"DiCaprio gives a turbocharged, ready-to-rock performance.... Stunningly shot ..."
—PETER TRAVERS, *ROLLING STONE*

THE AVIATOR • JOHN LOGAN

Do you remember Howard Hughes?

If you're a baby boomer, you probably remember stories of the crazy billionaire recluse, mythic as Bigfoot, rarely glimpsed, never photographed, rumored to have six-inch fingernails and unkempt hair, living out his days amid heaps of used tissues. If you're older, you may remember the dashing aviation pioneer, founder of TWA, designer of the world's most famous airplanes, and builder of the Spruce Goose. If you were born after 1980, you may well draw a blank at the name.

But Howard Hughes was as titanic—and improbable—a figure as ever stepped into the American scene. To conjure him today, you'd have to take the technical know-how of Bill Gates, the adventure-seeking daring of Richard Branson, and the entrepreneurial genius of Sam Walton, sprinkle some Ted Turner over the whole mix, and pour on some of the media hype that surrounds Donald Trump. Then imagine this already improbable man a major moviemaker (in the vein of, say, George Lucas) and a womanizer known for his dalliances with beautiful movie stars (in the vein of, say, the young Warren Beatty). What screenwriter wouldn't leap at the prospect of writing about such a figure?

Yet Hughes's life long resisted film adaptation. Jason Robards (*Melvin and Howard*) and Dean Stockwell (*Tucker*) both earned acclaim playing him, but their roles were cameos in stories about other men. Tommy Lee Jones played him in a 1970s TV biopic, but it didn't capture the sweep of Hughes's life. There were many abortive attempts to turn his life into a movie, some with very big names attached, but none ever came to fruition. By the turn of the twenty-first century, if ever a story were ripe for the picking, this was it.

Screenwriter John Logan thought so, too. "Howard Hughes was an American original," Logan said, "and one thing American movies should do is tell the stories of American originals." Logan lived with Hughes's story for five years as he researched and wrote the *The Aviator*. Working first with star Leonardo DiCaprio and producer/director Michael Mann, and then with director Martin Scorsese (after Mann decided to bow out of the director's role), Logan found the story a dream come true—but also a challenge.

The first dilemma he confronted was a question of setting limits. "The man's life was so complex," Logan recalled, "and there were so many elements to his life that the dramatist has to make some pretty severe choices. Do you treat the whole life? Do you treat part of the life? Do you focus on movies? Do you focus on women? Do you focus on aviation? Do you focus on business? When you turn that jewel of Howard Hughes to the light and turn it, there are so many facets, and they're all dazzling. But one has to make decisions."

The second, explained Logan, was the darkness at the center of Hughes's character. "He was an obsessive-compulsive. He had a legitimate germ phobia. He was very paranoid. He was hard of hearing, [an affliction] only made worse by the plane crashes he was in. So he is a very enigmatic figure to study. In my career as a dramatist I've dealt with big and complex figures, but nothing quite with the intensity of our Mr. Hughes."

Logan, who was forty-two as the film readied for release, would have seemed more likely to win a Tony than to become a writer of big-screen epics. Born to Irish parents who raised him on Shakespeare, he attended Northwestern with the intention of becoming an actor. But when he took a playwriting class—as "a fluke," he says—he was hooked instantly. "From the moment I sat down to write my first play, I've never wanted to do anything else. It was like the car shifted into the appropriate lane and I've been in that lane ever since." He stayed in Chicago, writing plays by night and working at the Northwestern Law Library by day. Some fourteen plays later, he was solidly established in Chicago theater; he even had a deal to have one of his plays filmed for TV by HBO.

Then HBO executive Brian Siberell dropped a bombshell. "He called me one day and said, 'HBO's not making your movie because I'm going to CAA, and do you want to be my first client?' I didn't have an agent, so I said sure. He said, 'You have to come out here—and bring ten movie ideas.'"

Logan borrowed money to fly to Los Angeles and meet with CAA to pitch movie ideas. "One of them was literally one line: King Lear in the NFL.

They said they'd handle that script if I took a year off from writing plays to write it." Logan took the bait, literally borrowing money to live, and emerged a year later with the first draft of *Any Given Sunday*.

After turning in the spec, Logan decamped for Australia, where a theater company was producing one of his plays. Then came another bombshell from Siberell. "I get a call from my agent saying, 'Oliver Stone's calling you in five minutes.' Three days later I was in Tokyo, meeting with Oliver—he was on a junket for *Nixon*—about *Any Given Sunday*." Three years and twenty-six drafts later, Logan had a produced movie and a terrific education in screenwriting, an art he said he's still learning every day.

By the time the subject of Howard Hughes came up, John Logan was solidly established as a writer of big-budget star vehicles and period pieces, with shared screenplay credits on *Gladiator* (he succeeded David Franzoni and preceded William Nicholson) and *The Last Samurai*. He'd known Michael Mann for some time, and the two had been looking for a project to work on together. One day Mann said, "How about Howard Hughes—Leonardo DiCaprio?" Logan jumped at the idea. "No hesitation. Absolutely, yes. Because I knew in my bones it was a great story. It was historical, which always excites me; it was American; and I knew enough about Hughes to know he was a fascinating protagonist."

Logan asked for six months to do basic research on Hughes before they even discussed a story, but the subject was bigger and more complex than he'd expected. "It was like a tree and the branches just shot out. I thought I was just going to do biographical research. But the more I got into it, the more I realized that with a character like Howard Hughes you can't just do biographical research—you have to research aviation, and engineering, and old Hollywood, and business and government contracts." Then there was the matter of Hughes's phobias. "Researching obsessive-compulsive disorder, and how the world manifests itself to a person living with that—it was a great, challenging, wonderful period of research."

Logan soon realized he was going to have to decide what to focus on in telling Hughes's story. On that score, he drew inspiration from *Lawrence of Arabia*. David Lean's film involved "one dark, complex central character you're following through the ups and downs of his epic experience," Logan noted. "But you're always tightly focused on the emotional reality of that character at that moment, [whether the film is showing] thousands of extras or just him looking at a match.

"So I knew that essentially we were going to have to find the reality of

Howard Hughes, and thankfully, for me, what clarified everything was aviation. I finally decided that this [would be] a movie about airplanes—about Howard Hughes the aviator, not Howard Hughes the moviemaker, not Howard Hughes the billionaire, not Howard Hughes the lover. . . . Because aviation was the one passion that truly remained for his entire life."

It was also the setting for one of the great dramas of Hughes's story. "The great battle [Hughes] waged to defend TWA from Pan Am was one of the great exciting events of his life," Logan noted. "Once that penny dropped in my head, all my research began to funnel into that central current."

There was no escaping the character's darkness, but focusing on Hughes's early life allowed Logan to avoid Hughes's bleak later years. And yet, when asked if there was one thing he wanted to hold on to from Hughes's story, Logan gave his answer instantly: "the sadness."

"When any dramatist looks toward a protagonist," he continued, "he has to look with compassion and empathy. It was most important to me that Howard Hughes not be presented as a stick figure with a label that says 'recluse' or 'billionaire' or 'freak.' An actual human being you felt compassion for."

Logan opened his screenplay with the young Howard Hughes and his mother, in a scene that established the roots of his germ phobia. Later, as the story advances through his Hollywood years, it's clear that Hughes is aware that his sanity is fragile and that he might lose his mind at any time; in fact, even while he was the toast of Hollywood and the consort of the likes of Katharine Hepburn and Ava Gardner, it was his greatest fear.

"That's why I say sadness," Logan notes. "We understand that this titanic figure was in fact very lonely, very scared."

With Mann helping guide the process, Logan began to work on outlines and drafts. But he also had another collaborator in Leonardo DiCaprio, who Logan said is probably the only other person in the world who read all fifteen drafts Logan wrote. Logan credits DiCaprio with doing copious research of his own, focusing on obsessive-compulsive disorder. "He and I would sit and go through those and go through all the permutations of Hughes's life. I've honestly never seen an actor work this hard and be so prepared to discuss a character and a script."

Mann, too, had been very committed to the project, but after directing *The Insider* and *Ali*, he decided to turn to a fictional project instead of another historical drama. DiCaprio suggested that Martin Scorsese might respond to *The Aviator*, and he did, so Mann stepped down as director (staying on as an active producer), and Logan found himself preparing to work with

an intimidating new director. He confesses that he was "terrified" to meet Scorsese, but the director put him at ease.

"He was so exciting and so excited by the material and so vibrant in his response to it—he was an absolute pleasure." Logan calls the process of working on the script with DiCaprio and Scorsese "fascinating." Certainly it must have been a relief to have two collaborators who were as immersed in Hughes's character as he was.

The process, he recalls, was "very respectful, very mature, very intellectual in a way. Either we would go to New York, or if Marty was out here we would meet at his bungalow at the Bel Air, and we would have very intense meetings where we'd sometimes read the script out loud page by page and discuss it." They traded ideas and storytelling strategies: "Should we dramatize this thing? Should we flesh out this character? I'd go and write stuff, I'd bring it in, we'd read it and talk about it, and gradually the script came to life."

Though he'd worked with Mann, Oliver Stone, and Ed Zwick (*The Last Samurai*), Logan called working with Scorsese his best experience with a director. He expected Scorsese to bring visual panache to the story, which he did. "What I was less prepared for," he said, "was his absolute compassion that he brought to it, because he's such a humanist. He cares so deeply about the characters. We all came to care so deeply about Howard and were very protective of him in a way. Marty was always very concerned that Howard was a fully rounded, complex, and real human being, and he was sensitive to what he was going through."

A signal demonstration of Scorsese's empathy came during a scene late in the script where Hughes attends a swank party but finds himself trapped in the men's room because he can't bring himself to touch the doorknob. "Marty thought it was important that the audience understand that when Howard Hughes looks at that doorknob he is truly terrified of it. It's not fun, it's not cute, it's not, 'Oh, look at the strange eccentric.' He looks at that doorknob and sees infection and disease, and he feels vulnerable to them."

Working with Mann and Scorsese from the outset not only insulated Logan from studio development pressures, it also freed him from having to think of the screenplay as a sales presentation that must impress script readers and junior executives. He was also able to suggest the tone of a scene with a simple line of scene description, without having to spell out details he knew Scorsese could conjure on his own. (For example, when Hughes visits Katharine Hepburn's family in New England, Logan writes, "Dinner with the Hepburns is a thrilling experience, if you like juggling axes blindfolded.")

Logan recalls the directors he's worked with as "intelligent, sensitive, intuitive people who understand—and here is the deadly word—literature. They understand that a writer suggests emotions, thought, character, an entire world in a sentence, and they can respond to that. They don't have to have it laid out. . . . When you're working with a Michael Mann or a Martin Scorsese, they smile and they get it."

DiCaprio's involvement also proved a luxury. "It allowed me to write a very intense character," he said, "because Leo is first and foremost a terrific actor. I knew there was nowhere I couldn't go with the character. As dark or as intense or as charming and romantic as I wanted to go with the character, he would be capable of bringing that to life." When it came to capturing Hughes's charisma, the actor's rakish persona didn't hurt, either. "Leo has such a dazzling luminescent look to him," he recalls—a quality that allowed the writer to explore "what Howard Hughes was like when he arrived in Hollywood in the late twenties. He dazzled Hollywood and actresses and the whole movie community, because he was like a movie star himself."

"The Coolest Possible Part"

JOHN LOGAN ON WRITING FOR ACTORS

I come from the theater. I've only been writing movies for eight years. I've been a dramatist for over twenty years. Any dramatist who says he's not writing for actors is foolish, because that's what playwrights and screenwriters do. They write parts for actors to play. I've never written a word of prose in my life. I'm not a painter, I'm not a poet, I'm not a composer or lyricist, I'm a dramatist. I know what I can do, which is write drama. [When I start a new project,] I always ask myself: What's the coolest possible part you could write for an actor to play? In this case, it was a happy synergy of the right actor with the right part with, I believe, the right writer.

My learning curve on writing movies—which, believe me, is still going on, under the tutelage of people like Martin Scorsese—[has involved] the amazing slapping-the-head realization that Leo DiCaprio's eyes communicate more than a paragraph I have written. Unlike writing for the stage, which is declamatory and presentational for an audience, in writing for a movie you're really trying to bring the audience in to see, to experience the world through a character's eyes. For me it's always stunning to watch actors communicate so silently with one another, in a way that's as powerful as the greatest line of dialogue I could possibly imagine writing.

The script jumps from a brief glimpse of Hughes as a child to his early days in Hollywood, when—as a twenty-five-year-old millionaire with no prior directing experience—Hughes made the epic aerial film *Hell's Angels*—at the time, the most expensive film ever made. That was chosen to show Hughes's determination to make his name.

"Look at where he came from: swampy pestilential Houston, making drill bits. He had incredible ambition, and the first way that manifested itself was with *Hell's Angels*, the most ambitious movie [he] could possibly make. And it required engineering, invention, creativity, and vision, which were the things Howard Hughes brought to every element of his life. So for us it was the perfect introduction to the character in action. Here is this guy; he's trying to make something out of nothing. Soon that will turn into making planes, but right now it's *making a movie* about planes."

Logan writes early in the morning—a reaction against his days as a playwright, when he worked early and had to write late. He keeps his tools simple. "To the frustration of everyone I work with, I write on WordPerfect 5.1 in DOS. I don't use a screenplay program, I just type." He keeps his desk facing a wall, so he has few distractions, and he keeps a steady supply of Diet Coke handy. He doesn't like to listen to music when he writes, but while conducting research he goes into "total immersion," listening to period music while boning up on books and magazines from the time. He came out of his research for *The Aviator* with a 250-page binder that he used as a bible, and though he tries not to depend on his research too slavishly when he's writing, he found himself referring to the binder constantly.

"As many worried studio executives and directors will attest, I tend to write very long drafts," he said. "My process of revision usually involves cutting, shaping, honing things down to the bare minimum, where it's appropriate." He has learned that cutting is often a matter of trusting that an actor can do far more with a look than a screenwriter can with a page of dialogue. But he also enjoys playing Hughes off against the other characters around him.

"The reason *The Aviator* is my favorite thing I've written is I was able to exercise—with the character of Hughes, for example—very terse, straightforward, evocative but simple language. At the same time, a character like Katharine Hepburn exists on the adrenaline of words, of verbosity and the quick slashes of synapses jumping to dazzling places you never expected. And putting those two characters together in the same scene, for example, was a great challenge and a great pleasure to write."

Cate Blanchett's performance as Hepburn won her the Academy Award for best supporting actress. DiCaprio was nominated for best actor, but lost to another actor in a biopic, Jamie Foxx of *Ray*. Logan was nominated for an Oscar as well, for original screenplay, but lost to Charlie Kaufman and the *Eternal Sunshine of the Spotless Mind* team.

It probably didn't help his chances that the *New York Times*, a few weeks before the nominations were announced, ran a long feature raising questions about Logan's sole credit.[1] The article suggested that he had used material from a specific Hughes biography without acknowledgment and revealed that Logan's agents at CAA had negotiated a contract clause giving him sole credit on *The Aviator*, regardless of any contributions made by Mann or Scorsese—a rare concession Logan had required after a credit dispute on *The Last Samurai*, on which director Ed Zwick had shared screenplay credit.

The article painted Logan in a somewhat unflattering light, specifically saying that he'd been handed a great deal of extant research material and had complained in e-mails to his agents about sharing credit. Those details turned out to be incorrect, and the *Times* eventually ran two separate corrections.

The article questions giving Logan sole credit and "pride of ownership"—a peculiar phrase, implying that the main value of authorship credits is self-esteem. It's true that there's a lot of ego riding on writing credits, but there can also be a lot of money in residuals riding on them as well—which is why the determination of those credits is the exclusive province of the Writers Guild. On a script written directly for the screen, the original writer is always credited, even if that writer has been completely rewritten. Beyond that, when a writer disputes a credit, an arbitration panel reviews the various drafts of the screenplay before determining final credits. Some writers have fought hard battles to win credit for a given film; some rewriters, on the other hand, have demanded *not* to have their names on the films they doctor, preferring to take their million-dollar fees quietly.

Sometimes the credits are quite complex, as they were on *Witness*, where three people shared story credit and two of them also shared screenplay credit. In contrast, solo "written by" credits like Logan's, without the director credited as a writer, are common—something that would seem odd to someone convinced that any film's true "auteur" is its director, but perfectly sensible to people who actually write movies for a living. The on-screen credit can be a

[1]"John Logan's Solo Show," by Dennis McDougal. *New York Times*, January 9, 2005.

screenwriter's last line of defense against directors who try to claim "pride of ownership," in the form of the "a film by" credit, for situations they didn't invent, characters they didn't create, and dialogue they didn't write.

Authorship debates aside, Logan said, *The Aviator* turned out to be "the most unlikely of movies." As he noted, "It's a very serious story, a big, expensive epic with an enigmatic, complex, thorny, edgy central character. It is the anti-studio-movie. It doesn't have a three-act structure. It's just an examination of that one character. It's like a play or an opera, in that it's really about Howard Hughes and how he moves through the world." And, for the team who brought his story to the screen, the challenge was clear: "How can we make that interesting and compelling and understandable to an audience?"

Logan's main goal was to put Hughes's story on the screen in a way that respects him and captures both his genius and his pain. "For me as a dramatist, it's a dichotomy. On one hand, he has incredible success; on the other hand, he's being tormented by these pernicious and harrowing inner demons that were active all through his life. That, for me, was a compelling story to tell—rather than the story of the Howard Hughes we knew when we were kids, the old man with the fingernails."

A SIMPLE PLAN

CREDITS

DIRECTED BY Sam Raimi
SCREENPLAY BY Scott B. Smith
NOVEL BY Scott B. Smith
PRODUCERS: James Jacks and Adam Schroeder
EXECUTIVE PRODUCERS: Mark Gordon and Gary Levinsohn
PRODUCTION COMPANIES: BBC, Mutual Film Corporation, Paramount Pictures, Savoy Pictures, Toho, Towa Video Inc., and UGC
ORIGINAL MUSIC BY Danny Elfman
CINEMATOGRAPHY BY Alar Kivilo
FILM EDITING BY Eric L. Beason and Arthur Coburn
CASTING BY Ilene Starger
PRODUCTION DESIGN BY Patrizia Von Brandenstein
ART DIRECTION BY James F. Truesdale
SET DECORATION BY Hilton Rosemarin
COSTUME DESIGN BY Julie Weiss

MAJOR AWARDS

None

CAST

Bill Paxton . . . *HANK MITCHELL*
Bridget Fonda . . . *SARAH MITCHELL*
Billy Bob Thornton . . . *JACOB MITCHELL*
Brent Briscoe . . . *LOU CHAMBERS*
Jack Walsh . . . *TOM BUTLER*
Chelcie Ross . . . *SHERIFF CARL JENKINS*
Becky Ann Baker . . . *NANCY CHAMBERS*
Gary Cole . . . *NEIL BAXTER*
Bob Davis . . . *FBI AGENT RENKINS*
Peter Syvertsen . . . *FBI AGENT FREEMONT*
Tom Carey . . . *DWIGHT STEPHANSON*

BUSINESS DATA

ESTIMATED BUDGET: $17 million
RELEASE DATE: December 11, 1998
U.S. GROSS: $16.3 million
FOREIGN GROSS: $2.9 million

REVIEW HIGHLIGHTS

"Gripping and unsettling. . . . When you get the shivers watching this wintry tale unfold, it won't be from the cold . . ." —JANET MASLIN, *NEW YORK TIMES*

"Lean, elegant, and emotionally complex—a marvel of backwoods classicism . . ."

—OWEN GLEIBERMAN, *ENTERTAINMENT WEEKLY*

"Billy Wilder meets the Coen brothers, in Raimi's quietly powerful adaptation of Scott Smith's roman noir . . ." —GLENN KENNY, *PREMIERE*

CHANCE, FATE,
AND HOMEWORK

A SIMPLE PLAN • SCOTT SMITH

Sabrina Dhawan isn't the only Columbia student to turn a class project into a produced feature. It was 1988 when Scott B. Smith, then twenty-five years old, found himself confronting a due date for screenwriting class. Unfortunately, he didn't get registered in time for the beginning of the term, so the class had already started and he had some catching up to do. "I needed something immediately, and I wanted a dramatic opening," he remembers. He quickly conjured up a scene involving a small-town sheriff who commits some murders to cover up his own guilt in a small crime.

A decade later, that scene from Smith's first assignment in his first and only screenwriting class had evolved into a bestselling novel, a lucrative screenwriting deal, and a major studio film: *A Simple Plan*.

The film opened some six years after Smith's manuscript became a hot Hollywood property. Two studios, several stars, and a parade of directors came and went, but somehow Smith hung on, becoming the only writer ever credited on the project, from book to screen credit. Along the way, *A Simple Plan* evolved from a gruesome thriller of a novel into a film that turned out to be something closer to tragedy, quite different from the book.

In the bargain, Smith also got a crash course in screenwriting. Other than his Columbia class, he began the development process with no screenwriting experience. By the time he was finished, he was able to hang in with accomplished directors and actors, defending the script. Yet the film that resulted was a puzzle: It got generally good reviews and earned Oscar nominations for Smith and Billy Bob Thornton, but never found an audience, grossing less than $17 million at the box office.

The story's evolution was slow; Smith was working from his own novel—which had become a bestseller—and his early screenplay drafts showed it. One draft, from October 1994, follows the book quite closely. It begins with a voice-over narration by Hank Mitchell, who recounts his childhood on an Ohio farm as the younger of two brothers, his years at college, his accounting degree, and his marriage to his college sweetheart, Sarah. Hank's elder brother, Jacob, was planning to take over the family farm, we learn, but debts piled up, their parents died in a car accident, and the farm was sold. As the story opens, Jacob is making a living doing odd jobs; Hank keeps the books at the local feed mill, Sarah works at the town library, and they have a baby on the way.

One New Year's Eve, Hank and Jacob make their annual trip to their parents' grave, along with Jacob's friend Lou, the town drunk. On their way home, a fox darts in front of Jacob's truck on a farm road, causing an accident. The men follow the fox into the woods and discover a small plane. The pilot is dead, but there is a duffel bag in the back—and inside the bag is $4.4 million in hundred-dollar bills. At first Hank wants to return the money, but Lou talks him into keeping it. They agree that Hank will hold the money, and if nobody comes looking for it by spring, they'll split it three ways and leave town.

Yet the brothers' plan starts to unravel almost immediately. The local sheriff, Carl Jenkins, happens by as they're still near the woods, and as Hank nervously explains why they're stopped, Jacob wanders over and asks, "Did you tell him about the plane?" Hank splutters that they'd heard a plane with engine trouble in the distance, and after Carl leaves, Hank chews out Lou and Jacob for being so stupid.

When Hank tells Sarah about the money, she warns him to return a half million dollars to the plane, so that when the plane is found, the site will appear undisturbed. Hank brings Jacob with him back to the farm road, but while Hank is at the plane, a farmer comes by on a snowmobile, hunting fox. Jacob panics and hits the farmer with a tire iron. Hank thinks the farmer is dead, so he decides to make his death look like a snowmobile accident. Hank carries the body off—but the farmer regains consciousness, so Hank decides to smother him rather than admit what's happened and risk jail. Jacob wants to turn himself in but agrees to keep silent when Hank explains that he, not Jacob, really killed the man.

Then Sarah happens upon a news item at the library about a pair of brothers who kidnapped a girl and received $4.4 million in ransom. Sarah is

thrilled, because the clipping says the ransom was paid in unmarked bills. Then Lou comes to Hank's door in the middle of the night, demanding some of the money. Hank refuses, insisting they stick to their plan, but Lou threatens to tell the sheriff who killed the farmer (by now Jacob has told him what really happened). Hank is cornered—and in the middle of the confrontation Sarah goes into labor.

In the recovery room, after giving birth to a baby girl, Sarah tells Hank to trick Lou into "confessing" the murder, and to tape the conversation so that Lou won't be able to blackmail Hank. Hank gets Jacob to agree to help, on the condition that Hank will let him use the money to buy their parents' old farm. Hank knows they'll be caught if Jacob ever goes back to the farm, but agrees anyway.

Hank tells Lou he's decided they should split the money now, and the three go to Lou's house to celebrate. Jacob helps Hank tape Lou. Hank plays the tape for Lou, warning him that if it came to Hank's word against Lou's, nobody would believe Lou. Furious, Lou threatens Hank with a shotgun. Jacob kills Lou with his hunting rifle. Lou's wife runs to the bedroom, grabs a pistol, and shoots at Hank, and Hank has to kill her with Lou's shotgun. Panicked, Hank calls Sarah, who tells him to lure their next-door neighbor up to the bedroom, shoot him, and make it look like Lou caught Nancy in bed with the neighbor. Hank follows the scheme and kills the neighbor in cold blood. Jacob wants to turn himself in, and with the police on the way, Hank shoots Jacob with the shotgun.

With Jacob dead, Hank seems to be home free—until Carl, the sheriff, asks him to come and meet an FBI agent who is searching for a lost plane. The agent claims that the plane was carrying money from an armored truck robbery, but Sarah becomes suspicious that he's actually the surviving kidnapper, looking for his brother and the ransom. Sarah confirms the worst, but too late; Hank's already committed to go with Carl and the FBI agent to search for the plane. Hank sneaks one of Carl's guns and goes with them to the farm road. When Carl finds the plane, Hank tries to warn him that the agent is a killer, but the agent kills Carl. Hank survives by killing the agent.

Again, it seems like Hank is home free, until he learns that the real FBI agents on the case have recorded the serial numbers of the hundred-dollar bills—the money is marked after all. Then Sarah tells him that she just spent one of the bills to buy champagne. Hank goes to the convenience store to steal the bill. When the clerk resists, Hank fights the man and hacks him to death with a hatchet. An old woman happens by, and he has to slaughter her,

too. He returns home and burns the money. Hank and Sarah return to their lives, trying to pretend they're like everyone else, living with the knowledge of all they did—and that it was for nothing.

With its violent story set within a wholesome American neighborhood, it's easy to look at *A Simple Plan* as a morality play with political overtones. Smith, however, says he had no such thing in mind. "Everyone always talks about the book and the movie being about greed and money, but for me it was always about not getting caught. Having done something that initially seemed like a small transgression—compared to what he ends up doing—[Hank's actions play out] almost like a Watergate scenario, where you do worse and worse crimes to cover up the initial crime."

In fact, Smith calls his original thriller a "potboiler." After finishing his MFA at Columbia, he'd moved to New Orleans to write, and when he needed to make some money, he went back to his old screenwriting assignment. The scene he'd written for class, he recalled, was the scene where Lou, his wife, the neighbor, and Jacob are all killed. At first he thought of the scene as the opening of a screenplay, but at that point he didn't know what the story was. "I needed something immediate, and I wanted a dramatic opening, and that's what it was," he said. But he did know that he wanted the story to feel inevitable, even tragic, with each step leading inexorably to the next. "I definitely wanted that feeling, from the beginning, with the fox running in front of the truck. It's that weird combination of chance and fate, which I found very intriguing, and I wanted that to come across in the film. . . . [That sense of] things clicking into place, carrying the story forward—I definitely wanted [that] to come across."

The Ohio winters of his own childhood gave him a key to the story's atmosphere, "this kind of low, gray sky, this flatness and this grayness that I wanted to permeate the whole book."

Smith spent a year and a half weaving a story about the events before and after that original murder scene. At that stage, he was thinking only of a book, not even dreaming of a movie. In 1992, he landed a book deal with publishing house Alfred A. Knopf, but *A Simple Plan* wasn't a hot property in the publishing world—at least not yet.

"Actually, the success of the book was very much powered by Hollywood's interest," said Smith. "My deal with Knopf for the hardcover was a very modest first-novel advance. Then, when Mike Nichols showed an interest in it, suddenly the sales for the foreign rights were so much larger than what I'd gotten for my domestic advance."

Nichols optioned the book in the fall of 1992, a full year before it was scheduled for publication, in a deal worth $1.1 million. Nichols was so enthusiastic that he put up $250,000 of his own money, with Savoy Pictures committed to the rest. Smith would get $150,000 against $350,000 to adapt the story.

Smith had pulled off the rare writer's hat trick—selling the book, selling the screen rights, and securing a deal to write the screenplay—far beyond the then-twenty-seven-year-old's expectations. "I was happy with the modest book deal," he remembers. "I didn't envision what happened in any way at all. It was all just good fortune."

By the time the book became a bestseller, Smith's onetime school project had become one of the most sought-after properties in Hollywood, with actors and directors lining up to get involved. Smith began a new career as a screenwriter, though not without some trepidation.

"The funny thing is, I'm kind of a solitary person, and when I first decided to write the screenplay I was horrified by the idea of doing anything like collaboration. It just seemed like a horrible experience, but I really ended up enjoying it."

By his own account, though, his first draft for Nichols was "just horrible." He recalled Nichols telling him to "transfer the book to screenplay form. I really had no idea what I was doing, and I think he took one look at [the result] and decided it would be best if he wasn't involved with the project."

Smith recounted all this with self-deprecating humor, but in fact no one would walk away from such a property simply because of a first draft by a novelist and first-time screenwriter, no matter how bad it was. Agents often hold out for the triple-dip of a book deal/rights deal/screenwriting deal, and if the property is in great enough demand, a studio and producer will pony up for all three pieces, even if they expect that first draft to be horrible. Jerry Bruckheimer Films, for example, gave Mark Bowden a shot at adapting his *Black Hawk Down*, almost certainly expecting to "burn off" that obligation and put another writer on it. It's just another cost of doing business. If the script turns out good, all the better.

In fact, Nichols's departure from *A Simple Plan* prompted a bitter lawsuit from Savoy. Nichols wanted to direct another novel adaptation, *All the Pretty Horses*, though he was willing to remain on *A Simple Plan* as a producer. Savoy wanted Nichols to do *A Simple Plan* first. Happily for Smith, though, the next director in line was Ben Stiller.

"Ben really taught me how to write a script," said Smith. "I don't know if he ever explicitly said it, but by imagining the script as a verbal description of

a movie, the movie that I wanted the book to be. That's very simple, but it really was the key to everything for me—just imagining what was on the page. I was shortchanging the visual in my script, concentrating on dialogue, which I imagine is a very common first-time screenwriter's mistake, and to suddenly just do it visually opened up everything for me."

The drafts Smith wrote for Stiller basically followed the same thriller plotline as the book. Then, once again, the project fell apart. Stiller wanted Ethan Hawke to play Hank, but Savoy signed Nicolas Cage to a $4 million pay-or-play deal. Frustrated at the casting and budget problems, Stiller dropped out.

Savoy was determined to push ahead with the project quickly, though. Various directors were approached, including Sam Raimi, but John Dahl got the nod. Dahl was to do his own minimal rewrite, Cage would star as Hank, and there was talk of Patricia Arquette playing Sarah, but that, too, came to naught. Eventually, Savoy Pictures itself was dissolved and its assets, including *A Simple Plan*, were sold off. Paramount bought the rights in the fall of 1995. Somehow, though, Smith was never replaced as the writer.

"I was very lucky, absurdly lucky really, given how many times the script changed hands. I kept waiting for someone to wake up and realize that maybe I was the problem, get rid of me," he laughed.

As time went on, though, Smith's long-term involvement proved an advantage. "I was the one link from the beginning. I was the one person who knew all the drafts, and when [a new idea] came up—"Why don't we do that?"—I'd been there three times already and I could say why not."

The years of development gave Smith time to hone his screenwriting skills, too, following Stiller's think-visually advice. In the original story, for example, Hank and Jacob's boyhood home had been demolished, and their visit to the site is a trip to an empty field. Smith liked the blankness of the image, but he also explained that "in the book, you're inside the character's head and you can see what was there. The idea of this erasure of their whole childhood, for me, was more moving than that house that's slowly falling down. But when you just see the characters you don't have all that past, unless they're talking about it." In the later draft and the film the farmhouse still stands and becomes one of the film's most important images.

In early drafts, Smith even tried turning Hank's thoughts into fantasy sequences, where the audience would see Hank's imagined idea of what would happen next. Then the story would jump back in time and we would see what *really* happened. "It was an attempt to get Hank's subjective experience onto the screen. It also just seemed fun to me, probably naively. It's a

kind of film-school 'Wow, look what we can do' idea. But I don't know if it really would have worked."

When Paramount acquired the rights, Scott Rudin came aboard as the producer. Rudin, known for being as brilliant as he is difficult, began to pressure Smith to find more depth in his story. "At the time I probably didn't recognize it," remembers Smith, "but he's very rewarding to work with, because he's very pushy, and pushy in a way that I think my story needed to go. He wanted more emotion. I can visualize his note in the margin—'more emotion'—in the scene out at the farmhouse. So I was constantly trying to find ways that would twist things up another notch between Hank and Jacob."

Rudin pushed Smith to make even small details more dramatic. The discovery of the plane, for example, is simple in the book and the early draft, but in the later draft, and in the film, the plane is covered with snow, and as Lou and Hank walk through the snow the simmering tensions between them lead to a half-bantering argument. Lou throws a snowball—which knocks loose a thin sheet of snow and reveals the plane. Not only is this a more dramatic scene, it fits perfectly with Smith's original idea of small, inevitable steps leading to tragedy.

Most important, Rudin focused on changing the placement and manner of Jacob's death. For a time, Rudin thought that Jacob should kill himself. He was concerned that the audience would reject Hank if he killed his brother, Smith recalled. "There was a lot of pressure to make Hank seem like a nicer guy." (Score another notch for "relatable.") It was a question that would dog the production until Sam Raimi returned years later. "I told Paramount that we would understand him at every step of the way," explained Raimi. "I'm trying never to create a situation in the film where he leaves us behind and we look at him objectively, saying, 'Why the hell did he do that?'" Raimi relished the challenge of getting the audience to bond with Hank, so that "they know exactly what he's thinking at every moment and they can sin with him. They can take the money with him. They'll make the decision with him to commit that sin. They'll say, 'Come on, take the money, you idiot.' And then he'll take the money. And then they'll be guilty, and their fate is bound up with his from that moment on."

Eventually, though, Rudin and Smith solved the problem of Jacob's murder with a new ending: Hank would still kill Jacob, but only reluctantly, and not until Hank returns to the plane with Carl and the FBI agent. This proved a crucial change, forcing Smith to move the focus away from the Hank/Sarah relationship and toward the two brothers.

Smith had always seen Hank as being pulled in two directions, torn between the ruthless, intelligent Sarah and Jacob's simple morality. As the story evolved, Sarah became less of a Lady Macbeth figure, guiding Hank's murders; more and more, Hank came to drive the action, coming up with most of his ideas on his own. As a result, one of the film's strengths is that Hank's illusions are stripped away as he plunges deeper into darkness, and he learns a series of terrible truths, most of them from Jacob.

With Rudin urging him on, Smith added a twist to the brothers' visit to their old farm: Jacob reveals that their father lost the farm because of Hank's college debts. In effect, Jacob's future was sacrificed for Hank's. In another, later scene, which Smith and Raimi had to fight to keep in the film, Jacob also reveals that their father killed himself, making it look like an accident so they could collect his life insurance. The college-educated Hank may think of himself as the smart one, explained Smith, "but Jacob's the one who really knows what's going on. Jacob's much closer to the parents, he knows all the family secrets."

Smith and Raimi eventually had to argue to keep the scene in the film. For Raimi, it was a crucial moment, because for him the film was the story of "two brothers discovering the love they have for each other." He credited longtime Paramount Studios chief Sherry Lansing for supporting his decision to preserve the scene.

Of course, Hank is morally oblivious, too; Jacob, who seems like a loser, has more moral sense than anyone in the story. This leads to one of the movie's most memorable scenes, when after Lou's murder, a depressed, drunken Jacob asks Hank: "Do you ever feel evil?"

Smith had struggled for a long time to find a way to show the weight of Jacob's guilt. "We went through a lot of bad ways to do it, like showing Jacob in church. This was the good way. Hank is anxious and fearful about the possibility again of getting caught, but he isn't thinking about the implications. He's thinking of his body rather than his soul, I guess you could say."

The shooting script followed that with a scene that didn't make it onto the screen—one of Smith's few regrets about the finished film. In the scene, Sarah tells Hank they should have Jacob over more often. It seems like a warm moment until she adds, "If he's gotta drink, I'd rather he did it here than somewhere else."

"She's thinking very coldly," said Smith. "There's that push again, where Hank is torn between his loyalties to his wife and his brother. I just like that feeling of Hank being pulled in two different directions."

Even with the weight of these scenes and others added onto their relationship, Hank is eventually forced to kill Jacob—but the scene has a further twist that makes the killing heartbreaking, and the hatchet murders that were the story's original climax were cut.

While Rudin was working with Smith, he was also lining up his stars: Bill Paxton to play Hank, Billy Bob Thornton as Jacob, and Bridget Fonda as Sarah. John Boorman was slated to direct, and the film was nearing production when Paramount stopped it over a budget dispute. Boorman left the project.

Then, finally, Sam Raimi signed on to direct—and Smith's new story nearly went out the window. "When [Raimi] first signed on," Smith recalled, "he wanted to go back to the earlier draft of the script. He wanted to make a real thriller. I think that's what excited him about the script. And Billy Bob Thornton was already attached, and his part is so much more interesting in the later draft that he had really no interest in going back. So for a while we went back and forth, trying to make a hybrid of the two, and it didn't work at all, so he resigned himself to doing the later draft."

By Raimi's own account, he was able to "push it in a few places where I felt I needed the suspense, back to what I liked about the script and the book," but the film is some of Raimi's best and subtlest work. Smith, for one, wasn't surprised by the outcome. "I knew immediately from talking to him that he got the story and he wanted to tell the story in a way that was appropriate. I think when people heard Sam Raimi they thought [there'd be] a lot of fancy camera movement or something, which is more appropriate for horror movies. He didn't do that at all. He was very interested in telling it simply and straightforwardly."

Remembering the book and the early draft he had read, Raimi tried at first to restore the original ending, with its convenience-store hatchet murders. But he soon came to side with Smith against it, even in the face of pressure from the studio to put it back in.

"After you've made that change so that it's about the brothers," said Smith, "and he's killed his brother, I really felt strongly that the movie was over then . . . To have him go off and do that very elaborate scene, a very violent scene, in the liquor store, [would] lose people."

Jacob's new importance came at the expense of Sarah's role, but she still has one gem of a scene, a devastating monologue where she lays out her dissatisfaction with the life they're living. This, too, was a shift from Smith's original characters. "In the book, it was Hank showing much more self-awareness,

thinking to himself that they're talking about how they can always burn the money, but it isn't really true, because once they've started envisioning their lives in a new way, their old lives, which they were formerly content with, suddenly seemed unlivable."

In the film, someone had to actually *say* as much, not just think it. The scene fell to Sarah—"It was a way of giving Sarah a moment, [when] she was fast losing all her other moments"—but it also gave Hank yet another terrible truth to discover.

Despite the years and many drafts it took for Smith's story to reach the screen, the film wound up retaining the same tragic sense of inevitability and bleak atmosphere Smith had wanted from the beginning. Smith found the film "a little slower" than the novel, "but it has more emotional depth." For a first-time writer, the process of adapting his own story was an extraordinary experience for Smith, complete with on-the-job training in screenwriting from an array of major Hollywood talents: Mike Nichols, Ben Stiller, Scott Rudin, John Boorman, and Sam Raimi, not to mention Billy Bob Thornton. Smith found them "amazing people to collaborate with. No ego involvement, an interest in really telling the story in the best possible fashion, throwing out ideas, and if the ideas don't work, they don't clutch at them because they're their ideas, and that allowed me to be the same way."

Raimi had fond words for Smith. "He's a gentleman, he's a man of great endurance and patience, and we wouldn't have a movie without him. So many different people tried to push and pull it in so many different directions, but he stuck with his vision, and that's really what we have on film here."

As it happened, a decade would pass before Smith published another book. His novel *The Ruins* appeared in 2006, earning Smith a scolding in print from Stephen King for his long absence and reviews less rapturous than those for *A Simple Plan*. *The Ruins was* more of a fantasy-horror story than *A Simple Plan*. But once again, Smith seemed to be on the road to a major feature: Two years before, his old friend Ben Stiller had made a preemptive deal for the rights. And Smith was assigned to adapt the script.

Welcome back to Hollywood.

The Hours

CREDITS

DIRECTED BY Stephen Daldry
SCREENPLAY BY David Hare
NOVEL BY Michael Cunningham
PRODUCERS: Robert Fox and Scott Rudin
EXECUTIVE PRODUCER: Mark Huffam
PRODUCTION COMPANIES: Paramount Pictures, Miramax Films, and Scott Rudin Productions
ORIGINAL MUSIC BY Philip Glass
CINEMATOGRAPHY BY Seamus McGarvey
FILM EDITING BY Peter Boyle
CASTING BY Patsy Pollock and Daniel Swee
PRODUCTION DESIGN BY Maria Djurkovic
ART DIRECTION BY Nick Palmer
SET DECORATION BY Philippa Hart
COSTUME DESIGN BY Ann Roth

MAJOR AWARDS

ACADEMY AWARDS: Nicole Kidman—Actress
GOLDEN GLOBES: Best Picture (Drama); Nicole Kidman—Actress
BAFTA AWARDS: Nicole Kidman—Actress; Philip Glass—Film Music
WGA AWARDS: David Hare—Adapted Screenplay

CAST

Meryl Streep ... *CLARISSA VAUGHAN*
Julianne Moore ... *LAURA BROWN*
Nicole Kidman ... *VIRGINIA WOOLF*
Ed Harris ... *RICHARD BROWN*
Toni Collette ... *KITTY*
Claire Danes ... *JULIA VAUGHAN*
Jeff Daniels ... *LOUIS WATERS*
Stephen Dillane ... *LEONARD WOOLF*
Allison Janney ... *SALLY LESTER*
John C. Reilly ... *DAN BROWN*
Miranda Richardson ... *VANESSA BELL*
Eileen Atkins ... *BARBARA IN THE FLOWER SHOP*

Margo Martindale ... *MRS. LATCH*
Linda Bassett ... *NELLY BOXALL*
Jack Rovello ... *RICHIE BROWN*
Michael Culkin ... *DOCTOR*
Colin Stinton ... *HOTEL CLERK*
George Loftus ... *QUENTIN BELL*
Charley Ramm ... *JULIAN BELL*
Sophie Wyburd ... *ANGELICA BELL*
Carmen De Lavallade ... *CLARISSA'S NEIGHBOR*
Christian Coulson ... *RALPH PARTRIDGE*
Daniel Brocklebank ... *RODNEY*
Lyndsay Marshal ... *LOTTIE HOPE*

BUSINESS DATA

ESTIMATED BUDGET: $25 million
RELEASE DATE: December 18, 2002
U.S. GROSS: $41.6 million
FOREIGN GROSS: $66 million

REVIEW HIGHLIGHTS

"*The Hours* is exquisitely written, graced with a gift for elusive emotions and an effortless ability to delineate lives. . . . A splendid film."

—**KENNETH TURAN,** *LOS ANGELES TIMES*

"Richly layered, deliberately paced, dealing with difficult emotions and life decisions, it feels like a moody wintry afternoon. . . . A powerful adaptation of a complex work of fiction." —**CLAUDIA PUIG,** *USA TODAY*

"Bathe—soak, more like—in the voluptuous sadnesses of Mss. Woolf, Brown, and Vaughan, delineated with such refinement by Nicole Kidman, Julianne Moore, and Meryl Streep . . ." —**LISA SCHWARZBAUM,** *ENTERTAINMENT WEEKLY*

THE HOURS • DAVID HARE

Adaptations of popular novels like *A Simple Plan* have been a staple of Hollywood filmmaking almost from the dawn of movies. In the first decade of the twenty-first century, as the studios attempt to invest their high-risk budgets in low-risk stories vetted by their success in another medium, they turn increasingly to established novels over original spec scripts.

So-called literary novels, however, rarely get made into movies. For one thing, literary fiction isn't terribly accessible or popular—so much so that popular (or mass-market) and literary fiction are considered separate categories in the publishing world. That lack of mass readership is a problem for filmmakers. After all, it costs tens of millions of dollars to produce a movie, and that means millions of people will have to buy tickets—or DVDs—or the investors lose money.

If that weren't barrier enough, there is the problem of adaptation. Internal action, the hallmark of quality contemporary fiction, presents a thorny problem for screenwriters. Even popular writers like Stephen King spend a lot of time inside their characters' heads. Often, it's the characters' thoughts, as much as their actions, that make the story compelling. Literary fiction can be so internal that sometimes it seems to boast no "action" at all. But short of laying voice-over narration on top of the action—a risky strategy for even the best screenwriters—how does a movie reveal those thoughts to the audience?

And then there's the problem of genre. Movie studios love genre categories, because they make movies easier to market. Yet literary fiction eschews genre. In one NPR commentary, critic Andrei Codrescu spoke repeatedly of the genre-bending literary novel, as if genre-bending were what makes modern literature, well, literature.

The Hours is a perfect example. In this acclaimed novel, writer Michael Cunningham reimagines Virginia Woolf's novel *Mrs. Dalloway*. Cunningham weaves together the stories of three women in three far-flung locales and time periods, linked primarily through Woolf's book. It's a literary novel based on another literary novel, and it glorifies reading and the power of literature. It's not light or upbeat, at least on the surface; death hangs over the story like the promise of a chill November downpour. The *Yale Book Review* called *The Hours* "one of the most daunting literary projects imaginable." And, just as Codrescu might have predicted, it's a genre-bender if ever there was one.

The Hours earned extraordinary acclaim, to be sure: The winner of the Pulitzer Prize for fiction and the PEN/Faulkner Award, it was named a Best Book of 1998 by the *New York Times*, *Los Angeles Times*, *Boston Globe*, and *Chicago Tribune*. Yet most people thought it was unfilmable.

To work as a movie, *The Hours* needed a very special kind of writer: someone who liked and trusted actors, who could write roles they'd line up to play. A demanding maverick, uninterested in regurgitating Hollywood formulas. An artist in his or her own right, who could stand in line with Virginia Woolf and Michael Cunningham without being either intimidated or dwarfed by them.

Enter David Hare.

No genre? No problem. For Hare, who's written nine Broadway plays, that's what drew him to the project in the first place. "I think that the cinema is dying from this exhaustion of genre," Hare said. "Cinema just gets duller and duller as it settles into genre. Every movie you go to, you know within two minutes what genre it's in. It's an action movie, it's a teenage comedy movie, it's a thriller, it's a film noir. Nearly all the cinema to which I'm responding now," he said, "can't instantly [be] consigned to genre."

The Hours, in Hare's view, was "not a women's picture, it's not a literary picture, it's not a heritage picture, it's just very, very unusual. Whether you like it or dislike it, it's of its own kind. You can't compare it to similar movies. There are no similar movies."

To many in Hollywood, that might sound like a death sentence; after all, it's a longtime convention that pitching involves making your story sound like a "fresh" combination of tried-and-true ideas: "It's *8 Mile* crossed with *Spider-Man*, with a nod to *Harry Potter*." Tell a producer "There are no similar movies," and you might expect, oh so gently, to be shown the door.

But Hare, of course, is not of Hollywood. He's a man of the theater, of

London and New York, of a world where the writer's words are king, and if they're good, they can last for centuries. He was just the man to make *The Hours* work, and he did. His script snared three of the English-speaking world's best movie actresses—Meryl Streep, Nicole Kidman, and Julianne Moore—and one of the year's most accomplished ensemble casts. It also secured him an Oscar nomination for best adapted screenplay (though he lost to Ron Harwood and *The Pianist*).

The genesis of *The Hours*, of course, lay with Virginia Woolf herself and her first great novel, *Mrs. Dalloway*. In the early 1920s, Woolf penned the story of a single day in the life of an upper-class Englishwoman as she plans and prepares a party for her husband, Richard. The conceit of the book is that all of the eponymous Clarissa Dalloway's life, from her memory of a single passionate kiss with another schoolgirl to her acceptance of death, can be encapsulated in just one day. Woolf was ahead of her time: Decades before the phrase "chaos theory" became a buzzword, Woolf was already exploring a key concept of fractals: that the whole can be found in the part.

Woolf battled depression and mental illness her entire life; feeling her sanity slipping away, she committed suicide in 1941. Decades later, a copy of her work fell into the hands of an American high school student named Michael Cunningham. "*Mrs. Dalloway* was the first great book I ever read," recalled Cunningham. "I was more interested in rock 'n' roll and smoking cigarettes. Then this girl I liked a great deal sort of became exasperated with my stupidity, and shoved this copy of *Mrs. Dalloway* at me, and said, 'Here, read this and try to be less stupid.' I wasn't positive I wanted to be less stupid, but I wanted to give it a try.

"So I read the book and of course I didn't understand it, but I did get the complexity and density and beauty of those sentences, and they were a revelation. I remember thinking, *She's doing with language something like what Hendrix does with a guitar.* It opened up the world of books to me. I wasn't opposed to books before. I just thought they were sort of dusty old things that were kept in book cemeteries. From *Mrs. Dalloway*, I learned that they can be living, active, ongoing parts of our consciousness."

Later, Cunningham read Hermione Lee's biography of Woolf, which made the writer and her life even more intriguing for him. The experience inspired him to write a present-day version of *Mrs. Dalloway*, taking the title of his book, *The Hours*, from Woolf's original working title.

The Hours does more than update Woolf's story; it extends her conceit, a woman's life revealed in the course of a single day, to three women: Woolf

herself, who faces a crisis with her husband, Richard, over a day during the writing of *Mrs. Dalloway* in 1923; a housewife named Laura Brown in 1951 Los Angeles, whose life is altered forever one day as she reads *Mrs. Dalloway*; and a book editor named Clarissa Vaughn, a contemporary version of the Mrs. Dalloway character. Clarissa revisits the entire arc of her life over a single day as she plans a party for her AIDS-stricken former lover, Richard.

Writer, reader, character: These three story lines show the relevance of Woolf's ideas across generations and reveal the power of a book to change our lives.

"It can sound like a kind of dry, academic exercise, to write a book based on another book," said Cunningham. "But for those of us who love books, certain books have been huge, cathartic, deeply emotional experiences. The fact that some girl was mean to you in college or the fact that your father was occasionally cranky when he got home from work are suitable subjects for a novel, and the first time you read Tolstoy is not, seems odd to me. It seems to underestimate what books and art in general can do. I did want to write a book about how much reading can mean."

For the writer essaying an adaptation, however, this does present a paradox. *The Hours* is, at least in part, about the power of literature. So when a reader enjoys the book, he's sharing the same experience as Laura Brown and can be moved in exactly the same way. It's a powerful structure that helps draw the reader into the story.

Movies sometimes use similar scenes to great effect. What movie lover doesn't relate to the early scenes of *The Purple Rose of Cairo*, as Mia Farrow flees her awful home life by going to the movies? Watching *The Green Mile*, only the flintiest heart could fail to be moved by the grin on doomed Michael Clarke Duncan's face as he watches and enjoys his first and only picture show—a Fred Astaire musical.

But those are movies within movies. *The Hours* had a book within a book. A book within a movie? Problematic. Is there anything less "cinematic" than watching someone read? It's yet another reason most thought the book was unfilmable.

Yet Scott Rudin thought otherwise. Before *The Hours* won its awards, Rudin saw a movie in it and decided to send it to David Hare, then best known as a playwright. By 2003 Hare had had nine plays produced on Broadway, including *Plenty*, *The Blue Room*, and *Via Dolorosa*. Many have included great roles for actresses; Meryl Streep had appeared in the film of *Plenty*, while Nicole Kidman earned great reviews in *The Blue Room* in London and New York. He

wrote the film *Damage* for director Louis Malle, and wrote and directed *Wetherby* in 1985, but he generally prefers playwriting to screenwriting.

Rudin had come to know Hare while producing some of Hare's plays on Broadway. "Scott knew how reluctant I am to work in the cinema," said Hare. "But he was convinced that this was something I would want to do, and he was right."

Coincidentally, Hare works in a former artist's studio in London that was once used by a member of the Bloomsbury Group, Woolf's creative circle. More important, he saw that—despite the doubters—there was a movie in this book. "In fact," he said, *The Hours* was based on what he considered "a very cinematic idea, which is: There are three stories, you don't understand the way in which they connect, and you play and tease with the idea that they will eventually connect. And when they connect, I hope it's satisfying to understand the way in which they connect." (The same interwoven story lines approach has been used to great effect in recent years, including *Traffic* [2000], *Crash* [2004], and *Babel* [2006].)

Hare began developing the script with Rudin and fellow producer Robert Fox in 1999. Hare began by having exactly one meeting with Cunningham. "He talked to me for six hours. I just let him talk," recalled Hare. It turned out that Cunningham had originally written a much longer book, which included detailed histories for all of the characters, and Hare was able to pick Cunningham's brain about even the most intimate details of the characters' lives.

The questions gave Cunningham great confidence in Hare. "He knew exactly the things to be talking about before you work on a screenplay," said the novelist. "It was not so much particulars of the story and how to manage the transition from one medium to the other as, who are these people? Where do they come from and how did they get to be the way they are? You need tons of knowledge about that to produce a character who feels plausibly alive, even though the audience doesn't get anything like the information you've got in mind." Before they parted, Hare remembered, Cunningham gave Hare his blessing. "[Michael] said something wonderful to me," said Hare, "which was, 'I've done one thing with this material; I now leave you free to do something else.' That was a wonderful act of trust from the author of a book to a screenwriter." From then on, Hare worked only with Rudin and Fox.

Besides the structure, there were some elements of the story he was determined to preserve. One was the characters' fluid sexuality. "The characters are

neither gay nor straight," said Hare. "On the contrary, sexuality is almost an electric charge which at any point can suddenly flow between two characters of either sex, almost arbitrarily. There was a modernity to the sexuality that I thought was very original, and which we haven't seen a lot of in the contemporary cinema."

He also wanted to maintain the pleasure a reader feels in watching how the story lines, which seem so irreconcilably separate, eventually mesh and become one. "It's like watching a machine, like taking the lid off a watch that works. The moment when you learn that Ed Harris is actually Julianne Moore's son is the moment the tumblers fall into place and the safe opens. And there's a great mechanical pleasure in that, I hope."

There would have to be changes, though, too. The book reveals Clarissa's memories of a summer when, as a young woman, she lived in a ménage à trois with Richard and another man, Louis. Hare spent his three years on the project fighting to keep those scenes out of the movie.

"By and large, our memories of how our most powerful feelings are exist in our heads. I think by embodying those memories in corny pictures of people running along seashores, you don't do them any service. I wanted to summon them up with words and the actors' intensity, not with a whole bunch of young people who don't even look like the young Meryl Streep and the young Ed Harris and the young Jeff Daniels. It just seemed to be a nightmare to go down that course."

The story's intricate three-sided structure also dictated cuts. One of Woolf's themes was that all lives are interconnected. To develop that idea in the screenplay, Hare needed to pare away anything in a given story that didn't somehow connect to the other two stories. That meant that many subplots had to go, especially one involving Clarissa Vaughn's daughter. "In the book," he said, "she's being besieged by a gay woman teacher at her university who is desperately in love with her and who makes Clarissa feel very bourgeois. So there's an argument there about whether sexual politics is or isn't radical politics. I simply didn't see how I could incorporate that in a way that illuminated all three stories."

Hare also realized that while two of the story lines are inherently dramatic, the third is not. In 1923, Virginia Woolf is either going to leave the suburbs—or kill herself. In 1951, Laura Brown realizes she is going to have to either leave her family—or kill herself. In 2001, Clarissa Vaughn is going to host a party—and it could be spoiled.

"So to me," said Hare, "the texture of [the third] story was harder to find, because it is essentially Richard who is the suicidal character, not Clarissa Vaughn. [I had to] make Clarissa's story seem not self-indulgent. After all, she's a rich, well-off person in a stable relationship, with a lovely daughter. What's her problem? The cinema audience could easily have become impatient of her, compared with the terrible problems that Laura Brown and Virginia Woolf are facing. So balancing out the modern story with the two old stories was for me the biggest challenge of the screenplay." In the end Clarissa's story turns out to be the most dramatic of all.

The internal-action problem plagued Hare for months. In Cunningham's book, like Woolf's, the reader knows what Virginia, Laura, and Clarissa are thinking. Hare wrestled for months with the challenge of bringing their thoughts onto the screen. For a while, it looked like a voice-over narration would be inevitable, but he was determined to avoid it. That meant inventing new scenes and illuminating bits of business that weren't in the novel.

"That's the whole challenge of it," said Hare. "You know what Meryl was going through by the way she walked through the streets. Or you put in scenes of the party planning and so forth. Those are all my scenes, not Michael's scenes, but if you forgo the right to go into somebody's head, then you've got to write new events."

Hare said he had to invent such new elements for each of the stories. "In Laura Brown's case, there's a sequence of cross-cutting where she's driving and her son is building a toy house. It represents his connection to his mother, his need for his mother, which I couldn't write in the way Michael could, by slapping it down in prose. The film is full of those completely invented sections to illustrate what is going on inside the characters."

He invented a birthday party scene in the 1950s story, in which Dan Brown, Laura's husband, explains the vision of happiness that led him from his service in World War II to this tidy home and family. The irony, of course, is that by the time this scene plays out, we know that Laura is miserable beyond words. It's one of the story's unifying themes: that we all make choices for happiness, but those choices often make those around us miserable. The characters in *The Hours* discuss their moments of happiness, usually in the past, or their longing for it, in words that echo from story to story. Those echoes, and small bits of action that echo in the three stories as well, help give the screenplay a coherence it might otherwise have lacked.

"It's a Piece of Music"

DAVID HARE ON SILENCES AND MUSIC IN FILM

As a writer, how do you work with silences, with what's left unsaid?

That's what the great actors do for you. When Virginia Woolf goes out into the garden and is suddenly looking at that little girl and the dead bird so intently, we very deliberately [included] a great deal of dialogue on either side of those moments, and then there's silence, and the intensity of the silence. That only works if you've got an actress like Nicole Kidman who can deliver the intensity of the silence, but all that silence is always planned. You can only achieve it by contrasting it with periods of great kerfuffle and bubble. That's what screenwriting is, isn't it?

You talk as if the screenplay is a musical composition.

Basically. It's a piece of music, and that's why finding a composer was the most difficult thing with this movie. I kept saying I don't know how anybody's going to score this movie, because score is the thing that defines genre. The minute James Horner comes crashing in on *Titanic*, you know, "Oh, this is going to be a period romance." As soon as Hans Zimmer produces those wonderful bass notes, you know, "Oh, it's an action thriller." What was difficult was to find a composer who was not going to confine this film to genre. You had to find someone who was an artist, rather than a pasticheur. And the music is not pastiche. It's not there to define genre. I haven't spoken to Philip Glass, but I knew it would be a very, very difficult film to score, because he'd have to work around my music.

I think that music is a real problem now in the movies. Everybody—actors, director, writer, everybody—works with so much subtlety, and then at the last moment somebody comes along and pours so much sauce over everything. The meal is just drowned out in this brown gravy that is now poured over the movies all the time. I think it's insulting to the composer and insulting to the actors.

"David handled the transitions from one story to the other brilliantly," said Michael Cunningham. "I think it's one of those things that feels effortless in the movie because he went through a great deal of trouble."

In the long run, though, Hare admitted that making sense of the links between the stories and the transitions between them actually took a great deal of trial and error.

"At the point where you don't understand where the three stories con-

nect, you have to make connections that the audience instinctively feels are moving the story forward, even though they don't yet quite know how." These connections are enhanced by images that repeat from story to story: Every story sees a character crack an egg or drop a shoe.

Hare also juxtaposed long scenes with much shorter ones. He points to Clarissa's first scene with Richard, which lasts almost twenty minutes. "Everybody said, 'Oh, we'll shoot it, but of course it won't appear in the final film in its full form.' Well, it's pretty close to its full form [in the final cut]." Similarly, the end of the film features a very long scene between Virginia and her husband, Richard. "I deliberately wanted to jumble up, to work the way Virginia Woolf worked—very, very short scenes sometimes with very, very long scenes. This film is marked out by far longer scenes than movies usually support."

Hare did send the script to Cunningham at one point, and the pair recall only one note, which actually led to a lingering argument. In Cunningham's book, when Laura Brown goes to a hotel, she brings bottles of pills and realizes that she really is capable of killing herself. The realization was too subtle and internal for film, so Hare had Laura find a gun in the house and bring it with her to the hotel. Cunningham didn't buy it.

"I said, 'There's only one thing: I don't know about the gun,'" said Cunningham. "But [Hare and director Stephen Daldry] both felt fairly insistent about it, and I felt pretty insistent about how wrong it seemed. Because she wouldn't shoot herself—that's just not something this woman would do. She wouldn't maim herself like that. She wouldn't do that to the people who'd find her. She wouldn't do that to the *linens*.

"And they wouldn't even have a gun in the house. The more this went on, the more I began to think that because David [Hare] and Stephen [Daldry] are both English, they actually think all Americans are packing all the time. I don't remember if I said this or just thought it, but I have some recollection of saying to David, 'You actually think that if this argument goes on much longer, I'm going to pull out my gun and shoot you, don't you?'"

Hare's version won out—until Julianne Moore weighed in. "She said, 'I don't see this, I don't think I can play it,'" said Cunningham. "When you're losing an argument," he added with a laugh, "try to get a movie star on your side."

Hare worked for a year, writing alone, getting notes from Rudin and Fox. Now and then he assembled a cast of New York actors for a group reading, so

he could hear the words read aloud and get a sense of how it worked. Only when they were satisfied with the script did they approach Stephen Daldry to direct. Daldry was best known for 2000's *Billy Elliot*, but like Hare, he had received his greatest acclaim in the theater. His revisionist production of *An Inspector Calls* won him a Tony Award and had a long run in London's West End. He had also directed Hare's one-man show, *Via Dolorosa*, which Hare performed in London and on Broadway.

With Daldry on board, work continued as the cast was assembled. Moore had fallen in love with the book and jumped at the chance to play Laura. In fact, Hare said that Moore really wanted to play the character in the book more than the character in his screenplay. Meryl Streep, on the other hand, loved the book just as much, but worked strictly according to the screenplay.

That helped build a give-and-take with Hare. Daldry and the actors went through an unusually long rehearsal period before shooting started, helping Hare and Daldry to refine the cuts and transitions between the stories. The process also gave Hare the chance to incorporate the actors' performances.

"One of the great pleasures of this film is that [when you're working] with so many great actors, once you see a rehearsal you want to change the scene because of what they can express or bring to it without words, or with different words. If you watch Meryl Streep rehearse, you're a fool if you don't tailor what you're doing to what she can bring to it—the extra dimension she can add to it through her gifts." Hare refers to this process as "bespoke tailoring."

"Normally you have to be the director" to have that luxury, Hare noted. "It's more cumbersome, and it requires a great level of collaboration, which I don't think I could have done if I didn't know Stephen so well and he hadn't directed me as an actor."

He calls his arrangement on the film "utopian." He was included for the entire process, including filming and post-production. "I've been treated better than any screenwriter could reasonably ask to be treated, and not a single word has gone into the picture that wasn't my word," he said.

When I spoke with Hare and Cunningham in mid-October 2002, they had not yet discussed the film. Hare suspected that Cunningham would be uncomfortable with the additions and changes, but in fact he was delighted.

"I may be the only novelist who's completely happy with a movie made

out of his book. They did a great job. That's one of the things I have loved about this experience, from writing it on to this moment: the idea that an impulse that started with Virginia Woolf almost a hundred years ago just lives on and on and on, and keeps changing and keeps evolving, and stays in some ways the same and becomes in other ways enormously different. I think it is a huge tribute to the notion that there are great works of art that just stay alive, long after the people that produce them are gone."

One of Hare's changes involved a subtle bit of poetic license. The film is bracketed by scenes of Woolf's suicide; the only dialogue in these scenes is Woolf's suicide note, read by Kidman, in the film's only voice-over narration. The screenplay's final words tie the film together like a final musical coda, echoing words and themes from earlier in the film—even the title.

Yet those final words are not in the published version of Woolf's suicide note. Asked about where the lines came from and who wrote them, Hare grew uncharacteristically quiet. "Oh dear," he said after a long pause. "Well, this is not a question I looked forward to being asked.

"I wrote it," he finally confessed. "I wanted to restate the spirit of the suicide note, but I didn't want to use exactly the same words. So I was faced with what I regarded as a moral problem, which was, could I write a piece of Virginia Woolf that's not by Virginia Woolf? I'm not wholly at peace with it.

"The issue is, are you trying to deceive an audience into thinking that it's by Virginia Woolf? Because otherwise, I play completely fair, by the rules. When I read extracts, the extracts are authentic. In that case I'd written a piece of Virginia Woolf that I think is true to the spirit of what she felt, but she didn't write it, and that does bother me."

For what it's worth, Cunningham was pleasantly surprised by the moment. "If asked before they shot the movie, I would have said no, I think it's a bad idea. Then, when I saw that scene in the movie, it seemed perfect and dead right—which, if nothing else, gave me to understand that there are sort of different laws of physics at work in the movies."

For Hare, though, there's also the knowledge that movies become history, and that some non-scholars in future years may conclude that those final lines were the last thing Virginia Woolf ever wrote. Some console Hare by reminding him that *The Hours*, the movie, has its own integrity as a work of art, apart from Cunningham's novel, Woolf's *Mrs. Dalloway*, and the true

events of Woolf's own life. But Hare still struggles with the idea of passing his own words off as Woolf's.

"I'd be a bit pissed off at having lines attributed to me that I didn't write. Particularly if I were Virginia Woolf, who struggled so hard to write exactly what she wanted to write and nothing else.

"I apologize to her ghost."

Evening

CREDITS

DIRECTED BY Lajos Koltai
SCREENPLAY BY Susan Minot and Michael Cunningham
NOVEL BY Susan Minot
EXECUTIVE PRODUCERS: Michael Cunningham, Jill Footlick, Michael Hogan, Robert Kessel, Susan Minot
CO-PRODUCERS: Luke Parker Bowles and Nina Wolarsky
PRODUCER: Jeff Sharp
ORIGINAL MUSIC BY Jan A.P. Kaczmarek and Piotr Tatarski
CINEMATOGRAPHY BY Gyula Pados
FILM EDITING BY Allyson C. Johnson
CASTING BY Kerry Barden, Billy Hopkins, Suzanne Smith
PRODUCTION DESIGN BY Caroline Hanania
ART DIRECTION BY Jordan Jacobs
SET DECORATION BY Catherine Davis
COSTUME DESIGN BY Ann Roth

MAJOR AWARDS

Not available at press time

CAST

Claire Danes . . . *YOUNG ANN*
Toni Collette . . . *NINA*
Vanessa Redgrave . . . *ANN GRANT LORD*
Patrick Wilson . . . *HARRIS ARDEN*
Hugh Dancy . . . *BUDDY WITTENBORN*
Natasha Richardson . . . *CONSTANCE LORD*
Mamie Gummer . . . *YOUNG LILA WITTENBORN*
Eileen Atkins . . . *MRS. BROWN*
Meryl Streep . . . *LILA WITTENBORN*
Glenn Close . . . *MRS. WITTENBORN*

BUSINESS DATA

ESTIMATED BUDGET: N/A
RELEASE DATE: June 29, 2007
U.S. GROSS: $12.5 million
FOREIGN GROSS: $1.7 million (incomplete)

REVIEW HIGHLIGHTS

"The immediate problem with this ambitious, elliptical film is Koltai and editor Allyson C. Johnson's difficulty in establishing a narrative rhythm, as the back-and-forth shifts in time that seemed delicately free-associative on the page are rendered with considerably less grace onscreen. In ways reminiscent of Stephen Daldry's film of *The Hours*, the telling connections between past and present feel calculated rather than authentically illuminating."

—JUSTIN CHANG, *VARIETY*

"This is one of the rare movies that are too sensitive for their own good. In the course of it, in both the past and the present, all the characters have to spill their feelings about everyone else, and the pileup of hurt, rue, and guilt— confessions and reconciliations and partings—becomes oppressive. The structure that the filmmakers have created is too complicated and fussy for their fairly simple story and what it has to say about time and memory, and some of Koltai's directorial touches, such as a scene in which Redgrave imagines herself chasing little white moths in her bedclothes, turn poetry into kitsch."

—DAVID DENBY, *NEW YORKER*

EVENING • SUSAN MINOT
& MICHAEL CUNNINGHAM

n the spring of 2007, when the editors of *Script* asked me how I felt about writing a script-to-screen article about *Evening*, I took some time to think it over. On one hand, I had found Michael Cunningham quite engaging when I'd talked to him about *The Hours*. Furthermore, both Cunningham and Susan Minot, who'd written the book, were produced screenwriters as well as acclaimed novelists. That rarity was enticing all by itself.

My hesitation was for entirely personal reasons. The previous June, my mother had been diagnosed with an aggressive, almost invariably fatal form of cancer. As she was preparing for surgery, I had arranged to spend several weeks at my parents' home, helping them as best I could.

During my time with them that summer, my mother was taking a cocktail of drugs, some to treat her tumor, some to make her more comfortable, still more to control the side effects of the others. The combined effects of the medication and her illness put her in a nearly impenetrable fog for most of the day. She slept a great deal and communicated very little while awake. When she roused herself to speak, I sometimes understood her, but more often I didn't. It's not that her mind was gone; rather, it was elsewhere, flitting through an inner landscape to which I had no map. It would alight now and then with the friends and loved ones who had gathered to be with her, but only briefly. By the time I was approached about *Evening*, that fog had lifted somewhat, but even then there were moments when only my father, her companion for half a century, could divine her thinking. At times, even he was baffled.

So I was reluctant to dive into Minot's novel, and I found it no easier after I'd said yes. The story was told from the point of view of a woman around

my mother's age who is dying of cancer. In the final days of her life, at once doped on morphine and in terrible pain, thrice-married nightclub singer Ann Grant Lord finds her mind returning to the loves of her life: her children, including a son who died tragically, and her husbands, two of whom died before her.

Most of all, though, she revisits the great love—and great regret—of her life, a man she had a three-day affair with some fifty years before. Harris Arden was eight years older, a doctor, and though they pledged love to each other, he warned her almost from the start that he had a pregnant fiancée. To make the memory even more painful, their weekend together at a friend's wedding ended with a tragedy—a tragedy to which Ann and Harris indirectly contributed. As Ann lies dying, that long-ago love occupies her thoughts, and it is Harris she imagines herself speaking to. But her grown children gathered at her bedside have never heard of "Harris." Is she delirious, they wonder, or does she have secrets they never imagined?

Evening proved that my experience at my mother's bedside, eager to share her remaining time but not quite able to reach her, is not unique. As it turns out, Cunningham himself had been through something similar not long before he was approached to adapt *Evening* for the screen.

"One of the reasons I agreed to do this was that my mother had just died of cancer and had been in and out the way Ann was," Cunningham recalled. "It was certainly one of the reasons that I spent years of my life on this story. It is one of the biggest things that happens to anybody—the loss of a parent."

Not surprisingly, then, Cunningham's screenplay stresses the plight of Ann's children more than Minot's novel does. But that is the least of the changes. Cunningham reinvented Minot's story almost completely, paring the novel down ruthlessly while finding at least one plotline in the story that Minot's novel barely suggests.

Minot said that *Evening* began as a short story called *Report from Nurse Brown,* which told the story of a dying woman's last new relationship—with her nurse—through the notes kept by that nurse. "That eventually became a couple of pages of the novel," she said. "I became more and more interested in what was going on in the mind of someone dying, and that's what the book became."

The book was first optioned by the Kennedy/Marshall Company, then affiliated with Disney Studios. Minot by that time had a formidable reputation as a novelist, and had written the screenplay *Stealing Beauty* for director Bernardo Bertolucci. By 1999, however, when Minot met producer Jeff Sharp,

then of Hart-Sharp (the partners have since split), at a wedding in Nairobi, Kenya, *Evening* was in turnaround at Kennedy/Marshall.

"He mentioned that he had liked the novel and asked about the film rights," says Minot. "I told him that Disney had put the project in turnaround, and some weeks later he contacted me about getting the rights and having me write the screenplay."

Minot relished the prospect of finding new angles on her story. "There were things I knew about these characters which perhaps never made it into the book. I liked reexploring their story. I liked being forced to think in only visual and audio terms." Her biggest challenge was simply "boiling it down"—a hurdle Cunningham would also find daunting.

When a few years passed without a production in sight, Jeff Sharp approached Cunningham to consider working on the project. *The Hours* had brought some fame to the novelist, and by now he had completed a screenplay for the film adaptation of his own novel *A Home at the End of the World*. It was his first screenplay.

"I wrote fiction for twenty-five years before I even thought about writing screenplays. I only started writing screenplays when I was asked to; I never just sat down and wrote a screenplay of my own volition," he says. But that doesn't mean he found it a chore. "My early sense was one of almost ecstatic relief [to be going] from what I had been doing most of my life to something I didn't have to be especially good at, because I was new. You've been doing something for a long time, and you begin to have some reputation, and the pressure starts to mount, and then you get a gig doing something different—you're a beginner again. You have a kind of beginner's license, a beginner's recklessness. That was a fantastic feeling for me."

A House at the End of the World was in post-production, he remembers, when Sharp called him to ask if he'd be interested in adapting *Evening*. Cunningham had read the book some years earlier. His own mother's death was fresh in his mind when Sharp contacted him, and that drew him to the project. As he recalls, though, "I knew immediately that I would have to make very dramatic changes. There are, like, a hundred characters [in Minot's novel]—[and] just enough events for a novel, but half again too much for a movie. Pregnant girlfriends and all that.

"I asked Jeff to tell Susan I'd love to do this, but if I were to do it, it would involve significant changes, and if she had a problem with that, I would just pass on the job. My first loyalty is always to my beleaguered fellow novelist, and the last thing I wanted was to be somebody who messed

up someone else's book. Susan, to her enormous credit, got back to me via Jeff and said, 'No, I assumed you would make enormous changes. Please go ahead.'"

Cunningham didn't find out until later that Minot had written a draft of the screenplay. "I think it really helps if you're not the [author of the work being adapted]," he says. "I couldn't have adapted *The Hours*. You're too immersed in the story as you told it in the book, and I think it can be really helpful to have somebody come in who sees the story from a different angle and can be objective about it."

Cunningham chose not to reread the novel while working on the script. But he remembered the book well enough to say that "the two versions are quite different—not just in terms of characters omitted, but in terms of some fundamental emotions and implications about what happens. I think I have a somewhat different take on Ann Lord than Susan did."

One major difference had to do with that old bugaboo, likability. "The Ann Lord I remember from Susan's novel is a less sympathetic character than the dying woman I wanted to write about. Sympathetic is a tricky term, often used to mean 'nice.' Who wants to know about a nice character? 'Sympathetic' to me has more to do with [demonstrating] how this character explains herself to herself.

"What I was really interested in was the whole notion that at the end of one's life, one could be confronted with the big motherfucking version of all those little nagging regrets that have plagued us throughout our lives. 'If only I'd said yes that night—if only I'd taken that job—things would have turned out differently.' For Ann, in both the novel and the movie, it's this brief affair with a guy who was able to remain untarnished in her mind because she didn't have time to get to the little domestic arguments and the hemorrhoids and the hair in the sink.

"It was my impression from Susan's book that to a certain extent Ann is right: She fucked it up, she failed to rise to the occasion of true love, and it never came again. Which isn't my feeling about love or life.

"I wanted to write a story about somebody who at the end of her life is fortunate enough to understand, before the lights go out, that there is nothing to regret, there is no missed chance—that's just an illusion. It's your life, [and] it's been a great gift, no matter how it went."

In the book, Harris simply wasn't available to Ann. She made no choices that led to their parting; he simply refused to leave his fiancée. Ann had no choice. So what, at bottom, was there for her to regret?

"I suspect that's part of the point," says Cunningham. "'Oh, little humans! Go ahead, die regretting something you couldn't have done anything about anyway.' That it's one of those jokes that God plays on us."

Cunningham started with a version that hewed closely to that of the book. But "part of the process of writing and rewriting and re-rewriting," he explained, involved "discovering, through trial and error, how much or how little the movie could bear." One thing Cunningham realized early was that he had to keep things moving briskly. "You can't make [all] this stuff happen in a script that's a hundred and twelve pages long." The Ann of the book had three husbands, two daughters, and two sons. Cunningham would cut one husband and both sons—including the tragic death of one—from his version.

"At a certain point, I almost felt as if I were hovering over this crowd of characters looking for somebody to focus on. All writers, especially writers who adapt from one medium to another, have to be at least a little bit heartless. Too many sisters; too many people in Ann's bedroom. You're gone, you're gone." There were other cuts: Harris's fiancée is absent from the screenplay, and Ann and Harris's circle of friends in 1954 Newport was trimmed back to a manageable lot.

"As you go through it and look at it, you have these eureka moments when you realize 'Okay, the lifeboat is foundering. There are too many people in it, people have brought too much stuff on board. What can we leave out? What if Harris's girlfriend isn't pregnant?' You try it that way and the boat is still taking on water. Then at some point it's, 'What if Harris doesn't have a girlfriend at all? What if they can't have a life together—not because he is betrothed to another, but for reasons that have more to do with both character and the workings of fate?'"

On the other hand, some characters, notably the new bride Lila Wittenborn and her brother Buddy, were expanded and reconceived for the screenplay. Buddy even became a pivotal character. In the novel, he's a womanizing charmer, but just one of a plethora of characters in the wedding party. In the script, Buddy becomes the third leg of a love triangle with Ann and Harris—in love, it seems, with both of them. "Buddy seemed very compelling to me, the alcoholic wastrel son of a repressive family. He just felt interesting and promising."

In the film, in fact, Buddy is as central to the mystery as Harris: In the first few minutes of the film, Ann tells her daughters that she had loved not only Harris, but "Buddy too. Harris and I killed Buddy." Buddy's unrequited love

Solving the Movie Puzzle

A novel can include a sort of panorama of characters, a little like the Brueghel painting with Icarus going down in the lower right-hand corner of the canvas. That's one of the reasons there are novels. That's one of the reasons we need novels and we need movies. A novel can account for randomness and can include a wide range of people whose fates just barely impinge on one another. I can't think of a way to tell a story like that in a movie that I would want to see.

I think movies are more closely related to short stories than to novels. A short story actually involves the compression you need for a movie, whereas a novel is another category of thing entirely. Was it Henry James who called a novel a big, baggy monster? That's what it is. That's why we love them. I think a short story, very much like a movie, has no room in it for extra baggage. It needs to move, it doesn't need to move directly, but it needs to move swiftly. It needs to be lithe and light and nimble, and though that forty-page digression to the Crimean War and how it resembles what's happening at the family dinner may be interesting, there's no room in a short story for it. Nor is there room in a screenplay for it.

In adapting a novel, [what I do is] first to try to reimagine it as a short story. Reduce it to its fundamental elements, and then adapt that.

There's something a little bit mathematical about writing a screenplay. You have a certain number of elements. You probably have about two hours to tell the story; no one's going to make a five-hour movie, or a forty-five-minute movie, for that matter. And it's a little like solving a puzzle: Okay, these people, these events, this outcome. Tell it in two hours. *Go.*

That clock ticks relentlessly throughout every page and line of dialogue. There's no slack, there's no surcease, there's no room to stop and take a breath and provide a little background. It's tremendously structured. It's like doing sprints, as opposed to a marathon.

[Whatever you write], what you're doing is asking people to pause in the middle of their very busy lives and look at [your story]. Wait a minute, stop what you're doing and look at this! Don't have sex, don't have lunch, don't learn French, get someone else to pick up your kids at school and do this instead.

You'd better give them something that's tense and taut and deep and meaningful. Otherwise, the fact that you wanted to do it, [or that] it expresses some untapped beauty of your own soul, isn't enough. You're doing it for yourself *and* you're doing it for other people. If you don't understand that both elements are equally important, narrative in any form is not really the job for you.

for Ann becomes a mirror of Ann's longing for Harris, but Buddy meets a rather pathetic end in the book. When the young revelers go out to the shore at night, he falls asleep behind their pickup truck in a field. As they depart, they inadvertently back up over him, and he is fatally injured.

"Buddy's death resonates, very subtly, with the drunken, privileged recklessness of these people," Cunningham says. "I think one of the unspoken themes of the novel, and the movie as well, is money. What does it do to people who have a little more than they need? Part of the way Buddy's death functions in the novel is to help create this air of excess and waste."

Cunningham sees the "tininess" of Buddy's end in the book as part of Minot's intention, but gave him a more dignified death in the script, making him the victim of a hit-and-run accident while trying to catch up to Harris and Ann, who are on their way to a tryst. "As a character who got a significant promotion, I wanted him to get a better finish," says Cunningham. "I wanted him to die chasing after an impossible love."

As it all sorts out in the screenplay, it sometimes seems that everyone's in love with Harris. (Late in the film, when the older Lila shows up, she says as much.) Ann falls for him in hours, Lila secretly pines for him, and Buddy, long smitten with Ann, turns out to be pining for Harris, in some way, as much as his big sister is.

"This gets down to some of the differences in the laws of storytelling physics in writing a novel and writing a screenplay," says Cunningham. "A novel has time for loose ends and vast numbers of characters whose relationships can be little more than that they're part of the same novel. I don't see how you could do that in this movie. [With] two stories [past and present-day], you have roughly an hour for each one. Buddy and Harris and Lila need to have a story together. Each one needs to be an integral part of the story of the other."

Evening was in development for more than six years, and had several directors attached. Both Minot and Cunningham credit producer Jeff Sharp for his work during those years. "Jeff never let the project die," Minot says. "It is due to his perseverance that the movie got made." Director Tony Goldwyn also worked on the script with Cunningham for a long time, a period Cunningham remembers as an "ongoing friendly argument." When Goldwyn got another gig, though, Jonathan Caouette, who'd made a splash with his autobiographical documentary *Tarnation*, came on board.

Working with Caouette, Cunningham says, "I felt differently encouraged to make it more magical and strange. . . . It was like somebody came down in

a bubble, like Glinda in *The Wizard of Oz*. He had made this amazing documentary, but he wasn't a Hollywood guy, he wasn't a screenwriting guy. He would say things like, 'What if Ann could fly in one scene? What if she wandered into the woods and came back all dressed in leaves and branches?' Which was great fun. And, like any sensible person, I would say, 'That's a great idea, that's an interesting idea, but I can't do it.'"

Eventually Caouette left the project for another commitment, and the job went to Lajos Koltai, who showed little desire to change the script. "My relationship with Lajos over the last year has involved my saying about certain lines: 'No, I can see now this one sucks.' 'No, no, no, it's beautiful!' [Koltai would respond.] 'No, Lajos, it's melodramatic, let's take it out.'"

"One of the things about writing a script as opposed to writing a novel [is that] you're with it long enough to develop a certain objectivity about it. You begin to see that certain lines that seemed like a good idea at the time are not playing. That actually, when spoken by living actors, they feel stilted and melodramatic and should be cut."

The script attracted something of a dream cast: Claire Danes as young Ann; Vanessa Redgrave as the dying Ann Lord; Redgrave's daughter Natasha Richardson as Ann's daughter Constance; Toni Collette as her other daughter, Nina; Meryl Streep as old Lila; and Streep's daughter Mamie Gummer as her younger self. Patrick Wilson, fresh off his turn as one New England dream hunk in *Little Children*, played yet another: Harris. Hugh Dancy played Buddy.

Thereafter, the project was developed much like a stage play. Cunningham attended some rehearsals, and even spent time on the set, tweaking the script during production. The actors gave their input, but he calls the changes they prompted "smallish."

Cunningham admits he's still learning the lesson Don Roos summed up as "Actors bring eyes." "On film, gifted actors like Claire and Vanessa can bring so much innuendo and resonance to a character through the way they perform a particular scene that a lot of the exposition and history that feels satisfying and necessary on the page just feels extraneous on film." Specifically, several scenes showing Ann with her two husbands began to feel extraneous during the rehearsal period. "On the movie you don't really want pause and see all that stuff happening to Ann, when on paper it feels perfectly natural."

The ending also changed. The script ended with a flashback to Ann on-stage, and a tourist popping a photo of her, the image freezing on her smile.

"It seemed fine on paper. God knows a movie script is read by ten thousand people before the cameras start to roll." Cunningham even played the tourist, in what would have been his first-ever speaking role. "We watched the movie from beginning to end and said, 'It seems to come out of nowhere. It doesn't resonate.'"

"If any narrative, any putative work of art, is going to be effective, you have to be alert to the ways in which your plans, though understandable, have simply not worked out the way you thought they would," he says. "If you insist on the way you wrote it in the face of what's not quite happening on the screen, you're a fool. You're going to sabotage your own movie."

So the ending changed to a series of shots of day turning to night over the water at the house overlooking the bay. "And I'm no longer in the movie, which makes me so sad," says Cunningham.

Cunningham admits that there's one scene he wishes had not been cut down: a confrontation between Ann's two daughters over the direction of one of their lives. "I know it was a long scene, but I would have voted to keep it in its entirety," says Cunningham.

Another scene was added after Natasha Richardson was cast as Ann's daughter. "We realized [that], since we have Vanessa's actual daughter, she should have some kind of scene with Vanessa. I wondered what it [should] be, and I remembered the last couple months of my mother's life, when she was pretty continually tuned out.

"I remember wishing so hard that she could tune back in and be herself for ten minutes because there were things I still needed to tell her. I wanted her to acknowledge that I was taking good care of her, that I was being a good son. And then I realized, 'Oh, that's not going to happen.' Without understanding it, I'd had my last conversation with her quite a while ago." That feeling would become the inspiration for a monologue from Richardson.

In the film, that led to a small irony. Constance, the daughter played by Richardson, never gets that lucid moment from her mother. But Ann does have such a moment with Nina. That encounter gives Ann the chance to tell Nina exactly what she needs to move into the next phase of her life.

Cunningham says that the set of *Evening* was an unusually happy one. And with that too-good-to-be-true cast and the story's extraordinary literary pedigree, *Evening* seemed like a sure bet to be released in the fall, when it would be fresh for awards season and the Oscars. But its distributor, Focus Features, had several prestige releases for the fall and scheduled the film for

June. "We debated with Focus about that and finally deferred to their experience and conviction about June," says Cunningham. "It's always a gamble, you never know, but I think it's pretty safe to say that all of us who made the movie were thinking, yeah, it'll come out in the fall."

The June date may have been the first tipoff that this wasn't going to be the powerful film experience one might expect. As a film with a summer setting, at least in the 1950s scenes, the studio may well have opting to market the film to the youth market as kind of summer romance. Its ad campaign, with its upbeat music, seemed to pitch it as a "chick flick." On the other hand, the release date may well have reflected Focus's recognition that the film, despite its assets, simply hadn't come out good enough to be a serious awards contender.

Many of the reviews remarked that *Evening* should have stayed a book, not become a movie. Such comments should be taken with a grain of salt: Presumably they come from critics who've read the book and liked it, and people who've read any book and liked it tend to be dissatisfied with the adaptation. Some of the critics who disliked *Evening's* screenplay made a point of tweaking Minot for it, sometimes without mentioning Cunningham at all.

Focus may also have wanted *Evening* as summer counterprogramming to *Spider-Man 3, Pirates of the Caribbean: At World's End, Shrek the Third,* and *Fantastic Four 2: The Rise of the Silver Surfer.* If so, they miscalculated. Many of the summer's blockbusters held their audiences well, and the popularity of *Knocked Up* and some of the other hits of the summer left *Evening* with little room to find an audience. It grossed under $13 million in the United States.

It's hard to say exactly what went wrong with *Evening.* Everything is in place for a terrific film. In fact, everything may be too precisely in place. The prestige cast, the gorgeous vistas, the literary tone, even the wistful piano in the score: It's all exactly what you'd expect, which has the downside of being, well, exactly what you'd expect. Even viewers who hadn't read the book or the script, as I had, seemed to find something predictable about *Evening*—not in terms of the plot, but in terms of the emotions it evokes. For whatever reason, something about *Evening* didn't click.

Even as I spoke to Cunningham, he may have had some intuition that such trouble was coming.

"Everybody had an amazingly great time making this movie. Nobody was in any way difficult. So much so that we worried we were having too good a time making it, which meant we were putting some sort of curse on it

once it was out in the world. Apparently there's some old Hollywood super-
stition that successful movies are always hell to make, and if you had a good
time making the movie the way we did the movie is doomed to failure. I can
only hope that's untrue.

"But as Ann Lord learned, you can only have the experience you've had,
you can only do the best you can do, and you just can't know what the world
is going to make of anything you do. I still haven't gotten over the fact that
The Hours, the arty little book that was supposed to sell three thousand cop-
ies and then vanish to the remainders table, has changed my life the way it
has. Nobody thought that was going to happen. It really confirmed some-
thing I always suspected: It's always a gamble. Good work succeeds some-
times; good work fails sometimes. All you can do is what you're able to do,
and then wait and see how the world responds."

Kiss Kiss, Bang Bang

CREDITS

DIRECTED BY Shane Black
SCREENPLAY BY Shane Black
NOVEL (*BODIES ARE WHERE YOU FIND THEM*) **BY** Brett Halliday
PRODUCER: Joel Silver
EXECUTIVE PRODUCERS: Susan Levin and Steve Richards
PRODUCTION COMPANIES: Warner Bros. and Silver Pictures
ORIGINAL MUSIC BY John Ottman
CINEMATOGRAPHY BY Michael Barrett
FILM EDITING BY Jim Page
CASTING BY Mary Gail Artz and Barbara Cohen
PRODUCTION DESIGN BY Aaron Osborne
ART DIRECTION BY Erin Cochran
SET DECORATION BY Jeannie Gunn
COSTUME DESIGN BY Christopher J. Kristoff

MAJOR AWARDS

None

CAST

Robert Downey Jr. . . . *HARRY LOCKHART*
Val Kilmer . . . *GAY PERRY*
Michelle Monaghan . . . *HARMONY FAITH LANE*
Corbin Bernsen . . . *HARLAN DEXTER*
Dash Mihok . . . *MR. FRYING PAN*
Larry Miller . . . *DABNEY SHAW*
Rockmond Dunbar . . . *MR. FIRE*
Shannyn Sossamon . . . *PINK HAIR GIRL*
Angela Lindvall . . . *FLICKA*
Teresa Herrera . . . *NEWSWOMAN*
Daniel Browning Smith . . . *RUBBER BOY*
Jake Eberle . . . *PATROL COP*
Bobby Tuttle . . . *HOTEL CONCIERGE*
Stephanie Pearson . . . *TEEN HARMONY*

BUSINESS DATA

ESTIMATED BUDGET: $15 million
RELEASE DATE: September 14, 2005
U.S. GROSS: $4.3 million
FOREIGN GROSS: $11 million

REVIEW HIGHLIGHTS

"Deliriously enjoyable. . . . The duo make a whole greater than the sum of their parts, a couple of highly flammable actors as famous for their volatile off-screen reputations as for their redoubtable acting chops."

—LISA SCHWARZBAUM, *ENTERTAINMENT WEEKLY*

"*Kiss Kiss, Bang Bang* mocks, celebrates, wallows in and ultimately exemplifies the allure of the traditional Hollywood formula."

—MICK LASALLE, *SAN FRANCISCO CHRONICLE*

"Essentially a pumped-up screwball comedy with a big body count and a soupçon of gross-out, *Kiss Kiss, Bang Bang* clinches its status as a resurrection story . . ."

—J. HOBERMAN, *VILLAGE VOICE*

24 THE RETURN OF THE (SPEC) KING

KISS KISS, BANG BANG • SHANE BLACK

A s I said early on, there are many ways to define success in the movie business—and there are writers who fit every one of them. We've met some screenwriters who have enjoyed commercial success, such as David Benioff and David Franzoni, and others who have a cult of fans, including Sofia Coppola, Todd Solondz, John Waters, and Charlie Kaufman. All are successful in their own ways.

How many screenwriters, though, have defined an era in Hollywood?

The question itself seems nuts. We're talkin' *Hollywood*, baby, where screenwriters are lucky if they're allowed to define the arc of their own scripts. Stars and directors get the glory. Screenwriters get to go to therapy and scrounge for tickets for their own premieres. They do not get to define eras.

But there was a time, not so long ago, when screenwriters seemed to sweep through Hollywood like marauding Vikings. From the mid-1980s to the mid-1990s, they raked in seven-figure spec sales with shocking regularity. Call it a frenzy, call it a bubble, but for a while the spec market became a kind of lottery, where a high-concept script was the winning ticket. Whether it was Joe Eszterhas or a Kroger's clerk, it seemed like anybody could score a million-dollar sale in Hollywood. And nobody scored bigger than Shane Black.

Black and Eszterhas were kings of the spec when the spec was king. Black, for those who don't remember, was an aspiring actor (he was one of Arnold Schwarzenegger's commandos in *Predator*) who seemed to come out of nowhere with his first spec sale, *Lethal Weapon*.

His high-concept, bigger-than-life action specs *The Last Boy Scout* and *Last Action Hero* earned him escalating paychecks until *The Long Kiss Goodnight* found him topping out at an unprecedented $4 million sale. Anyone who was trying to break in as a screenwriter in those days knows exactly what Ken Nolan meant when he casually referred to this time as "the Shane Black era."

Black was the talk of the town. But he also became a lightning rod, and he didn't like it.

"I was just trying to write stories," Black recounted over a plate of green beans in a Hollywood Hills café, "trying to understand what it is creatively that I have to say, if anything, and present it as powerfully as I can. After a time, no one mentioned that [anymore]. It was all about the money. Every time I talked to anybody, it was 'You screwed them out of $4 million—you must be a pretty good businessman.' I don't want to be a businessman. I'm trying to write, [and all I hear is], 'Yeah, well, it's action movies. It could have happened to anybody. You were there, man, when they spun the wheel. You were the one. You won the lottery.' There was very little acknowledgment of the work."

So what did Shane Black do? He stopped.

For nearly a decade, there were only occasional sightings: the junior development exec who dated him a couple of times, the writers who heard him speak at a seminar. All told the same story—of a man unimpressed by his own success, uncomfortable with his own notoriety, and too introspective to enjoy his big paychecks.

Then, in the winter of 2003, Shane Black returned. And like a slogan from a trailer, this time, it was personal. Well, *more* personal, anyway.

That's not to say he came back with an autobiographical coming-of-age story. Rather, with *Kiss Kiss, Bang Bang*, he wrote and directed a modestly budgeted murder mystery quite different from the balls-out action movies that made his name.

Kiss Kiss, Bang Bang pays homage to the pulp detective novels and B movies of the 1930s and 1940s. It's the story of Harry (Robert Downey Jr.), a onetime magician and small-time thief who, while fleeing a botched robbery, ducks into a New York casting office and finds himself in line for the lead role in a movie. Sent to Hollywood to prepare for his role as a detective, he is paired with a real-life tough-guy private eye, Perry (Val Kilmer), who is unapologetically gay, though not obviously so. (The character's slug in the

script is "Gay Perry.") Harry is also reunited with his long-lost best friend and dream girl from high school, Harmony (Michelle Monaghan), a frustrated actress whose great claim to fame is her role opposite a talking bear in a national commercial.

Harry is still finding his way around La-La Land when a routine assignment with Perry leaves him framed for a murder. Meanwhile Harmony, who thinks Harry is a real detective, enlists his help investigating her sister's suicide. Harry, Perry, and Harmony bicker their way through a convoluted modern-day noir mystery reminiscent of the pulp novels Harry and Harmony grew up on.

Shane Black grew up on those stories, too—especially the detective novels of Brett Halliday. A Pittsburgh native who came to Los Angeles as a boy, Black was an aspiring journalist in high school who won prizes for his writing on the school paper. But everything changed for him when he went to the Universal lot to do interviews on the set of the TV series *Delta House*. So nervous he could barely speak, he interviewed some extras, then wrote an article about them. When he returned to school, his everyday surroundings "had all faded" in contrast. "It was like sepia tone. It looked ugly and bleak. This was not where I belonged. I felt I should do something in movies."

After high school, Black went to UCLA and studied acting in hopes of finding his way into show business. A few years later he turned to writing and began work on the first of the long series of action films that culminated with *The Long Kiss Goodnight* (1996). At the height of his success, Black was vilified for the over-the-top violence of his writing. In fairness, some noticed that the movies that got made from his scripts were never as violent as what was on the page, but that didn't mollify his critics. That such gory imagery could be such an effective sales tool seemed to say something bad about the industry. Black was making a lot of people uncomfortable.

Eventually, the feeling became mutual. "I felt a real aversion to Hollywood, and I think that Hollywood had become very averse to me, in a way," he said. "The whole environment had become sort of toxic. I felt I had stepped into a spotlight I wanted no part of. I'm happy to make money; who doesn't want to sell his script? But it was an unpalatable place to be. So for a while I just backed off."

But Black didn't just stop shopping his work. He stopped writing, too.

"Writing scripts is loathsome work, very difficult, and ultimately [I

realized that] my reward for writing a script was that I got to write another one. There was no fun in it. There was some money, but that to me was not sufficient reward. Just writing scripts and selling them, [just so I could] take a month off, feel good that I made a bunch of money, and then come back to the same set of problems and the same hideous task in front of me, was not appealing."

It took a few years before Black was ready to get back to it. Finally, he borrowed an office from his friend James L. Brooks and started writing a romantic comedy.

Six or eight months went by. He would show pages now and then to Brooks, but the veteran writer was puzzled. "It's not that this is all bad," Black recalled him saying, "it's that it's meandering. It's muddled. It's almost like you're trying to be me."

"Guilty," confessed Black.

"Maybe don't do that," Brooks replied. "Instead of going from A to Z, try going from A to maybe F. I pictured you doing something that was still a genre picture, like *Chinatown*, but not an action picture. Something that has a lot of twists and turns and a character-driven plot, but still a bittersweet ending."

That sage advice was all it took: Black turned his rom-com into a murder mystery. "All the runways sort of cleared out and everything arrived. As it arrived, I put it on paper. That took me another eight months."

Black wanted to craft a story that would feel like something from the pulp novels he'd loved as a boy, featuring heroes who were trying to fill the shoes of the old-time detectives but not up to the task. He remembered a Brett Halliday novel with a rich villain who imprisons his own daughter in an insane asylum, then uses a double to substitute for her in court, and got the idea of adapting that part of the plot. So he approached Halliday's daughter and got permission to use the plot.

As the script came together, it acquired a kind of loopy energy. "I have nothing to lose," he said flatly. "I've been very curmudgeonly the last few years, a little grouchy and grumpy. Not the best person to be around. Not even the most coherent person to be around. But when I did sit down at the typewriter, which is usually where I speak best, I just said, 'I'm going to throw in the kitchen sink.' I'm so pent up, and I have so many influences on this, I just tried everything."

He wound up with two hundred pages of script, far too many to get a

studio behind the film. He boiled it down to "a coherent hundred and twenty." In classic B-movie fashion, Black used a lot of narration. But his Harry Lockhart isn't merely an unreliable narrator, he's an *incompetent* one, constantly botching his own story line, doubling back when he realizes he's left out some vital piece of setup. That helps establish that Harry is a very ordinary guy trying to rise to an impossible challenge.

"These movies, these adventure films, the tough-guy movies, are about masculine archetypes, which we tried to live up to when we were young, but we can't, because nobody can live up to them. I grew up on James Bond, Sean Connery's Bond. No one can be Connery's Bond. The same is true of any iconic celebrity. In that respect, I thought it was important that I make the character noble, with a desire to be heroic, without quite having the ability to pull it off." In Black's view, the movie was about "finding in normal people the desire, if not quite the wherewithal, to be heroic."

To Black, the "ultimate question" posed by *Kiss Kiss, Bang Bang* was "If you really want to be a hero bad enough, can you just shrug off the real world, which tries to remind you at every turn of the impossibility of the task? Can you just say 'fuck you' to reality itself—say, 'I'm going to save this girl, I'm going to make this situation happen, because I believe in a hero. I'm going to spit in the face of the real world, and for a moment become something more than that, touch the myth for a moment'?"

In the movie's climax, Black has Harry perform physical feats that no human being could ever accomplish. For Black, it was a matter of layering reality with fiction. "He's dying, basically; he's been shot. But [Harmony] says a magic incantation, and he realizes he has to believe in things again, as purely as he did as a child." For those few seconds, Harry becomes as heroic as his beloved pulp detective. "He basically warps reality. Then reality's back."

Reality came back for Black in 2002, when he took the script out to buyers. "Nobody wanted to make the [film]," he recounted. "Nobody even wanted to read it." He found himself in meetings with green young development execs who were in grade school when he wrote *Lethal Weapon* and didn't know his name or his work.

A Black-Box Process

Writers are the low man on the totem, simply because writing is a black-box process. The studio buys paper, which is really cheap, throws it at some writer. They don't see what he does. They don't get any sense of his process. Then he comes back with a script. They say, "Well, we don't like this one." Then they give it to someone else to retype it, to move all the paper around. You can't reshoot things in this town for less than two hundred thousand dollars a day, minimum, but you can sure rewrite things to death.

After the big spec sale period came a period when movies had fifteen writers each. I didn't see the quality of scripts improve, I just saw more writers. But even then, I think writers in general don't have it in them to stand up without rancor. You hear writers whining about how bad things are without trying to change anything. People say to me, "Isn't it horrible that once the studio buys your script, they can change anything?" They say that with tears in their eyes. I say, "Yes, they can, but you're accepting it [as if] if it's inevitable." In fact you have to go in and argue as persuasively and compellingly as possible. [You have to] make friends with the people making the film, to take the director aside, court his creative collaboration.

The basic reason you enjoy a movie is the story. All the things surrounding [the story]—the photography, the style, the atmosphere, the design—all those things are quantifiable. But the most basic thing is so huge that if anyone understood it they'd already be king of the hill, and that's "What's a good story?" Not everybody knows how to light a movie, but everyone knows whether they like the story or not. It's also what makes the writer's task maybe the hardest task, because it's the least quantifiable, the most elusive. People who've made movies for twenty years will make a movie that fails, because the story didn't work. Making movies for twenty years doesn't mean you know how to make a good story. It's as elusive as "What's romantic? What's exciting?"

What I'm trying to say is [that] writing is a bag of tricks and no one really understands it or sees how it's done. If you want to light a film noir, [I can tell you to use] light from below, or use harsh top light, or add grain, or whatever. But I can't tell you what's romantic.

It's a frustration shared by many veteran screenwriters who've been through the same kind of meeting. Even more exasperating was the reception he got from people he'd met his first time around the business. "From the responses I was getting, it was clear that they hadn't read it. They'd skimmed it, or they'd had an assistant read it. One sent me a note saying, 'We don't

want to do a period piece.'" Fair enough—except that *Kiss Kiss, Bang Bang*, for all its noirish overtones, is set in the present day.

"Doors slammed, slammed, slammed. It was very humbling." The guy who hated the limelight had gotten his wish; he was being treated like a nobody. He realized he'd overcompensated, and he got angry.

"Why did I let these people influence me so much that I stepped out of the business?" he asked himself. "Because I didn't want to be in a negative environment? I didn't want them angry with me? Because pride goeth before a fall, and I didn't want the fall? What was it? I don't know, but I got pissed. This is ridiculous." He resolved to proceed with the film at all costs. "I don't care if they're angry with me. I don't care if I get slammed for this or if I make ten million dollars. I'm going to make it anyway."

So he wound up turning to *Lethal Weapon* producer Joel Silver, who had always been a supporter. "He was the only one who *got* the script," said Black. Silver told Black he'd produce the film—and hand over the directing reins to Black—with one catch: The budget would be only $15 million, not a lot of money for a movie with stunts and action elements.

The good news was that Silver wouldn't make him rewrite. There would be some cuts for budgetary reasons, but none for content. "For the first time, what you see on the screen is basically what I wrote," said Black. The writer saw an ironic lesson there: "The script I sold for the most money, *Long Kiss Goodnight*, was extensively rewritten. The one no one wanted, that I got paid the least money for? No rewriting."

Inevitably, Silver's commitment was followed by a period of courting big stars, with the proviso that if a star signed on, the budget would go up. So 2003 went by as the team waited for the likes of Harrison Ford or Mel Gibson to commit. "To his credit, Joel was willing to make the fifteen-million-dollar movie," said Black, "but Warner Bros. doesn't need to make that movie; they did it as a favor to Joel. And because it's Joel, his first instinct is, if we can get Harrison Ford, let's get Harrison Ford."

But after months of turndowns from Hollywood's biggest stars—especially for the part of "Gay Perry"—Silver and Black decided to go ahead and make the smaller film they had discussed in the first place. Robert Downey Jr. was available, and coincidentally so was Val Kilmer. That had Black and Silver wondering if they dared to cast such a notorious pair of Hollywood bad boys.

"They were on best behavior," said Black, acknowledging that their cooperation had as much to do with Silver's involvement as with his own skills

as a director. "These guys needed a shot in their careers. They behaved themselves. They needed to behave, but Joel was also ready to smite them."

With *Kiss Kiss, Bang Bang*, Black made his peace with the movie business. "I don't need to make four million dollars. But I want back in the spotlight. I want to make movies." And he had learned another lesson, right down to his bones: "Writing doesn't get easier, it gets harder. If you learn to make shoes, and you've been in the business thirty years, you can make a pretty good shoe, better than you did before; you can probably do it in your sleep. Writing is harder each time. Each time you write a script it's more difficult." For Black, writing the film was a conscious process of deconstruction and reconstruction. "With the love story and the murder mystery and all I tried to get into it, this was like a watch you've taken apart; the pieces were all over the table. I thought, *If I ever finish this, if this ever becomes a script and a movie, then the impossible is really possible.*

"The message of the movie is true: The impossible is possible. And I'll never worry again."

The Caveman's Valentine

CREDITS

DIRECTED BY Kasi Lemmons

SCREENPLAY BY George Dawes Green

NOVEL BY George Dawes Green

PRODUCERS: Danny DeVito, Scott Frank, Elie Samaha, Michael Shamberg, Stacey Sher, and Andrew Stevens

EXECUTIVE PRODUCERS: Don Carmody, Nicolas Clermont, Samuel L. Jackson, Shane Kinnear, Eli Selden, and Julie Yorn

PRODUCTION COMPANIES: Franchise Pictures, Epsilon Pictures, Jersey Shore, Arroyo Pictures, Homeless Film Productions, and Universal Pictures

ORIGINAL MUSIC BY Terence Blanchard

CINEMATOGRAPHY BY Amelia Vincent

FILM EDITING BY Terilyn A. Shropshire

CASTING BY Jaki Brown-Karman and Nadia Rona

PRODUCTION DESIGN BY Robin Standefer

ART DIRECTION BY Stephen Alesch and Grant Van Der Slagt

SET DECORATION BY Peter Nick

COSTUMES BY Denise Cronenberg

MAJOR AWARDS

None

CAST

Samuel L. Jackson . . . *ROMULUS LEDBETTER*

Colm Feore . . . *DAVID LEPPENRAUB*

Ann Magnuson . . . *MOIRA LEPPENRAUB*

Damir Andrei . . . *ARNOLD*

Aunjanue Ellis . . . *OFFICER LULU LEDBETTER*

Tamara Tunie . . . *SHEILA LEDBETTER*

Peter MacNeill . . . *CORK*

Jay Rodan . . . *JOCY PEASLEY/NO-FACE*

Rodney Eastman . . . *MATTHEW*

Anthony Michael Hall . . . *BOB*

Kate McNeil . . . *BETTY*

Leonard Thomas . . . *SHAKER/GREATER NO-FACE*

Sean MacMahon . . . *ANDREW SCOTT "SCOTTY" GATES*

BUSINESS DATA

ESTIMATED BUDGET: N/A

RELEASE DATE: March 2, 2001

U.S. GROSS: $687,000

FOREIGN GROSS: $199,000

REVIEW HIGHLIGHTS

"The filmmaker's preference for expressive, fluid, nocturnal, operatically 'feminine' imagery is emerging as her artistic signature. . . . There is a pleasure in giving oneself up to the gutsy swirls of the film's imagery."
—LISA SCHWARZBAUM, *ENTERTAINMENT WEEKLY*

"To watch Samuel L. Jackson in the role is to realize again what a gifted actor he is, how skilled at finding the right way to play a character who, in other hands, might be unplayable."
—ROGER EBERT, *CHICAGO SUN-TIMES*

"The film's pretensions and elaborately orchestrated ambiguities ultimately prove more off-putting than intriguing, spelling a limited commercial future."
—TODD McCARTHY, *VARIETY*

"ALL YOU NEED IS ONE
PERSON TO BELIEVE IN YOU"

THE CAVEMAN'S VALENTINE •
GEORGE DAWES GREEN

I end this idiosyncratic survey of the screenwriting landscape with an un-
likely story. The movie in question was not a smash. It's unlikely you've
seen it; hardly anyone did. If this were a "how to write a hit screenplay"
book, the story of *The Caveman's Valentine* would never have made the cut.
Sure, it was based on an award-winning mystery novel, and its author has
had two books turned into features. As a feature film, though, *Caveman*
grossed less than $700,000 in the United States, less than $1 million world-
wide, and it seemed to disappear without a trace shortly after its March 2002
opening. Though its story is built around an intriguing and very unusual
hero, and it had the advantage of being vetted in another medium before
coming to the screen, it can hardly be considered a template for anyone hop-
ing to make a killing in movies.

This isn't a how-to book, though, and the lessons of the story of George
Dawes Green and *The Caveman's Valentine* are subtle, yet also profound.
Green's experience is a reminder that any of us can have our *own* character
arc—that at any point we can throw off our inner shackles and achieve a level
of success we coveted but never dared reach for.

When I spoke to him, right around the end of 2000, George Dawes Green
was a prosperous and successful writer. He had two popular novels behind
him, had adapted his first novel into a screenplay, and was even branching
out into making documentaries. Eight years before, though, he'd been a
ne'er-do-well-turned-businessman returning to writing after giving it up
more than a decade before. The onetime poet had decided to try his hand at
a mystery novel, but had so much trouble getting his pages done that he had
to resort to desperate measures.

"I was so restless that I kept getting up from my chair and walking around," Green said. "I would forget what I was doing. I finally started tying myself into the chair. I just took a string and wrapped it around my arm and the arm of the chair, so every time I would start to get up I'd remember, 'Oh, I'm really not supposed to be getting up.' I kept myself tied to the chair until I'd done [a certain] number of pages."

That first novel was *The Caveman's Valentine*. It's a mystery—not a literary tour de force in the vein of *The Hours*, or a bestselling thriller like *A Simple Plan*. Nonetheless, it won awards and established Green as a novelist to be taken seriously, someone with enough ambition to be interesting while still being commercial. When *The Caveman's Valentine* was made into a movie starring Samuel L. Jackson and directed by esteemed indie director Kasi Lemmons (*Eve's Bayou*), Green went one better and adapted his own screenplay.

The film version of *The Caveman's Valentine* is intriguingly close to Green's novel, but its changes illuminate the profound differences between novels and screenplays. The film is a murder mystery featuring a truly unusual sleuth. Romulus Ledbetter is a paranoid schizophrenic, a Juilliard-trained pianist and musical genius. He is also a real-life caveman—famous for it, in fact. People on the street know him as "Caveman"; only those who know him well call him Romulus.

Romulus lives in a small cave in Inwood Park, in the northern reaches of Manhattan. A fiercely proud man, he is convinced that he is threatened by an evil mastermind who exists entirely in his own mind: Cornelius Gould Stuyvesant, who lives at the pinnacle of the Chrysler Building. Stuyvesant is a mighty lord of evil, whose minions include the bureaucrats and social workers who would coax Romulus into shelters, the police who help them, and any other evildoers in New York.

Romulus's cave has no electricity, but it has a television, which allows Romulus to watch the news of the world and receive taunting messages from Stuyvesant. (The television is unplugged, and the images all in his mind.) Then, one icy February morning, Romulus discovers a valentine from Stuyvesant just outside the cave: a young man's body, perched in a tree and frozen solid.

Romulus calls his daughter, Lulu, a police detective. The victim proves to be a homeless gay man named Scott Gates. Romulus soon learns from Gates's lover, Matthew, that Gates was certain he was marked for death. Gates had been spreading rumors that he had been tortured by no less than the world's

most famous photographer, David Leppenraub. No one would have cared about Gates's ravings, but he claimed to have a videotape to prove he was telling the truth.

What's more, Matthew explains, Gates had admired Romulus, considering him a truth teller. Matthew is sure that Leppenraub had his beloved Scotty killed. Romulus is certain that his nemesis Stuyvesant is behind Leppenraub, and that Stuyvesant arranged to leave Gates's body outside his cave as a perverted valentine. Romulus is furious when the NYPD treats the death as a simple case of a homeless man freezing to death. He sets out to prove Leppenraub is Scotty's murderer, enraging Lulu along the way. He is forced to fight through his own delusions to solve the murder and earn the respect of his only child along the way.

There's a long film and literary history, of course, of madmen with a sort of special insight, including the likes of Hannibal Lecter in Thomas Harris's novels and the movies that have been made from them. As a paranoid schizophrenic who solves a murder mystery, Romulus seemingly follows in that tradition. Yet Green says he never thought of his protagonist as having any kind of gift. "I thought Romulus was crazy," said Green flatly, "and I wanted that to be understood.

"When the book came out, so many people felt there was a great truth to Romulus's paranoia. I was adamant that there was no truth to it, that these elaborate conspiracies that we [all] come up with, about why we're not doing well in the universe and who or what unseen powers are trying to obstruct our powers or our process—that those things are imaginary and that really the only thing that prevents us from succeeding is ourselves. At the end, Romulus finally begins to understand that a little bit." Green points to a scene at the end when the image of Romulus's wife, Sheila, who appears to him like a muse throughout the story, tells him that it's all just craziness and that his conspiracy theories were nothing but his imagination. The Imaginary Sheila is the voice of the rational part of Rom's mind, and he knows it. "It's not a struggle he's even aware he's going through, but at the end of the book he finally has some glimmering that he is his own worst enemy."

Green confessed to some doubts about how this resolution would play on-screen. "What the movies always do is take imaginary enemies and make them real. So to go in the other direction is interesting." In fact, though, making imaginary enemies real is exactly what the movie version of *The Caveman's Valentine* does. One of the film's most startling visual elements is its on-screen depiction of the "Moth-Seraphs." In the book, Romulus thinks

of his illness as a function of these tiny winged creatures that live in his mind, but for the most part he's quite offhanded about it. When he feels his madness stirring, the narration might mention that he feels "a fluttering of the Moth-Seraphs," but there are no detailed depictions of the Moth-Seraphs themselves. They are simply Romulus's private metaphor for what he feels.

"The Moth-Seraphs are an example of why it's so difficult to make movies out of books," said Green. "The Moth-Seraphs are utterly indescribable, I think." Nonetheless, when Green was asked by Jersey Films to begin adapting his story for the screen, he chose to put the Moth-Seraphs on-screen.

It would prove a critical decision. At the moment when Green was finishing up his second draft of the screenplay for *The Caveman's Valentine*, writer/director Kasi Lemmons was finishing up work on her first feature, *Eve's Bayou*, which also starred Samuel L. Jackson. Lemmons had worked for years as an actress (she played Jodie Foster's FBI roommate in *The Silence of the Lambs*) and struggling writer, but with *Bayou* she vaulted to the front rank of independent film directors.

When Jersey Films asked Lemmons's agent to consider directing *The Caveman's Valentine*, she had to be coaxed to even read it. She was interested in working with Jersey Films, and Jackson was already attached to play Romulus, giving her the chance to continue her working relationship with the man she calls "the best actor in the world."

But filming *The Caveman's Valentine*—an oddball crime drama by another writer—wasn't the direction she thought she wanted to pursue. "I really didn't want to be a director for hire. I really wanted to write my own material. But my agent made me read the script and I said, 'Now this is exactly what I'm looking for.' It was me in a hundred ways. I had an obsession with reality, and what is completely subjective, and art and the meaning of art, and brilliance versus insanity, brilliance versus mediocrity." She also loved Romulus, who she described as "maybe the best character for a black actor that I had read."

There were also those Moth-Seraphs. "I had a long obsession with black angels, more specifically the lack of black angels in art. It had become sort of a political issue for me. So here they were, these black angels."

Green is actually vague about the precise appearance of the Moth-Seraphs, both in the book and in the script. "I didn't feel that creating the Moth-Seraphs was my responsibility," he explained. "I felt that was the responsibility of the people who do the costumes and so forth." But Lemmons was intrigued with the chance to put the Moth-Seraphs on-screen. "I think it was an incredible choice." In her vision, the Moth-Seraphs changed from

something a reader can easily understand but may not be able to visualize, to something that the audience sees but may not understand. "You hear [Romulus] talk about them in the movie, but you don't know what they are. You have a general sense that they're his Furies, they're a manifestation of his insanity, certainly, and something that seems to work with him and against him. He uses them to muster up courage."

Nor are the Moth-Seraphs the only specific manifestation of Romulus's madness. He must also grapple with a new weapon: the seductive "Z-Rays," which come at Romulus in the guise of kindness. "They do represent kindness, but they also represent compromise," explained Green. "Their very greenness is sort of wrapped up with money and living in the world. At the time when I originally came up with them, these were all issues that were extremely important to me personally, issues that I was really grappling with. Romulus is really based on me."

It is hard at first to put the soft-spoken, intellectual Green together with the raving madman of his book. To see the connection, you need to know a bit more about Green himself.

"It's a very long, strange journey," said Green of the road that brought him to his writing career. He is from an island near Savannah, Georgia, where he dropped out of high school. "I started hitchhiking around and taking odd jobs here and there, and eventually I wound up living on a farm and writing fables. I started to publish these in literary journals and started to get a reputation as a poet.

"Then one day I decided I didn't want to live this monkish existence anymore," he explained. So after six years as a poet, he left the United States and traveled around the world. After about four years of traveling, he began buying handmade fabrics in Guatemala and Mexico. "Then I began to produce my own handmade fabrics, and began to produce what you would call fashion-forward sportswear for women, which we sold all over the world."

Green's clothing label, which he called Under the Volcano, brought serious money into his life for the first time—but that came at a price. "I was sort of chained to cash-flow statements and P&Ls. I had become a businessman, willy-nilly, and had never really wanted to. It was a life-changing adventure, and a very profound one. To be a businessperson is to understand the preoccupations of most of the people on earth. And [it wasn't] until I had done it, [until] I was walking around the streets worried about cash flow, that I began to realize that that's what most people were worried about. That had a very profound influence on my way of thinking."

Green's experience informed *The Caveman's Valentine*, with its portrait of one man's "constant struggle to survive day-to-day." As Green recalled, "What Romulus was doing, his day-to-day existence, somehow seemed more real to me having run a business."

In fact, one of the many tidbits from the book that didn't make it into the film involves Romulus's fierce pride at not being "homeless." He simply chooses to live in a cave, growing his own food in the summer, finding patches of earth to cultivate in parks and along railroad tracks. In his own eyes Romulus is free—perhaps the only free man in New York.

"He's able to hold on to this great freedom, and he can hear the chains clinking of the slaves all around him," Green says. "I believed that at the time about myself. When I was finally able to sell my business, even though I wasn't going to be making much of a living, I felt so much freer."

After seven years as a successful businessman, Green decided to return to writing. More specifically, he decided to *make a living* as a writer. "I felt I had to give it a shot. I felt I ought to be a writer, and I would be happy being a writer, and I could tell good stories. So I went ahead and said, 'I'm going to do it.' But I knew it was a great gamble."

That inherent risk was one of the reasons Green chose the mystery genre. One of his friends was the writer Andrew Klavan, who wrote the novel *True Crime*, which became a Clint Eastwood movie. "Here's my dear friend who always wanted me to get back into writing," Green recalled. "We had been struggling poets together. And he was the one who sort of recommended that I try the mystery form, which I always loved. So I guess when I sat down to write a mystery I was really serious.

"It was a big career change for me at a very late date. Very few people are starting their writing career at that time. There were a lot of people telling me that I ought not to be doing this. So it was very risky."

Green focused on an idea that had been kicking around in his head since he'd read the germ of it in a newspaper article about a murdered Juilliard-trained musician who had been living in a cave in Inwood Park. "Somehow in my head I thought this guy would make a fascinating detective." He knew he wanted to write a detective story, but he was in search of a "really challeng-ing" take on the genre. "So I thought, *What if I made [him] a schizophrenic detective?* I thought that would be challenging enough, since everything about a detective is about rationality."

For research, he spent a lot of time in New York City parks, even camping out in Tompkins Square, then a major encampment for Manhattan's home-

less. "There were lots of people living in the park and out on the streets who were college-educated. The thing is, if some kind of dementia descends upon us, it's as likely to descend upon extremely well-educated people as not."

By choosing a homeless, paranoid schizophrenic musical genius—and a man of a different race—as his protagonist, it may have seemed that Green was tossing the "Write what you know" rule out completely. "Romulus is a black man. Romulus is a paranoid schizophrenic. Romulus was a pianist who studied at Juilliard. And Romulus lived in a cave. And I am not any of those things, and I have not done any of those things," he said. "So it was a work of imagination to invent all of that. I can't think that it was any more difficult to put myself inside the head of a black than it was to put myself inside the head of a paranoid schizophrenic. But I could be wrong."

As Green sees it, "Write what you know" is advice to be taken with a grain of salt. "I think I know what it is to be human. I don't think I know much more than that. I believe that writers should create works of imagination. And that every character has to be imagined. So the idea that Toni Morrison shouldn't be writing about white characters because she's not white seems to me to be some strange invention of the late twentieth century, which I think will fade soon enough."

In fact, Green is quick to say that as far as he is concerned, he *is* Romulus, and Romulus is him. Green may not be black, a pianist, or a cave dweller, but Romulus's anxieties are Green's—especially the fear of Z-Rays. When Romulus finds Z-Rays—or compromise and danger, if you prefer—in an offer of kindness, it's a sign of Green's own anxieties coming through.

"I was going to turn away from the world of business and making money and reach for something more important, and it was a tough decision to make. I really did feel as if my life were being created by forces over which I had no control. I always felt as if I were struggling against the world. And I was beginning to understand, as I wrote this book, that my struggles were really wholly with myself, and I think that's what the theme of the book was, and to some extent the theme of the movie."

Green pointed to another illustrative passage from the novel that didn't make the movie. In the scene, Romulus's older siblings—all of them much more successful than he—throw him a birthday party. "My siblings had done the same thing for me. They just felt that there was something crazy about me, that I just wouldn't settle down, and I wouldn't reach out and accept success." For Green, the Z-rays "represent this offer of an easy life, of a warm, easy, wonderful life, but they also represent losing something of your

own soul. Because we do tend to lose our personalities as we reach for this life of ease. So there is something very powerful about people like Romulus. When I was on the street and talking to these [homeless] people, I did feel a great spiritual power coming from them. It's not something that's likely to cling to bankruptcy lawyers and dot-com CEOs."

Once he'd finished the manuscript of *The Caveman's Valentine*, Green couldn't find a publisher—or even an agent—for it. "It was just too strange. Nobody would touch it. I ran out of money while I was trying to find an agent. Then finally, just at the brink of giving up this career, I did find an agent, Molly Friedrich, and she was able to place the book with Jamie Raab at Warner Books." The book was published in hardcover in 1994.

"It immediately became a big hit, and it won the Edgar Award for best [first novel]," remembered Green. "And when I won the award I immediately became celebrated among the same editors and agents who turned down the book. It was very strange."

He soon wrote another novel, *The Juror*, which was made into a film starring Demi Moore and Alec Baldwin. But Green wasn't involved in writing the screenplay. Instead, by 1996 he'd thrown himself into work on the screenplay of *The Caveman's Valentine*.

"When I work on a script," Green said, "I spend all of my waking hours writing until I'm done with my first draft. What I tend to do is go away with somebody, with a secretary, to some remote location, and dictate the script at a very rapid rate. I love to dictate, because it keeps me focused. And then I go back and slowly start editing it. But I like the idea of a script just pouring out quickly."

To write *The Caveman's Valentine*, he took his assistant to upstate New York. "We just really slammed away at it and did nothing else. I think the day we were done was the day I could finally go have a few Jack Daniels and shoot a little pool." He describes the initial writing experience as "pretty awful." Like many writers, he finds the basic work a challenge: "I don't like to write. I don't like to be cooped up. It's tough for me. But it's what I do, and if I don't do it for a while I start to feel a hollowness inside of me. But that doesn't mean that the actual process is easy. I'd always rather play than write."

He'd already written two drafts when Kasi Lemmons came aboard to direct in 1997, beginning a years-long process of rewrites. "The first script I read of *The Caveman's Valentine* was thick as a Bible," remembered Lemmons. "I think Jersey Pictures [sic] had told him to put all the stuff in that he loved from the book, and the script was just huge and unwieldy." Ultimately,

several sequences from those early drafts would be compressed or cut altogether.

Green recalled it as an intense process. "Kasi and [producer] Scott [Frank] and I would talk out a scene and I'd go back and do a draft and we'd all get together and tear it all apart again. Kasi took a crack at it, and then I took it back and rewrote it again."

Lemmons, for her part, minimizes her role in the rewriting. "I worked on it for years, the way that directors do. It's a process of becoming the project and making it your own—and yet, when we finally had the last draft of *The Caveman's Valentine*, it really wasn't mine. I went back and compared it with the first script I read, and even though it had been years and many rewrites, it really wasn't that far away. The thing that stayed the same through the entire process was Romulus Ledbetter. That character is completely George's. I felt uncomfortable even changing dialogue for him, because the character was so specific and full-blown and fleshed-out in his imagination, on paper. . . .

"At one point, George accused me of being too faithful," she said, laughing. "But I'm proud of that."

Of course, there were some changes. For one thing, Romulus's arc became simpler and more concrete. In the book, he seems mainly to be fighting fear while reconnecting with the human race. "It's an odyssey," said Lemmons. In the book, Lulu has accepted her father; in the film there's much more tension between them.

"In the book, I felt that Lulu was the one refuge Romulus [had from his] difficulties with the world. Lulu was the one thing he could turn to, the one oasis of love. And in the book it was Romulus who is resistant to Lulu's love—[he] is holding back from love everywhere. The world keeps reaching out to Romulus. So there was a shift in the movie. Romulus had this underlying wish to reconnect with the world, and that was symbolized by his relationship with Lulu."

Lemmons felt that there was much more tension between father and daughter at the outset of the story, and Romulus should focus more specifically on reconnecting with her. "I thought the relationship was very sweet in the book," she explained. "Even though as a reader I didn't mind it, I just didn't feel it was authentic as it could be. I felt it needed more pain. I felt it would be very painful for her to be abandoned by her father and then to be [a] cop trying to toe the line, and here's this guy who won't get help—that you love, though it's very painful to love him. So we made her a little more

arch. The relationship is not as sweet as at first. They kind of earn that in the film. It's something that George and I talked about a lot and I felt strongly about it."

One part of Romulus's character that never changed was his obsession with the story's villains, the imaginary Stuyvesant and the real-life Leppenraub. Lemmons explained: "There was something essential that I wanted to preserve, about the dynamic between two artists who are both obsessed with angels and are both in pain. Leppenraub changed a great deal, but there was a dynamic between the two men that I found very interesting."

Green had once had a girlfriend who had struggled to break into the New York art world, so he took a special pleasure in lampooning that world. "There is a sense that Leppenraub is a bit of a banality, that there's something slightly cheesy about Leppenraub's work. He represents some of the phony edge of the New York art world, the scene, the *monde*."

In the film, Leppenraub manages to be both a more intimidating and, ultimately, a more likable figure than his literary counterpart. One scene at the end of the story reflects the change. In the book, after the killer has been caught, Romulus has a drink with Lulu's detective boss, who has come to admire and respect "the Caveman." In the film, the scene is largely the same, but instead of a detective, Romulus's new admirer is Leppenraub himself.

"I see Leppenraub as a not-very-frightening person," said Green. "Romulus's reaction is terrified—[but] so many people are terrified of the New York art world and of the successful artists, and if the book is to be said to have a message, it's that these terrors are not real. . . . So I thought the last scene was kind of interesting and fun. When Romulus kind of sees who Leppenraub is, he's kind of a paper tiger all along. That's what Romulus is learning."

Green insists that he wasn't "trying to say anything" in the novel—that he was "just trying to get from one end of the book to the other." But he does feel that all of us, to some extent, are beset by terrors like those that dog Romulus. "We're all nursing conspiracy theories, [whether they're] our own personal theories or great, involved theories à la Oliver Stone. I think they're all garbage. Very seldom do we encounter these creatures of pure evil that we create in our heads. Leppenraub was an example of that. Romulus turned him in his head into a creature of pure evil. But he wasn't that at all. He was just an artist trying to make a buck."

Far more difficult than putting Leppenraub on-screen, it turned out, was devising a strategy for evoking Stuyvesant. Of course Stuyvesant doesn't exist, and unlike the Moth-Seraphs, he makes no appearance in the film. His

stand-in is the Chrysler Building, which punctuates the skyline of midtown Manhattan with its distinctive art deco crown.

Unfortunately, between the book's publication and pre-production on the film, the image of the Chrysler Building was trademarked by its owners, giving them legal control of its use. "I don't think it's ever been tested in the courts," said Green. "And I suspect that if it ever really did get to the Supreme Court that they'd have a hard time asserting that the skyline of New York is really under their control. But they contacted Universal's lawyers, and some rather protracted negotiations had to be conducted before we were allowed to use it."

"We had to have it," said Lemmons. "It was something that had to happen. I was lighting candles, meditating—whatever I could do to make that happen I would have done, because it was a major character in the movie." In the end, the deal allowed the filmmakers to use the image of the building but not refer to it by name. In the film it is known only as "that tower."

As the focus shifted away from Romulus's personal odyssey, pacing became a more critical concern. One sequence from the book, where Romulus hops a freight train to the South to track down some evidence, had to be cut completely.

"I think a motion picture is closer to a play than it is to a novel," said Green. "I think there's a sense that it needs to adhere to the [dramatic] unities. A major shift in locale at that point in the story seems more difficult to pull off in a motion picture. What you want to do [in a screen story] is always concentrate and focus your energy." Lemmons puts it more simply: That kind of shift in scene "just can't happen," she laughed. "At this point in a movie, nobody's going to go on that trip. Especially in a mystery. You just have to keep the pace going. And I had no idea, even after shooting and editing the film, just how far I was going to have to go [to make the film work]. It really is true, you have to keep the pace going."

For Green, who was getting his first taste of screenwriting, that proved to be an abiding lesson. "Screenplays are all about editing. Particularly when you're writing an adaptation, your editing muscle becomes so powerful. Because that's all you do, you just leave things out."

Another sequence that was cut found Romulus stopping into an upstate bar and entertaining the locals by playing piano for them. "It was an important piece of his journey, but it was sort of self-contained," said Green. "It's important when making a thriller to keep up the forward movement. It's a question Kasi really wrestled with; [for a long time she] was very adamant

about keeping Walter's Bar. I think she finally decided she could lose it." In fact, Lemmons wrestled with the decision all the way into editing before deciding that the scene was too much of a diversion to make the cut.

In the editing process, Green noted, "you take things that take four or five minutes of exposition and boil them down to one moment. The discipline of writing a screenplay is so unlike the discipline of writing a novel. You really do develop different muscles. I know that when I go back to writing fiction, having worked on a script, it's difficult for me to relax and get into the expansive mode of writing novels. When I was doing [the adaptation of] *Caveman's Valentine*, I began to think of everything I did in terms of editing. If I was ordering at a restaurant, I'd be angry with myself if I took seven words longer to order my scrambled eggs than I needed."

Green was happy with the film version of *Caveman*—happier than most screenwriters are seeing their story go through development. "As a writer I have a certain job to do," he said. "But there's also the work of the director, and Kasi Lemmons is a very powerful director with a very powerful imagination, and Sam Jackson is a very strong actor who has his own visions of the world."

As a screenwriter, Green says, "I don't want to be prescriptive as much as I want to be descriptive. I want to lay out a script for [the director and actors] that will allow them a certain amount of leeway. Kasi made her own choices with this movie, and I think she did a brilliant job. They didn't all come from the book, but I wouldn't want [all of] her choices to come from the book. I

Celluloid Monsters

GEORGE DAWES GREEN ON THE PAIN OF SEEING A BOOK MADE INTO A FILM

It's a very difficult thing for an author to watch a movie made from his book. John Updike talked about going to see *Rabbit, Run*, starring James Caan, which I guess was the first of his books to be made into a movie. It was a difficult experience for him, a harrowing experience. And he wrote that he himself was never going to be able to think of Rabbit again without seeing the image of James Caan. He expressed that these frail creatures of our imaginations, these characters that we create, are overwhelmed by these celluloid monsters that are twenty-five or thirty feet high. These images are so powerful that they can overwhelm and crush a book. I think he's resolved that he'll never go see another one of those.

wanted her to see this story in her own terms, and she did that. She re-created this story, and I thought that was a powerful thing . . . and the right thing for her to do."

When I spoke to Green, he had returned to writing poetry, hand-writing new verses in his upstate New York farmhouse. "I use a notebook and just sort of wander around," he said. When he is writing fiction, on the other hand, he sits at a computer, alone, with no distractions. "I have to go off in a little room and then work however many hours. I don't keep a regular schedule, but I try to work four or five hours a day."

Maybe the best news is that he no longer needs to tie himself to a chair to finish his pages. "I eventually learned. I don't have to do that anymore. That really is what it's all about, isn't it? I always laugh when people ask, 'Don't you have to wait to be inspired?' I don't know that I've ever been inspired. No, you just have to sit there and force yourself to confront the blank page. And if you can do that, that's ninety percent of the battle right there."

George Dawes Green did just that, putting aside the doubts of his family and the voices in his own head, all of which were whispering that the risk was too great. He wrote the book he wanted to write, and when it didn't sell right away, he didn't give up, or go back to the clothing business, or retreat to writing poetry. He kept on trudging up the mountain, and if he didn't get to the summit, he got closer than many of us ever do.

"The one thing that Drew Klavan told me when I was struggling along," he remembered, "was, 'All you need is one person to believe in you and all the others will come along.'

"He was right about that."

ACKNOWLEDGMENTS

I 'd like to thank the Academy. Really, I would—but since they haven't actually done anything to help with this book, I won't. On the other hand, there are many, many people who contributed to the creation of this book, or at least of its author, and they should not go unmentioned.

Many wise men and women have taught, counseled, or mentored me over the years in ways beyond enumeration. Some are gone now, alas, but none are forgotten: Tom Avery, Peter Stelzer, Jarka Burian, Peter Bennett, Nicholas Dunn, Gene Frankel, Meg Simon, Fran Kumin, Rick Leed, Bob Verini, Margery Kimbrough, Winnie Chung, Marcella Marlowe, Mike Tenneson, Robert O'Hare, Alex Wexler, Todd Cunningham, Michael Speier, Steven Gaydos, and Peter Bart.

Script magazine editor Shelly Mellott and managing editor Andrew Schneider were especially instrumental in getting me started in journalism and in making these interviews happen. My agent, Helen Breitwieser of Cornerstone Literary, saw the potential in my *Script* articles and with great skill secured my opportunity to complete this book. Calvert Morgan of HarperCollins improved the manuscript greatly and with his assistant, Brittany Hamblin, guided me through this thicket, answered many questions, and made a first-time author feel supported and well taken care of.

Special thanks to Anthony D'Alessandro of *Variety* for providing definitive box office figures for these films.

Particular thanks go to the many writers I've interviewed over the years, both those who are included here and those who are not. They have been extraordinarily generous in sharing their histories, their processes,

and sometimes their private thoughts. To them any glory really belongs, not to me.

Finally, my special love and gratitude go to my parents, Mort and Esther, and my brothers, Dan and Steve, who were patient with me when lots of patience was needed, and my wife, Sue Ellen, and stepdaughter, Miranda, who have been both an inspiration and the happiest of distractions.

INDEX

DAVID GLENN HUNT
MEMORIAL LIBRARY
GALVESTON COLLEGE